Blackburn
College

Library
01254 292120

Please return this book on or before the last date below

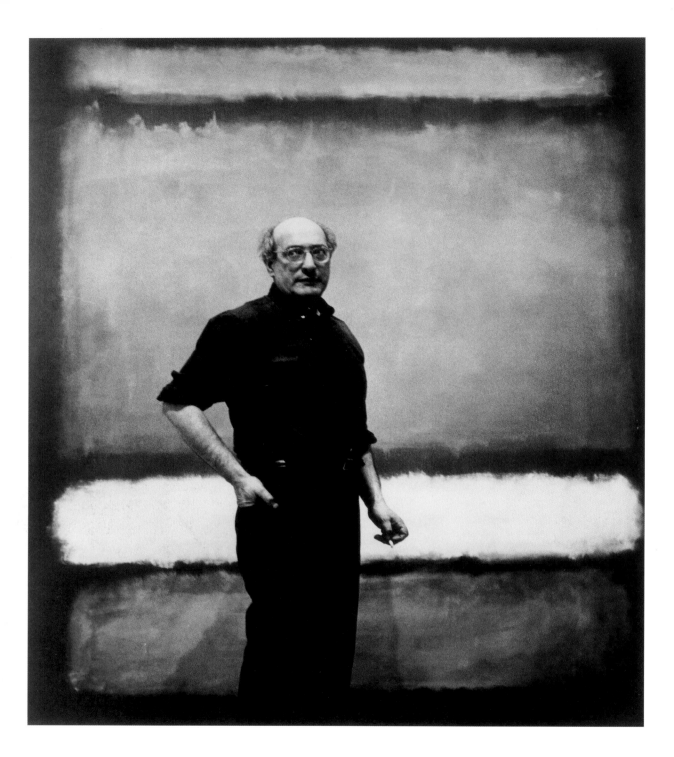

BONNIE CLEARWATER

THE ROTHKO BOOK

TATE PUBLISHING

First published 2006 by order of the Tate Trustees
by Tate Publishing, a division of Tate Enterprises Ltd,
Millbank, London SW1P 4RG

www.tate.org.uk/publishing

British Library Cataloguing in Publication Data
A catalogue record for this book is available from
the British Library

ISBN 10: 1 85437 573 3
ISBN 13: 9781 854 37573 5

Distributed in the United States and Canada by
Harry N. Abrams, Inc., New York

Library of Congress Cataloging in Publication Data
Library of Congress Control Number: 2006931282

Designed by Esterson Associates

Printed in Hong Kong by South Sea International Press Ltd

Front cover: *Light Red Over Black* 1957 (fig.78 detail)
Oil on canvas 232.7 x 152.7, Tate
Frontispiece: Mark Rothko in front of his painting *No.7* c.1961
Gallery Archives, National Gallery of Art, Washington

Measurements are given in centimetres, height before width

For James Clearwater
I extend my deep appreciation to Judith Severne, editor at
Tate Publishing, for her dedication to this publication, and
John Jervis for initiating it. Sarah Brown managed the
production with consummate skill, and Lillian Davies
assisted throughout the editorial stages. Alessandra Serri
was indefatigable tracking down the images for reproduction
and Jay Prynne and Kuchar Swara at Esterson Associates
provided the handsome design for the book. I extend my
thanks to Esther Park for preparing the manuscript and Sue
Henger, Sheldon Nodelman and the other readers for the
helpful suggestions. My research was aided by Ruth Fine,
Curator for Special Projects of Modern Art, National Gallery
of Art, Washington, Renée E. Maurer, also of the National
Gallery of Art, Carol Rusk, Benjamin and Irma Weiss Librarian,
Whitney Museum of American Art Archives, New York, and
Joy Weiner, Reference Specialist, Archives of American Art,
Smithsonian Institution, New York Office. A special note of
thanks to Morris I. Stein, Irving and Lucy Sandler and Donald
Blinken for their early encouragement. A very special thanks
to Kate Rothko Prizel and Christopher Rothko for providing
their assistance and permission to reproduce images and
text.

Bonnie Clearwater

Mark Rothko's signature paintings, composed of luminous, soft-edged rectangles arranged horizontally on large canvases, are among the most enduring and mysterious works of the mid twentieth century. He belonged to a generation of American Abstract Expressionist artists that included Jackson Pollock, Barnett Newman, Clyfford Still, Robert Motherwell, Adolph Gottlieb, Franz Kline, and Willem de Kooning, among others of the New York School, who began painting large-scale, generally abstract canvases in the late 1940s.

It took Rothko three decades to arrive at the paintings that would bring him world renown. With only a minimum of formal art education, he moved in stages from expressionistic representational paintings in the 1920s and 1930s, to canvases based on classical mythology in the early 1940s, followed by a period of Surreal abstractions, and finally arriving at pure abstraction by the end of the decade. This development was fuelled by his prodigious study of art history, his extensive reading of philosophy and psychology, and his exchanges with his colleagues.

Although recognition came late to Rothko, his position in art history was assured when, in 1961, the Museum of Modern Art in New York gave him a retrospective, at the age of fifty-seven. The critically acclaimed exhibition travelled to the Whitechapel Art Gallery, London, and then to Amsterdam, Brussels, Basel and Rome. Positive response to the work in London led to discussions between Rothko and Sir Norman Reid, then Director of the Tate Gallery, which resulted in a major gift of paintings to the museum. He did not have another one-man exhibition in his life time after the MoMA retrospective. During the last decade of his life, however, he received two major mural commissions, one from Harvard University, the other for a chapel in Houston. Both of these projects provided exceptional opportunities for new avenues to explore. These last years were also filled with illness and disappointments. Despite success and critical acclaim, Rothko, ill and depressed, took his own life on 25 February 1970.

Rothko and his contemporaries faced the dilemma of what it meant to be an artist during a period of great social change and human suffering as a result of the Great Depression of the 1930s, the Second World War, the Holocaust and the Cold War. In his writings of the 1940s, he observed that there is no doubt that artists are 'both changed and influenced by their environment.'[1] He also recognised that as time advances, distance allows art historians to identify influences that have contributed significantly to the understanding of the artist and his motivations. He saw the history of art as the 'demonstration of the inevitable logic of each step as art progresses on its way from point to point'.[2] He insisted throughout his career that his work was the result of his esoteric reasoning and that through his paintings he meant to inspire thought in the viewer. He succeeded in creating a new kind of pictorial space that provides ample room for us to think, feel and respond.

Introduction

This is a most opportune time to present a new monograph on Rothko. In recent years, several important resources have been made available that have provided invaluable insight into his paintings and career. These include a biography by James Breslin, the catalogue raisonné of the paintings by David Anfam, Sheldon Nodelman's in-depth study of the Rothko Chapel, an anthology of Rothko's writings on art, edited by Miguel López-Remiro, and the publication of a recently discovered manuscript by Rothko on his philosophy of art, edited by his son Christopher Rothko. Moreover, the general shift in current art-historical methodology away from formal criticism and chronological narratives has opened up new possible responses to his work, which are discussed in the following pages. Although these chapters are arranged chronologically, they follow the format of Tate Publishing's new series of artist monographs, by each focusing on a topic that will provide insight to the development of Rothko as an artist, the evolution of his philosophy on art, his relationship with other artists of his generation, and his position in art history.

Note about titles and dates
Many of Rothko's works have appeared with various titles. There is also some uncertainty regarding the exact date of many works as he rarely inscribed the year onto his paintings at the time of their creation. This book follows the titles and dates inthe catalogue raisonné by David Anfam unless specified otherwise by institutional collectors or noted by the author.

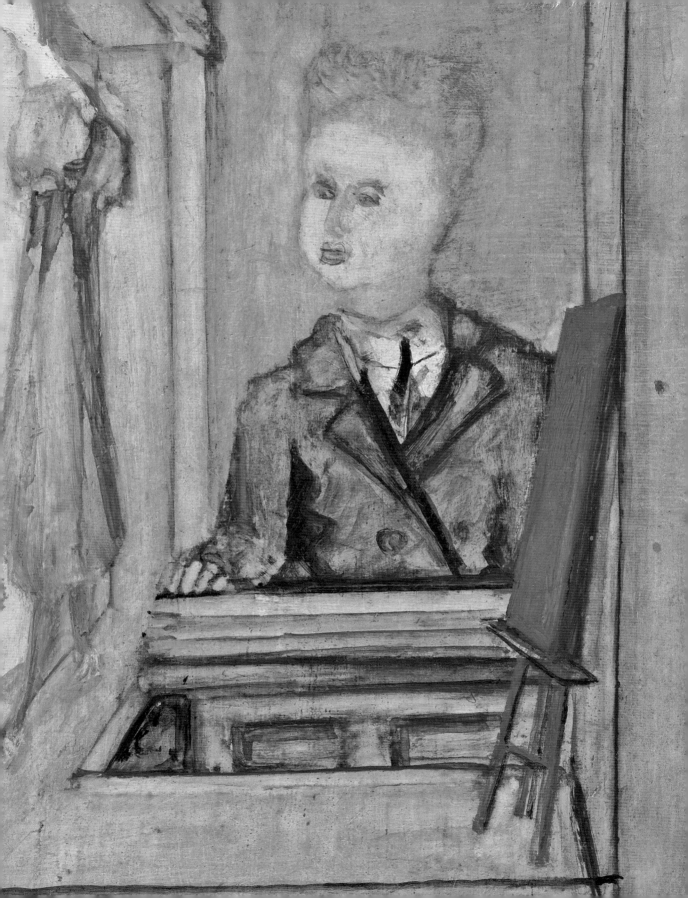

There is little in Mark Rothko's childhood to suggest that he was destined to become one of the most important artists of his era. Born Marcus Rothkowitz into a Jewish family in Dvinsk, Russia, in 1903, he witnessed the Russian persecution of the Jews and the terror of the pogroms. A pharmacist, his father did not prosper in Dvinsk, and like many American immigrants of the early 1900s, he left his family behind in 1910 in search of a better life for them. His older brothers Moise and Albert sailed for the United States two years later. Rothko, his mother, and his sister Sonia followed after a few months, arriving by second-class passage in Brooklyn and thus avoiding the hardship of most poor immigrants who passed through New York's Ellis Island. After a brief stay with relatives in New Haven, Connecticut, they continued cross-country to Portland, Oregon, where they were reunited with the rest of the family.

Rothko had landed in New York just a few months after the controversial Armory Show in the spring of 1913, which ushered in modern art to the United States. Marcel Duchamp's *Nude Descending a Staircase (No.2)* 1912 (Philadelphia Museum of Art), which was included in the exhibition, attracted most of the hostile criticism. In the autumn of 1913, just as the young Rothko was taking up residence in Oregon, the Portland Art Association showed this notorious work in an exhibition of post-Impressionist art.[1] Thus Rothko and modern art converged simultaneously in Portland, but it was unlikely that he and his family took note of this cultural milestone. Portland's residents, however, responded positively to the exhibition, and the accompanying lectures on modern art drew significant attention. Around the time of this exhibition, the Portland School District established an innovative art education programme involving museum visits and slide talks on art for children. Photographic reproductions of artworks were displayed in school hallways and classrooms.[2] These innovations in art education coincided with Rothko's enrolment in school. Though he would remark later in life that he was not exposed to art as a child, family members recall him spending time drawing, and in an interview with the *Sunday Oregonian* in 1933, he mentioned that he began his art education as a child.[3]

Rothko's father died in 1914, leaving the family to struggle financially. They did not encourage Rothko to pursue art as a career, having different hopes for the academically inclined youth. In school he showed a particular interest in literature, philosophy and social studies, and excelled scholastically, graduating from high school in just three years instead of four. During his youth, he developed a deep, life-long love of music and immersed himself in reading Greek tragedy, choosing drama as his elective at Lincoln High School. His intellectual proclivities and academic achievements gained him a scholarship to Yale University in New Haven, Connecticut.

From 1921 to 1923 Rothko followed a general programme at Yale, studying psychology (among other subjects) and

1 Early Years

aspiring to a career as a lawyer or engineer. He did not enroll in any art classes, but continued to draw and sketch.[4] Growing up, he had been part of an extended family in the Jewish community of Portland; a community united both by a common religious belief and by the immigrant experience. In contrast, his time at Yale made him acutely aware of the fragmentation of modern life. He was a minority in a student body that was predominantly upper class and Christian, and anti-Semitism was overt at Yale during his time there. As an outsider he became critical of the scions of the wealthy, who seemed to squander their entitlement at Yale. Rothko and two of his friends founded an underground newspaper, the *Yale Saturday Evening Pest*, which provided him with the opportunity to develop his polemical writing skills. His articles, mostly written anonymously, railed against the faculty and the students. The dissenting position and phrasing of these provocative articles resonate in his later writings and statements on art.

When Rothko and his fellow Lincoln High School classmate Max Naimark were recruited by Yale, they had been assured that tuition fees would not be an issue. By the second semester, however, their situation had changed: they were offered school loans instead of scholarships. Naimark left school at the end of the first year. By working part time and taking many of his meals with his relatives in New Haven, the Weinsteins, Rothko was able to enrol at Yale for a second year. Nevertheless, he began to lose interest in his studies, achieving only average or below-average grades. Despite his family's great expectations for his future, he decided to leave Yale without graduating in the autumn of 1923.

With no definitive plans beyond a trip west to visit his family in Portland, Rothko drifted to New York, where he took a few art classes at the Art Students League. He had tried acting as a possible career, but abandoned this plan when he failed to win a scholarship to the American Laboratory Theater in New York in 1925. Once again he turned his attention to art, enrolling in the New York School of Design, a small, commercial art school, where he could develop skills for a profession in graphic design. Here he took one class with the Armenian painter Arshile Gorky, who lectured to his students about the painting techniques of the old masters.

The defining moment in Rothko's emergence as an artist came in October 1925 when he enrolled in Max Weber's still-life class at the Art Students League. Weber is acknowledged as one of the first American Cubists (fig.1). A Russian-born Jew like Rothko, he immigrated to New York City in 1891, in his late teens. He began his studies at New York's Pratt Institute with Arthur Wesley Dow, one of the early proponents of modern art in America. In 1905 he sailed for Paris, where he studied under Henri Matisse in 1907. Still in his expressionistic Fauve period, Matisse communicated his reverence of Cézanne to his students. Weber was able to study Cézanne's work in depth in the Salon d'Automne in Paris in 1906 and at the major posthumous retrospective presented there the

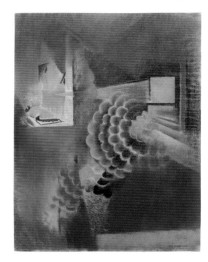

1
Max Weber
Slide Lecture at the Metropolitan Museum
1916
Pastel on paper
62.2 × 47.5
Metropolitan Museum of Art
Gift of Dr Irving F. Burton

2
Untitled [Landscape]
c.1928
Oil on canvas
66 × 81.3
The Klein Family, New York

3
*Untitled [Oregon
Landscape]* 1928–30
Oil on canvas board
50.5 × 40.6
Collection of Mr and Mrs
Marshall G. Berol,
San Francisco, California

following year. He returned to New York in 1910 and embarked on a Cubist phase, of which *Chinese Restaurant* 1915 (Whitney Museum of American Art), a prismatic kaleidoscope of geometric patterns, is among the best known examples. By the time Rothko studied with him, Weber had renounced Cubism in favour of expressionistic figurative painting that was an interpretation of Cézanne's style (fig.4), and he encouraged his students to study Cézanne's compositions.[5]

Weber was one of the most sought-after instructors at the Art Students League. Although Rothko's studies with him lasted only six months, they had a profound impact on his painting and philosophy of art. Weber's writings reveal the points he likely made while teaching. For example, he insisted that a painting had to be more than the arrangement of colour and form; it should suggest something profound and spiritual.[6]

It is significant that through Weber, Rothko's introduction to modern art was based on the study of Cézanne, rather than Picasso and Cubism. His paintings of the 1920s and 1930s and writings of the 1930s and 1940s reveal his admiration for the way in which Cézanne gave the sensation of physical weight to the objects he painted.[7] Rothko's *Beach Scene* c.1927 (A9), for example, is reminiscent of Cézanne's bathers, whose fleshy, modelled bodies seem more sculpted than painted. He also adopted Cézanne's technique for suggesting distance on the flat surface of the canvas by layering planes one over the other without the use of perspective. In the still life *Untitled* c.1926 (A6), however,

which also shows the influence of Weber, he used dabs of paint to build forms that project forward from the picture plane rather than recede into the distance. Similarly, *Sketch Done in Full Sunlight*, August 1925 (A4) is a cityscape constructed of overlapping facades. The buildings in the foreground are perceived as closer than those on the horizon, but the interlocking planes of the facades make the entire scene seem to protrude from the picture's surface.

Despite being enrolled in Weber's still-life class, there are few examples of this genre by Rothko dating from the 1920s. To Weber, still lifes were more than an arrangement of things. He stated in his *Essays on Art*: 'Culture will come only when every man will know how to address himself to the inanimate simple things of life. Culture will come when people touch things with love and see them with a penetrating eye.'[8] Weber's emphasis on 'things' may have influenced Rothko's approach to objects and eventually his abstract forms, which he referred to as 'things' he put on a canvas. However, in these early years, Rothko was drawn to representing living things rather than inanimate objects.

In the United States, in the decade before the First World War a group of artists that included Robert Henri, John Sloan (fig.5) and William Glackens were making urban life the subject of their radical paintings. Because of this they became known as the Ash Can School. They influenced younger artists including Edward Hopper, who was a student of Henri. Rothko similarly mined the rich subject matter of New York at the beginning of his career. Portraits and urban scenes populated by anxious city dwellers dominate his paintings during the 1920s and 1930s. He infused his works with emotional states that captured the struggles of city life. Friends and family members were among his models (fig.6), while his travels by subway provided him with an unlimited cast of additional characters to study. He made numerous sketches of naturalistically rendered fellow passengers on small pieces of paper. The subjects of some of these quick ink and pencil line drawings found their way into finished paintings after having been reworked in numerous preparatory sketches. Although the

4
Max Weber
Strewn Apples 1923
Oil on canvas
91.4 × 66
Gerald Peters Gallery,
Santa Fe, New York, Dallas

5
John Sloan
Nurse Maids, Madison Square 1907
Oil on canvas
61 × 81.3
Sheldon Memorial Art Gallery and Sculpture Garden
University of Nebraska-Lincoln, UNL-f M, Hall Collection

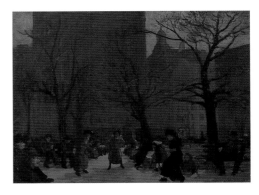

6
Head of Woman (Sonia Rothkowitz) 1932
Oil on canvas
44.1 × 37.1
National Gallery of Art, Washington
Gift of The Mark Rothko Foundation, Inc.

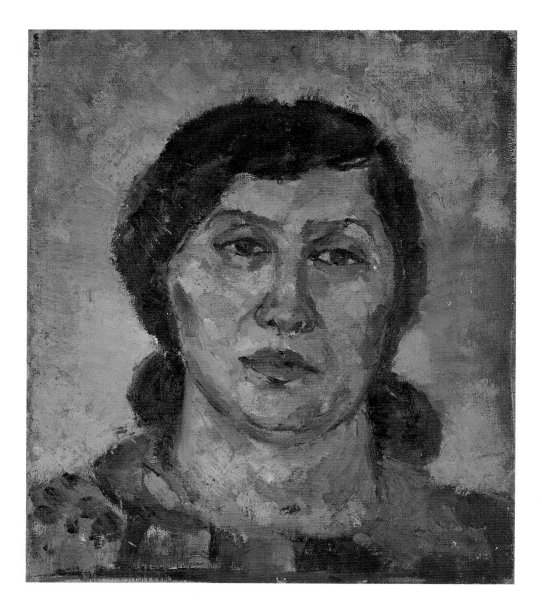

initial drawing was usually taken from life, Rothko would exaggerate and contort his figures in his paintings, placing them in an ambiguous space. His city dwellers often look lost in thought, and even when he painted groups, he tended to represent them as estranged individuals. His choice of deep earth tones and dark red and ochre contrasted with blues and greens, contributed to these ponderous compositions. This mood was typical of other artists working in this vein, most notably Hopper (fig.7).[9]

However, Rothko could also express human tenderness and bonding in paintings such as *Proposal* 1932 (A27), of a couple cuddling on a couch, *Family* c.1936 (A89), depicting proud parents doting on their cherubic infant, and *Untitled* 1924–5 (fig.8), in which two orthodox Jewish men are conversing in the street. Even without defining the features of these two figures, Rothko conveyed the intimacy of their encounter. The grey-bearded, stoical man, clasping his hands behind his back, attentively listens to his companion, who wears a long black gabardine coat and balances his weight on a cane. The two stand so close to each other that their overlapping coats fuse them together as one body, while their upper torsos lean away.

Weber encouraged his students to study ancient, primitive and modern cultures as a way in which to discover common ground between the art of the past and present. He noted that the more we study the art of antiquity, 'the better are we able to discern the new of today, even if the intent differs greatly from the art of the past'.[10] Rothko's early investigation into ancient art may have been stimulated by Weber, but he had further incentive to study it when he was hired in 1927 to draw illustrations for *The Graphic Bible*, a book by Rabbi Lewis Browne. The illustrations consist of maps of Israel and its neighbouring countries, animated with scenes and symbols that represent the accompanying text (fig.9). For this project, he studied the Metropolitan Museum of Art's collection of Assyrian art and consulted Friedrich Delitzsch's book *Babel and Bible*, which included images of ancient ornament and design.[11]

The linear, graphic style of illustration in *The Graphic Bible* was based on Browne's own illustrations for his previous book *Stranger than Fiction*, and had little in common with Rothko's expressionistic paintings at the time. Although Browne was initially supportive of the struggling young artist, he grew impatient with his work ethic. He deemed Rothko's work sloppy and dismissed him from the project. The artist in turn sued Browne and the publisher MacMillan for fees due and recognition in the book as illustrator, but lost the case.[12]

The 731-page transcript of the trial provides the earliest statements by Rothko on art. In his court testimony, he stated that it was an acceptable practice for an artist to trace images from another source if he 'imagined it useful' in carrying out his ideas.[13] He mentioned that he had learned how to enlarge and flip an image when he was a student at the New York School of Design. These techniques

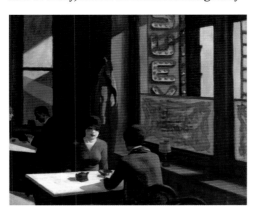

7
Edward Hopper
Chop Suey 1929
Oil on canvas
81 × 96.5
Collection of Barney A. Ebsworth

made it possible for him to transfer imagery from his source material to his illustrations in *The Graphic Bible*. Although this project was a disappointing foray into a potentially lucrative field of commercial art, the research he performed for *The Graphic Bible* would provide important source material for his Surrealist works of the early 1940s.

Fortunately for Rothko, he did not have to pursue commercial work after he was hired by the Center Academy of the Brooklyn Jewish Center to teach art to children in 1929; he would remain on the faculty until 1952. In preparation for his work at the Center Academy, which had a progressive curriculum that integrated secular and Jewish studies, he was introduced to new methods of teaching. The school sought to encourage spontaneous learning and develop the natural abilities of the students rather than force them to acquire facts. He was clearly impressed by the raw talent of his students, and was inspired by their natural approach to colour, form and space. The students also were very fond of him.

Teaching required Rothko to organise his ideas on art so that he could relay them to his students and other faculty members. By 1934, he published these ideas in an article called 'New Training for Future Artists and Art Lovers', in the *Brooklyn-Jewish Center Review*. He based many of his remarks on the observations he made of his own students, noting how children created art instinctively, whereas adults consciously order the elements in their work. If you watch children making art, he wrote, 'you will see them put forms, figures, and views into pictorial

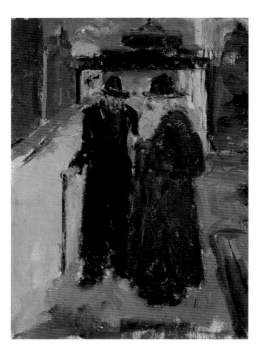

8
Untitled [Two Jews]
1924–5
Oil on canvas board
41.3 × 29.9
Marjorie G. Neuwin

arrangements, employing out of necessity most of the rules of optical perspective and geometry but without the knowledge that they are employing them', just as they are 'unconscious that they are using the rules of grammar' in speech.[14] Modern art, in Rothko's opinion, was closer to the elementary impulses of man than the paintings of the Old Masters, which are governed by style and tradition. He was convinced that if the conscious rules of perspective, composition, style, etc were eliminated from art, and the basic elements of painting revealed, artists would be able to develop a more immediate level of expression.[15]

During this time Rothko kept a scribble book, in which he jotted down some of his observations about the art of children. He noted, for instance, how a child may 'limit space arbitrarily and then heroify his objects or he may infinitize space, dwarfing the importance of objects, causing them to merge and become part of the space of the world.'[16] These reflections on the arbitrary nature of scale in children's painting correspond to his own approach to space at the time. In many of his paintings of the 1930s, he created a claustrophobic emotional space by cramming his colossal, broad-shouldered figures into tiny rooms, so that their heads look as if they might bump the ceiling (fig.10).

As a teacher, Rothko felt so strongly about the work of his young students that he shared his first solo exhibition in the summer of 1933 at the Portland Museum of Art with a display of their work. He also organised a show for his students at the Brooklyn Museum early in 1934.

This exhibition at the Portland Museum of Art in 1933 coincided with Rothko's trip to his home town to introduce his new bride Edith Sachar to his family. The couple had met during the summer of 1932 at a campsite on the shores of Lake George in the northern, mountainous region of New York State. Although the nineteen-year-old Edith was initially reluctant to become romantically involved with Rothko, they were married on 12 November 1932. This was a time of desperation for America, which was experiencing the depths of the Great Depression, and a particularly inopportune moment to embark on an art career since there were few collectors interested in purchasing works by unknown American artists. Rothko's salary from the Center Academy provided only modest support. In 1935, the United States Government established the Federal Art Project of the Works Progress Administration to provide employment for artists during the Depression, but Rothko, who did not become a citizen until 1938, was unable to secure financial assistance from the programme until 1936, when he enrolled in The Treasury Relief Art Project, and, subsequently, the easel division in 1937. Edith also contributed to the couple's income in the late 1930s with sales from the costume jewellery she designed. The extreme poverty of the time gave rise to several politically and socially liberal organisations such as the First American Artists' Congress Against War and Fascism and the Artists' Union. Although Rothko participated in these groups, concerned about the plight of artists during

9
Illustration in Lewis Browne, *The Graphic Bible: From Genesis to Revelation in Animated Maps and Charts*, pub. The MacMillan Company, New York 1928, p.64

Untitled [Nude] 1937–8
Oil on canvas board
60.7 × 46.1
National Gallery of Art,
Washington

the Depression and the spread of Fascism, he opposed the infiltration of politics into art.

The Portland Museum of Art exhibition in 1933 gave Rothko the chance to start building his reputation and attracting sales. Most of the works in the exhibition were watercolours of the mountains and forests of Washington Park outside Portland, where he and Edith had camped. The reviewer for the *Sunday Oregonian* wrote favourably of the works of Portland's former resident:

The watercolors are chiefly landscapes and studies of forests in which the artist has sought to return the effect of complexity one finds in the outdoors and to show its ultimate order and beauty. A hint of his admiration for Cézanne is in these watercolors. They are carefully thought out and in no way theatrical or dramatic, as are the temperas which were spontaneously conceived and executed and which depend on the richness of their blacks against white for effect. [17]

At the time of the Portland exhibition, Rothko told the reporter of the *Sunday Oregonian* that he had just been invited to hold his first solo show in New York at the Contemporary Arts Gallery (an association for the introduction of new artists in every field), and that his work was already in a number of private collections, including one in Germany.

In 1928, Rothko had met Milton Avery, an artist eighteen years his senior, who became an important early role model. Avery's simplified forms and flat areas of colour offered an alternative to Weber's heavily painted canvases (fig.11). Although figurative, Avery's paintings were devoid of narrative. In the late 1920s and 1930s, Rothko visited the older artist's studio almost daily and participated in the weekly life-drawing sessions at his apartment that were attended by other artists including Adolph Gottlieb, who became a close friend. By the time they met, New York-raised Gottlieb, also the son of Jewish immigrants, had been studying art since high school and had already travelled through Europe, where he frequented museums. The younger artists would summer with Avery and his wife Sally in the coastal art colony in Gloucester, Massachusetts, where the informal study sessions would continue.

Avery's dedication to his work was an inspiration to Rothko. In the memorial address he delivered for Avery in 1965, he revealed his deep respect for the late artist:

I cannot tell you what it meant for us during those early years to be made welcome in those memorable studios on Broadway, 72nd Street, and Columbus Avenue. We were, there, both the subjects of his paintings and his idolatrous audience.

There have been several others in our generation who have celebrated the world around them, but none with that inevitability where the poetry penetrated every pore of the canvas to the very last touch of the brush. For Avery was a great poet-inventor who had invented sonorities never seen nor heard before. For these we have learned much and will learn more for a long time to come. [18]

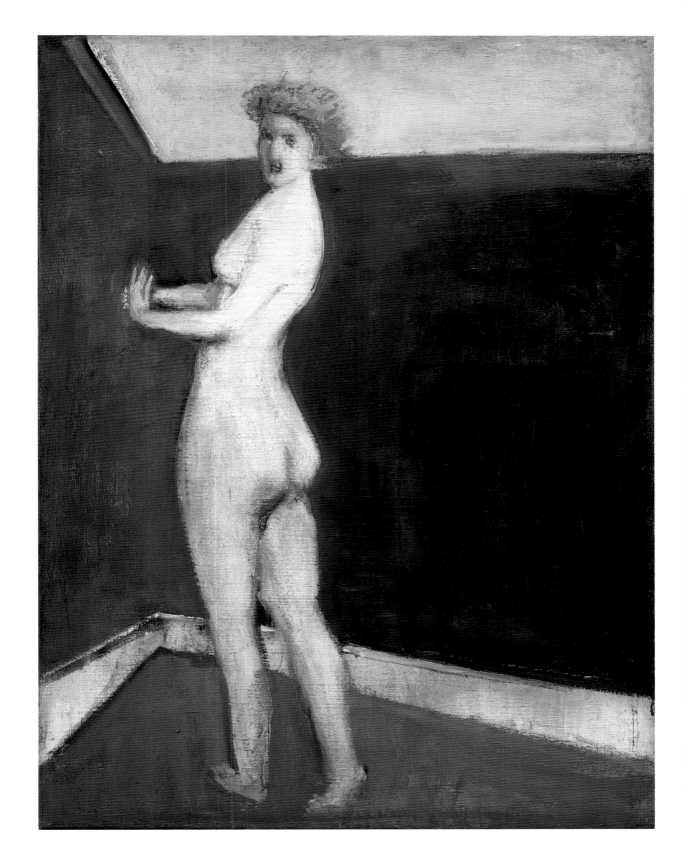

Rothko's palette gradually lightened during the time he was closely associated with Avery's circle. Like his mentor, he also began to apply his colours more broadly than the Weber/Cézanne dabs he used previously. In his notebook he wrote that colour could be 'sensuous or functional'. He added that 'tonality implied a romantic control. Pictorial functions of color involve aggressive advancing or depressions. Coming forward or going back can be accomplished either by color (warm or cold) or values.'[19]

These notes on colour suggest a source more sophisticated than the art of children. Weber, for instance, emphasised the spatial value of colour and, through his study of Cézanne and Matisse, was conscious of colour as a constructional element in a painting. The spatial function of colour was also one of the issues that dominated discussions at Avery's studio. As Sally Avery recalled, the artists would want to discuss his paintings and talk 'about the color and the shapes and the forms and how Milton could make a brilliant color recede when it would normally come forward.'[20] Rothko's notes indicate that the function of colour was of interest to him, and his paintings of the 1930s already reveal his experimentation with making colour advance and recede, and using tonality for romantic effect.

The lightened palette is particularly evident in the paintings from the late 1930s, included in the exhibition *New Work by Marcel Gromaire, Mark Rothko, Joseph Solman* at the Neumann-Willard Gallery, New York, in January 1940. One of the paintings in the exhibition, *Entrance to Subway* 1938 (fig.12), is surprisingly bright in coloration for an underground scene. The flat figures descending the stairs give the painting the appearance of an archaic frieze. Despite the dreary interior of *Contemplation* 1937–8 (A116), another work in the exhibition, the golden tones that bathe the solitary old man contribute to a contemplative mood. Both compositions rely on vertical and horizontal lines to organise their large, flat planes.

Like Avery, Rothko painted with tempera on coloured construction paper in the 1930s. His results with this medium varied considerably from Avery's and demonstrate the different emphasis he placed on his forms. The older artist used the coloured ground to intensify the tempera pigments he painted on top, which produced a cloisonné or stained-glass effect, with figures flattened against the surface (fig.14). Rothko, meanwhile, once again demonstrated a preference for forms that project in front of the picture plane, as in *Untitled* 1930 (fig.13). Mystery and dread permeate these tempera paintings on paper. Following Avery's cue, Rothko bathed the faces of these figures in unnatural tints of chartreuse, pink and yellow. But unlike his mentor, he used colour to contribute to the eerie, tense mood of his paintings on paper. The effect of building forms with paint on the coloured surface of the construction paper clearly appealed to Rothko and provided an important precedent for his mature paintings on coloured fields.

Rothko was able to supplement his studio education by visiting museums and galleries.

11
Milton Avery
Amusement Park c.1929
Oil on canvas
81.3 × 101.6
Maier Museum of Art,
Randolph Macon Woman's
College, Lynchburg,
Virginia
Gift of Sally Michel Avery,
1994

12
Entrance to Subway 1938
Oil on canvas
86.4 × 117.5
Collection of Kate Rothko
Prizel

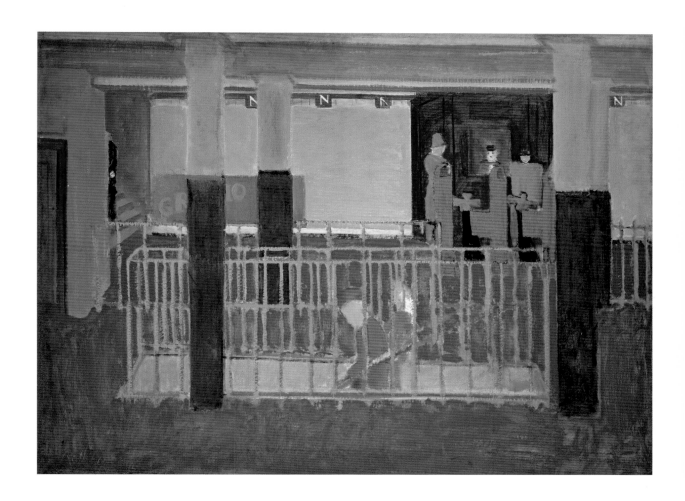

Trips to the Museum of Living Art, Albert Gallatin's private collection housed in New York University on Washington Square in Greenwich Village, gave him the opportunity to study the collection's paintings by Cézanne and Matisse and the Cubist works of Picasso and Braque. The opening of the Museum of Modern Art on the twelfth floor of the Heckscher Building at Fifth Avenue and Fifty-seventh Street in November 1929, added considerably to the great examples of modern art available for artists to study, as did the Société Anonyme, an experimental museum founded in 1920 by Katherine Dreier, Marcel Duchamp and Man Ray to promote the study of modern art and ideas in America, through exhibitions, lectures and symposia. The 1939 opening of The Museum of Non-Objective Painting (later, The Solomon R. Guggenheim Museum), with its major holdings of paintings by Wassily Kandinsky, helped advance the appreciation of abstract art in New York.

Rothko did not experiment with Cubism, but he greatly admired Picasso's proto-Cubist style based on Iberian sculpture. Picasso's 1906 *Two Nudes* (Museum of Modern Art, New York) seems to have been the model for Rothko's *Untitled (Two Nudes Standing In Front of a Doorway)* 1939 (fig.15). He represented the hefty bodies of his nudes in a sculptural manner similar to Picasso's approach, making the figures appear to project forward like a sculptural relief. As in the Picasso painting, Rothko's nudes are monumental, almost filling the painting, top to bottom. The doors open to a room beyond, while the figures stand on a narrow proscenium at the front, also as in Picasso's painting. Rothko was known to remark that Picasso was great 'because he's three-dimensional', and he would refer to the older artist's monumental nudes to support his claim. [21]

Avery and Weber were admirers of Matisse, and Rothko was also drawn to his work in the 1930s. The contorted figures in such paintings as *Untitled (Reclining Nude)* 1937–8 (fig.16), demonstrate Rothko's interest in Matisse's paintings of reclining nudes, and the more lyrical contours of Rothko's *Untitled (Mrs Irving Tow)* 1937–8 (fig.17), are similar to lines found in Matisse's portraits. In *Untitled (Woman Reclining on Couch)* 1938–9 (A148), Rothko attempted a pose reminiscent of the exoticism of Matisse's odalisques. But it would not be until the 1940s that Matisse's work would make a significant impact on Rothko's use of colour to create space in his paintings.

The Metropolitan Museum of Art provided a rich trove of historical art for Rothko. He used its encyclopedic collections to study everything from Assyrian art to Renaissance painting, synthesising his observations into the development of his own style. In the 1920s, he reportedly spent hours studying the Rembrandts. The Dutch master was still an important reference for him in 1943, when he remarked in a radio broadcast that:

The real essence of the great portraiture of all time is the artist's eternal interest in the human figure, character and emotions – in short in the human drama. That Rembrandt expressed it by posing a sitter is irrelevant. We do not know the sitter but

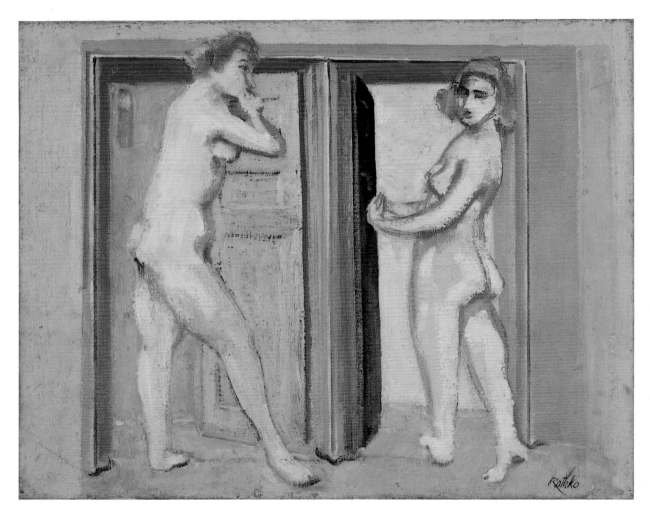

15
*Untitled [Two Nudes
Standing in Front
of a Doorway]* 1939
Oil on canvas
42.4 × 50.6
Neuberger Museum of Art,
Purchase College
State University of New
York
Gift of The Mark Rothko
Foundation, Inc.

16
Untitled [Reclining Nude]
1937–8
Oil on canvas
60.9 × 45.6
National Gallery of Art,
Washington
Gift of The Mark Rothko
Foundation, Inc.

we are intensely aware of the drama. It must be noted that the great painters of the figure had this in common. Their portraits resemble each other far more than they recall the peculiarities of a particular model. In a sense they have painted one character in all their work. This is equally true of Rembrandt, the Greeks or Modigliani, to pick someone closer to our own time. [22]

As David Anfam suggests, Rothko's understanding of Rembrandt's greatness was probably influenced by two major illustrated monographs published in the early 1920s by Adolph Rosenberg (1921) and David Meldrum (1923), among other contemporary publications. [23] Filippo Lippi and Murillo are also cited by Anfam as historical antecedents. [24] In a number of his paintings from the mid-to-late 1930s, Rothko emulated these models by framing his figures with an open window, an adaptation of the traditional half-portrait motif. In two such paintings, the women appear to be wearing period dress (fig.18; A102). The wall in these works is painted as the extension of the wall on which the canvases are hung. Rather than receding back into the interior rooms, the figures project out in front of the windowsill, creating the illusion that they have entered the viewer's space.

Living in New York gave Rothko almost as much access to the art of the past – through museum collections and exhibitions as well as reproductions in books – as his European counterparts. When he broke with tradition in later years, it was with an extensive knowledge of this art. As Adolph Gottlieb remarked in 1950:

There is a general assumption that European – specifically French – painters have a heritage which enables them to have the benefits of tradition, and therefore they can produce a certain type of painting. It seems to me that in the last fifty years the whole meaning of painting has been made international. I think Americans share that heritage just as much, and that if they deviate from tradition it is just as difficult for an American as for a Frenchman. It is a mistaken assumption in some quarters that any departure from tradition stems from ignorance. [25]

Rothko's writings of the 1930s and 1940s reveal that he consulted several art-historical texts including the writings of Bernard Berenson on Renaissance painting and the prominent American muralist Edwin Howland Blashfield's *Italian Cities*. [26] Both writers discussed Giotto's works, and it is possible that the paintings Rothko made on gesso board during the late 1930s and 1940 were meant to emulate the dry appearance of frescos. Among these works is his mural proposal for the Social Security Building in Washington, D.C., 1940, representing the life of Benjamin Franklin.

Rothko's expressionistic paintings contrasted sharply with American Scene Painting, Regionalism, Social Realism and the geometric abstract works by the painters who formed the American Abstract Artists group in the mid-1930s. Although American artists of the 1920s embraced modernism, the years

of the Great Depression saw the elevation of figurative painting, exemplified by the works of Thomas Hart Benton (fig.19) and Grant Wood. American Scene painting and Regionalism glorified life in the United States, while Social Realism took a critical stance on labour relations, poverty and the bourgeoisie. These were paintings with a social message and edifying narratives, as opposed to the art-for-art's-sake of the modernists. Although Rothko's paintings were generally set in an urban environment, his interest was in his subject's inner life, rather than in creating a social tableau.

Being unsympathetic to American Scene Painting or geometric abstraction, Rothko and Gottlieb banded together with a group of like-minded artists at the Uptown Gallery in 1934 (renamed Gallery Secession when it moved downtown to Greenwich Village later that year). Among the artists shown were Ben-Zion (Ben Zion Weiman), Louis Harris, Yankel Kufield, Louis Schanker and Joseph Solman. In late 1935, these artists, along with Rothko, Gottlieb, Ilya Bolotowsky and Nahum Tschacbosov formed The Ten (the tenth artist was frequently rotated). All were from Jewish immigrant backgrounds, and were united by an Expressionist style (with the exception of Bolotowsky, who painted geometric abstractions) based on the European Expressionism of the early twentieth-century, which conveyed the inwardness of the subject. Like Rothko in his paintings of the 1930s (fig.20), most of these artists exaggerated the proportions of figures and used muddy or vivid colours to depict urban scenes, still lifes and portraits. The artists of The Ten would meet to discuss and critique their works, and these sessions provided Rothko with a forum in which he could continue to refine his ideas about art. By promoting themselves as a group with a common vision rather than as individuals, The Ten could define their position in the art world more effectively. The strategy helped the artists obtain and create exhibition opportunities, which led to reviews and notoriety. As one member, Joseph Solman, noted, 'The term expressionist was aesthetically subversive at the time.'[27] Jerome Klein, writing for the *New York Post* on 11 January 1936 about The Ten's exhibition at the Municipal Art Gallery captured the rebellious attitude of these artists: 'the raucous boys known as The Ten, really [are] the life of the party. They roar as lustily as they did in the show just closed at Montross. And they are not merely shouting in the dark, either.'[28] By 1936, the group had even landed an exhibition in a Paris gallery.

However, Edward Alden Jewell, art critic of the *New York Times*, was unsympathetic to these artists' works. In his review of The Ten's exhibition at the Montross Gallery in December 1936, he wrote, 'I do not believe I understand the American "expressionist" so very well. Many of these paintings at the Montross I feel I do not understand at all. Often they look to me like silly smudges; and if a painting looks like a silly smudge, it is safe to conclude that you do not understand it.'[29]

The negative response the artists received

17
Untitled [Mrs Irving Tow]
1937–8
Oil on gesso board
17.7 × 12.7
Private collection, Illinois

18
Conversation (Untitled)
c.1937
Oil on linen
91.4 × 61
National Gallery of Art,
Washington
Gift of The Mark Rothko
Foundation, Inc.

from some members of the art establishment only hardened their resolve and opposition to American Scene Painting and Regionalism. Their November 1938 exhibition, for example, was titled *The Ten: Whitney Dissenters* and was held just two doors down from the Whitney Museum of American Art (then located on Eighth Street in Greenwich Village), at the Mercury Galleries. Only one artist in the group, Bolotowsky, was included in the *Whitney Annual Exhibition of Contemporary American Painting*, which ran concurrently with The Ten's exhibition. In the catalogue essay, Rothko and Bernard Braddon, co-owner of the Mercury Galleries, criticised the Whitney Museum's selection process for the Annual, which resulted in the inclusion of a large number of American Scene painters. They declared: 'A new academy is playing the old comedy of attempting to create something by naming it. The effort enjoys a certain popular success, since the public is beginning to recognize an "American Art" that is determined by non-aesthetic standards – geographical, ethnical, moral or narrative.'[30] They further remarked, 'A public which has had "contemporary American art" dogmatically defined for it by museums as a representational art preoccupied with local color has a conception of an art only provincially American and contemporary only in the strictly chronological sense.' They were appalled that the Whitney curators tended to reject Cubist and innovative abstract painting, while promoting artists who in their opinion were derivative of

'Titian, Degas, Breughel and Chardin'.

The Ten's protest went beyond just the one museum, and they hoped that there were other dissenters in the United States besides themselves. They also discovered that their controversial dissension from the Whitney Annual was popular with the media. Braddon, Sydney Schechtman, another co-owner of the gallery, and Louis Harris aired their views about 'What's Wrong with American Art?' on WNYC radio.[31] The forum gave wider exposure to the points that had appeared in the catalogue essay.

Gottlieb, one of the key members of The Ten, spent the winter and spring of 1937–8 in Tucson, Arizona. Away from The Ten and the influence of Avery, Gottlieb was able to paint in isolation from the New York art world. He focused on 'real shapes, real objects', some of which derived from the desert landscape.[32] These arid paintings marked Gottlieb's foray into Surrealism. Meanwhile, Rothko, in New York, continued to focus on the city as his subject. In several paintings from this period, elongated subway riders echo the vertical columns of the station's architecture, the platform making an ideal stage for the daily underground dramas (figs.12, 21, 24). Like Gottlieb, Rothko also began experimenting with Surrealism at this time, influenced primarily by the proto-Surrealist Giorgio de Chirico, whose work was included in the landmark *Dada, Surrealism and Futuristic Art* exhibition at the Museum of Modern Art, December 1936 to January 1937. Just as de

19
Thomas Hart Benton
Cotton Pickers 1944
Oil and pencil on paper
53.3 × 66
Private collection

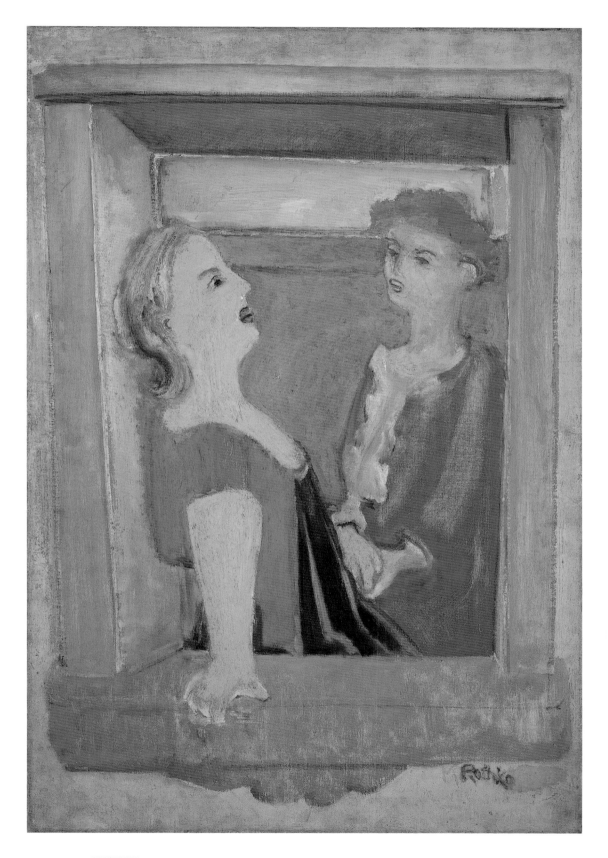

20
Street Scene 1936–7
Oil on canvas
91.5 × 55.8
National Gallery of Art,
Washington
Gift of The Mark Rothko
Foundation, Inc.

21
Untitled [Subway] c.1937
Oil on canvas
51.1 × 76.2
National Gallery of Art,
Washington
Gift of The Mark Rothko
Foundation, Inc.

Chirico could turn a city square or a train station into a nightmarish scenario using long shadows and exaggerated perspective, Rothko imbued his subways and street scenes with a sense of dread. Right from the beginning of his career, he had rejected the use of perspective and virtually avoided the employment of diagonal lines, which create the illusion of recessive space, but in a number of paintings of subway platforms of the late 1930s, such as *Subway* 1939 (A166) and *Untitled* c.1938 (fig.24), he used extreme perspective to represent train tracks, similar to the way in which de Chirico exaggerated the street in *Gare de Montparnasse* 1914 (fig.23). The vanishing point moves the track upwards so that it appears as though it is almost parallel with the picture plane. The unique composition *Thru the Window* 1938–9 (fig.22), with its windows-within-a-window composition, mannequin and canvas propped up on an easel, owes a significant debt to de Chirico.

Gottlieb returned to New York in June of 1938, but was reluctant to show his new paintings to The Ten until the autumn of that year. When he finally got up the nerve, the general response of the group was negative, with the exception of Rothko.
The members of the group were moving in different philosophical directions. By 1939, The Ten had disbanded, but Rothko and Gottlieb continued their friendship and entered into a period of collaboration that would lead both to a new phase in their work.

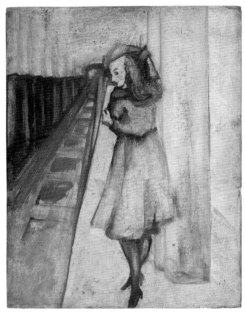

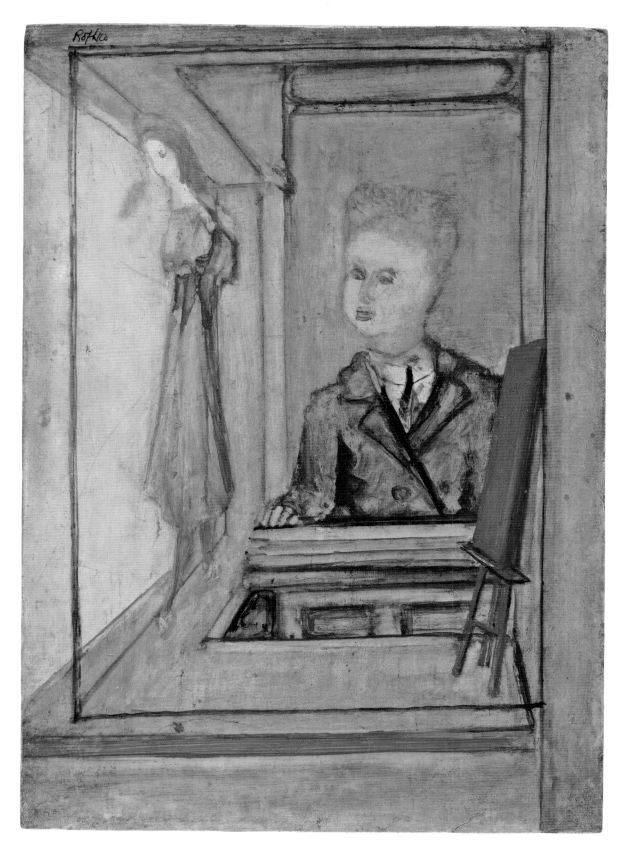

Untitled (Still Life with Mallet, Scissors and Glove)

Untitled (Still Life with Mallet, Scissors and Glove) 1938–39 belongs to an intriguing, little-known group of oil-on-gesso-board paintings (see *Thru the Window*, fig.22, *Self-Portrait*, fig.77 and *Untitled (Woman in Subway)*, fig.24). The exact date of these works is not known, with the exception of a study related to a proposal for a mural competition for the Washington, D.C. Social Security Building that Rothko submitted in 1940. The thin application of paint on the smooth, chalky surface of the gesso board gives these works the appearance of frescos. Rothko wrote extensively about frescos, particularly Giotto's murals, in his manuscript *The Artist's Reality*, which dates from around this period. It is possible that his interest in mural and fresco painting coincided with the first mural competition he entered in 1938.[1] The primary sources on Giotto that he cited in his manuscript were Bernard Berenson's *The Florentine Painters of the Renaissance* (1896) and Edwin Blashfield's *Italian Cities* (1900). (Blashfield was the pre-eminent twentieth-century muralist in the United States, producing murals for the Library of Congress.)

This small still life (12.6 x 17.6 cm) represents jewellery tools, which probably belonged to Rothko's wife Edith. Rothko had studied still-life painting with Max Weber at the Art Students League in 1925, but made few works in this genre early in his career, preferring human figures. By the end of the 1930s he became increasingly interested in representing inanimate objects. Several canvases and gesso-board paintings from this time are of domestic arrangements: clocks, vases, radios on narrow ledges, as well as work tools.

In most of Rothko's representational paintings, forms remain flat; he eschewed conventions of modelling and aerial perspective. But in this still life, he uncharacteristically employed foreshortening to suggest that the scissors are receding into space, and turned the tools in at an oblique angle to the picture plane. Although he represented these tools with a convincing sense of volume, the pictorial space is very shallow. It is quite possible that his in-depth study of Giotto's tactile space aided his conception of volume and space in this and related works. The woman's coat in *Untitled (Woman in Subway)* (fig.24) undulates like the folds of Giotto's drapery. In *The Artist's Reality*, Rothko noted that Giotto, like the Byzantines, divided space into horizontal and vertical planes and that the vertical background plane is never far from the surface.[2] The composition of Rothko's still life is likewise divided into horizontal and vertical planes. His interest in Giotto also explains the shallow space of this work. In his writings, he noted how the confined space accounted for the strong feeling of movement of forms projecting forward and back from the picture plane in Giotto's frescos, an effect that he found especially desirable and clearly sought to achieve in his own paintings.

Giotto's novel use of colour value also contributed to the extraordinary tactile quality of his compositions.[3] 'Color intrinsically possesses the power of giving the sensation of recession and advancement', writes Rothko. 'The bluntest statement of this property is that cold colors recede while warm colors advance.'[4] In contrast to later Renaissance artists who created the illusion of recession by greying colours as they recede into the distance, Giotto achieved this tactile quality using colour value alone. His colours 'made no attempt to resemble atmosphere at a distance', and therefore gave the sensation of coming forward and going back. Rather than treating space as an empty vacuum, Giotto gave atmosphere a 'tangibly mucous character'. His figures actively reacted to the space surrounding them, for, as Rothko noted, 'every motion in any direction is always resisted by a sensed mass or solid space'.

There is no air in Rothko's still life. The rear wall seems almost equal to the picture plane; only the tool bar separates them. Rothko's tools, trapped in their slots and sandwiched between the shallow background and the picture plane, twist and turn in their allotted shallow space. Although the tools are inanimate objects, they play out a drama of conflict and resistance. The plasticity of Rothko's composition and limitation of space gives this painting a monumental power that defies its diminutive size.

The choice of jewellery tools for this still life is also revealing in terms of Rothko's interest in the plasticity of painting. In *The Artist's Reality*, he used the methods of metal-working by jewellers as an example for how artists produce tactile, sculptural forms in painting. He observed how the jeweller fashions small sculptural adornments from flat pieces of metal by hammering protuberances from behind, and sloping edges to create a sense of concavity. Like the jeweller, Rothko points out, the artist uses paint to model forms with a series of back and forth pushes in relation to the original flat plane.[5]

Untitled (Still Life with Mallet, Scissors and Glove), along with Rothko's other still lifes of the late 1930s, coincide with his growing fascination with ancient myths, and therefore they most likely represent his early exploration of using

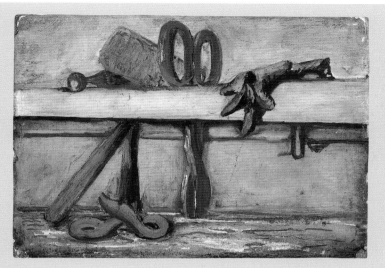

25
*Untitled (Still Life with Mallet, Scissors and Glove)*1938–9
Oil on gesso board
12.6 × 17.6
National Gallery of Art, Washington
Gift of The Mark Rothko Foundation, Inc.

inanimate objects as symbols to enact the human condition.

The tactile, sculptural quality of the forms in this painting relates it to the bas-relief effect of the early myth-based paintings, particularly *Antigone* 1939–40 (fig.31). In fact, Rothko noted that fresco painting is an extension of bas relief and that it 'is itself simply a variation of painting employing, rightly, the concepts of relief in the round rather than draftsmanship'.[6] This still life, with its shallow space divided horizontally and vertically, its association with bas-relief, and use of inanimate objects as symbols of conflict and resistance, provides an important link between Rothko's figurative paintings and his foray into the myth-based paintings of the early 1940s.

Rothko went through radical changes in his life and work during the first half of the 1940s. By this time he had begun to use the name Mark Rothko professionally. His tumultuous marriage to Edith Sachar resulted in a number of separations and finally divorce in 1944, the same year that he met his second wife Mary Alice (Mel) Beistel. Along with Adolph Gottlieb, he abandoned Expressionism in favour of paintings based on ancient myth, primitive and archaic art and Surrealism. This was also a pivotal period in the development of his theory and philosophy on art. Most of our knowledge about his intentions comes from his published and unpublished texts, statements and letters from this time. An important new source was added in 2004 with the publication of his manuscript *The Artist's Reality*.[1] This manuscript reveals Rothko's scholarly aspirations, which is in contrast to the defiant language he and his colleagues assumed in their written oppositions to the American art establishment. His letters to friends, however, reveal elements of his personality – concern for their health and well-being, his goals, challenges and anxieties as he forged into new territories in his work, and his sense of humour.

The early 1940s also was a period when many of the European modern artists who fled their countries took refuge in New York, including Fernand Léger, Piet Mondrian, André Breton, Max Ernst, and Yves Tanguy. Although only a few of the American artists of Rothko's generation had much direct contact with these artists (most of them spoke little or no English) their presence provided a direct international alternative to the perceived provincialism of the American art scene. The Surrealists, with their interest in dreams and the subconscious, offered new avenues of exploration. Among their techniques for unlocking the subconscious was pure psychic automatism in which the artist drew without any preconceived notions.

The centre of activity for the European Surrealists in New York was The Art of This Century gallery, established in 1942 by Peggy Guggenheim – heiress, collector and wife of Max Ernst. Marcel Duchamp, who had lived in New York intermittently since 1915, was an advisor to Guggenheim and an important force at her gallery. Several of the exhibitions he organised presented new concepts of art installation and performance to the New York art world.

Salvador Dalí helped to popularise Surrealism in America with several high profile installations and events. In June 1939 he created a Surrealist pavilion *Dream of Venus* for the New York World's Fair, replete with live topless mermaids swimming in an aquarium, erotic tableaux and a sound work. Earlier that year he installed a tableau of a mannequin in a tub in the Fifth Avenue window of the Bonwitt Teller department store. The project generated headlines when Dalí, outraged that the store altered his arrangement, overturned the tub, which smashed through the window. Dalí landed on the pavement with the tub, where he was arrested for the fracas. The sponsor of the *Dream of Venus* pavilion also modified the installation after it opened, prompting Dalí to

2 The Spirit of Myth: Painting in the Early 1940s

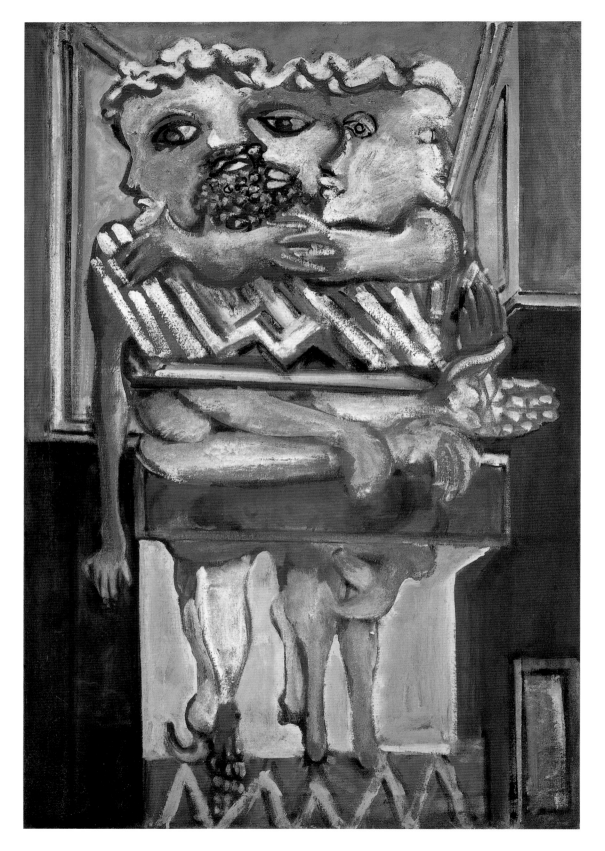

pen a manifesto about the artist's rights to his work. Copies of this document were dropped from an airplane over New York. Although both sensations were prompted by Dalí's anger over outside interference in his work, his antics demonstrated that the American mass media was receptive to the controversy modern and Surreal art could ignite. The American magazines *Vogue* and *Harper's Bazaar* were quick to co-opt the dream-like visions of Dalí and other Surrealists and even invited them to participate in creating fashion spreads for their pages.[2]

Several of the American artists, including Rothko and Gottlieb, believed that the times demanded a new art form. Pollock's interest in tribal art, Picasso, and Mexican mural painting was instrumental in the emergence of his hybridised creatures of the late 1930s, such as *Bird* c.1938–41 (fig.28). David Smith drew inspiration from his subconscious as well as the works of the Surrealists and Picasso for his metal sculptures (fig.27). With the outbreak of the Second World War, these artists also acknowledged that there was a crisis in subject matter, evaluated their commitment to their work and questioned their role as artists in society. The continued provincialism of art in the United States, characterised for them by the American Scene painters, fanned their belief that they had to make a break with figurative painting, which they associated with the past. Barnett Newman, a friend of Rothko and Gottlieb, who was part of the Avery circle of artists, took the radical step of giving up painting altogether (he would begin again by 1944).

Gottlieb's solution was to paint what he called 'pictographs' (fig.29). He divided these compositions into several rectangular compartments in which he inserted personal symbols. These irregular grids suggest building blocks of ancient edifices incised with hieroglyphics. Rothko's paintings similarly display an architectural organisation; using composite human body parts and animal and plant forms, he arranged his paintings like low-relief archaic friezes in works such as *Antigone* (fig.31).

Interest in primitivism and archaic art was pervasive in the New York art community in the 1930s and early 1940s, with the Museum of Modern Art's presentation of African art in 1935 and its mounting of a large exhibition *Indian Art of the United States* in 1941. Artists also had access to the ethnographic collections of the American Museum of Natural History on Central Park West and the Brooklyn Museum, and Robert Goldwater's landmark book *Primitivism and Modern Art*, published in 1938, contributed to the artists's discourse.

Rothko's own experience in teaching art to children helped shape his understanding of and interest in primitive art. In his notes on children's art education he quoted extensively from the pioneering theories of the Viennese art educator Franz Cizek, which were published in English in 1936. According to Cizek, 'the unspoiled child knows no perspective. Perspective is a matter of geometry, as anatomy is a matter of medical science. Why does the work of the ancient Egyptians appear to us so strong? Because they are created according to the same laws as

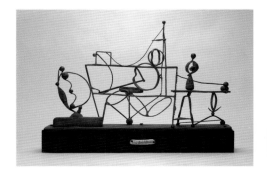

children's drawings.'[3] Cizek's theories on primitivism and the innate laws of children's art, along with Rothko's own close contact with his young students, helped prepare him for the first major transition in his work. As Rothko observed, Expressionism, despite its introspectiveness, was still based on the nostalgia of recapturing the innocence of childhood.[4] By the late 1930s, Rothko seemed receptive to Cizek's prophecy that 'in the place of present-day art an entirely new art will come into being. And this new art will reflect the immense changes of our time and will express the desires and longings of the period.'[5]

In *The Artist's Reality* Rothko pondered, 'Why paint at all?'[6] This existential question could have led him to the rejection of painting, just like Newman. Rothko, however, justified the artist's role in society by arguing that art is a sociably redeemable act: 'When the artist produces something which is intelligible to himself', he wrote , 'then he has already contributed to himself as an individual, and with the effect has already contributed to the social world (just as we benefit ourselves, and therefore also society, when we eat).' When individuals improve themselves, he argued, they automatically improve society because 'the empirical measure of society's welfare is the aggregate good of its constituents'.[7] He reasoned that the 'satisfaction of personal needs is never an escapist form of action'. In the end, it may benefit society more than 'a hundred acts of philanthropy and idealism'. There was no need for him to illustrate his politics in his paintings since the very act of painting was a form of social action.

Rothko's concern about his relevance to society as an artist and how his work could be of any benefit to humankind when there was so much suffering in the world pre-dates the popularisation of Existential philosophy in the United States after the Second World War. Like Jean-Paul Sartre and other Existentialists, Rothko recognised the limits of reason and the entire rationalist tradition that dates back to the Renaissance. Human suffering as well as ecstatic experiences could not be explained through rationalisation. The Existentialists, like Rothko, looked inward, to their own subjectivity, for answers. The similarities between Rothko's philosophy and that of the Existentialists may be attributed to one of their common sources – the writings of the nineteenth-century German philosopher Friedrich Nietzsche, who contemplated the human condition of loneliness, anguish and doubt.

By the early 1940s, Rothko was discussing his paintings in terms of subject matter, by which he meant: 'What is the picture trying to say or express? What does it mean?'[8] Although he might have been motivated by these thoughts early in his career, his written statement demonstrates that this was clearly a major emphasis in his work. He used myths to make his philosophical position evident to the viewer. Nietzsche suggested that the Greeks needed to have their myths enacted in drama and poetry to make life endurable and comprehensible. To him, the function of art was to produce an intelligible basis for

29
Adolph Gottlieb
Pictograph 1946
Oil on canvas
91.4 × 96.5
Albright-Knox Art Gallery,
Buffalo, New York
Gift of The Martha Jackson
Collection at The Albright-
Knox Art Gallery, 1976

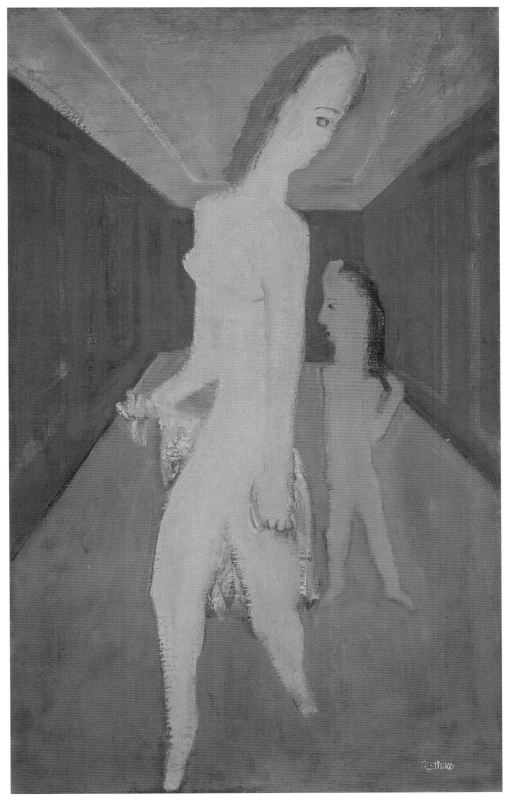

30
Mother and Child c.1940
Oil on gesso board
91.4 × 55.9
Collection of Christopher
Rothko

coming to terms with the inevitability of death. Rothko was intrigued by the symbolic content of myths and the way in which they deal with most of the human actions and perceptions that are fundamental to existence.[9]

During ancient times, myths gave unity to existence by reconciling sensual/subjective characteristics with objective tendencies. Nietzsche used the myth of Dionysus and Apollo as the basis for an analysis of the discord between the objective and the subjective in art – Apollo representing the physical form, as in sculpture, and Dionysus, the nonimagistic arts of music and poetry. These gods were always in conflict with one another, and their battles resulted in the birth of tragedy.[10] The Dyonistic arts of music and poetry represented by the dithyrambic chorus of Greek drama excited the audience to such a degree that the masked actor, representing the Apollonian arts, was transformed through their rapture into a true tragic hero. This ecstatic dramatic moment produced a stasis in the battle between Apollo and Dionysus.[11]

Rothko admired the Greeks' ability to integrate the duality of the mind and the senses in art. He also recognised that Early Christianity achieved this balance. 'In a sense', he observed, 'both Jesus and Zeus were in the position of scientists who were called upon at will to demonstrate their power to order nature.'[12] In Christian dogma, Christ's suffering as a man contributed to the salvation of humankind. But Rothko also recognised that in modern life, unlike ancient Greece, there was no overriding belief that

could reconcile the sensual and objective understanding of existence. Instead, fragmentation was the condition that characterised the mid twentieth century. He listed examples of this compartmentalisation of modern life: 'we have religion to serve our souls, we have law to serve our notions of temporal and property justice, we have science to qualify the structural world of matter and energy, we have sociology to deal with human conduct', and 'we have psychology to deal with man's subjectivity'.[13] In modern times, he wrote: 'Our own struggles are individualized and remain our individual preoccupations.'[14] Several of his paintings from the early 1940s represent multiple crucifixions, with figures that are fragmented and compartmentalised. The architectural details provide a unifying structure to these scenes of communal suffering.

Even if the conditions of the mid-twentieth century were not conducive to the kind of unifying beliefs that were held by the ancient Greeks and early Christians, Rothko contended that it was possible to devise symbols to express his desire for cohesion. Based on his consideration of the role of myths, he initially turned to the Greek tragedies of Sophocles and Aeschylus for his paintings of the early 1940s. *Antigone* 1939–40 (fig.31) and *Oedipus* c.1940 (A179) are the earliest of the paintings based on classical Greek works (Gottlieb also named a 1941 painting after Oedipus). It is not clear whether Rothko was drawn to Sophocles's tragic heroine Antigone as a dutiful daughter and sister who was born into a doomed family, or

31
Antigone 1939–40
Oil and charcoal on canvas
86.4 × 116.2
National Gallery of Art,
Washington
Gift of The Mark Rothko
Foundation, Inc.

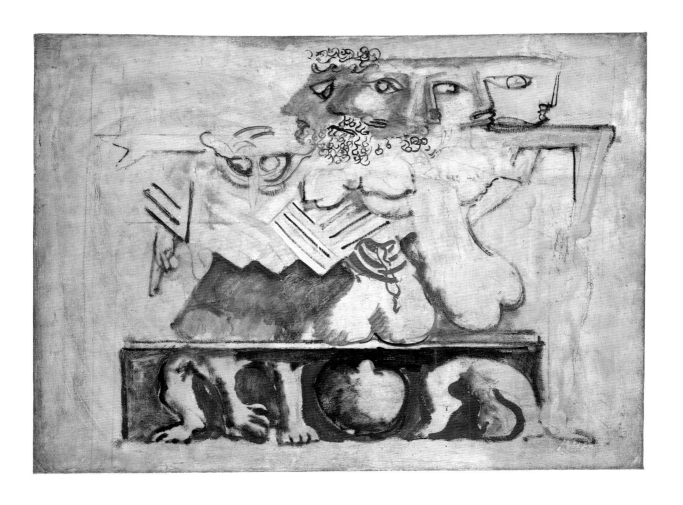

as an anarchist who defied authority in the face of death. The painting, in which five heads merge as one, suggests Antigone's complicated genealogy as both the daughter and half-sister of her father Oedipus and the daughter and granddaughter of her mother. However, the pose of the figure on the left with its finger raised in declaration also suggests that Rothko may have been reflecting on the play *Antigone*, the second in Sophocles's Oedipus cycle in which a single action – King Creon's decree that Antigone's brother Polyneices, who was killed by his own brother Eteocles, should remain unburied – set off a chain reaction of death and despair. Antigone, defying Creon's edict, buries her brother and is then sentenced to death by the king. She takes her own life, which causes her betrothed, Creon's son, to commit suicide. His death in turn triggers his despondent mother to take her own life. Thus Creon is left to suffer alone as a result of this tragedy, brought on by his own stubborn resolve to administer punishment in disregard to the opposition of his subjects and the warnings of the prophet Tiresias. Rothko inserted a globe at the bottom of the painting to suggest the universal human condition represented by this tragedy.

Rothko painted *Antigone* on top of an earlier composition, executed in his expressionistic style, of a woman wearing a large hat.[15] It is so thinly painted that it is possible to see the pencil lines that define the figures of the new painting, as well as the ghostly outlines of forms that he ultimately decided not to paint in. The contours optically project a depth suggestive of low-relief wall carvings. The overall white palette, highlighted with touches of colour, contributes to the stone-like appearance of the painting. The faces, especially the curly beards, appear to have been based on Assyrian sculptures, such as those on view at the Metropolitan Museum of Art and the illustrations of Assyrian beasts and human figures that feature in *Babel and Bible*, one of the sources for his drawings for *The Graphic Bible* (fig.9).[16] Multiple figures fused into a single form intrigued Rothko right from the beginning of his career. We have already seen how in *Untitled* 1924–5, the bodies of the two orthodox Jews combine as one (fig.8 on p.16). Several paintings from the 1930s contain multiple figures huddled together. These groupings, as well as the multiple-headed creature in *Antigone*, seem to represent the fragmentation of modern society that Rothko aimed to unify in his paintings.

Oedipus similarly combines multiple figures, this time a trinity that may be a reference to the Oedipus Cycle's three tragic plays: *Oedipus Rex*, *Oedipus Colonus* and *Antigone*. Anfam connects this tripartite form to a quote from Nietzsche's *Birth of Tragedy* that describes Oedipus as 'the murderer of his father, the husband of his mother, the solver of the riddle of the Sphinx!'[17] Since the Classical myths and Christian dogma were interchangeable to Rothko, the figure in Oedipus could also represent the Christian Trinity, with the splayed torso in the centre conveying the human suffering of Christ. However, Rothko's writings in *The Artist's*

32
The Omen of the Eagle
1942
Oil and pencil on canvas
65.4 × 45.1
National Gallery of Art,
Washington
Gift of The Mark Rothko
Foundation, Inc.

Reality provide another explanation. He ascribed three attributes to the human body: it is 'the embodiment of mechanical perfection, spiritual perfection, and the beauty to the senses unified within a single form – The unison of the three must remain the ideal of perfection of any age.'[18]

Agamemnon, Aeschylus's tragedy based on the Trojan War, preoccupied Rothko in 1942. Paintings such as *The Omen of the Eagle* 1942 (fig.32) encapsulate the omen recited by the chorus at the beginning of the play, foretelling the destruction of Troy by the victorious Greeks. The chorus warns of two eagles devouring a pregnant hare. Breslin and Anna Chave have noted the timeliness, for a work painted during the Second World War, of Rothko's use of this tragedy, which addresses the origins of military conflict.[19] In 1943, Rothko stated that although the theme of the painting is from Aeschylus's tragic trilogy, 'the picture deals not with the particular anecdote, but rather with the Spirit of Myth, which is generic to all myths at all times. It involves a pantheism in which man, bird, beast and tree – the known as well as the knowable – merge into a single tragic idea.'[20] Nevertheless, *The Omen of the Eagle* is the culmination of several earlier paintings based on the same theme (see fig.39). In these works, Rothko inserted specific references to the omen, and the two eagles and the hare are more easily identifiable.

Rothko's choice of symbols and imagery in his mythic paintings was not, for the most part, derived from his subconscious as is sometimes assumed. Although he expressed

an interest in the automatic-drawing technique prescribed by the Surrealists as a method to unlock the subconscious, he modelled some of his figures and symbols on sources that were familiar to him and readily available, particularly the illustrations he had produced in 1927 for *The Graphic Bible* and the other books he used as his references for this project. For example, the arm of destruction in *The Graphic Bible* (fig.33) corresponds to the two disembodied arms reaching into the painting in the *Sacrifice of Iphigenia* 1943 (fig.50 on p.66). The multi-headed figure in *Untitled* c.1942 (fig.34) was fashioned after the Birth Goddess statue in *Babel and Bible* (fig.35). The similarities between the two images include the shape and location of the breast, the curve at the knee, where the statue's legs are broken, and the elongated neck and torso. One could draw the conclusion from this evidence that Rothko's figure also represents a birth goddess. And since this painting is one of the variants of *The Omen of the Eagle*, the figure seems to be a reference to the pregnant hare that will be destroyed, like Troy, along with its progeny. Rothko also appears to have selected some of the images from these early illustrations for his mythic paintings in order to symbolise different moods. In his court testimony from his law suite against Lewis Browne in 1929, he stated that he drew thistles on the maps of Israel in *The Graphic Bible* to represent mournful times (fig.36).[21] The stylised, thorny vegetation in such myth-based paintings as *Untitled* 1941–2 (fig.37) seems to have been added to suggest a similar emotional state.

34
Untitled 1942
Oil on canvas
75.9 × 91.8
National Gallery of Art,
Washington
Gift of The Mark Rothko
Foundation, Inc.

35
Illustration of the Birth
Goddess, in Friedrich
Delitzsch, *Babel and
Bible: Two Lectures before
the Members of the
Deutsche Orient-
Gesselschaf in the
Presence of the German
Emperor*, ed. with intro. by
C.H. Johns, New York and
London 1903

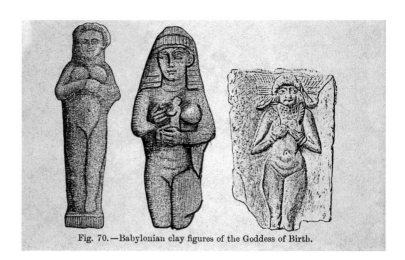

Fig. 70. — Babylonian clay figures of the Goddess of Birth.

36
Illustration in Lewis
Browne, *The Graphic
Bible: From Genesis to
Revelation in Animated
Maps and Charts*, The
MacMillan Company, New
York 1928, p.82

Although Rothko may have painted *Antigone* as early as 1939, he did not exhibit it or any of his paintings based on myths until January 1942, in a show organised by Samuel Kootz for R.H. Macy's department store in New York City.[22] Kootz was a public-relations executive for the film industry, who achieved recognition in the art world for his book *Modern American Painters*, published in 1930. His letter, published in the *New York Times* on 10 August 1941, bemoaning the lack of exciting, experimental art by American artists in galleries and museums, set off what became known as the 'Bombshell' controversy.[23] The result was weeks of lively debate in the newspaper's letter section. In another letter to the paper, Kootz clarified his position: the problem was not that there were no good artists; rather, that no venue existed in New York where one could see experimental work by American artists.[24] Many of the correspondents encouraged Kootz to visit artists' studios. He met the challenge and was so surprised by what he found that he decided to organise an exhibition. Having no gallery of his own at this time, he brought the idea to Macy's. The exhibition reflected a variety of directions including abstraction, Expressionism, Surrealism and Realism, and listed the artists George L.K. Morris, Stuart Davis, Bolotowsky, Avery, Gottlieb and Rothko, among others. Rothko's paintings *Antigone* and *Oedipus* were appropriate for this exhibition because they represented the kind of experimentation that Kootz expected from American artists.

The New York museums in the early 1940s, however, continued to present American Scene Painting and Regionalism to the exclusion of much of the work by American artists shown in Kootz's exhibition. The Metropolitan Museum of Art's exhibition *Artists for Victory*, which opened in December 1942, was weighted in favour of the more conservative trends in American art. Rothko and Gottlieb participated in two exhibitions that were organised in protest in early 1943: *American Modern Artists: First Annual Exhibition*, held at the Riverside Museum, and *New York Artist-Painters: First Exhibition*, which took place at 444 Madison Avenue. The introduction to the catalogue for *American Modern Artists* was written by Barnett Newman, who echoed the views previously promoted by The Ten in their *Whitney Dissenters* exhibition. Newman wrote that the artists had come together:

To present to the public a body of art that will adequately reflect the new America that is taking shape today and the kind of America that will, it is hoped, become the cultural center of the world. This exhibition is a first step, to free the artist from the stifling control of an outmoded politics. For art in America still is the plaything of politicians. Isolationist art still dominates the American Scene. Regionalism still holds the reins of America's future.[25]

Newman was probably expressing the aspirations of many of the artists in the exhibition when he concluded with the statement: 'America has the opportunity of becoming the art center of the world. It

37
Untitled 1941–2
Oil on canvas
81.1. × 60.7
Neuberger Museum of Art,
Purchase College,
State University of New
York
Gift of The Mark Rothko
Foundation, Inc.

cannot do so if the perversion of our cultural forces makes possible the strengthening of false artists and their movements. We mean to crystallize these forces.'[26]

Curiously, although Rothko had exhibited two of his mythic paintings in Kootz's exhibition at Macy's, he submitted two of his Expressionistic-style paintings to *American Modern Artists*, an exhibition that touted the presentation of new art. It is possible that he did not feel he had a sufficient number of resolved mythic paintings for this show *and* the *New York Artist-Painters: First Exhibition*, which opened a little more than a month later.[27] To this second protest exhibition, he submitted four mythic paintings, *A Last Supper* 1941 (A184), and *The Omen of the Eagle* (fig.32), *The Eagle and the Hare* (fig.39) and *Iphigenia and the Sea* (A217), all of 1942. As *The Omen of the Eagle*, *The Eagle and the Hare* and *Iphigenia and the Sea* were all based on Aescychules's *Agamemnon*, it probably did not make sense to break the group up for the two, back-to-back exhibitions. Moreover, *Iphigenia and the Sea* and *A Last Supper* allude to the theme of sacrifice, another reason to keep them together rather than dilute the grouping by dividing them between the two shows.

For the third annual *Federation of Modern Painters and Sculptors* exhibition, held at Wildenstein and Company in June 1943, Rothko showed another mythic painting *Syrian Bull* 1943 (fig.40). The catalogue introduction for this exhibition adopted a defiant posture, calling for a new form of American artistic nationalism in the face of the devastation of the Second World War:

'today America is faced with the responsibility either to salvage and develop, or to frustrate Western creative capacity'.[28] America's relationship to world events shifted from 1938 (when The Ten organised its *Whitney Dissenters* exhibition) to when it entered the war overseas in December 1941.[29] Moreover, America greatly benefited from the influx of many great European artists exiled there during the war at a time when there was a growing vitality among native talents. The Federation artists wanted to seize this unique moment, but, as the catalogue introduction cautioned, New York could not become an international art centre until it shed its provincialism and adopted a truly global outlook. Thus emphasis was on the universality of the artists' work.

The exhibition caught the attention of the *New York Times* art critic Edward Alden Jewell, who pronounced after seeing the show that he doubted 'anything globally halcyon had yet materialized.'[30] He singled out the work of Rothko and Gottlieb, stating, 'You will have to make of Marcus Rothko's "The Syrian Bull" what you can.' And he added, 'Nor is this department prepared to shed the slightest enlightenment when it comes to Adolph Gottlieb's "Rape of Persephone".'[31] (fig.38) Gottlieb telephoned Jewell on the day the review appeared and offered to supply him with a statement about the paintings. Eleven days later, excerpts from this statement, written jointly with Rothko, appeared in Jewell's column. The artists refused to provide a narrative description of the forms in their paintings, stating that 'Since art is timeless,

38
Adolph Gottlieb
The Rape of Persephone
1943
Oil on canvas
86.8 x 66.3
Allen Memorial Art
Museum, Oberlin College
Gift of Annalee Newman in
honour of Ellen Johnson

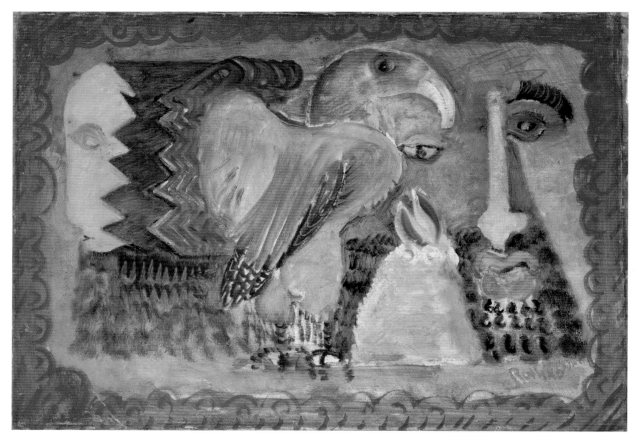

39
The Eagle and the Hare
1942
Oil on canvas
50.5 × 71.1
Collection of Christopher
Rothko

40
The Syrian Bull 1943
Oil and pencil on canvas
100.3 × 70.9
Allen Memorial Art
Museum, Oberlin College,
Ohio. Gift of Annalee
Newman in honor of Ellen
Johnson, 1991

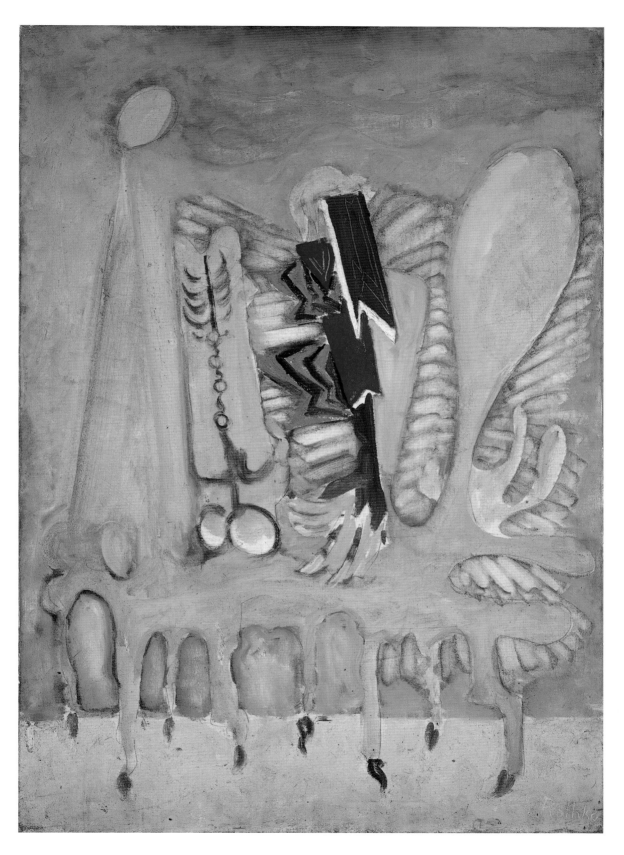

the significant rendition of a symbol, no matter how archaic, has as full validity today as the archaic symbol had then.'[32]

Claiming that 'no possible set of notes can explain our paintings', the artists, instead, listed some of their goals:

To us art is an adventure into an unknown world, which can be explained only by those willing to take the risks.

This world of the imagination is fancy-free and violently opposed to common sense.

It is our function as artists to make the spectator see the world our way – not his way.

We favor the simple expression of the complex thought. We are for the large shape because it has the impact of the unequivocal. We wish to reassert the picture plane. We are for flat forms because they destroy illusion and reveal truth.

It is a widely accepted notion among painters that it does not matter what one paints as long as it is well painted. This is the essence of academicism. There is no such thing as good painting about nothing. We assert that the subject is crucial and only that subject-matter is valid which is tragic and timeless. That is why we profess spiritual kinship with primitive and archaic art. [33]

This joint letter was edited by Barnett Newman, although he did not sign it. Rothko had initially planned to write his own letter rather than collaborate with Gottlieb, and the artists ultimately felt that the statement was a compromise, with each going along with the other's statements. In the numerous drafts of his individual letter, Rothko attempted to clarify his position to Jewell. The tone of these drafts was more conciliatory than the adversial joint letter sent for publication. In one of the drafts he wrote: 'What you are experiencing in my work is simply another aspect of the preoccupation with the archaic. In naming my picture *The Syrian Bull*, I was helping the onlooker by naming our association with the art of the past, which once my picture was done, I could not but observe.'[34] He added, that although the elements of the earlier painting, *The Omen of the Eagle*, were selected with specific reference to the tragedy *Agamemnon*, he denies a similar reading of *The Syrian Bull*. He further noted: 'The truth is therefore that the modern artist has a spiritual kinship with the emotions which these archaic forms imprison and the myths which they represent.'[35] He also indicated in these drafts that he placed greater value on the viewer's emotional response to his paintings than on the critic's formal analysis, stating: 'The public which reacted so violently to the primitive brutality of this art, reacted more truly than the critic who spoke about forms and techniques.' Moreover, 'That the public resented this spiritual mirroring of itself is not difficult to understand.'[36]

Rothko and Gottlieb were invited to comment on their controversial paintings in a radio interview broadcast on 13 October 1943. Here, Rothko restated his interest in representing an ideal, remarking: 'what is indicated here is that the artist's real model is an ideal which embraces all of human drama rather than the appearance of a particular individual. The whole of man's experience becomes his model, and in that sense it can be

said that all of art is a portrait of an idea.'[37]

Much as the paintings based on Classical mythology marked a decisive change in Rothko's paintings, another distinctive shift occurred late in 1943. The change was precipitated by the emotional turmoil brought on by the split from his wife Edith, which apparently caused Rothko to suffer a breakdown so severe that he checked himself into the hospital. As part of his recovery he travelled to Portland to visit his family and spend time with his friend Louis Kaufman and wife Annette in Los Angeles. The Kaufmans took Rothko to visit the Louise and Walter Arensberg collection of modern art in Los Angeles, the pre-eminent collection of works from the New York Dada movement in the mid-to-late 1910s. The Arensbergs had moved to Hollywood from New York in 1927, where their home and collection became a private forum for modern art.[38] Duchamp was the prime catalyst of this collection and the couple owned many of his major works. These paintings, with their gliding, bio-mechanical figures, may have triggered the significant and immediate change in Rothko's work that occurred at this time, inspiring him to paint more abstract, gyrating, biomorphic shapes.

Prior to this trip, Rothko had already begun abstracting the forms of his mythic paintings, perhaps as a response to the works of the Spanish Surrealist Joan Miró that he could have studied in depth at the Museum of Modern Art's survey in 1941, as well as in the solo shows at the Pierre Matisse Gallery. The mechanical, swirling figures, however, were not evident until the autumn of that year,

when he included a work in this mode in a group exhibition (fig.42).[39] While still in Los Angeles, Rothko met Buffie Johnson, a young American artist who had lived in Paris before the Second World War. Rothko showed her a small spiral notebook of watercolours that he had painted on his trip. Johnson was impressed by the 'Surrealist' style and recommended his work to Peggy Guggenheim, whom she had known in Paris.[40] By 1943, the American Howard Putzel had replaced Duchamp as Guggenheim's advisor and he encouraged her to show the younger, unrecognised American artists. The first solo exhibition was of Pollock's paintings of mythic content and symbolic images in November 1943, including the large-scale *Male and Female* 1942 (fig.41), and *Guardians of the Secret* 1943 (San Francisco Museum of Modern Art). The new programme provided the young Americans the opportunity to show in the same gallery as the avant-garde Europeans. Although Guggenheim initially had no interest in looking at Rothko's paintings, she and Putzel must have recognised the resemblance to Duchamp's work and included him in the *First Exhibition in America of Twenty Paintings* in the spring of 1944. They also gave him his first solo exhibition at the gallery, early in 1945. The exhibition received favourable notices and helped establish Rothko's reputation. Only three works were sold; one of them, the monumental *Slow Swirl at the Edge of the Sea* 1944 (fig.43), was bought by Guggenheim herself. This was Rothko's largest painting to date.

41
Jackson Pollock
Male and Female 1942
Oil on canvas
186 × 124.3
Philadelphia Museum
of Art
Gift of Mr and Mrs H. Gate
Lloyd

42
Untitled c.1943
Oil and pencil on canvas
47.9 × 33
Collection of Mr and Mrs
Byron Gerson, Michigan

The symbolism of *Slow Swirl at the Edge of the Sea* is open to multiple interpretations and brings to mind many art-historical sources, including Sandro Botticelli's *The Birth of Venus* c.1485–6 (Uffizi, Florence), which was exhibited in the Museum of Modern Art's *Italian Masters* exhibition in 1940.[41] Duchamp's *The Bride Stripped Bare by Her Bachelors, Even (The Large Glass)* 1915–23, on view since 1943 at MoMA, with its suggestion of metamorphosis and the electric shock of sexual attraction, may also have provided the impetus for *Slow Swirl*, which was painted during Rothko's courtship of his second wife, Mary Alice (Mel) Beistel. Mel, who came from a relatively affluent family in Cleveland, Ohio, was only twenty-two when she met Rothko. A recent graduate of Skidmore College, a small women's college in Saratoga Springs in upstate New York, she pursued her childhood aspiration by studying art. She moved to New York in the spring of 1944 where she supported herself with commercial art work. The couple met at a party in December 1944 and the young, attractive Mel was immediately impressed by Rothko, an artist who was already exhibiting his work regularly and receiving considerable attention. They married the following March.

In *Slow Swirl*, the dome-like head of the figure on the left, its wasp waist and bladder-shaped pelvic area, echo the physiogamy of Duchamp's 'bride' in both *The Large Glass* and the study for this figure in the painting *Bride* 1912 (fig.44), which was then in the Arensberg collection. Rothko's incorporation of repetitive, sequential forms to suggest

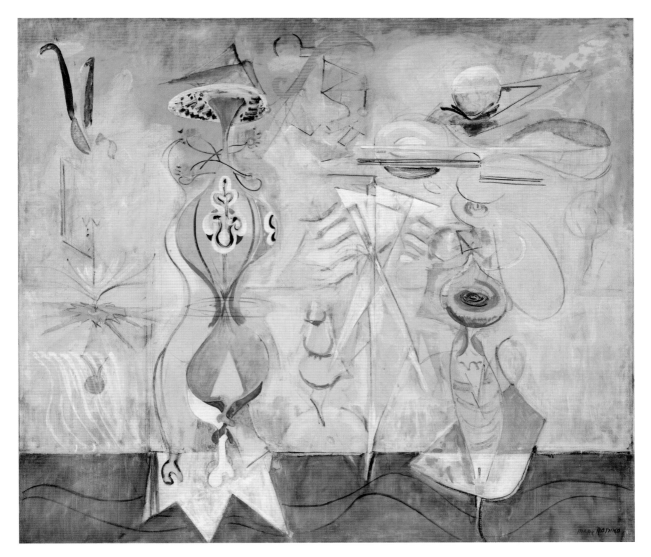

43
*Slow Swirl at the Edge of
the Sea* 1944
Oil on canvas
191.1 × 215.9
Museum of Modern Art,
New York

movement and the progression of time in *Slow Swirl* point to his familiarity with other Duchamp paintings such as *Nude Descending a Staircase (no.2)* and *The King and Queen Traversed by Swift Nudes* 1912 (Philadelphia Museum of Art), both of which he could have seen in the Arensberg collection the previous summer.

Although Rothko did not make a statement about the meaning of *Slow Swirl*, he repeatedly stressed its importance to him. On 23 April 1946, Guggenheim wrote to the director of the San Francisco Museum of Modern Art, which was organising a solo exhibition, stating that Rothko: 'would like to show the large canvas since he considers it his most important', a point that was reiterated by the artist when the museum accepted it as a gift from Guggenheim in June 1946: 'It is my favorite of all those I have painted'.[42] (In 1962, he traded the San Francisco Museum of Modern Art a dark, classic painting of 1960 (A672), for *Slow Swirl*. He gave the painting to Mel, who hung it in their home).

Ritualistic procreation became one of the subjects of Rothko's paintings during his biomorphic phase. While he seems to have represented a birth goddess in *Untitled* c.1942 (A207) and the coupling of two figures, presumably Oedipus and his mother, in one of the studies for *Oedipus* (A179), the symbolisation of procreation became more abstract in his paintings around 1944. In *The Artist's Reality*, he wrote: 'fertility symbolizes the biological necessity for procreation – for the extension of self – of which the whole art process is itself a part.'[43] The mechanical, spiralling forms of *Slow Swirl* seem to be a

ritualistic, sexual dance, suggestive of some kind of action or change. A similar swirl appears in paintings from late 1943, such as *Entombment* (A222), which also represents a form of metamorphosis, in this case death. *Ritual* 1944 (A232), with its womb-like vessel expelling a pod or fetus, replicates birth, as does the painting *Birth of Cephalopods* 1944 (A231), which is populated by newborn sea creatures moving along the bottom of the sea on their heads.

As he revealed to Newman in a letter of 1945, one of Rothko's methods of working was to challenge himself with a problem: 'I have assumed for myself the problem of concretizing my symbols, which give me many headaches but make work rather exhilarating. Unfortunately one can't think these things through with finality, but must endure a sense of stumblings toward a clearer issue.'[44] He was probably referring to a process that eventually led to such well-resolved paintings as *Phalanx of the Mind* 1945 (fig.45) and *Ceremonial* 1945 (fig.46), both of which were included in his solo exhibition at the San Francisco Museum of Modern Art, which opened in August 1946. The symbols in these paintings are more precisely drawn and geometric than the amorphic, diaphanous shapes of some of the late Surrealist paintings. They seem more concrete in form, functioning as actual things in the painting. *Phalanx of the Mind* is divided into two zones, a dominant brown area and a narrower grey zone below, which can be read as a room: a vertical, transparent rectangle stands like a pane of glass (possibly a reference to

Duchamp's *The Large Glass*) on the grey 'floor'. Rothko contributed to the transparent appearance of the freestanding rectangle by allowing the line formed where the grey and brown zones meet to show through. This painting demonstrates an early attempt to create a form that is simultaneously transparent and substantive.

The title *Phalanx of the Mind* provides some clues to the painting's meaning. The central cluster of forms literally illustrates a military phalanx, where infantry is massed closely together with their shields and spears overlapping. A phalanx is also a group of individuals unified for a common purpose. Both definitions are consistent with Rothko's goal to create unity out of the fragmentation of modern life.

Rothko clarifies the reason why he aimed to make his symbols more concrete in *The Artist's Reality*. He notes how children and 'primitive' artists give a 'concrete sense of reality' to the symbols they create in order to represent the unseen powers of their environment. 'In fact', he writes, 'they achieve a sense of reality so compelling that to the African, his images are real gods, and to the ancient Egyptian, those figures on the wall will be boon companions to banish the loneliness in the long solitude of a tomb, while the sarcophagi of the Christian Saints are actual embodiments of them, possessing the power to heal the sick and give new courage to the soul.'[45] The idea of giving concrete existence to his forms persisted as Rothko's paintings became more abstract.

Watercolour became increasingly important to Rothko during his Surrealist phase and he conceived many of these paintings on paper as finished works of art (figs.47 and 48). Although the Surrealist watercolours of the mid 1940s appear to be the result of pure automatic drawing, and are the most spontaneous to date, he felt the need to structure his compositions. In most cases he first drew his design with pencil and ruled the horizontal divisions, but even the under-drawing was not truly spontaneous, since the compositions of many of these watercolours appear to be modelled after some of his mythic paintings. A watercolour from 1944–5 (estate number 1099.44), for instance, abstracts the multiple figures and transforms the pointing finger in *Antigone* into an arrow. He also appears to have continued to use existing models for his images. The serpent in one of his last Surrealist watercolours, *Vessels of Magic* 1946 (fig.48), for example, closely resembles the snake representing the invasion of Israel by Egypt depicted in one of the illustrations for *The Graphic Bible* (fig.49).

Rothko evolved a personal watercolour technique during these years. Using soft-bristled brushes, he applied the watercolour, gouache and tempera to the paper. Before the paint dried, he would define contours or create independent gestures with black ink. When introduced into areas still wet with paint, the ink would bleed, resulting in the black bursts that spot some of these works. Pointillist dabs sometimes fill horizontal planes, and an occasional charcoal highlight creates velvety, opaque passages. As a final

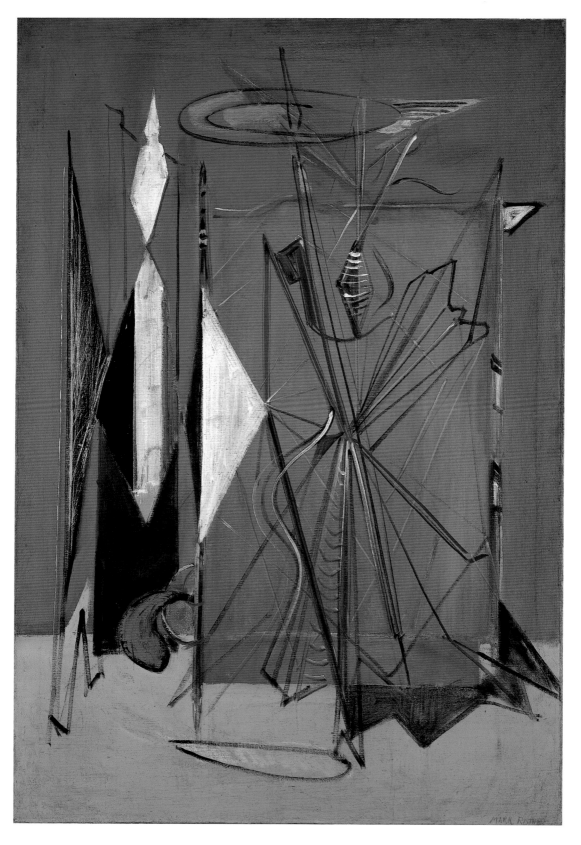

THE ROTHKO BOOK

45
Phalanx of the Mind 1945
Oil on canvas
137.9 × 90.8
National Gallery of Art,
Washington
Gift of The Mark Rothko
Foundation, Inc.

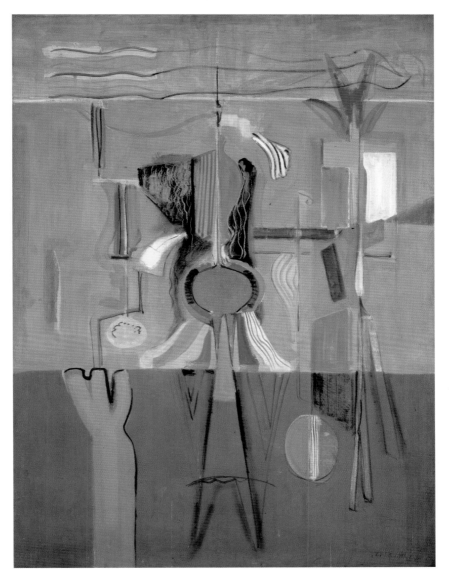

46
Ceremonial 1945
Oil on canvas
136.8 × 100.3
National Gallery of Art,
Washington
Gift of The Mark Rothko
Foundation, Inc.

47
Untitled 1945–6
Watercolour and ink on
paper
69.9 × 52.1
National Gallery of Art,
Washington
Gift of The Mark Rothko
Foundation, Inc.

step, Rothko would scratch and gouge the paper with a razor blade, the back of a brush, or some other sharp implement, exposing the white paper beneath the pigments. As one might expect, this experimentation influenced his canvases of the mid 1940s. He began to use oil paint as if it were watercolour, thinning the medium and applying it in overlapping glazes.

By 1946, the biomorphic paintings brought Rothko closer to abstraction. The previous year, however, he was still struggling with his dual allegiance to Surrealism and abstraction, stating: 'I quarrel with surrealist and abstract art only as one quarrels with his father and mother recognizing the inevitability and function of my roots, but insistent upon my dissension: I, being, both they, and an integral completely independent of them.'[46] He was drawn to Surrealism because 'the surrealist has uncovered the glossary of the myth and has established a congruity between the phantasmagoria of the unconscious and the objects of everyday life [that] constitutes the exhilarated tragic experience which for me is the only source book for art.' In other words, by drawing on the subconscious, the Surrealists made their imagination a concrete reality.[47] But Rothko also appreciated the abstract artists for giving 'material existence to many unseen worlds and *tempi*'. His ideal art was 'an anecdote of the spirit, and the only means of making concrete the purpose of its varied quickness and stillness'.

By 1947, Rothko came to the conclusion that in order to create a truly transcendent art, he would have to free himself from familiar subjects and styles, and bring into existence works that were miraculous. Such paintings would startle viewers by looking unlike anything they had seen before, revealing an 'unexpected and unprecedented resolution of an eternally familiar need'.[48]

During the final years of transition in his work from Surrealism to abstraction, Rothko expected the shapes in his paintings to perform as credible organisms that would 'move with internal freedom', without being bound to the laws governing beings in the physical world. Although his forms have 'no direct association with any particular visible experience', the viewer recognises in them 'the principle and passion of organisms'. A successful painting, he stated, was one from which he could step back, divorcing himself as the creator, and indulge himself in the miraculous image before him.[49]

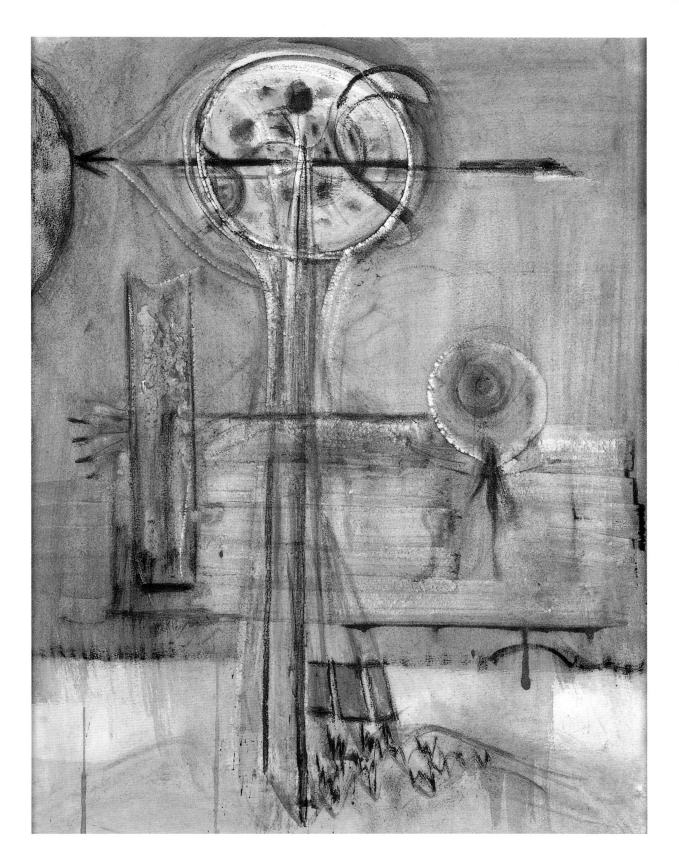

48 (opposite page)
Vessels of Magic 1946
Watercolour on paper
98.4 × 65.4
Brooklyn Museum of Art,
New York

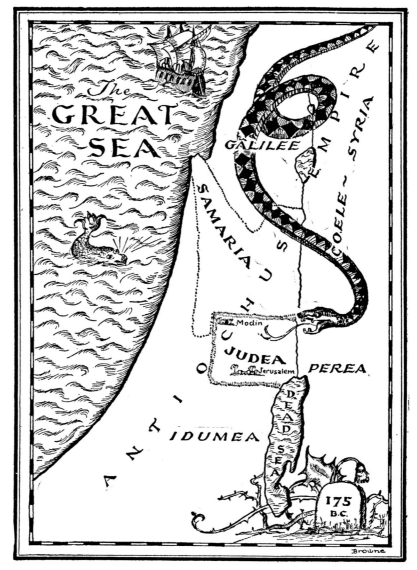

49
Illustration in Lewis
Browne, *The Graphic
Bible: From Genesis to
Revelation in Animated
Maps and Charts*, New
York 1928, p.83

Sacrifice of Iphigenia

By 1942, Rothko's figurative mythological compositions of the early 1940s began to give way to more abstracted symbols. It was not easy for him to abandon the figure. He belonged to a generation that was preoccupied with this subject, and felt that it was the primary area for study. Therefore, it was only with the 'utmost reluctance' that he found that the figure no longer met his needs, since 'no one could paint the figure as it was and feel that he could produce something that could express the world'. His predicament triggered his foray into mythological subjects, 'substituting various creatures who were able to make intense gestures without embarrassment'. These transmogrified into abstracted,'morphological forms', but he ultimately found that this was 'unsatisfactory'.[1]

Sacrifice of Iphigenia 1942 is one of the earliest paintings that marks the transition from the mythological works to the morphological forms. As in a number of his other mythological paintings, the title of this work is based on Aeschylus's play *Agamemnon*. Iphigenia was the daughter of Agamemnon, leader of the Greek forces in the Trojan War. He was forced to sacrifice his daughter in order to appease the goddess Artemis, who had imposed a contrary wind to stall the Greek fleet from sailing to Troy.

In *Sacrifice of Iphigenia*, Rothko captured the essence of this tragedy. Rather than representing the protagonists as hybrid creatures in low-relief as in previous mythological paintings, he reduced the figures to flat symbols. Iphigenia is presumably represented by the black cone sprouting spindly legs. A tiny circle tilted demurely to the left tops this form. In a related sketch made in Rothko's scribble book, the circle is dotted with three further round shapes representing eyes and mouth. This schematic female figure also appears in *Untitled* 1942 (A209), another untitled painting from that year (A211) and *The Syrian Bull* 1942 (fig.40), among other works. The two disembodied arms reaching into the painting from the right bear a striking resemblance to the arm of destruction that appears in *The Graphic Bible* (see fig.33). These extended arms seem to gesture the command for Iphigenia's sacrifice. The totem-like figure on the right, and the jagged red-and-green geometrical pattern behind Iphigenia, seem to be greatly abstracted versions of the eagles in related drawings in the scribble book, and in paintings such as *Untitled* 1942 (A209) and *The Omen* (A216). If these are indeed two eagles, they refer to the omen of the eagles at the beginning of *Agamemnon* that foretells the Trojan War.[2]

The forms, with the exception of Iphigenia, are supported by a peach-coloured platform or stage. As in his late 1930s still lifes arranged on narrow ledges, Rothko restricted the space of these figures to this platform and flattened the backgrounds against the picture plane. The suggestion of recession is greatly reduced as a result of the schematic shapes. Nevertheless, Iphigenia's cone dress and the totem project forward from the picture plane, thus providing the pictorial plasticity that Rothko aimed to maintain. The significance of this painting in Rothko's transition from the early mythological paintings to the biomorphic works is underscored by its inclusion in his first solo exhibition at Art of This Century in 1945, since it was the earliest work in an exhibition that culminated with *Slow Swirl at the Edge of the Sea* 1944 (fig.43).

In Aescylus's play, Agamemnon agonises over his predicament as he is forced to slay his own, innocent daughter for the good of his country. *Sacrifice of Iphigenia* was painted during the Second World War, and could therefore be perceived as Rothko's rumination on the sacrifice that was being made by young soldiers for the sake of humanity. His interest in the subject of sacrifice, however, was more universal: he also painted scenes of crucifixion in the 1930s and early 1940s (fig.67 on p.103).

The concept of sacrifice was still on Rothko's mind in 1958. During his lecture at Pratt Institute that November he recommended to his audience 'a marvelous book: Kierkegaard's *Fear and Trembling*, which deals with the sacrifice of Isaac by Abraham'. He had read this book by the nineteenth-century Danish Philosopher in 1955.[3] Rothko noted that there were earlier tales of sacrifice, such as those of the Greeks and 'the Agamemnon story (state or daughter)', but that what 'Abraham did was un-understandable'. Whereas Agamemnon was praised for his willingness to undertake this painful personal action for the welfare of the state, Abraham overstepped ethical boundaries entirely. His act was an absurd choice because it meant the suspension of reason in the face of faith. Abraham's act was unprecedented and completely original. However, Rothko noted, 'As soon as an act is made by an individual it became universal.' He apparently equated Abraham's unique act with artists such as himself who take a leap of faith to create unprecedented gestures.

Rothko was also intrigued by another ethical question raised by Kierkegaard in regard to Abraham's predicament: should he tell his wife Sarah and Isaac what God commanded of him? Abraham resolves not to explain his actions. According to Kierkegaard, he could not do so

50
Sacrifice of Iphigenia 1942
Oil and pencil on canvas
127 × 93.7
Collection of Christopher Rothko

because his actions would not be understood. As Rothko told his audience at The Pratt Institute, 'This is a problem of reticence', which could be applied to art. He remarked that some artists 'want to tell all like at a confessional'. He, however, 'preferred to tell little'. Although this statement can be interpreted as an explanation as to why he virtually stopped making published statements about his work in 1950, from the rest of his presentation it is clear that he was referring to his classic paintings, which, as he acknowledged, were essentially 'facades' that revealed little of his intent to the viewer. To Rothko, the mythological paintings of the early 1940s, which were based on dramatic anecdotes, gave viewers too much specific information; even

the biomorphic forms that replaced the figure were too symbolic. The figurative elements and the anecdotes were impediments to the universality that he hoped to achieve in his work. Ultimately, and with 'utmost reluctance', he had to sacrifice the figure to make a unique gesture, which itself could not be explained in words. According to Rothko, there were two things that were basic to painting: 'the uniqueness and clarity of image and how much does one have to tell'. As he moved from the mythological paintings to abstraction, he concluded that there was 'more power in telling little than in telling all'.

By 1950, the burgeoning New York art scene was attracting the attention of the European art establishment. The June 1951 issue of the French monthly *Art d'aujourd'hui* was devoted to painting in the United States. It included an article by Michel Seuphor on the New York art scene, the first written by a European on the Abstract Expressionists.[1] Seuphor, who travelled from Paris to New York during the winter of 1950–1 to research his article, marvelled at the astonishing growth of Manhattan and its art world, remarking, 'It is only in the past five or six years that modern painting has begun to live. I mean it has entered the ranks of society, it is talked about.'[2]

Seuphor arrived in New York at an ideal moment, and he referred to the winter of 1950–1 as the 'apogee' of abstract art in America. He was able to attend the Museum of Modern Art's exhibition *Abstract Painting and Sculpture in America*, and on 5 February he was present at the opening of a 'magnificent exhibition' of Mondrian at the Sidney Janis Gallery, and an evening symposium at the Museum of Modern Art in which six artists – G.L.K. Morris, Robert Motherwell, Fritz Glarner, Willem de Kooning, Alexander Calder and Stuart Davis – discussed what abstract art meant to them. Two other exhibitions opened during his stay, *Contemporary American Painting* at the Whitney Museum of American Art, which included Rothko, and *American Painting Today*, a national survey at the Metropolitan Museum of Art.

To the foreign critic, the New York art world seemed to have emerged almost overnight, but even Seuphor recognised that what he had experienced was the culmination of a long period of education, exposure to art and the establishment of relationships between artists, dealers, collectors, critics and museum professionals. In such a small art world, individuals could have an impact on the course of its evolution, and Rothko's participation was significant. He thrived on the intellectual exchange within small groups of artists, first with The Ten in the 1930s, then with Gottlieb and Newman during his early Surrealist phase, and later with Newman and Clyfford Still as he delved into abstract painting in the mid 1940s. As American Scene Painting and Regionalism were still the American art movements that were predominantly represented in the New York museums during the 1940s, Rothko and his colleagues built their reputations on a position of dissent.

The centre for the New York School was focused in New York's downtown, in and around Greenwich Village. Rothko lived in Brooklyn in the early 1940s and Manhattan's west side in the later half of the decade, and so was geographically separated from the downtown artists. Moreover, he and Mel lived a conventional domestic life, in contrast to the Bohemian lifestyle of such downtown artists as de Kooning. He had his steady teaching job at the Brooklyn Jewish Center and he maintained friendships with artists, musicians and writers who shared his interests.

During the final years of Rothko's

3 The Irascibles

transition from Surrealism to pure abstraction, his relationship with Newman and Still would play an important role. The three artists worked closely together, especially from the mid-to-late 1940s, with ideas freely circulating among them. Like Rothko, Newman believed that painting had to be more than a practice in formal relationships of colour and shapes. He had considerable interest in Jewish mysticism and nature, and studied botany and ornithology, a subject that Rothko also appreciated. His particular focus was to investigate the genesis of life.[3]

From Rothko's correspondence to Newman in the 1940s, it is clear that he valued his response to his work and ideas, as well as his friendship. He was frank about his successes and failures, and eagerly awaited Newman's correspondence. In a letter from the seaside haven of East Hampton, New York, dated 10 August 1946 he reported that the curator of the Museum of Modern Art wanted to see his recent works, and added an aside, wondering what this could mean. His summers in the small town of East Hampton where other artists also summered made contact with a wider group of his colleagues easier than in the city. He described his impression of East Hampton and of some of these artists and critics:

All in all, I find Bob [Motherwell] a gracious and interesting guy and [William] Baziotes a swell and vivid person. Pollock is self contained and sustained adverting concern and [critic] Harold Rosenberg has one of the best brains that you are likely to encounter, full of wit, humanness, and a genius for getting things impeccably expressed. But I doubt that he will be of much use to us.[4]

In the 1930s Newman actively participated in the discussions among the circle of artists in New York that included Rothko and Gottlieb. He wrote introductions and essays for exhibition catalogues and organised exhibitions for various galleries, including a show of Northwest Coast Indian art for the opening of the Betty Parsons Gallery in the autumn of 1946. He also introduced Parsons to other artists. This close association helped to establish the gallery as the premiere venue for the American avant-garde after Peggy Guggenheim closed her gallery in the late spring of 1947.

Newman, who had given up painting around 1939–40, resumed this activity in 1944. By 1946–7, he had arrived at an image for his painting that captured the essence of his penetration into the world mystery, particularly the origins of life and the awe inspiring abyss. In paintings such as *The Euclidian Abyss* 1947 (private collection), a single line traverses the canvas from top to bottom. Rather than appearing as a line drawn on top of a dark field, it registers as a crevice or abyss between forms. This line also appears in *Death of Euclid* 1947 (fig.51). Here it is joined by a dark, embryonic form on the right, which is surrounded by an aura suggestive of the energy field of creation. The vertical lines in both paintings, while not hard edged, display a distinct contour, whereas the aura circumscribing the disc in *Death of*

51
Barnett Newman
Death of Euclid 1947
Oil on canvas
40.6 × 50.8
Fredrick R. Weisman Art Foundation, Los Angeles

Euclid is soft and defuse, without any defined lines. In these early paintings he suggested the original creation by producing a void from which other forms seem to emanate.

The suggestion of a void, a characteristic of Newman's paintings in 1946–7, had already appeared as a feature in Still's paintings by 1945. In such works as *Untitled* 1946 (Museum of Modern Art, New York), craggy stalagmites and stalactites grow towards each other, either interlocking or leaving a gap for a radiating light or dark abyss. Still lived in New York from 1945 to 1946, and was drawn into the circle of artists that included Newman and Rothko, whom he met in the summer of 1943. At that time, Still was living in Berkeley, California, and Rothko visited him there during his trip west after the breakup with his wife. In California, Still was following a path in his painting in which he used mythological symbols much like the New York artists – Rothko, Gottlieb, Pollock, the sculptor David Smith, among others. Rothko immediately became an enthusiastic advocate of his work and facilitated exhibitions for him in New York, including his first solo show at Art of This Century in February 1946. He even wrote the essay for the catalogue for this exhibition. Rothko was struck by the fact that Still began using symbols to represent myths independently of the New York artists, and consequently concluded that this development was the inevitable outcome of the times rather than just a local influence. Rothko wrote 'It is significant that Still, working out West, and alone, has arrived at pictorial conclusions so allied to those of the small band of Myth Makers who have emerged here during the war.' Of particular interest to Rothko was that Still had arrived at 'a completely new facet of this idea, using unprecedented forms and completely personal methods'. Rothko admired Still for being able to bypass the 'current preoccupation with genre and the nuance of formal arrangements.' Rothko admired his work for being neither figuration nor concerned with the early modernist tradition of geometric abstraction. Still was creating something completely new that would 'replace the old mythological hybrids who have lost their pertinence in the intervening centuries'.[5] 'For me', Rothko wrote:

Still's pictorial dramas are an extension of the Greek Persephone Myth. As he himself has expressed it, his paintings are 'of the Earth, the Damned, and of the Recreated'. Every shape becomes an organic entity, inviting the multiplicity of associations inherent in all living things. To me they form a theogony of the most elementary consciousness, hardly aware of itself beyond the will to live – a profound and moving experience.[6]

Rothko had begun the final transition to pure abstraction when he wrote the introduction to Still's catalogue. In his statement 'The Romantics Were Prompted' published in *Possibilities* (1947–8), he used similar terminology to describe his own transitional abstract paintings. He stated that he thought of his pictures 'as dramas', while 'the shapes in the pictures are performers' and

'organisms with volition and a passion for self-assertion'.[7]

In 'The Romantics Were Prompted' Rothko was referring to the paintings often identified posthumously as 'multiforms' (figs.55, 56, 57). The paintings continued some of the shapes found in the biomorphic paintings. Gone, however, were the symbols and the calligraphic lines of these earlier works. As in Still's paintings, Rothko's new canvases were broken up into a multitude of forms. No longer confined by contour drawing, as in his previous paintings, these shapes bleed at their edges, causing a vibration that provides both an inner light and movement. The reaction between the forms is organic; some abut each other at their edges or seem to engulf smaller shapes, while others drift apart, revealing a primordial region behind. In their suggestion of movement, the multiforms provide an interesting comparison with Pollock's 'drip' paintings, which emerged in 1947. In these works, Pollock eliminated most vestiges of recognisable imagery and used a gesture in which he dripped rather than brushed paint onto unstretched canvas rolled out onto the floor, to create an all-over composition. The poured paint formed multiple overlapping, fluid lines. Like Rothko's multiforms, Pollock's paintings capture a moment of flux. However, his lines are a permanent record of the artist's action, whereas Rothko's multiforms, instead of representing the artist's gesture, seem able to move and breathe on their own.

Unlike Newman and Still, who maintained a defined edge for their forms, or Pollock, whose paintings were a web of dripped skeins of paint, for the most part, Rothko eliminated all lines that would limit the appearance of potential growth. Although his shapes occasionally interlock, they generally swim free in front of the picture plane. Another important detail in the multiform paintings is the way in which he controlled the space surrounding the forms. In his notes for *Types of Composition* in his scribble book, Rothko jotted: 'Painting around an object.'[8] The areas circumscribing his forms are not lines painted on the surface, but comprise the space of an abyss that separates each form. Newman similarly painted the space between forms as active and interrelated to the forms themselves and he advocated the creation of a new art in which 'form can be formless'[9]. The indeterminate space surrounding Rothko's areas of colour became an essential element of his paintings.

Still was on the faculty of the California School of Fine Arts, and at his encouragement Douglas MacAgy, the dynamic young director of the school, engaged Rothko to teach during the summers of 1947 and 1949. Benefiting from the G. I. Bill that provided tuition assistance to servicemen returning to civilian life after the war, the school functioned as a cultural complex where studios were open all night, musical and literary events were held, and there were lectures by notable speakers, among them Man Ray and Salvador Dalí. In 1949, he organised the Western Round Table on Modern Art that included Frank Lloyd Wright, Duchamp, Mark Tobey, and Robert Goldwater among other distinguished

participants. MacAgy's wife Jermayne was assistant director and subsequently director of San Francisco's California Palace of the Legion of Honor in the 1940s, and along with her husband was an early advocate of the Abstract Expressionists. She included works by a number of these artists in group shows and gave a solo exhibition to Still in 1947, which was on view during Rothko's residency at the school. In later years, Jermayne moved to Houston, where she became the first professional director of the Contemporary Art Museum. She organised a major Rothko exhibition there in 1957, and played an important role in encouraging the patronage of Houston collectors, John and Dominique de Menil, both in terms of contemporary art in general and of Rothko's work in particular, eventually leading to the commissioning of the Rothko Chapel in 1964.

By the time Rothko arrived in San Francisco to teach in the summer of 1947, he was already known in the Bay Area; the San Francisco Museum of Modern Art had presented his first solo museum exhibition since his 1933 exhibition in Portland in the summer of 1946, and had acquired *Slow Swirl at the Edge of the Sea* (fig.43on p.57) for its permanent collection, installing it for public view in the museum's rotunda. Rothko's living arrangements in San Francisco were especially grand. He and Mel had a house on Russian Hill (an irony the Slavic Rothko noted in a letter to Herbert Ferber[10]) with an exquisite view of the bay on one side and Coit Tower and Telegraph Hill on the other.

MacAgy gave him a little studio in the school. As for teaching, he reported to Newman that:

I have had enough nerve to go into these sessions completely unprepared, and just ramble along and perhaps have conveyed many of our mutual ideas with a vividness which would not have been equaled had I tried to organize the material into some sort of system.[11]

A conflict of an unspecified nature appears to have arisen between Rothko and Newman at this time, concerning discussions they had had in New York. Rothko assured Newman in a letter of 19 July 1947 that 'discussions that are between you and me were strictly a personal matter, and since our terminology differs, our conflicts were never duplicated here [in his classes in San Francisco].[12] Despite the genuine warmth of Rothko's letters to Newman and the camaraderie they enjoyed, they felt they had to guard their innovations and ideas about art.

While Rothko was separated from Newman in the summer of 1947, Still and MacAgy were his constant companions. He also became friends with other San Francisco area artists teaching at the school, including Elmer Bischoff, Hassel Smith, and Clay Spohn. Rothko's stay in San Francisco was so enjoyable that he frequently remarked on these pleasures in his letters to Spohn. Most importantly, he seemed to achieve an important breakthrough during his time in San Francisco, which he acknowledged in a letter to Spohn after his return to New York:

I have already received and stretched the canvases I did in San Francisco. Elements occurred there, which I shall develop, and which are new in my work and that at least for the moment stimulate me – which gives me the illusion –at least – of not spending the coming year regurgitating last year's feelings.[13]

MacAgy apparently was privy to this breakthrough and took the opportunity of his presence in San Francisco to begin work on an article on Rothko, which although it was not published until January 1949, was the first lengthy feature article on him in an art journal. It appeared in the *Magazine of Art* and included reproductions of paintings from the biomorphic Surrealist period, such as *The Source* c.1945–6 (fig.52) and *No.18* c.1946–7 (fig.57 on p.87), a purely abstract painting.[14] The leap was precipitated by Rothko's formulation of a philosophy of space. MacAgy wrote, 'If we subscribe to the notion of painting as a symbolic act, we are on the way to understand what Mark Rothko means when he says that a painter commits himself by the nature of the space he uses.'[15] Until the recent publication of Rothko's *The Artist's Reality*, the meaning of MacAgy's statement could not be fully understood. It is now apparent that MacAgy had access to Rothko's manuscript and was paraphrasing his statements on pictorial space.[16]

In his book, Rothko described two modes of space intuition: the tactile type and the visual or illusionary. He identified tactile space as characteristic of the art of Ancient Greece, China, primitive cultures and children. In tactile space, the viewer has the sense of an actual physical and tangible sensation of recession and advancement. It is a space that is known through touch, even when it is only sensed by the eye. Visual space was made possible by the invention of linear perspective during the Renaissance. This type of vision is systematic and aims to achieve the illusion of objects as they appear to the eye. Modern psychology, as Rothko noted in his book, demonstrated the fallacy of linear perspective.

Although Rothko did not cite the source for his writings on space intuition, MacAgy revealed in his article that these theories were based on two books: *On the Rationalization of Sight* (1938) and *Art and Geometry* (1946), both by William M. Ivins Jr, the first curator of prints at the Metropolitan Museum of Art.[17] Ivins's study of perspective identified the two types of space intuition that Rothko described. Most significantly, Rothko shared with Ivins the observation that both methods were usually in operation in a painting. According to Ivins, the presence of these two contradictory methods creates a crisis because the mind needs to choose one over the other in order to understand the relationship of the objects or forms in a painting. Moreover, the space intuition that a culture chooses in order to organise vision influences its philosophical point of view. The Greeks, for instance, opted for tactile vision when the two types were in conflict.[18] As proof, Ivins noted how the Greek philosophers' distrust of visual apprehension and knowledge led them to deem visual art imitation and therefore a falsehood. Socrates

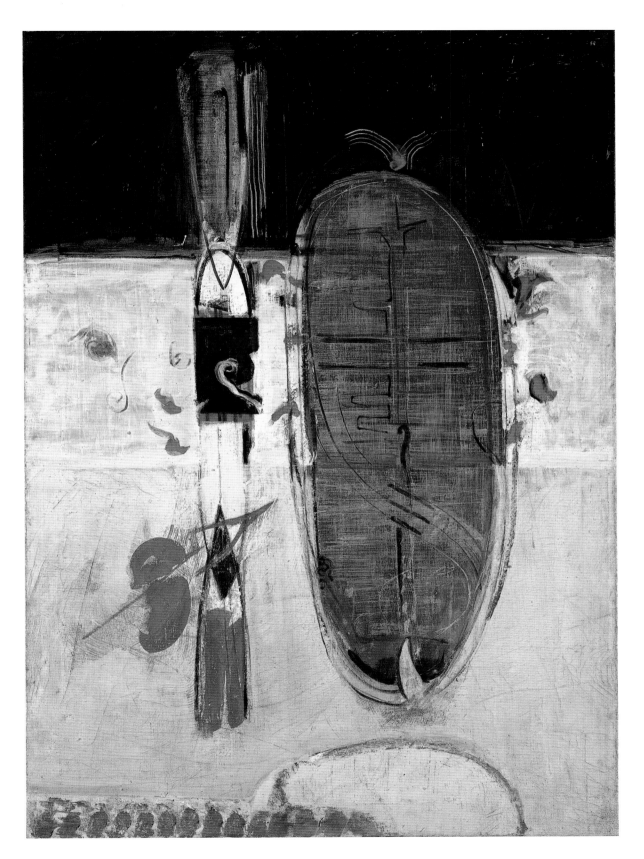

53
No.4 / No.32 c.1949
Oil on canvas
73.8 × 127.6
Los Angeles County
Museum of Art
Gift of The Mark Rothko
Foundation, Inc.

and Plato, writes Ivins, 'even went so far as to take a moral stand' against the visual arts on this basis.[19] The modern painters, as Rothko observed, also chose tactile space intuition partly because twentieth-century scientific analysis proved that it was the most basic and natural method for the 'plastic expression'. But even with the new sciences, Rothko recognised that it was still difficult to reconcile the subjective and objective comprehension of reality. Scientific advances, as Rothko observed, produced in Dadaism and Surrealism a philosophy of skepticism aimed at painting. For the Dada artist, any attempt to represent reality by illusionistic means was futile.[20] Duchamp's readymades avoided the issue of illusion by presenting real objects as art rather than as representations of reality.

Rothko, who had rejected perspective in his formative years, now had a philosophical basis for committing himself to synthesising the tactile and visual approach to pictorial space. In paintings based on linear perspective, the areas around objects appear as empty air. Tactile space intuition takes into account the fact that air is an actual substance, with a pressure of fifteen pounds per square inch, as Rothko noted. Based on this observation, he began conceiving his pictures as 'a plate of jelly' in which 'a series of objects are impressed at various depths'.[21] Rothko achieved this effect in some of his later multiforms, such as *No.4/No.32* c.1949 (fig.53) in which amorphous shapes advance and recede in a substantive space.

The creation of a new type of pictorial space was not an end in itself. The philosophical decision to commit himself to the unity of tactile and visual space intuition fuelled Rothko's determination to create forms that appear to be in a state of flux. Linear perspective fixes objects in a painting in relation to each other and to the viewer. Their position never changes. By eliminating perspective and any other conventional indicators of measure that would help locate these forms in space, Rothko was able to produce organisms that appear to be constantly shifting their position. Shapes in these paintings are seen simultaneously as sitting on the surface and receding into the distance. Colour, the relative size of the shapes, and the overlapping of forms were the means that Rothko used to establish a space philosophy that was both illusionary and tactile.

The representation of new pictorial space was not Rothko's ultimate goal. This space was essential to the drama he aimed to enact in his canvases. The shifting relationships between Rothko's forms also captured the experience of the constant state of flux that characterised modern times. MacAgy raised a conundrum that Rothko obviously pondered, which is how art can suggest transitional existence while working 'within the confines of a framed canvas.'[22] Rothko's solution in his late multiforms and classic paintings takes into account the fact that the canvas has terminal edges. He aimed to prevent the border of a painting from acting as a final enclosure. Instead, one may glimpse a scene of illimitable dimensions. The edge, in effect,

acts like a freeze-frame of a film, which captures just one episode of dramatic transformation.

MacAgy's article is particularly revealing in terms of how Rothko conceived his late multiforms (1947–9) in relation to ancient myths. These works are dynamic fields of action in which the shapes are constantly transforming themselves. As MacAgy notes, this phenomenon calls to mind 'the myths where gods are interchangeable with the forces of nature.'[23] Rothko gave concrete existence to these invisible forces so that the viewer could visualise them.[24] The breakthrough Rothko achieved the summer of 1947 was more conceptual than formal. This philosophy of space, however, eventually led him to conceive his signature image and remained a constant condition of his approach to his work throughout the rest of his career.

During Rothko's first stay in San Francisco the summer of 1947, he and Still continued their discussions, begun the previous April, about founding an art school in New York that would truly address the needs of developing artists. The concept of this experimental school was appealing to Rothko, who had been using progressive methods to teach art to children since 1929. In 1948, Rothko, Motherwell, William Baziotes and David Hare established The Subjects of the Artist school. Still also participated in the development of the school when he moved to New York in the spring of 1948, but his concept of a school run by artists with no administration, and which would allow teachers to instruct however they chose, was too informal for the other founders. He removed himself from the project in the summer of 1948 and returned to teach at the California School of Fine Arts. The Subjects of the Artist opened in October 1948. By January 1949 Newman had joined the staff. In the spring, the school added an important component of Friday evening seminars, presented by advanced artists or intellectuals, that were moderated by Motherwell. Although the artists were enthusiastic about this school, it was a short-lived experiment that closed by the spring of 1949.

As the paintings of the American artists of the late 1940s became increasingly abstract, the emphasis on subject became an urgent concern and the founders of the school aimed to impress this philosophy on a new generation of artists. Motherwell recalled that the name of the school was Newman's and that the other founders agreed that it was right because it made the point that their works, although non-objective, did have subjects.[25] The curriculum promoted a complex new method of image-making without using figures or symbols.

The exhibition *The Ideographic Picture*, which Newman organised at Betty Parsons in January 1947, aimed to define the new focus prevalent among American artists and to demonstrate that this work, although abstract in style, had content. He wrote in the exhibition catalogue, 'Spontaneous, and emerging from several points, there has arisen during the war years a new force in American painting that is the modern counterpart of

the primitive art impulse.'[26] Neither Surrealistic nor abstract, this new painting was based on the ideograph, which was defined as a 'character, symbol or figure which suggests the idea of an object without expressing its name.' These pictures embodied the strength he discovered in early Native American art, in which 'a shape was a living thing, a vehicle for an abstract thought complex.'[27] This group exhibition included works by Hans Hofmann, Ad Reinhardt, Rothko, Theodoros Stamos and Still, all of whom were represented by Parsons. Newman wanted to include Gottlieb, but his dealer Samuel Kootz would not permit it. Fortunately, Gottlieb's solo exhibition at the Kootz Gallery, located across the hall from Parsons, coincided with the opening week of *Ideographic Picture*. Newman also took the opportunity to exhibit his own works for the first time.

Rothko was represented in *The Ideographic Picture* by *Tiresias* 1944 (A247) and *Vernal Memory* 1946 (A311). *Tiresias*, painted in Rothko's biomorphic style, made specific reference to a Greek myth. Blinded by Hera, Tiresias was given visionary powers by Zeus, and was the prophet who warned King Creon on the consequences of his edict. In Rothko's painting, Tiresias appears to be symbolised by the large circle containing a single, dark oculus, which explains the work's inclusion in a show on ideographs. *Vernal Memory*, however, marks the transition from the biomorphic paintings to the looser, less defined abstract shapes of the multiforms. Its selection for the exhibition supports the belief held by both Newman and Rothko that abstract forms were as potent as the symbols of ancient and primitive civilisations.

On 29 January 1948, Newman discovered in a work in progress that he inadvertently created a radical expression of space that had not previously existed in his paintings. He had painted a small canvas (69.2 x 41.2 cm) with brownish red paint and then fixed a piece of tape over the colour field and down the centre. He scumbled a red-orange paint over the tape in order to test the colour before committing himself to painting it on canvas. Initially, he planned to continue working the background colors as he had in previous works to create an atmospheric effect, but decided it was perfect just as it was. He titled the painting *Onement I* (fig.54) and spent the following months trying to analyse why it produced a spatial quality so different from the paintings that preceded it. Undoubtedly, Rothko was included in this probing of *Onement I*. As Yve-Alain Bois notes, Newman, in later years was critical of his paintings pre-*Onement I* for their atmospheric effect. Newman realised that prior to this painting, he was 'filling in the void with forms' because he took for granted that the atmospheric approach was a prior condition of pictorial space. Much like Rothko, he had been occupying this space with gestures and marks that functioned like actors.[28] Newman did not identify the cause of his epiphany about the nature of pictorial space, but as revealed in his essay 'The Sublime Is Now' (December 1948) he was preoccupied, like Rothko, with the battle between the objective and subjective

54
Barnett Newman
Onement I 1948
Oil on canvas
69.2 × 41.2
Museum of Modern Art, New York
Gift of Annalee Newman

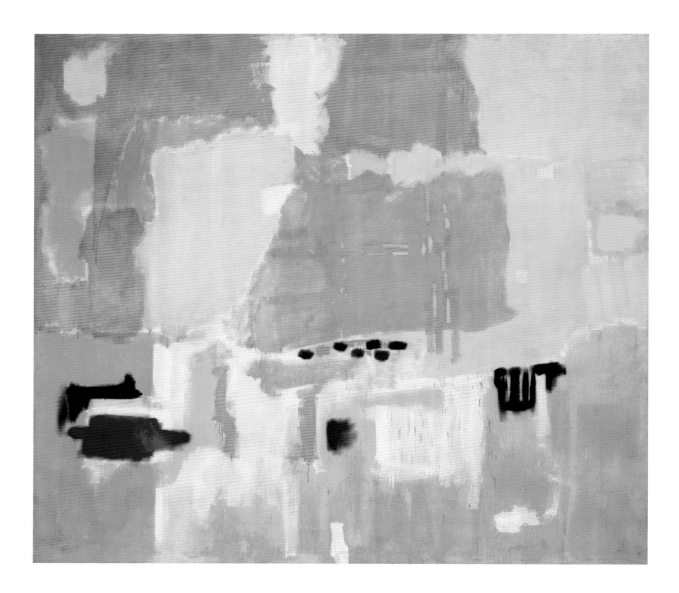

55
No.1 [Untitled] 1948
Oil on canvas
270.2 × 297.8
Museum of Modern Art,
New York

response to the world in modern art.[29] In *Onement I* the flat, minimally modulated areas of colour create an expanse that extends beyond the edge of the canvas. The painted tape strip or 'zip' is a marker that establishes the viewer's location in a space that has no boundaries.

Rothko probably saw in *Onement I* the creation of a new kind of space he had been envisioning since the previous summer. At this time in their relationship, Rothko considered his and Newman's pursuits as a shared expedition rather than exclusive to each other's achievements. In later years Newman insinuated that Rothko was too easily influenced by him.[30] Although *Onement I* and the subsequent 'zip' paintings may have served as a catalyst for Rothko, the impact was not immediate. In fact, in May 1948 he was feeling disillusioned about the life he had chosen for himself. In a letter to Clay Spohn he revealed that he was struggling with his work:

I am beginning to hate the life of a painter. One begins by sparring with his insides with one leg still in the normal world. Then you are caught up in a frenzy that brings you to the edge of madness, as far as you can go without ever coming back. The return is a series of dazed weeks during which you are only half alive.[31]

In October of that year Rothko's mother died, and for an extended period of time he reportedly became too depressed to paint. Nevertheless, he produced a number of works during this period, among them the multiforms *No.1* 1948 (fig.55), *No.5/No.24* 1948

(A386), and *No.7/7A/No.5 (Untitled)* 1949 (A393) that were included in his third solo exhibition at the Betty Parson Gallery in spring 1949. In these new works the shapes are rarely uniform, and the thin application of paint allows the pigment in the underlying areas to bleed through the top. In these paintings, Rothko created a zone of colour surrounding the forms that ignites an electrifying vibration (fig.56). The *pentimenti* visible throughout these paintings are the vestiges of his slight though constant adjustments to colour, size, brightness and position from one form to the next (in some cases, they are the remains of earlier compositions that he overpainted).

The reviews for the 1949 show picked up on the transitional nature of the paintings. Most acknowledged that these were ambitious paintings that needed more direction. The exhibition did not gain Rothko the widespread attention that Pollock received a few months later in the 8 August issue of *Life* magazine.[32] The article, written for the mass American audience, ridiculed Pollock, but it also established his reputation for his innovative 'dripping' technique and as a controversial figure of the American avant garde, as well as raising the nation's awareness of its radical artists.

Rothko, Still and Newman each arrived at their distinct style before 1950. They shared a common goal in their work and imbued their abstract paintings with profound subject matter. The informal forum that Rothko established with Still and Newman was mutually stimulating, and it helped him

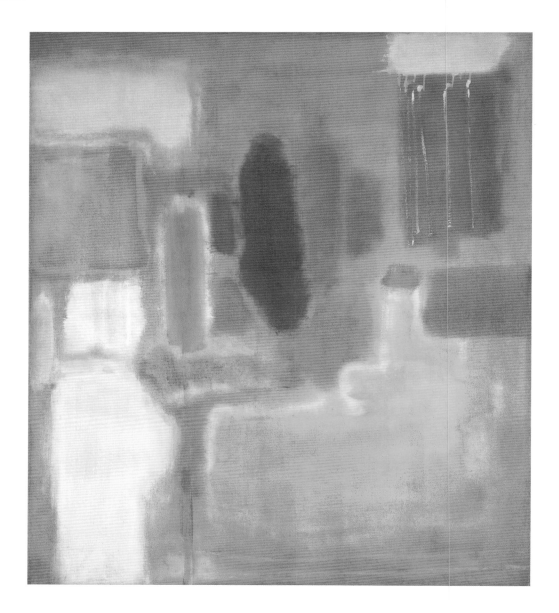

THE ROTHKO BOOK

crystallise his thoughts. Each artist resolved his works to his own needs and satisfaction without duplicating the others' style. Yet the mutual give and take that they seemed to enjoy in the mid and late 1940s to great productive ends eventually led to misunderstandings, and the end of their friendship by the early 1950s.

The three artists were still very much involved in each other's lives and careers in the spring and summer of 1950. On 29 March, Rothko and Mel sailed to Europe on the *Queen Elizabeth* and travelled for five months. The trip was made possible by a small inheritance that Mel had received from her mother. The couple's daughter Kathy Lynn (Kate) was conceived during this trip (she was born in New York on 30 December).

Rothko and Mel visited Paris, Cagnes-sur-Mer, Venice, Florence, Arezzo, Siena, Rome and London. In a letter written to Newman from Paris on 17 April 1950, Rothko remarked:

I did just want to tell you that from my slight impressions, not all the differences that we had postulated between our own state of minds and that of Paris ever approached even a fraction of the actuality. Never did I ever conceive that the civilization here would seem as alien and as unapproachable as the actuality as it appears to me. Therefore, for Betty's [Parsons] information at least, our reluctance to send pictures over here seems to have been correct.[33]

He was more sympathetic to the Early Renaissance murals in Italy, particularly the contemplative frescos by Fra Angelico for the cells at the Monastery of San Marco in Florence.[34] During this trip he had the opportunity to see the Giotto frescos he previously admired from black-and-white reproductions.

Distance did not diminish Rothko's involvement with his colleagues during the five months he was in Europe. Writing to Newman from Paris he expressed concern regarding Still and his upcoming exhibition in New York. He was deeply appreciative that Newman was helping Still prepare his canvases for the exhibition and hoped that Still would 'get something he wants out of the show, or at least not be bruised to[o] deeply.'[35] (Still's exhibition received only perfunctory mention in the *New York Times*, prompting Newman to draft a letter to the editor in April 1950 protesting against this 'summary dismissal' of his work.)[36] On 30 June Rothko wrote to Newman asking him to send news about Still's show and the 'Irascibles', referring to the group of eighteen painters and ten sculptors, including himself, who had sent a letter on 30 May to the president of the Metropolitan Museum of Art, protesting against the planned December exhibition *American Painting Today, 1950*.[37] They contested the show on the grounds that it would be selected by jury and would consequently be biased against avant-garde artists. Their protest resulted in the iconic 'Irascibles' photograph of Rothko, Newman, Still and fifteen other artists that appeared in *Life* magazine's 15 January 1951 issue, which coincided with the announcement of the winners at the Metropolitan exhibition.

Towards the end of his trip, Rothko began to dread his return to the New York art world. He wrote to Newman from London in August of his anxiety:

Obviously, now that we are coming home and that we have read your report of the end of the season, we must find a way of living and working without the involvements that seem to have been destroying us one after another. I doubt whether any of us can bear much more of that kind of strain. I think that this must be a problem of our delayed maturity that we must solve immediately without fail. Perhaps only ranting against the 'club' was no more than a cry of despairing self-protection against this very danger.[38]

Rothko was probably referring to Studio 35, also known as the Club, which continued the Friday evening lectures begun by the Subjects of the Artist school in 1948. Its members comprised most of the artists who became known as the Abstract Expressionists, including the former faculty of the Subjects of the Artist school, with the exception of Rothko, who nevertheless delivered a lecture there on 18 November 1949 titled 'My Point of View'. As Irving Sandler reported, 'Reacting against the hostile public at large, vanguard artists met at the Club to seek out their own audience, mostly of fellow artists.'[39] It is not clear why Rothko had ranted about the Club. One could speculate that he was expressing solidarity with Newman who attempted, but failed, to rally their colleagues at Studio 35 to cosign his letter to the *New York Times* protesting its neglect of Still's exhibition,[40] or

that he objected to the general direction of the conversations. With their rising notoriety, artists were trying to define their work, while avoiding being limited by these definitions. (In later years, a number of these artists contested the use of the terms Abstract Expressionism and Action Painting to describe their works). As Sandler notes:

The artists found it more exciting to discuss how and why an individual involved himself in painting. Conversation was treated as the verbal counterpart of the painting activity, and artists tried to convey what they really felt in both as directly, personally, and passionately as they could. This often led to trenchant and provocative insights that more than compensated for the frequent lapses into confused and egotistic bombast.[41]

After the breakup of The Ten, Rothko was not inclined to socialise much with artists who did not share his point of view. Unlike Pollock and de Kooning, he rarely frequented the Cedar Street Tavern in Greenwich Village, the more informal locus of the emerging Abstract Expressionists. In 1955 he condemned the 'ambitious egotists out for grabs', adding that 'It's this kind of egotist who frequents the clubs and by the way the Cedar Street Tavern is nothing but a club.'[42]

Another source of tension between Rothko and Newman may have been caused by the reception to their solo exhibitions at Betty Parsons in January 1950. Parsons gave Newman his first solo exhibition, which ran from 23 January 1950 to 11 February 1951

(Newman chose these dates to coincide with his birthday on 29 January). The exhibition premiered the paintings that he would later call 'zips.' Following in the tradition of the gallery, the exhibition was not installed by the artist or the dealer, but by another member of the stable, in this case Rothko along with Tony Smith. One of Newman's paintings known as *Horizon Light* 1949 (University of Nebraska at Lincoln, Sheldon Memorial Art Gallery and Sculpture Garden), was installed vertically instead of horizontally, which Newman later asserted was its original orientation.[43] Newman wrote a statement for the gallery to give to visitors. He insisted that the works were not abstractions, and nor did they depict some 'pure' idea. Rather, 'They are specific and separate embodiments of feeling, to be experienced, each picture for itself. They contain no depictive allusions. Full of restrained passion, their poignancy is revealed in each concentrated image.'[44] The show was panned by critics and artists alike, and only one sale was made, to a friend of the artist's wife Annalee. Ann Temkin observed that the negative response was in part because the paintings seemed to arrive from nowhere.[45] Whereas artists, critics and regular gallery-goers could follow the development of works by Rothko, Pollock and Still over the years, Newman only showed sporadically and had never had a solo exhibition before. Since he was known as a curator and a polemicist, the art world was not ready to accept him as a serious artist. In fact, his name is conspicuously missing from Seuphor's 1951 article on the New York art world, which

attempted to be comprehensive. Although the 'zip' emerged before Rothko's classic canvases, his first presentation of these startling canvases followed immediately after Rothko's sympathetically received exhibition of paintings that contained many of the characteristics associated with his signature work (3–21 January 1950). Newman's second exhibition of 'zip' paintings at Parsons opened on 23 April 1951 and, once again, was a critical and commercial disappointment. Newman withdrew from the gallery after this exhibition. Meanwhile, Rothko, whose exhibitions continued to receive favourable reviews and even resulted in some modest sales, remained with the gallery until 1954.

Dissent from the American and European art establishments and a united goal to forge an art form that was representative of the new postwar world, brought Rothko, Newman and Still together. The growing international recognition of the burgeoning New York art world and its effect on the artists, however, would eventually drive them apart.

Recognisable figures virtually disappear in Rothko's paintings by 1946. Even the poetic titles vanish, replaced by either numbers or colour sequences or simply untitled. These early abstract paintings, known as 'multiforms', also mark a departure in Rothko's conception of space and movement in his paintings. His writing on pictorial space in *The Artist's Reality* centred on the tension between two types of space intuition – the tactile and the illusionary. With tactile space, viewers have the sensation that the forms could actually be measured and experienced through touch, as in Giotto's frescos, whereas illusionary space was made possible by the invention of perspective in the Renaissance. Tactile space intuition more closely approximates the way in which we actually comprehend objects in space, whereas the conventions of illusionary space are learned: i.e. pictorial space recedes to a vanishing point, forms in the foreground appear larger than those in the distance, colours are sharper and brighter at the picture plane and grow dimmer as they recede, etc.

A painting based on perspective is conceived as a receding, self-contained picture box in which the position and size of objects remain fixed to each other and to the viewer. Rothko, in contrast, consistently opted for tactile space in his figurative and mythological paintings. Whereas the plasticity of these early works could be compared to the *repusee* of metalwork, with forms hammered in and out of the flat surface, by the mid-1940s he was conceiving his canvas as 'a plate of jelly' in which a series of objects are impressed at various depths. Unlike the empty space of Renaissance paintings, Rothko aimed to produce a pictorial space that took into account the fact that air is an actual substance, with a pressure of fifteen pounds per square inch. He achieved this effect with the multiform *No.18* 1946–7, in which amorphous shapes advance and recede in a primordial ooze.

That Rothko was committed to unifying tactile and illusionary space intuition in his paintings is revealed in Douglas MacAgy's article on his work written in 1947–8 (published in 1949), and in Rothko's own writings. *No.18* was reproduced in MacAgy's article presumably because he and/or Rothko believed that it demonstrated the conflict between the two space intuitions and the dramatic movement that results.

Compositionally, *No.18* bares a structural resemblance to some of his early mythological paintings, such as *Untitled* 1941–2 (fig.26 on p.39), in which an architectural niche frames the central forms. In *No.18*, amorphous shapes

coalesce to create a swirling frame around a large, reddish torpedo shape and a small oval, also red. If one uses illusionary space intuition to view this painting, the forms seem to separate as the smaller oval recedes and the larger form projects. However, without any conventional indicator of measure that would fix these forms in space, it is also possible to read the two shapes as a large and small form that exist on the same plane without any depth between them. The conflict keeps the two in constant movement as the relationship changes according to the form of vision that the viewer chooses at any given time.

Unlike the mythological paintings, in which Rothko created forms that look as if they were carved in shallow relief and which could be measured backwards to the shallow wall, the forms in *No.18* are flat with no definitive contour. He creates tactile space, nonetheless, using colour and tone. As Rothko noted in his writings, the most rudimentary rule of the perceptual impact of colour is that warm colours project and cool colours recede.[1] In *No.18*, the warm, reddish forms dominate the foreground, while the touches of cool blue at the top seem to exist on a plane slightly further away. The white forms appear to hover over the surface as the dark brown area carves out a niche or stage in the centre. The iridescent white 'frame' makes the brown area look darker and deeper in contrast. However, as in the late figurative paintings and the mythological canvases, the space in the niche is very shallow, and the back plane seems to pull forwards until it is almost equal with the picture's surface.

Although areas of this work are thinly painted, Rothko used vigorous brushwork and even a palette knife to enliven the surface. Occasionally, he even incised the surface, as with the scrafito that provides actual texture in his biomorphic watercolours. None of the forms are painted as flat colour; rather, each is modulated with lighter or darker shades of the dominant colour (unlike in traditional modelling, he did not grey the forms at their extremities). Line is almost non-existent in this painting, and Rothko surrounds several of the lighter forms with a darker shade, and darker shades with a halo of light, which increases the sensation of projection and illumination.

At this time, Rothko commented that he thought of his paintings as 'dramas' with the 'shapes as performers'.[2] By eliminating the figure, he was able to make his abstract forms perform in ways that would have been impossible without distorting the human form

57
No.18 1946–7
Oil on canvas
155 × 109.8
National Gallery of Art,
Washington
Gift of The Mark Rothko
Foundation, Inc.

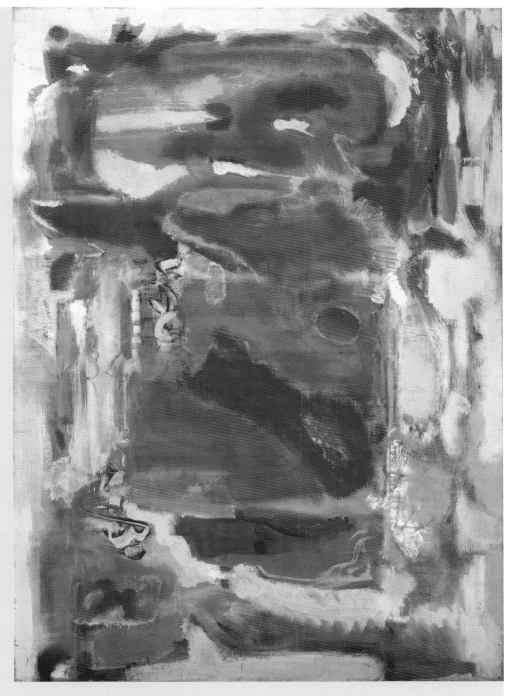

and forcing viewers to suspend their disbelief. Rothko produced a prodigious number of multiforms from 1946 to 1949. The variation is at once staggering and consistent, as he probes the possibilities of this new territory. In retrospect, it is possible to see in works such as *No.18* the intimations of his mature paintings. It is important, however, to consider these works in relation to what was of the utmost interest to him at the time that they were created: the creation of forms that could perform dramatically and independently in a space at once tactile and illusionary.

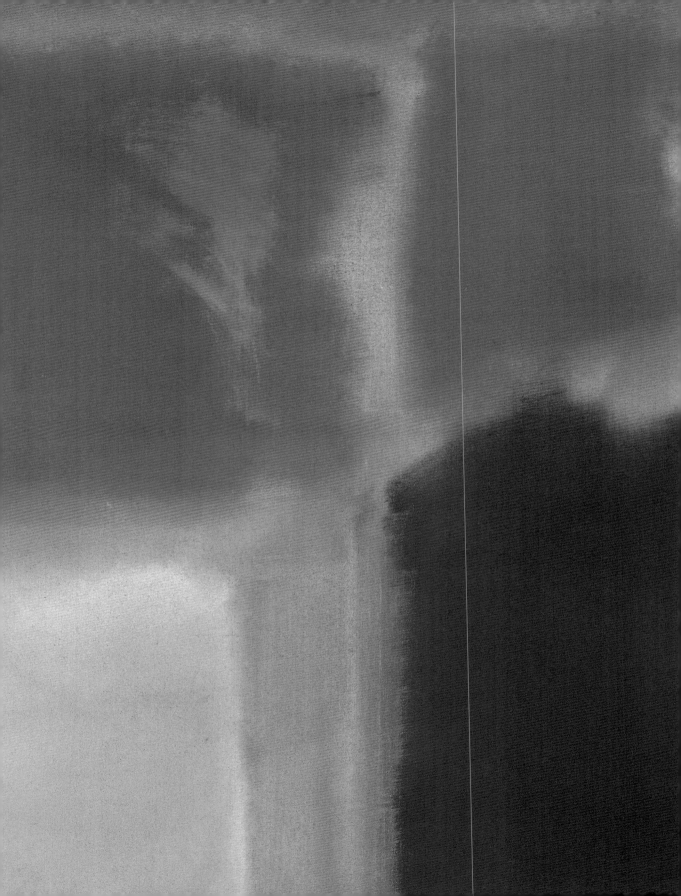

For an adult the first picture is always the easiest.
Mark Rothko, c.1938

We may never be able to identify Rothko's very first fully realised 'classic' painting, as Rothko rarely dated his work and the canvases from 1949 to the early 1950s exhibit a wide variety of compositional and colour arrangements. He was not alone among the Abstract Expressionists in establishing a single image for his work. Newman arrived at the 'zip', Motherwell, the large black 'Elegies' and Gottlieb, slightly behind the others, invented the 'Burst'. Unlike Newman, who acknowledged *Onement I* 1948 (fig.54 on p.79) as his first resolved 'zip' painting, Rothko never made a similar declaration. In many ways the classic Rothko, with its shimmering bands of colour unfied into a single iconic image, is a radical departure from even the multiforms that preceded it. This major change occurred by the time of his January 1950 exhibition at the Betty Parsons Gallery, in which he showed several paintings that came close to his signature image.

The early multiforms of 1946–8 were abstract paintings, but they are closer in effect to the biomorphic paintings that preceded them than to the classic Rothko. In the early multiforms each irregular shape draws attention to itself as an organism occupying space. In the classic Rothko the viewer initially takes in the total image rather than breaking it down into its individual components. The horizontal bands of these paintings do not fill the void like the smaller shapes in the multiforms. Instead, they are the progenitors of light and space. Their form is essentially formless as they seem to shrink and grow in the viewer's eye.

For the most part, the early multiforms were densely painted, their colours tending towards opacity even when the paint is thinned. The works in the 1950 Parsons Gallery exhibition were produced using an innovative technique that had first appeared in some of Rothko's multiforms, in which he sized the canvas with rabbit-skin glue mixed with powdered pigment. This gave his canvas the appearance of being stained. The pigment, however, is suspended in the crystals of the sizing and therefore does not actually stain the weave of the canvas itself, as in Helen Frankenthaler's work of 1952 onwards. Rothko often experimented with a variety of mediums, combining oil paint, powder pigment, eggs, turpentine, and varnish in a single painting to achieve a variety of effects. Although the paint initially appears to have been applied evenly, brushy marks, splatters, and drips are evident throughout while areas of paint have been scraped away and incised with the side of a palette knife. All of these incidents keep the surface active and provide areas of surprise that become more noticeable with prolonged viewing.

No.3 1949 (fig.68), *No.5* 1949 (A412), and *No.6* [?]/*No.12* 1949 (A413), were the paintings in the 1950 Parsons Gallery exhibition that most closely resembled Rothko's signature image. In these works, he created a new image of a radiating edifice constructed from shimmering bands of modulated colour. He

4 The First Picture

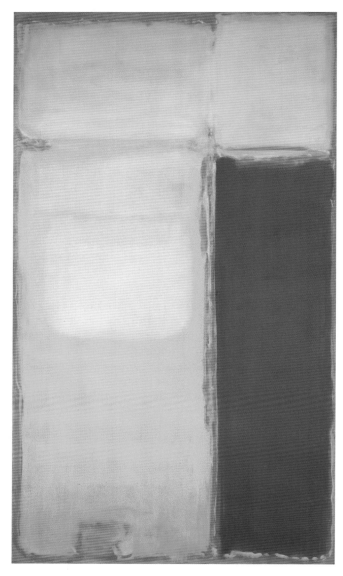

58
No.11/No.20 [Untitled]
1949
Oil on canvas
238.1 × 134.6
Collection of Christopher
Rothko

had not, however, completely resolved his format. Although a number of the works in the 1950 exhibition are in the stacked rectangle arrangement, Rothko also exhibited a canvas that represented an alternative vertical composition. In *No.11/No.20* 1949 (fig.58), two rectangles arranged like sentinels, one yellow, the other greenish brown, are topped by a pair of smaller, pale rectangles. A variant of this work, *No.17/No.15* 1949 (fig.61), was exhibited in *Young Painters in US and France* at the Sidney Janis Gallery in October 1950. In both examples, Rothko contrasted a dark rectangle with a lighter one. Ultimately, he decided not to pursue this direction at this crucial juncture in his career.

Anna Chave has proposed that the arrangement of the two vertical rectangles of *No.17/No.15* is the culmination of the double portrait motif that Rothko used in his representational and Surreal paintings (fig.60); and that this painting in particular is a schematic representation of *Nude* 1933 (fig.59).[1] Both works pair light and dark vertical figures that fill the canvas from top to bottom. She identified the stacked rectangle paintings as the 'symbolic descendents' of the squat, solid couple in *Untitled* 1938 (A144). For Chave, Rothko's abstract paintings were the result of a 'relentless editing of forms'.[2] It is also possible to see how the mythic paintings of fragmented human beings bundled together as a single block could lead to the classic composition of striated bands united within a large rectangle (fig.26 on p.38). However, it is likely that Rothko, in his figurative, Surreal and abstract works, was

primarily pursuing a means by which he could capture the movement of attracting and repelling beings or organisms. Rothko achieved this action in the vertical arrangement of *No.17/No.15* by painting an aura surrounding these forms that seems to grow and shrink simultaneously.

Although the structure of Rothko's classic painting may have its origins in his early works, the progression was not systematic. In fact, the image of his classic painting is so well established in our imagination that it is surprising to discover how much variation there is in the organisation of forms in the paintings from 1949 to 1952. *No.9* 1951 (fig.62) and *Untitled* 1951–2 (fig.74) are among the closest to the generally perceived classic format. But as late as 1951, he painted such atypical works as *No.21* 1951 (fig.63), with its upturned black U shape, and *No.4* 1950–1 (fig.75 on p.130), composed of large, lavender and black, lopsided rectangles. Rothko thought highly enough of these paintings to include them in the *Fifteen Americans* exhibition at the Museum of Modern Art in 1952. But by the time of his 1954 exhibition at the Art Institute of Chicago, his first solo show of his classic paintings at a museum, Rothko had settled on the single-image composition. Rothko recognised at the time that he had achieved a format with desirable results, and that his course in reaching this image was by no means logical and ordered, although it was possible to see the germination of ideas in earlier paintings.[3]

The paintings in the January 1950 Parsons exhibition were characterised by a strident palette of bright oranges and greens and combative complimentary colours. The soft pastels associated with the classic canvases of the early 1950s became more predominant in 1951 (fig.62). It is possible that these muted, chalky hues were inspired by Rothko's first-hand experience of Giotto's frescos in Italy.

A number of the paintings in the Parsons exhibition still maintained some of the asymmetry of the multiforms, which required Rothko to resort to a certain amount of traditional composing to keep the painting balanced. *No.8* 1949 (fig.64), for instance, displays almost all the characteristics of a classic Rothko with the exception of the pale lines that extend down the left-hand side of the canvas. To balance the composition, he painted a rectangle at the top register, right of centre, that is slightly darker and smaller than the large, pale square containing it, and a red rectangle jutting from the left into a more brilliant large, red field at the bottom region. Rothko virtually eliminated this convention of composition when he decided to arrange his forms more symmetrically. Symmetry is a characteristic of most primitive art, and Rothko's classic composition may have been a means to create a similarly powerful image. In his classic painting, Rothko created a unified image that could be taken in at a glance, without breaking it down into its individual components. The impact was magnified by the large scale of these paintings (*No.3/No.13* measures 216.5 × 163.8 cm). Although modest in size by today's standards, several canvases in the Parsons exhibition barely fitted on the gallery's walls. Other artists of Rothko's

59
Nude [Untitled] 1923
Oil on canvas
100.3 × 44.8
National Gallery of Art,
Washington
Gift of The Mark Rothko
Foundation, Inc.

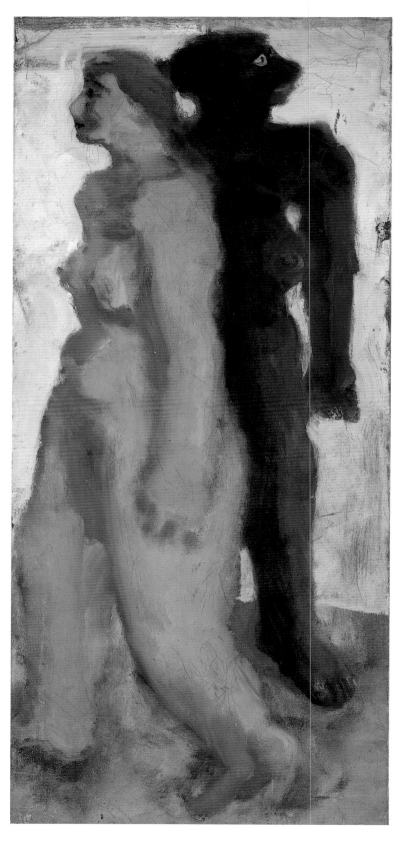

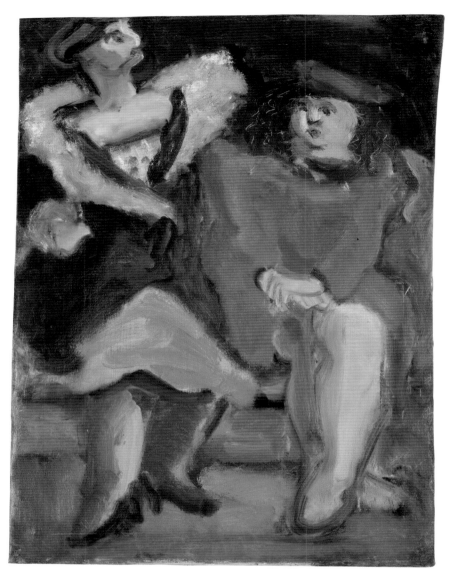

60
Untitled [Two Seated Women] c.1934
Oil on canvas
79.7 × 59.7
National Gallery of Art,
Washington
Gift of The Mark Rothko
Foundation, Inc.

61

No.17/No.15 [Multiform]
1949
Oil on canvas
131.8 × 74
National Gallery of Art,
Washington
Gift of The Mark Rothko
Foundation, Inc.

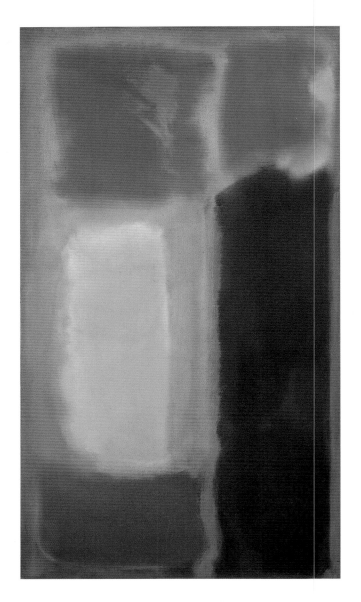

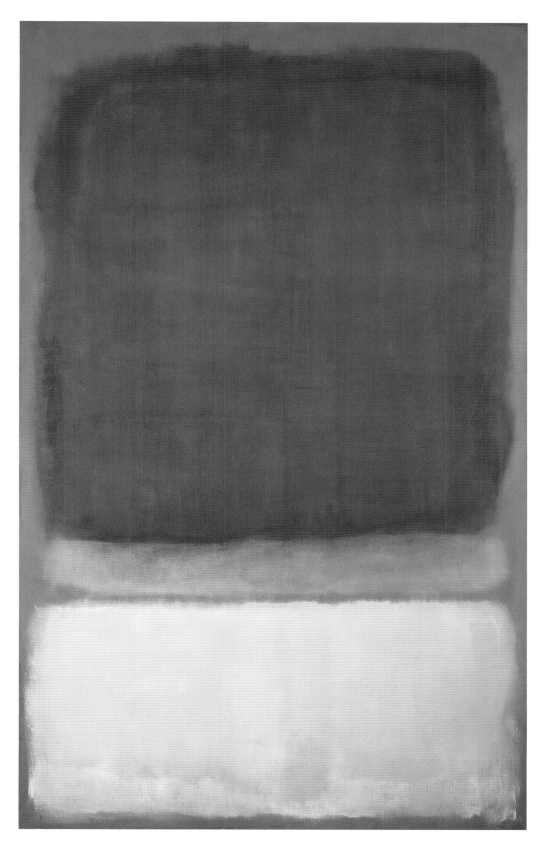

62
No.9 [Untitled] 1951
Oil on canvas
236.9 × 144.5
Collection of Jane and
Terry Semel, California

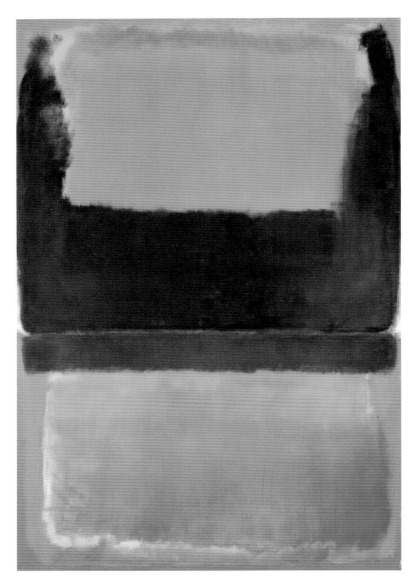

64 (opposite page)
No.8 [Multiform] 1949
Oil on canvas
228.3 167.3
National Gallery of Art,
Washington
Gift of The Mark Rothko
Foundation, Inc.

63
*No.21 [Red, Brown, Black
and Orange]* 1951
Oil on canvas
241.5 × 162.5
Private collection, Paris

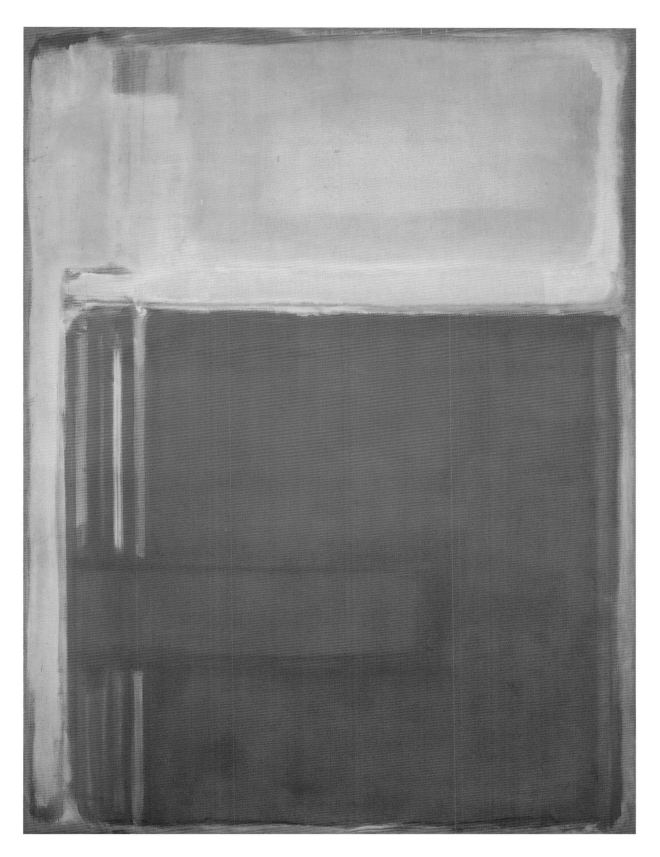

generation, notably Pollock, had increased the scale of their paintings, but Rothko did not enlarge his works to compete. He had previously painted large canvases, such as *Slow Swirl at the Edge of the Sea* (191.1 x 215.9 cm; fig.43 on p.57), but this work has the presence of a big easel painting. In contrast, the proportions of his classic paintings, starting with those shown in 1950, contributed to the overall impact and function of the work. The large scale placed the viewer within the painting's field. As Rothko remarked in a symposium in 1951, the reason he painted large canvases 'is precisely because I want to be very intimate and human. To paint a small picture is to place yourself outside your experience, to look upon an experience as a stereopticon view, or with a reducing glass. However, you paint the larger picture you are in it. It isn't something you command.' He added that this explanation also applied to other artists.[4] Newman, for example, similarly remarked that the expansive field of his paintings allowed viewers to 'participate with' rather than react to a work.[5] The scale also conditions the way in which we see the painting. Focusing on its centre, we depend on our peripheral vision to take in the work in its entirety. The soft focus that occurs naturally at a form's extremities due to peripheral vision is exaggerated in Rothko's paintings by the blurred edges of the rectangles and the continuation of the field around the side of the stretcher.

The large dimensions also disguise the complexity and nuances of the painting. By perceiving a painting as a single iconic image, the viewer is likely to overlook variations in its form, colour and texture. If measured, one would discover that the image is not even symmetrical. There is considerable variation in the texture and hue within each band of colour. Serendipitous marks such as drips and *pentimenti* are prevalent throughout the compositions. At first glance the surface and dominant colours seem uniform, but after a prolonged engagement with the work, the viewer becomes aware of the modulations.

Another characteristic of Rothko's classic paintings is the palpable quality of their forms. This is true even for *No.4/No.32* c.1949 (fig.53 on p.76), one of the paintings in the Parsons show, which seems to bridge the earlier multiforms and the classic paintings. In this work, it is possible to observe the continued influence of Cézanne. The painting looks as though Rothko magnified a section of a Cézanne painting and concentrated on the way he constructed his work, using broad areas of colour. Despite the fact that Rothko had thinned his paint to the consistency of watercolour in this painting, each of the irregularly shaped forms projects the illusion of weight much like the strokes in a Cézanne watercolour. The palette of pale greens and yellow is also suggestive of Cézanne's colours. Most importantly, Rothko seemed to grasp how the pioneering modernist built his paintings with dabs of colour. Unlike the chaotic arrangements of the earlier multiforms, Rothko stacked his shapes in this painting as solidly as stones in a wall. By piling his diaphanous areas of colour one on top of another, he could keep the forms from

65
Henri Matisse
The Red Studio, Issy-les
Molineaux 1911
Oil on canvas
181 × 219.1
Museum of Modern Art,
New York
Gift of Mrs Simon
Guggenhein

66
No.21 [Multiform/Untitled]
1949
Oil and acrylic with
powered pigments on
canvas
203.2 × 100
Metropolitan Museum
of Art
Gift of The Mark Rothko
Foundation, Inc.

floating upwards. Although he abandoned the use of small units of colour in his classic format, he continued to employ the stacked arrangement for the horizontal bands to provide order and a sense of weight.

The pictorial space in the classic painting is also distinct from the early multiforms. It is possible that the spatial qualities of Rothko's colours for his paintings in the 1950 exhibition at Parsons Gallery were influenced by Matisse's paintings, particularly *The Red Studio* 1911 (fig.65). Rothko recalled standing in front of this painting almost every day for months following its acquisition by the Museum of Modern Art in 1949. As he remarked, when you looked at this painting 'you became that color, you became totally saturated with it as if it were music'.[6] Bernice Rose has even identified Rothko's large, red multiform (fig.66) made the year the museum acquired *The Red Studio* as a variation on Matisse's painting.[7] Although the red field is flat and fairly uniform in Matisse's painting, the viewer can comprehend the composition as a room due to the schematic linear elements defining the objects in the studio. Rothko did not introduce drawing into his canvas; he used colour alone to envelop the viewer in its space.

It is also likely that Rothko's venture into creating a new kind of pictorial space with the use of colour was made possible by his familiarity with early twentieth-century discoveries in the science and psychology of perception that paralleled those of the Modern artists. William Seitz, in his doctorial dissertation, 'Abstract Expressionist Painting

in America', written in the early 1950s, suggested that these advances in the study of perception may have influenced Rothko's transition from the multiforms to the classic paintings, particularly in his technical finesse with colour. Seitz, who interviewed most of the Abstract Expressionists, including Rothko, for his dissertation, acknowledged the 'striking resemblances between the means of modern painting and the experiments and theories of the configurational or gestalt school of psychology'.[8] The early twentieth-century discoveries in the science and psychology of perception were popularised after the Second World War. Seitz identified one such study by David Katz, *The World of Color* (published in English in 1935) documenting the parallel discoveries of scientists and modern artists. Katz, according to Seitz, distinguished three modes of colour: 'A given tone can resemble a solid surface, a transparent film, or a volume.'[9] Seitz found the distinction between surface colour and film colour particularly relevant to Rothko. 'Surface colors are those which are encountered most often on objects of paper, cloth, wood, or metals; they embody the tangibility of everyday artifacts.'[10] Film colours 'have a spongy texture just short of transparency. Intangible, like the blue of the sky, they are seen (by the experimenter through a spectroscope) as colored light.' Seitz adds, a surface colour 'presents a barrier beyond which the eye cannot pass'; whereas 'one feels that one can penetrate more or less deeply *into* the spectral colour'.[11] Katz's theory, Seitz noted, demonstrated that other physical conditions can affect the perception of colour. For example, the 'lack of sharpness', i.e. the blurring of textural detail and edges, as in Rothko's classic format, can make surface colour look as if it is receding. Surface colour is transformed into film colour when an aperture (or framing device) is placed before an object to conceal it completely, except for the part appearing through the aperture. One can observe how Rothko created this effect by surrounding the entire image in his early classic paintings with a narrow border.

It is not known for certain whether Rothko had read Katz, but his manuscript from the 1930s/1940s includes references to experiments in phenomenology and Gestalt psychology. For example, in *The Artist's Reality* he referred to psychological experiments that he read in the newspaper about a young man who had been blind from infancy and whose sight was restored by a surgical miracle:

At first he could not get any sense of reality from sight only and had to corroborate what his eyes showed him by touch before he could satisfy himself as to the existence of an object. He had to learn that things diminish in size at a distance, and that colors are grayed. In other words, he had to learn how things looked in space in relationship to others, just as we must learn through touching that a shadow represents volume.[12]

Although Cézanne, Matisse and Giotto may have provided the visual stimulus for Rothko's evolving colour sense, and his technique may have been based on scientific discoveries, his impulse to create a unique

pictorial space came out of his own esoteric reasoning. Rothko's interest in space intuition as described by Douglas MacAgy in his *Magazine of Art* article and in Rothko's own writings of the mid 1940s provided the impulse to conceive space as an actual physical substance rather than empty air, for as Rothko noted in his manuscript, air had a pressure of fifteen pounds per square inch. The coloured bands appear as a translucent jelly or filmy substance that pulsates at varying depths. Weight is implicit in the classic paintings as the larger rectangles usually are painted at the top, thus creating the impression that the lower bands are being compressed under this pressure.

While dark colours dominated Rothko's late paintings, bright colours overpowered the paintings of the first half of the 1950s to such a degree that it is possible to overlook the important role black played in his early classic paintings (fig.69 on p.117, fig.74 on p.129). It appears that at this stage, Rothko felt that the introduction of black was necessary in order to give light form.

As MacAgy revealed in his article, Rothko used the physical characteristics of his paintings to represent the essence of ancient myths. The battle between Dionysius and Apollo was the myth that most intrigued Rothko at the time he began his classic paintings as it represented the conflict between the objective and subjective comprehension of reality. Transformation and tension were the means for conveying it.[13] The double pillar arrangement that he used in *No 17/No.15* 1949 (fig.61) exemplifies the concept of a form separating into two parts. This bifurcation, however, impeded his attempts to unify the painting into a single image. The rectangles remain identifiable as two separate presences, which may explain why Rothko abandoned this composition in favour of the stacked bands. The activity or drama (to use Rothko's word) that occurs as a result of the expansion, contraction and vibration of colours, makes the forms in his classic paintings look as if they are actually, rather than metaphorically, separating from or gravitating towards each other. In these paintings Rothko creates a suggestion of unity in a single, large image that is broken down by the multiple striations of rectangles, aiming to produce the sensation that the viewer is witnessing the conflict between the forces of Apollo and Dionysus and all it entails – birth, life, death; tragedy, ectasy and doom.

Rothko also associated Apollo in his 'extreme' as the 'god of light'. He imagined that Apollo 'in the burst of splendor not only is all illumined but as it gains in intensity all is also wiped out'. He added, 'that is the secret which I use to contain the Dionysian in a burst of light'.[14] The power of this tangible light produces a tactile, plastic substantiality that contradicts the painting's physical attributes and initially obliterates the minute details and variations in the colours. Based on this aspiration, it is understandable why he insisted on blinding artificial illumination for his exhibitions in the early 1950s. The bright light also served to slow down the viewer, as it made the details difficult to distinguish. Unlike the Impressionists who painted

atmospheric light, which led to 'the dissolution of the unity of a particular shape', Rothko wanted to maintain a physical structure in his paintings much as Cézanne had.[15] In his classic paintings, Rothko gave sculptural form to the intense light that engulfs the canvas and forcefully enters the viewer's realm.

Around the time that Rothko's classic composition emerged, he decided to cease making published statements about his work.[16] The few exceptions to this rule shed some light on how he perceived these works and his motivations for painting them. In the early 1950s, he discussed the evolution of his work in an interview with Seitz for his dissertation on the Abstract Expressionists. He pointed out that his early works and his recent paintings were connected by their subjects. As Seitz wrote in his notes, 'Trying to bring him out on the development of his work, I remarked that the thing that tied his early figure things, his symbolic things, and his late things together was the backgrounds. That it was as if he had removed the figures or swirling calligraphy, symbol, etc and simplified the three toned backgrounds.'[17] Rothko disagreed with Seitz and impressed on him his concept of the progression of his work: 'It was not that the figure had been removed, not that the figures had been swept away, but the symbols for the figures, and in turn the shapes in the later canvases were new substitutes for the figures.'[18] He considered his abstract forms objects or things, with a perceptible density just like figures or symbols, that could trigger an emotional response and stimulate thought, but could do so more precisely than his earlier figurative works.

Rothko felt an urgent need to disassociate himself from geometric abstraction and Cubism, because he truly recognised that the motivations behind his work were not the same as those of Picasso, Braque, Léger and Mondrian. In the late 1940s, in response to a question posed to him by the artist Clay Spohn during a session at the California School of Fine Arts about his view of Picasso, Rothko replied: 'Picasso is certainly not a mystic, nor much of a poet, nor does he express having any very deep or esoteric philosophy. His work is based purely upon the physical plane, a plane of exciting sensuous color, form, and design, but it does not go very far beyond this.'[19] A similar formalist reading of Picasso, his Cubist work in particular, had been advanced by Alfred Barr, who wrote in the catalogue for the *Cubism and Abstract Art* exhibition that he organised in 1936 at the Museum of Modern Art, New York, 'The Cubists seem to have had little conscious interest in subject matter. They used traditional subjects for the most part, figures, portraits, landscapes, still life, all serving as material for Cubist analysis.'[20] Rothko, like many artists of his generation, felt compelled to advance beyond the achievements of the previous generation of modern painters. Picasso, in particular, was the artist to surpass. When Spohn asked Rothko if 'there is a possibility of producing paintings that are more in advance than say Picasso, or any other top-ranking painter of today, or masters of the

past – what direction do you think those paintings might take?'[21] Rothko responded, 'Toward esoteric meaning; expressing qualities of, or the essence of, universal elements: expressing basic truths.' He added, 'The most interesting painting is one that expresses more of what one thinks than of what one sees.'[22] The advance in art, as Rothko saw it in the late 1940s, while he was in the midst of his final transition to the classic image, would necessarily be in philosophical content.

When asked by Spohn how young artists could prepare themselves for their future. Rothko prescribed the following: 'By learning the physical elements of painting, their use and control, and by formulating some personal philosophy of painting. By getting some general understanding of psychology, philosophy, physics, literature, the other arts, and writings of the mystics, etc.'[23]

He expanded on these concepts in a lecture delivered to art students at Pratt Institute in 1958, by providing a wry but informative formula for how he transformed philosophic thought into form:

There must be a clear preoccupation with death – intimations of mortality. Tragic-art, romantic art, etc. deals with the knowledge of death.
Sensuality. Our basis of being concrete about the world. It is a lustful relationship to things that exist.
Tension. Either conflict or curbed desire.
Irony. This is a modern ingredient – the self-effacement and examination by which a man for an instant can go on to something else.

Wit and play for the human element.
The ephemeral and chance or the human element.
Hope. 10% to make the tragic concept more endurable.[24]

The question and answer period that followed the lecture provided additional insight. For instance, Rothko remarked, 'The form follows the necessity of what we have to say. When you have a new view of the world you will have to find new ways to say it.'[25] This statement reinforces MacAgy's thesis that Rothko's painting was the physical representation of his new concept of space. In his Pratt lecture, Rothko had made the point that he used colour as his primary vehicle because line 'would have detracted from the clarity of what I had to say'.[26] Death and mortality, he added, were always present in his mind when he painted. This, after all, was the human condition, and it was his hope that it would be present in his work without his having to illustrate it with skulls and bones.[27] At this point Rothko could have thought back to his own earlier attempts to use figures to represent this idea of a living death – namely, his expressionistic rendering of the Crucifixion in 1935 (fig.67), as well as his early mythic paintings of the same subject. Rothko's emphasis on death and mortality was not a personal fixation; it was a view that was pervasive in his time. The philosopher Kenneth Burke, for example, whom MacAgy had invited to speak at a conference on modern art in San Francisco in 1949 (the transcript of which was sent to Rothko) noted that 'the Christian culture was built on this

67
Crucifixion 1935
Medium and support unknown
Dimensions unknown
Whereabouts unknown

injunction, to "live a dying life", as enjoined in the *Imitation of Christ*.'[28] Burke recognised that this principle had become secularised in modern times and that it underlies everything, including science. 'You can detect it in the whole cult of abstraction', he added, 'as you see if you consider the dialectics of Plato. For abstraction, as a transcending of the sensory, is a way of dying and yet living.'

Among the ingredients for painting that Rothko included in his list at Pratt were 'wit and play'. These elements are usually overlooked or under-emphasised by scholars of Rothko's work, since they seem at odds with the tragic concept of his paintings. Rothko was specific in his discussion on how wit and humour enter his work, stating: 'In a way my paintings are very exact, but in that exactitude there is a shimmer, a play in weighing the edges to introduce a less rigorous, play element.'[29] Wit and play provide the human element, and like hope (the last ingredient) they make the 'tragic concept more endurable'. Significantly, Rothko remarked that 'feelings have different weights' and that he preferred Mozart over Beethoven 'because of Mozart's wit and irony and his scale'. The emotional weight of Beethoven's music was more basic or, as Rothko put it, 'a farmyard wit'.[30] Most importantly, he made the distinction between self-expression and the expression of the human condition. He was not interested in giving form to his own emotional state, which would have meant stripping himself of 'will, intelligence, civilization'. Rather his 'emphasis is upon deliberateness'.[31]

Rothko added 'irony' as another ingredient. At the time of his Pratt Lecture he considered irony to be a modern concept that provided him with the ability to distance himself from his work and to bestow it with autonomy – a life of its own. By giving his paintings an independent life, Rothko escaped his mortal fate. He further elaborated on the subject of irony in a 1960 interview with Peter Selz, curator of his 1961 MoMA retrospective. He remarked that 'Shakespeare's tragic concept' embodies 'the full range of life from which the artist draws all his tragic materials; including irony; irony becomes a weapon against fate.'[32] How curious it is to see Rothko refer to irony in relation to his work; it was a condition associated with Dada, an art movement that he identified as promoting a philosophy of scepticism. However, there is much that is ironic in Rothko's paintings besides his distancing of himself from them. The canvas is flat, yet spacious; the paint is thinly applied, yet seems formidable; the physical size of the paintings is large, yet the experience is intimate; the pigment may be dark, but filled with light, and although the image is static, the tension pulls the forms asunder. The irony in Rothko's paintings, as in Shakespeare's plays, is based on the human condition. Rothko's paintings reveal the fallacy of our vision – the conflict between what is seen and what is felt. We see all the physical attributes of his paintings, but perceive them as the opposite of this reality. Rothko's paintings make us aware of these contradictions. The fallacy of our vision is our tragic flaw.

Rothko reflected on his journey toward abstraction in a statement published in 1949:

The progression of a painter's work, as it travels in time from point to point, will be toward clarity: toward the elimination of all obstacles between the painter and the idea, and between the idea and the observer. As examples of such obstacles, I give (among others) memory, history or parodies of ideas (which are ghosts) but never an idea itself. To achieve this clarity is, inevitably, to be understood.[33]

This statement is generally considered in terms of the evolution of Rothko's style, but from his writings in *The Artist's Reality*, it appears that he was referring to his development of a philosophical point of view and the means he devised to present it using the basic physical properties of painting. When he talked of 'memory' he alluded to the way in which people tend to interpret paintings by comparing the imagery with their remembrance of familiar things. According to this logic, if the image agrees with the viewer's memory of a picture that is good, then it too must be beautiful. Rothko, however, wanted viewers to discover something new in his paintings that did not correspond to their memory of any other art. The 'geometry' of linear perspective and geometric abstraction, i.e. Mondrian, was another impediment that Rothko believed had to be eliminated so that viewers could contemplate the conflict between tactile and illusionary space.

There are those who think that Rothko, by sticking to his single-image painting, had painted himself into a corner, but there is little evidence to suggest that he felt constrained by his format. In fact, the contrary seems to be true. Once he found the form that could best represent his philosophical view, he was liberated to contemplate this condition anew in each successive painting. In the Pratt lecture, he could still refer to his paintings as 'portraits' because, like all great portraiture, they were about the 'artist's eternal interest in the human figure, character and emotions – in short in the human drama'.[34] The repetition of the classic image was in itself irrelevant, because the great portraits throughout time are the painting of 'one character'. He added, 'What is indicated here is that the artist's real model is an ideal which embraces all of human drama rather than the appearance of a particular individual.'[35]

When Rothko delivered his lecture, he had been painting his classic format for a little over eight years. From his remarks, it is clear that each new work he painted was as if it were the first. As he stated:

Today the artist is no longer constrained by the limitation that all of man's experience is expressed by his outward appearance. Freed from the need of describing a particular person, the possibilities are endless. The whole of man's experience becomes his model, and in that sense it can be said that all of art is a portrait of an idea.[36]

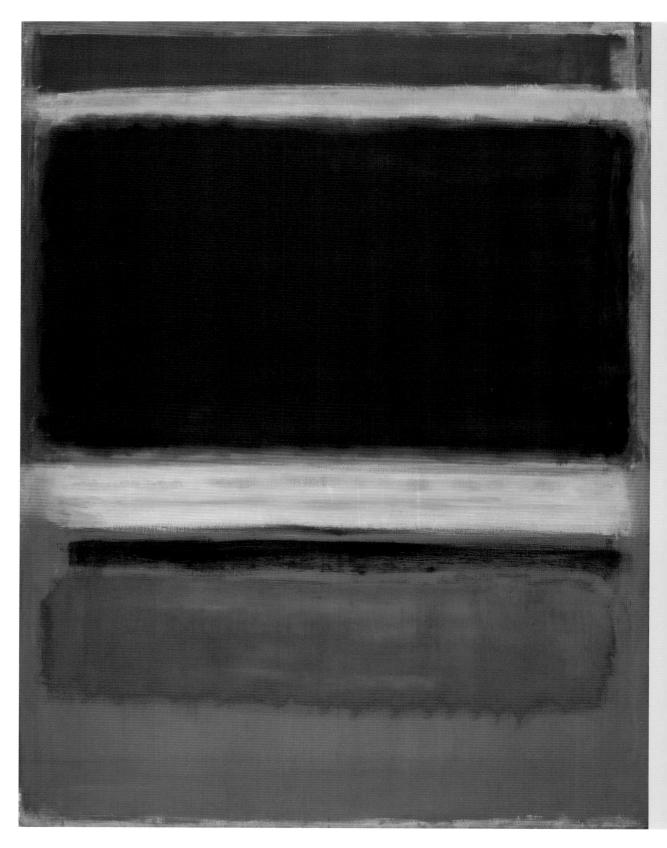

THE ROTHKO BOOK

No.3

No.3 1949 is one of the paintings included in Rothko's one-man exhibition at the Betty Parsons Gallery in January 1950 that came close to his classic painting. Among the characteristics it shares with the works of the 1950s is its large scale, nearly symmetrical arrangement of multiple striated bands and rectangles stacked horizontally on a monochromatic field. These forms do not extend to the edge of the canvas, rather the coloured ground narrowly frames and contains them.

Like the classic paintings, *No.3* is the result of considerable thought and constant adjustment and modulation of form and colour. One such adjustment was actually documented in an early photograph of this painting.[1] The thin black line in the lower part of the painting originally extended down the right side of the canvas, a characteristic that was typical of his late multiforms. He subsequently decided to crop this extension in favour of keeping all of the lines parallel, which is a feature of the classic paintings.

Although thinly painted, this work maintains a strong sense of the plasticity of paint that had appealed to Rothko since the late 1930s. Rothko conceived the space of this painting as a spongy substance or a plate of jelly rather than as empty air. Each striation looks as though it was inserted at various intervals into this dense surface, thereby creating the sensation of recession and progression. Rothko preferred the term 'depth' to 'space' with its implication of the empty atmosphere of Renaissance painting. In *No.3* and the subsequent classic paintings, the viewer experiences distance by penetrating the layers of the forms.[2] As in his late representational paintings, the depth is shallow like a low-relief wall sculpture with the ground almost equal with the forms painted on top. Rothko achieved this effect by altering the width, length, and tangible weight of the bands and rectangles, and employing colours that optically shift position in depth. The soft-edged bands and rectangles constantly appear to be shrinking and expanding. As in his late representational and mythological paintings, he used darkened areas in his classic paintings to create the appearance of a shallow relief. In *No.3*, for example, a thin black line at the bottom edge of the white band in the lower register of the painting propels it forward. He also employed a little back lighting at the bottom edge of the black rectangle to make this dark form project rather than recede in space.

The painting runs the full scale of hot to cool colours, starting with the iridescent yellow at the bottom edge that laps at the orange/red field and warms up the green rectangle. The painting cools off in the large black rectangle. When the red re-emerges at the top it turns into a purplish magenta. Although the individual bands and rectangles initially read as solid colour, each is modulated by underpainting, adjoining colours and dabs of similar or contrasting hues that keep the painting's surface alive with activity.

In this painting, Rothko created dramatic tension by contrasting the extreme complimentary colours of green and orangey red, which fight each other for domination. (A more subtle tug-of-war occurs at the top where the orangey yellow and purple/magenta collide.) The conflict contributes to the overall movement of the painting as the forms simultaneously attract and repel one another. Its palette is more aggessive than the soft pastels that characterise many of the early classic paintings.

The monolithic, nearly symmetrical image of *No.3* and subsequent canvases is immediately recognisable as a classic Rothko painting, and therefore viewers might be inclined to pass them by after making this quick identification. Rothko, however, used the apparent symmetry of the image to immobilise the viewer right at the centre of the canvas. Viewers become hyper aware of their senses as they reconcile the objective/physical qualities of the work with their own subjective and emotional response. For Rothko, the manner in which a successful work materialised would be as mysterious to him as to the viewer.

68
No.3/No.13 [Magenta, Black, Green on Orange]
1949
Oil on canvas
216.5 × 163.8
Museum of Modern Art, New York
Bequest of Mrs Mark Rothko through The Mark Rothko Foundation, Inc.

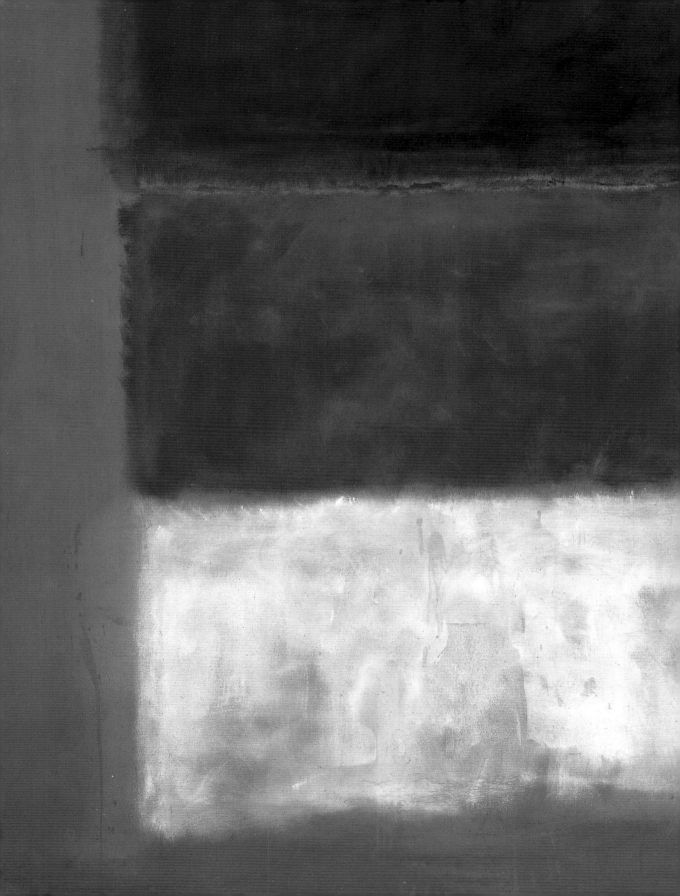

Rothko's paintings were the product of thought and he expected them to inspire thought in the viewer. Of equal importance for him was that his intentions should be understood. However, he virtually ceased making published statements about his own work in 1950, suspicious of any mediation, including his own, that would interfere with the viewer's direct experience of his work. Anthropologists at the time offered similar perspectives on art. Gregory Bateson, for example, recognised that a barrier between art and the viewer existed in modern times.[1] Because European and American society had become increasingly fragmented and specialised, intermediaries such as critics had assumed the role of interpreters of art. But to Bateson, this was interference and was responsible for diminishing the viewer's immediate response.

In the late 1940s and 1950s, the role of the viewer in relation to the work of art was seen by many artists as essential to its completion. Duchamp, for example, held that viewers who were able to recognise the aesthetic impact of a work of art without any mediation, while rare, played an important role in the creative act, for they 'form the third term of the trinity: artist, work of art, recognition'.[2] He also noted that 'the creative act is not performed by the artist alone; the spectator brings the work in contact with the external world by deciphering and interpreting its inner qualifications and thus adds his contribution to the creative act.'[3]

If Rothko sought clarity in his classic paintings, and the elimination of 'all obstacles between the painter and the idea, and between the idea and the observer',[4] then it was probably with much dismay that he read what he believed to be the erroneous critiques of his work. His constant emphasis on the philosophical basis of his paintings was difficult for most critics to comprehend or find relevant at the time, especially with the rise of formalism as the dominant method of criticism.

The formalist critics agreed with Rothko and his colleagues that American artists had to advance beyond Cubism, but their emphasis was on the innovations in the plastic elements and style of painting rather than on content and esoteric reasoning. The elimination of all vestiges of Renaissance spatial illusion and representational forms, and the flattening of the picture plane so that it paralleled the literal surface of the canvas were recognised as distinguishing characteristics of modern painting. Seitz, in his dissertation on the Abstract Expressionists, summed up the progress of modern art as follows: 'The adjective modern, applied to a painter's style, usually indicates that he has either renounced or radically departed from the pictorial means traditionally employed during the three hundred years from the sixteenth to the nineteenth centuries: a change which has paralleled a gradual abandonment of the idea that art should mirror the physical world.'[5]

Modern paintings were no longer the windows into illusionistic space that began with Renaissance art. Because Rothko painted broad areas of colour, it was often assumed

5 The Eyes of the Sensitive Observer

that his goal was to flatten his forms. Seitz, for example, referenced the statement that Rothko and Gottlieb had written to the *New York Times* in 1943 to demonstrate that the flattened picture plane was one of his goals:

We are for the large shape because it has the impact of the unequivocal. We wish to reassert the picture plane. We are for flat forms because they destroy illusion and reveal truth.[6]

Gottlieb, however, in later years revealed that he authored this point, and that Rothko merely went along with it, just as Gottlieb compromised on some of the points Rothko added to the letter.[7]

Clement Greenberg, who was the most influential modernist critic in America in the 1950s and 1960s, observed that every one of the Abstract Expressionists 'started from French art and got his instinct for style from it; and it was from the French, too, that they all got their most vivid notion of what major, ambitious art had to *feel* like.'[8] He added:

The first problem these young Americans seemed to share was that of loosening up the relatively delimited illusion of shallow depth that the three master Cubists – Picasso, Braque, Léger – had adhered to since the closing out of Synthetic Cubism. If they were to be able to say what they had to say, they had also to loosen up that canon of rectilinear and curvilinear regularity in drawing and design which Cubism had imposed on almost all previous abstract art.

Greenberg credited Rothko with being the first to eliminate the problem of the spatial illusion that occurs once pigment is applied to the surface of the painting. He wrote, 'he seems to soak his paint into the canvas to get a dyer's effect and avoid the connotations of a discrete layer of paint on *top* of the surface.' He recognised that Rothko did not actually stain the canvas but achieved this effect by scumbling colours on top of each other.[9] At the time of writing in 1955, Helen Frankenthaler, an artist whom Greenberg championed, had gone the extra step of staining paint directly into the fibres of the canvas. As Irving Sandler notes, 'Rothko accepted Greenberg's description of his formal innovations. But objected to the implication that he was primarily a picture-maker whose intention it was to avoid any allusion to cubism in order to paint flat color-fields.' Moreover, Rothko 'disapproved of Greenberg's purist point of view'. Greenberg argued that visual art should only address itself as a visual experience, making no reference beyond itself. The notion that a painting was a self-contained object with no outside reference was, as Sandler notes, alien to Rothko.[10] Greenberg also commended Rothko and Newman for destroying the Cubist notion of the picture edge as a confine. However, he was most impressed by what Rothko and Newman, especially, accomplished with line. 'What is most new, and ironical,' he writes:

is the refusal of Newman's and Rothko's linearity to derive from or relate in any way to Cubism. Mondrian had to accept his straight lines, and Still

has had to accept the torn and wandering ones left by his palette knife. Rothko and Newman have refused, however, to take the way out of Cubist geometry that Still shows them. They have preferred to choose their way out rather than be compelled to it; and in choosing, they have chosen to escape geometry through geometry itself. Their straight lines, Newman's especially, do not echo those of the frame, but parody it.[11]

Rothko denied that he had any use for lines at all in his Pratt Lecture in 1958. Seitz, who had the rare opportunity to interview Rothko about his classic paintings almost at their inception in 1952 and 1953, comes closer to an understanding of these works than Greenberg. His dissertation, however, was not published in book form until 1983, and was previously available only in the form of microfilm and photocopies, and thus was not as readily accessible as Greenberg's renowned essay. As Seitz noted:

Pressed on the question of space, Rothko insists that, like color or flatness, it is not essential to his conception. He emphasizes the material facts: that his variously shaped color areas are simply 'things' placed on a surface. From this viewpoint, spatial and atmospheric phenomena are subjective responses of the spectator, and not necessarily part of the artist's intention. The painter's remarks notwithstanding, the spatial impact of his works cannot be ignored.[12]

Of the spatial impact in Rothko's first classic paintings, he made the following observation:

The shapes are not the results of division and subdivision: they are more independent, and their field is separated from the edge of the format by a contrasting periphery. Thus, the picture plane cannot be seen as a simple equivalent of the canvas surface, though intermittently one or more of the areas appear strikingly dense and impenetrable as a mass of concrete; but as the eye moves upward or downward – the only directions that the balanced format will permit – the spatial and the physical effects shift, and what was mass becomes mist.[13]

Seitz recognised the irony and contradictions in Rothko's paintings by pointing out the conflict between what the mind comprehends as its factual, physical characteristics and its subjective, illusionary elements. The shifting relationships of Rothko's forms create a space that looks like mass one minute only to hollow out the next.

Although Seitz makes a convincing analysis of how Rothko achieves certain spatial effects and movement in his paintings, he falls just short of connecting the mechanics of the painting to its content. Rothko, in one of his interviews with Seitz, encouraged the art historian to go beyond the technical aspects of his painting. When Seitz told Rothko that he reacted to his paintings in terms of the space in his coloured areas, Rothko prodded, 'But what do they *mean* to you? Just because an area [is] like undulating silk, is this important? Lots of people can make like undulating silk. Writing should look into the writer and find what the painting really means.'[14] In his Pratt lecture, Rothko repudiated the formalist analysis of

his work. 'Neither Mr Gottlieb's paintings nor mine should be considered abstract paintings. It is not their intention either to create or to emphasize a formal color-space arrangement.'[15] And in one of his interviews with Seitz, Rothko clearly stated, 'I am not a formalist.'[16]

The formalist critique of Rothko's painting had a significant impact on the next generation of artists. Frank Stella, for instance, who was an admirer of Greenberg while still an undergraduate at Princeton University where he was taught by Seitz, could turn to Rothko's iconic, symmetrical image and Newman's 'zip' as a starting point for his breakthrough black stripe paintings of 1958–9 (fig.91 on p.154). Even Roy Lichtenstein, who began his career as an abstract painter, used single, symmetrically positioned images, such as a hot dog on a bun in his early Pop art paintings, to create perceptual unity of form and space, as was ascribed by formalist critics to Rothko's paintings.

'A picture lives by companionship', Rothko stated in *Tiger's Eye* 1947, 'expanding and quickening in the eyes of the sensitive observer. It dies by the same token. It is therefore a risky and unfeeling act to send it out into the world. How often it must be permanently impaired by the eyes of the vulgar and the cruelty of the impotent who would extend their affliction universally!'[17] It is more likely that he was referring to critics in this statement than to the general public. Critics after all, had the power to extend their 'affliction universally'. He held the public in much higher regard. In a draft for his letter to the *New York Times* in 1943, he extolled 'the public which reacted so violently to the primitive brutality of this art, reacted more truly than the critic who spoke about forms and techniques.'[18]

Rothko told Seitz that he wanted 'pure response in terms of human need. Does the painting satisfy some human need?'[19] In his view, the emotional element with which he felt he had imbued his work appealed to the imagination of the general observer more than formal analysis. One of the most influential, non-formal interpretations of his paintings was advanced by the art historian Robert Rosenblum, first in an article 'The Abstract Sublime' (1961), then more extensively in a book published in 1975, *Modern Painting and the Northern Romantic Tradition: Friedrich to Rothko* and again in 1987 in his essay for the retrospective catalogue published by the Tate Gallery, London.[20] Rosenblum sensed that Rothko shared affinities of feeling and structure with two of the greatest Romantic landscape painters, Casper David Friedrich and J.M.W. Turner.[21] He wrote, 'Rothko, like Friedrich and Turner, places us on the threshold of those shapeless infinities discussed by the aestheticians of the Sublime.'[22] He proposed that the 'achievements of Rothko's art extended these nineteenth-century masters' efforts to depict the awe-inspiring infinities of the natural world as a metaphor of the supernatural world beyond.'[23] Moreover, he noted:

It is surely Friedrich and Turner who first pursued most passionately and successfully the creation of a pictorial world without matter, usually conveyed through a vision of landscape, seascape, or skyscape that would free us from the pull of terrestrial gravity and immerse us, without ruler or compass, in some primordial element of water, cloud, colour, light or a fusion of all these ungraspable mysteries of nature.'[24]

Rosenblum identified similar transcendental qualities in Rothko's paintings. His convincing comparison of the viewer of a Rothko painting with the lone figure looking out at the infinite ocean in Friedrich's *Monk by the Sea* 1809 (Nationalgalerie, Berlin) is difficult to forget: 'we ourselves are the monk before the sea, standing silently and contemplatively before these huge and soundless pictures as if we were looking at a sunset or a moonlit night.'[25] It is important to note that Rosenblum did not state that Rothko's paintings were abstracted landscapes, but that they created a similar transcendental experience for the viewer.

Abstraction was still relatively new for the American public when 'The Abstract Sublime' was published in 1961, and in general, people continued to look for recognisable images in non-objective forms. Vertical compositions suggest upright figures, while horizontal compositions are perceived as suggestive of the sky and ground of landscapes. In 1947, Rothko had included 'memory' as one of the obstacles needed to be eliminated in order for art to progress, since it was responsible for

encouraging viewers to associate abstract forms with things they already knew. He wanted to create an image that had never existed before and deliberately avoided any reference to figures and landscape, even in terms of their compositions. His striated areas of colour are not boundless vistas, for example; the surrounding borders keep them from extending beyond the picture's edge. Rather, they provide a sense of intimacy that positions the viewer within the space of the work itself.

The landscape analogy, nevertheless, persists to this day in art-historical interpretations and in the popular press. As Jeffrey Weiss noted, *Life* magazine contributed to this misconception by juxtaposing a photograph of the artist sitting in front of one of his canvases so that the focus was on the hot red and yellow striation at the centre of the painting, with a photograph of a similarly coloured landscape below (the entire canvas was reproduced on the facing page).[26] Although the caption made the distinction that the painting and the sunset inspired similar emotional responses without actually calling the Rothko a landscape, the juxtaposition of the two photographs may have led readers to this assumption.

If one eliminates references to the natural world as ways with which to analyse Rothko's work, little else remains to focus on but colour. Several scholars and critics have concentrated on the meaning and function of the various hues he employs. Although Rothko rarely spoke of his colours in symbolic terms, John Gage, in his extensive essay on

Rothko's use of colour, examined the philosophical and art-historical sources that Rothko may have used in order to find possible meanings in his colour combinations. For example, Gage postulates that his occasional use of the maximal complementary contrast of red and green, i.e. *No.16 (Green and Red on Tangerine)* (A562) may be expressive of the antagonism between Apollo and Dionysus as described by Nietzsche. He also pointed to Rothko's interest in the murals depicting scenes of the Dionysian legend at the Villa of Mysteries in Pompeii. He quoted the artist's description of these murals as having 'the same broad expanses of somber color' as his paintings for New York's Seagram Building in 1959 (figs.83–5 on pp.141–3). As Gage notes, 'The Mysteries are those of Dionysus and include musicians, initiation and sacrifice, and an orgiastic dance. They may indeed throw light on the deep but occasionally also fiery reds that kindle unexpectedly in the Seagram series.'[27]

Rothko's colours clearly contribute to the tension in his compositions, which is so crucial to the meaning of his paintings. However, he discouraged an appreciation of his paintings based on colour alone. When, in the late 1950s, Seldon Rodman referred to Rothko as 'a master of color harmonics and relationship on a monumental scale', Rothko denied that he was concerned with the relationship between colours or forms. In an attempt to set Rodman straight he added, 'I'm interested only in expressing basic human emotions – tragedy, ecstasy, doom. And if you, as you say, are moved only by their color

relationships, then you miss the point.'[28] The colour relationships were instrumental in the way they produce the pulsating tension of forms pulling towards each other and pushing away. Thus the physical force produces the sensation that a conflict of life and death – the essence of human existence – is being acted out on the canvas.

Once Rothko had decided to cease writing statements about his work, he looked for other means to take control of his paintings after he sent them out into the world. When the painter Elaine de Kooning, wife of Willem, asked him questions about his work for her article about his and Franz Kline's paintings for *Art News* in 1957, his responses were elusive.[29] As Breslin reported, when she showed Rothko the article, which was due the following morning, he told her he disagreed with her entire premise. He stayed up with her all night as she revised it, and he continued to make changes on the new draft until he was satisfied with the final copy. After its publication, Rothko repudiated the article in a letter to the editor of *Art News*. He especially objected to the article's title, 'Two Americans in Action: Franz Kline and Mark Rothko', since he had rejected the critic Harold Rosenberg's term 'Action Painting' as a name for the new American abstract painting. 'I reject that aspect of the article which classified my work as "Action Painting"', he wrote. 'An artist herself, the author must know that to classify is to embalm. Real identity is incompatible with schools and categories, except by mutilation.'[30] Since his college days at Yale as an editor of the *Saturday*

Evening Pest, and his association with The Ten in the 1930s and Newman, Gottlieb and the other 'Irascibles' of the 1940s, Rothko frequently opposed the establishment. *Art News*, as one of the most influential art publications in the US, had published an article on his work that Rothko feared would erroneously classify his work as Action Painting and he was compelled to set the record straight. He added, 'To allude to my work as Action Painting borders on the fantastic. No matter what modifications and adjustments are made to the meaning of the word action, Action Painting is antithetical to the very look and spirit of my work. The work must be the final arbiter.' Rosenberg had coined the term to describe the work of artists such as Pollock, whose paintings record his highly physical movements as he worked. There are few tell-tale signs of gesture in a Rothko painting. There *is* action, but it is the shapes that do the performing, not the artist.

One of the few articles about his work that appealed to Rothko was Robert Goldwater's 'Reflections on the Rothko Exhibition', published in *Arts Magazine* in March 1961,[31] and written on the occasion of his retrospective at the Museum of Modern Art. Goldwater managed to discuss the artist's paintings without destroying their enigmatic and unclassifiable characteristics. The art historian was in a unique position to understand Rothko's work. His book *Primitivism in Modern Painting* (1938) was widely read in the New York art circles, and probably influenced some of these artists in their use of primitive source material.[32] As editor of the

Magazine of Art and the husband of sculptor Louise Bourgeois, he was intimately involved with the New York School artists. Criticism's prime function, he contended, is 'simply to serve as a method whereby the observer is arrested by a work for a longer time than, were he unaided, that could hold his attention'.[33] He added that the critic of modern art must reconcile the role of educating the public with the preservation of the artist's individuality in expressing his or her view of the world.[34]

Goldwater accepted Rothko's position that he was not a colourist, whilst recognising that colour is the key element in his paintings: 'Of course what Rothko means is that the enjoyment of color for its own sake, the heightened realization of its purely sensuous dimension, is not the purpose of his painting.'[35] He pointed out that the form and colour in Rothko's paintings served to achieve a specific goal. '[O]ver the years,' he observed:

he has handled his color so that one must pay ever closer attention to it, examine the unexpectedly jointed hues, the slight, and continually slighter, modulations within the large area of any single surface, and the softness and the sequence of the colored shapes. Thus these pictures compel careful scrutiny of their physical existence, of their variations in handling and arrangement, all the while suggesting that these details are means, not ends.[36]

Since Rothko's early interest in Greek drama was known, there was a tendency among critics to make a literal reading of the abstract paintings. Some even discovered in

them modern doomsday scenes such as the aftermath of nuclear explosions. Goldwater dismissed all these interpretations of the works, such as 'likening them to Greek drama, gathering from them the notes of impending doom, or seeing in them the symbolic action of storm clouds gathering in an immense horizon.'[37] 'Such literary fancies', he remarked, 'are program notes that relax the visual hold of these canvases, filter their immediacy, and push away their enigmatic, gripping presence.'[38] He continued:

These are motionless pictures; but despite the repetition of the horizontal – line or rectangle – they are not pictures at rest. The floating shapes convey no sense of relaxation. Nor is there a hint of how they came to be, nothing that suggests the action of the artist (pace, Action Painting), either through gesture or direction or impasto, nothing that defines the imposition of the will, either through an exact edge or a precise measurement. And yet in the unrelenting frontality of these pictures, their constant symmetry and simplicity, there is the immediate conviction of an enormous will.[39]

In Goldwater, Rothko had finally found his 'sensitive observer', who understood how his forms and juxtaposition of colour could inspire thought in the viewer; how, as one scrutinises the canvas, one becomes conscious of the process of looking and reconciling the objective and subjective concept of reality. Rothko had the article reprinted in the catalogue for his retrospective when it travelled to the Whitechapel Art Gallery in

London, and named him as one of the original trustees of the foundation he established in 1969. Towards the end of his life, he sanctioned Goldwater to write a book about his work. He cooperated fully with the author, providing him access to his papers, but sadly, Goldwater died in 1973 without having written it.

Given that Rothko mistrusted the ability of most critics to mediate his work to the viewer, the only other means to control the response to his paintings was through the manner of their exhibition. By 1952, he was determined to avoid participation in group exhibitions. He even refused to sell his work to the Whitney Museum for its permanent collection because, as he wrote to the museum's associate director Lloyd Goodrich, he felt that the 'real and specific meaning of the pictures was lost and distorted in these exhibitions'. He added, 'Since I have a deep sense of responsibility for the life my pictures will lead out in the world, I will with gratitude accept any form of their exposition in which their life and meaning can be maintained, and avoid all occasions where I think that this cannot be done.' Rothko was well aware that his refusal might be considered arrogant, and concluded his letter by expressing his predicament: 'in my life at least, there must be some congruity between convictions and actions if I am to continue to function and work'.[40] When his works were exhibited at museums and galleries, Rothko insisted on complete control over the installation, and the selection of works. The curator Dorothy

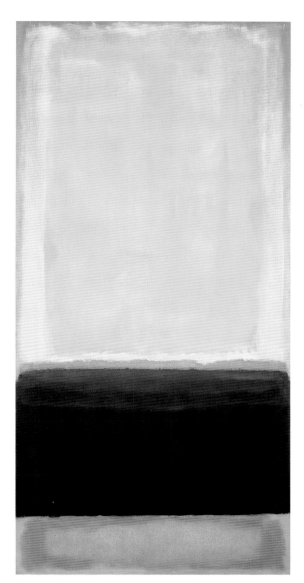

Miller included Rothko in her *Fifteen Americans* exhibition at the Museum of Modern Art in 1952. Although this was a group exhibition, which included Still, Herbert Ferber, Pollock, and eleven other artists, Rothko and Still each had their own room. As Miller recalled, she chose the paintings for the exhibition, but Rothko changed the selection and added more works than there was room for in the gallery. He also insisted on hanging his own room without Miller's interference. 'He wanted to have the four walls of the gallery completely covered with paintings touching one another, and he did not wish to accept the Museum's gallery lighting, proposing instead to have blazing lights in the center of the ceiling.' Miller stood her ground, concerned that if his gallery was so different from the others, it 'would be very destructive to the show as a whole'. It took the arguments of Alfred Barr and ultimately, the Museum's director René d'Harnocourt, to persuade Rothko to accept Miller's hang.[41] Rothko and Still refused to allow their paintings to travel when the *Fifteen American*'s exhibition toured to Europe, since they would not be able to control the installation.

Rothko exercised similar control over his solo exhibition at the Art Institute of Chicago in 1954. The curator Katharine Kuh had hoped to publish an interview with him (in the form of correspondence between them) for the exhibition brochure. He refused to participate, however, citing his misgivings that it would be 'an instrument'

with which 'we will tell the public how the pictures should be looked at and what to look for'. Although the aim of such a document was to aid the viewer, Rothko believed that it would result in 'the paralysis of the mind and the imagination (and for the artist a premature entombment)'.[42] Kuh compromised with a brief essay, quoting two passages from one of Rothko's letters.

Again, Rothko wanted control over the installation of his paintings in Chicago (*No.4*, fig.69 was among those exhibited). Distance, however, limited his powers in this respect. Kuh sent him blueprints of the gallery, but he had trouble visualising the 'real feeling of the room' so he provided her with the general guidelines he had arrived at during the course of his experience in hanging the pictures. It is clear from these that one of his fears was that the paintings would end up looking decorative. This concern had been voiced since the early twentieth century by pioneering abstract painters, including Kandinsky, who ascribed greater meaning to colour and form – whether spiritual, emotional or philosophical – than mere wall decoration. Rothko wrote:

Since my pictures are large, colorful and unframed, and since museum walls are usually immense and formidable, there is the danger that the pictures relate themselves as decorative areas to the walls. This would be a distortion of their meaning, since the pictures are intimate and intense, and are the opposite of what is decorative, and have been painted in a scale of normal living rather than an institutional scale.[43]

Through his experience of hanging his own work he discovered that it was possible to avoid the decorative effect 'by tending to crowd the show rather than making it spare'. He observed that, 'By saturating the room with the feeling of the work, the walls are defeated and the poignancy of each single work' becomes 'more visible'.[44]

Rothko included an unusually large painting for this exhibition that was wider than it was high (*No.10 [?]* 1952–3, 299.1 × 441.3 cm, A483). He told Kuh that typically he would hang 'the largest pictures so that they must be first encountered at close quarters, so that the first experience is to be within the picture.'[45] His belief was that the positioning of his works, rather than a text, could aid viewers in their response. He added that this initial powerful impact 'may well give the key to the observer of the ideal relationship between himself and the rest of the pictures'. It was possible to reinforce the corresponding relationship between the viewer and the work by hanging the paintings, the largest ones in particular 'as close to the floor as is feasible', and to make the space as confined as possible.

It was one thing to be misunderstood by the public and critics; it was another to be judged by one's fellow artists. Still and Newman had been critical of Rothko in the early 1950s, after they had fallen out over their conflicted beliefs and relation to the art world. The three colleagues, who once provided mutual intellectual and artistic exchange, no longer communicated. The rift between them, which was well known

within the art community, generated some trepidation among fellow artists, critics, collectors, and possibly dealers, when the prestigious Sidney Janis Gallery gave Rothko a solo exhibition in the spring of 1955 (fig.70). Although his reputation had grown with the Betty Parsons Gallery, she had not been successful in generating significant sales. Pollock had left her gallery in May 1952 for the Janis Gallery, and Still had also signed up by December 1953. By February 1954, Rothko had quit Parsons, when he, too, joined Janis. Newman left Betty Parsons after his exhibition in 1951 and was without gallery representation for several years. Rothko had not had a major exhibition in New York since his inclusion in the Museum of Modern Art's *Fifteen Americans* in 1951. Laverne George, writing in *Art Digest* in May 1955, captured the sense of anticipation leading up to the Janis exhibition, stating that there was 'a nervous tendency to dismiss it as the proof' that Rothko's 'direction is no direction at all'.[46] Newman and Still each felt compelled to write a letter to Janis explaining that they refused to go to Rothko's opening.[47]

The reception of his works at the 1955 Janis exhibition, therefore, was especially important to Rothko. As Janis recalled, 'He placed and re-placed every canvas.'[48] From the description of this exhibition it is clear that he had his way with the installation, since it was similar to the original plans for the *Fifteen Americans* exhibition that had been vetoed by MoMA's curator and director. The walls of the Janis gallery were crammed with twelve paintings, including *No.27* 1954 (fig.71), *Yellow and Blue* 1955 (A528), *Earth and Green* 1955 (A532) and *No.12 (Red and Yellow)* 1954 (A516), and according to Janis, Rothko also insisted on bright illumination. Works were displayed floor to ceiling so that the viewer was completely surrounded. The arrangement was remarkable for the dissonance it created between the canvases as well as within each work. Rothko achieved this tension by placing a green-and-blue painting inches away from a yellow-and-pink or ochre-and-orange one.

The exhibition was a triumph. The critic Thomas Hess even hailed it as 'the most enjoyable show in several years', adding that it 'emphasized the international importance of Rothko as a leader of post war Modern Art.'[49] Hess, as well as Robert M. Coates, were particularly struck by the glowing light produced by these paintings.[50] They noted that it was the collective effect of the ensemble rather than any one canvas that created the impressive environment.

Rothko's thoughts about the installation of his work evolved over the next few years as the paintings themselves were restricted to narrower colour values. Rather than recreating the dissonant arrangement of the 1955 Janis Gallery exhibition, by 1957 Rothko favoured grouping his paintings according to similar hues and using 'normal' illumination. This had thrilling results in his 1958 exhibition at the Sidney Janis Gallery. The critic E.C. Goosen observed that the installation and the spectral closeness of the paintings made such huge paintings as *No.16 / Two Whites, Two Reds* (fig.72) resemble a

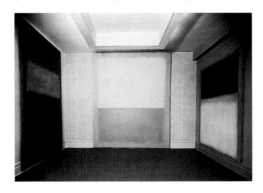

70
Installation of *Mark Rothko* exhibition at the Sidney Janis Gallery 1955

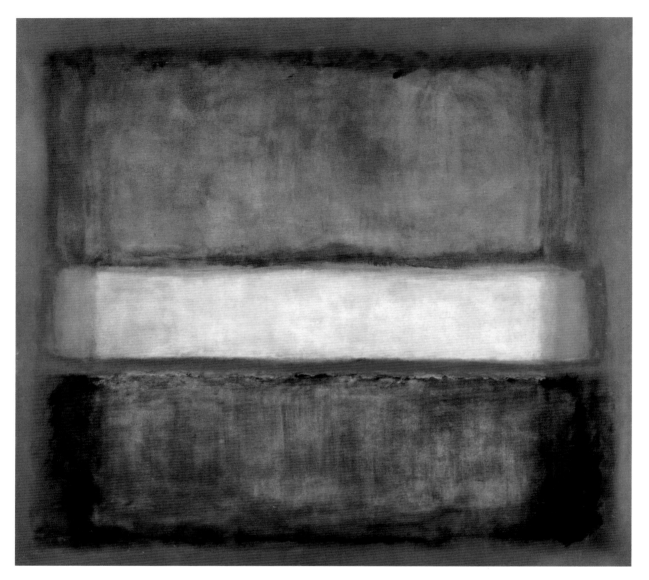

71
No.27 [Light Band] 1954
Oil on canvas
205.7 × 220
Private collection

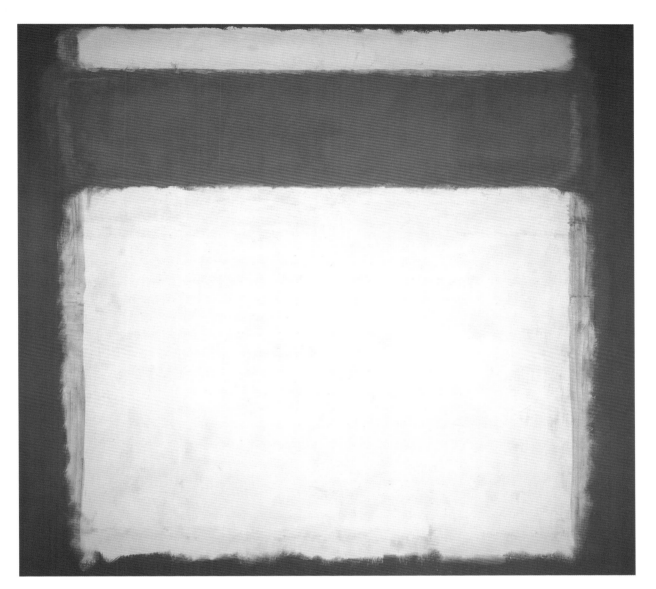

72
No.16 *[Two Whites, Two Reds]* 1957
Oil on canvas
265.4 × 292.4
National Gallery of
Canada, Ottawa

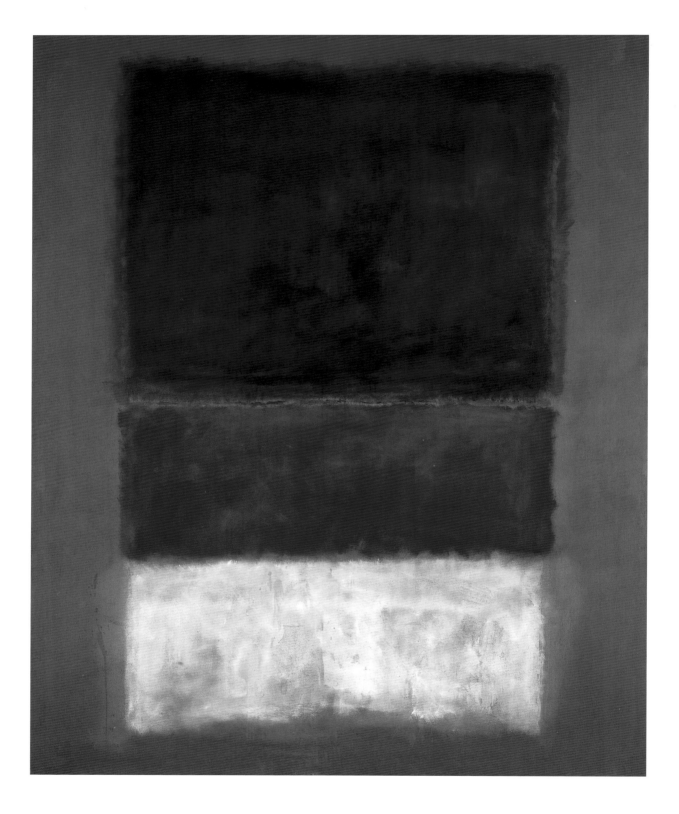

THE ROTHKO BOOK

73
No.14 [White and Greens in Blue] 1957
Oil on canvas
258.5 × 208.3
Collection of Mrs Paul Mellon, Upperville, Virginia

white screen flooded with light from a projector in a reddened room.'[51] The dimmer lighting, as Dore Ashton reported, made the eye strain to penetrate behind the paintings.[52] The conditions for showing his work in this exhibition apparently appealed to Rothko, since he applied them to all of his subsequent exhibitions and commissions. Although the hang at the Janis 1958 exhibition might seem to be a contradiction of his earlier insistence on bright light and closely arranged paintings of dissonant colours, it is important to stress that the darkened palette of the late 1950s may have warranted the change (fig.73). The paintings of the 1950s were generally bright with discordant colours that were enhanced by the bright lights. The experience of the dark, closely valued hues of the paintings of the late 1950s was intensified by the dimmer lighting.

He was also involved with the selection and hanging of his major exhibition at the Museum of Modern Art in 1961. Although the show was a retrospective he refused to include any of his early works, and despite the fact that he had been planning the exhibition for at least eighteen months, two days before it opened he withdrew six paintings and added seven new ones. One suspects he felt it best to allow his works to seem to have emerged almost fully resolved, beginning with a few biomorphic Surrealist paintings and leading into the final multiforms of 1949. The absence of his early canvases added to the notion of his paintings as miraculous works without historical precedent. As Goldwater noted of the selection in his review of the exhibition:

'even the movement of development has been underplayed, and the insight of origins has been denied the spectator, who is confronted by a vision without sources, posed with a finality that permits no questions and grants no dialogue.'[53] Rothko may have been attempting to discourage such explanations as Seitz had offered on the development of his work from his representational, Surreal and abstract periods as the progressive simplification of the background.

Goldwater believed that there were some problems with the hang. He contended that it was important to encounter each painting on its own, isolated from the others. But in the first-floor galleries, 'where the canvases have been hung close together, and where, too often, the vista of another room, another mood, another idea, disturbs the concentrated view. Suddenly we are aware of colors, where we are being asked to commune with presences.'[54] He considered the 'small chapel-like room' which contained three of Rothko's paintings for the 1958–9 Seagram building murals, the most successful arrangement. 'Partaking of the same somber mood, they reinforce each other, as they were destined to do.'[55] Unlike the arrangement suggested by Rothko's tempera studies for the Seagram paintings, in which the canvases seem to be joined in a continuous frieze, the group of paintings shown at MoMA were hung separately and unattached (see pp.133–44, 170–1 for discussion of Seagram murals).

When the retrospective travelled to the Whitechapel Art Gallery in London, Rothko

made extensive recommendations for the installation, which were transcribed by MoMA. (These constitute the most detailed existing document recording his thoughts on the installation of his paintings).[56] He especially liked the grouping of the dark Seagram murals at MoMA, and he asked if this room could be duplicated at the Whitechapel Art Gallery. He noted that the MoMA hang 'gave an excellent indication of the way in which the murals were intended to function'. Nothing was left to chance. Wall colour, for instance, 'should be made considerably off-white with umber and warmed a little by red', so that the walls would be as unobtrusive as possible: 'if the walls are too white, they are always fighting against the pictures' noting that otherwise the walls tend to take on a greenish cast in contrast to 'the predominance of red in the pictures.'[57]

He requested 'normal' lighting, like the illumination he began using in his 1958 exhibition at Janis. The phenomological effect of the paintings works best in a normally lit room; as Rothko remarked, 'the pictures have their own inner light and if there is too much light, the color in the picture is washed out and a distortion of their look occurs.'[58] He had painted them with the normal lighting of his studio (a mixture of natural and incandescent light), and cautioned that they 'should not be over-lit or romanticized by spots', since this too would cause distortion. (Because normal lighting looks dim compared to hot spot lights, a general misconception has arisen that Rothko desired a darkened room for his paintings.)

It seems that all of Rothko's instructions were intended to maintain the same conditions under which the works had been painted, thus providing viewers with an experience similar to the one he himself had undergone when painting them. This included the height at which the paintings were to be hung. 'The larger pictures should all be hung as close to the floor as possible, ideally no more than six inches above it. In the case of the small pictures, they sh ould be somewhat raised but not "skyed" (never hung towards the ceiling). If this is not observed, the proportions of the rectangles become distorted and the picture changes.'[59] Raised, the rectangles would loose their frontal relationship with the viewer and the rectangular forms would appear keystoned. The exception was the Seagram murals, which he painted to be hung approximately four feet six inches above the floor.

In his arrangement of the paintings at the Whitechapel Art Gallery, Rothko was more concerned with the effect they created for the viewer than with demonstrating a chronological evolution. As he noted in his instructions, he intended all the works to hang as 'units', with the 'watercolors separated from the others'. The murals were also hung as a unit. The instructions counselled that the remaining works should be arranged 'according to their best effect upon each other. For instance, in the exhibition at the Museum, the very light pictures were grouped together – yellows,

oranges, etc – and contributed greatly to the effect produced'.[60] The homogenous chromatic grouping would serve to create a complete environment that surrounded the viewer, who would not only be in the painting, but would become part of the entire installation. (He had recommended a similar scheme for his exhibition at the Contemporary Art Museum in Houston in 1957.)

The ideal situation for Rothko was to have his paintings hang permanently as a group in a museum. Fortunately for him, the Phillips Collection in Washington, D.C., was sensitive to his concerns. The collector Duncan Phillips, excited by his first Rothko purchase, *No.7 (Green and Maroon* 1953 (A491), wrote to Janis in 1958, 'I often wish we had room for another Rothko. He wears so well and is definitely an artist after my own heart. For such a man I would make room if I found one with irresistible color.'[61] Phillips visited Rothko's studio several times and eventually bought more paintings from the Janis Gallery. When an annex was built to the original Phillips Collection building, he and his wife Marjorie designated one of the new galleries 'the Rothko room' and worked out the arrangement of their paintings on a maquette supplied by the architects. When the annex opened in 1960, *No.7 (Green and Maroon)*, *Orange and Red on Red* 1957 (A599) and *Green and Tangerine on Red* 1956 were installed in the room. *The Ochre (Ochre, Red on Red* 1964 (A517), purchased in 1964, was later added to the group. Arthur Hall Smith, a former museum assistant at the Phillips

Collection, recalled Rothko's first visit to the room while in Washington for President John F. Kennedy's inauguration in January 1961. He promptly informed Smith that he would like to suggest some changes in the lighting by eliminating spotlights and the paintings were rearranged on the spot.[62] The following week, Phillips, whose taste was shaped by late nineteenth and early twentieth century European and American painting, rehung the gallery in the original arrangement. Although the Phillips Collection did not follow Rothko's preferred hanging, this room is often emulated as a model for subsequent installations. The experience may have reinforced Rothko's resolve to create an environment over which he would have ultimate control.

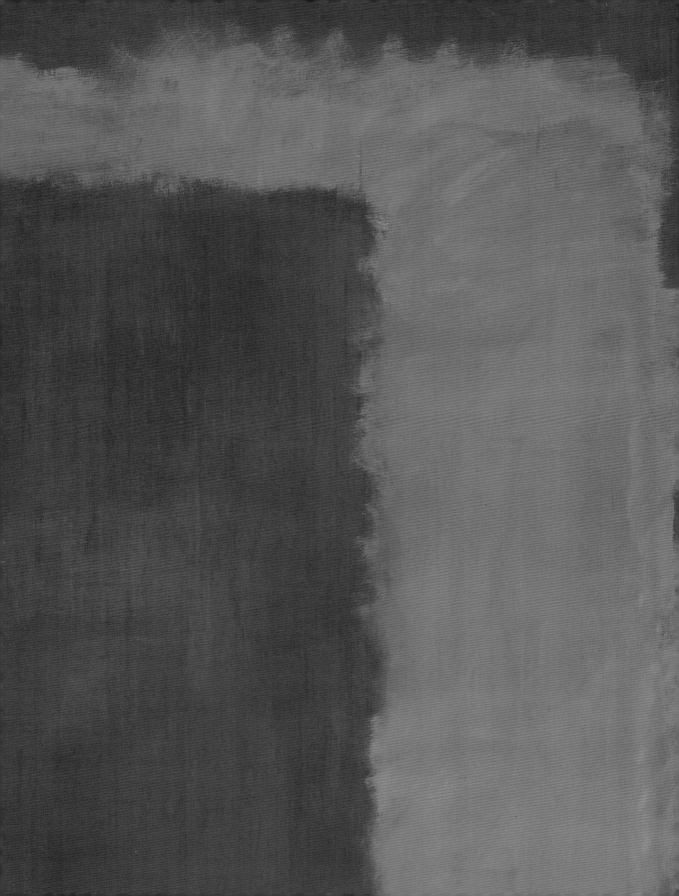

One of the most indelible impressions of Rothko's works was created through the installation of his posthumous retrospective at the Guggenheim Museum, New York, in 1978. Few who attended this exhibition can forget the experience of seeing his canvases descending from the top of the museum's spiral, the bright paintings of the 1950s giving way to the dark, late works at the bottom of the ramp. The knowledge that Rothko's life ended in suicide in February 1970 brought about a general perception that these dark works were the result of bleakness and doom in his life. There are strong arguments that contradict this biographical interpretation, but the impression persists.[1] The darkest paintings, in fact, coincide with some of the most shining moments in his life and career. He enjoyed a reunion with Avery and Gottlieb the summer of 1957 when all three artists summered in Provincetown, Massachusetts, reliving the camaraderie they experienced earlier in their careers.[2] His retrospective at the Museum of Modern Art in 1961 was a critical success and the show was also presented in major museums throughout Europe. In August 1963, his son Christopher Hall Rothko was born and, in the same year the prestigious Marlborough Fine Arts Gallery signed him to a one-year exclusive agreement for its galleries in New York and Europe. In addition, Marlborough bought fifteen of his canvases outright, thus providing him and his family with financial stability. He received three commissions, one for the Seagram building in New York (1958), another for Harvard University (1961) and a

third for a chapel in Houston in 1964, which would occupy his time for more than four years. And on 9 June 1969, Yale University granted him an honorary doctorate.

There was no doubt, however, that despite his late-won glory, Rothko's last decade was also filled with stress and conflict. Even the honorary doctorate from Yale was bittersweet as is suggested in his acceptance letter: 'When I was a younger man, art was a lonely thing: no galleries, no collectors, no critics, no money. Yet it was a golden time, for then we had nothing to loose and a vision to gain. Today it is not quite the same. It is a time of tons of verbiage, activity and consumption. Which condition is better for the world at large I will not venture to discuss.'[3] In his last few known written statements, Rothko remarked on his feeling of alienation from the new generation of artists. He made attempts to connect with younger artists by teaching at the University of California, Berkeley (1967) or inviting artists to his studio, but in general, he felt he was perceived as 'an old man with values belonging to the past.'[4] A new generation of artists was gaining international notoriety and success more rapidly than he and his colleagues had, and Rothko feared that his career might be eclipsed. He was plagued by bouts of depression throughout most of his adult life, along with new physical illnesses – he suffered a debilitating aortic aneurysm in April 1968 and was diagnosed with bilateral emphysema in 1969. His marriage to Mel had disintegrated by January 1969, when he moved out of their home to live in his studio

6 Containing Light

on East 69th Street. Still, as he often remarked throughout his career, he did not consider his works as reflections of his emotional state when he painted them, and he hoped that viewers would not interpret them as specific to his own moods.

The dark palette was actually introduced into his paintings in 1957, when he began creating canvases of closely related hues such as the deep blue and green in *No.15* 1957 (fig.76). Dark colours were not novel in Rothko's work. Most of his paintings of the 1920s and 1930s, for instance, were in deep tones of brown, black, ochre and dark reds and blues, brightened by chiaroscuro effects that he created with white or yellow highlights. Several of the late multiforms and early classic paintings, such as *No.3/No.13* 1949 (fig.68 on p.106), *Untitled* 1951–2 (fig.74), and *No.4* 1953 (fig.69), contain large areas of black. These blacks are often contrasted with a lighter colour, as in *No.3/No.13*, in which the larger black element floating in a red field at the top is sandwiched between two narrow bands of white and yellow. At first glance, these bands, glowing like fluorescent lights, are so dominant that they obscure the details and nuances in the black. Yet the longer one looks at this painting, the more the red stain under the black bleeds through.

Rothko experimented in the early 1950s with pairing two competing forms, one of which was black, as seen in *No.4 (Two Dominants)* 1950–1 (fig.75). In this painting, two large, lopsided rectangles, pink-plum at top and black at bottom, battle each other for domination of the space. The bright colour at the top draws the first glance, but the weight of the black at the bottom pulls forward (rather than recedes) to grab the viewer's attention. The orange stain beneath the black gives it a little push in its competition with the bright colour on top.

One of the characteristics that distinguish the dark paintings of 1957 from Rothko's earlier works using black and other deep colours is the lack of strong contrast between these hues. The greens, blues and blacks that he used in *No.3, Untitled* (A581), and *No.15* (fig.76), both of 1957, are so close in value that, under the dimmer lighting conditions that Rothko preferred by now, it would take a considerable length of time for the viewer's eye to distinguish one colour from the other.

Although there is a change in approach to his paintings of 1957, it is not clear whether Rothko's preference for dim lighting conditions for displaying his work in the late 1950s inspired him to alter his palette or vice versa. Of the blue-green paintings of 1957, he reportedly considered *No.14* (fig.73) a breakthrough. He painted it while teaching at Tulane University in New Orleans, in the spring of 1957.[5] In this painting, he added a white rectangle at the bottom, which he dematerialised by means of aggressive brushwork. The blue field peeks through the strokes, creating shadows that break up the form and transform the white area into a mist of light-reflecting particles. The verdant colours of these 1957 paintings are similar in palette to his few early landscape oil paintings, the Cézannesque *Untitled* c.1928, and the more conventional *Untitled* 1928–30

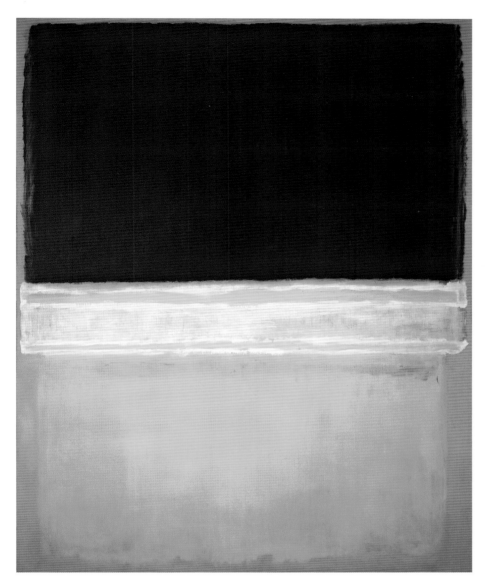

74
*Untitled [Black, Pink and
Yellow Over Orange]*
1951–2
Oil on canvas
294.6 × 235
Collection of Norman and
Irma Braman, Miami

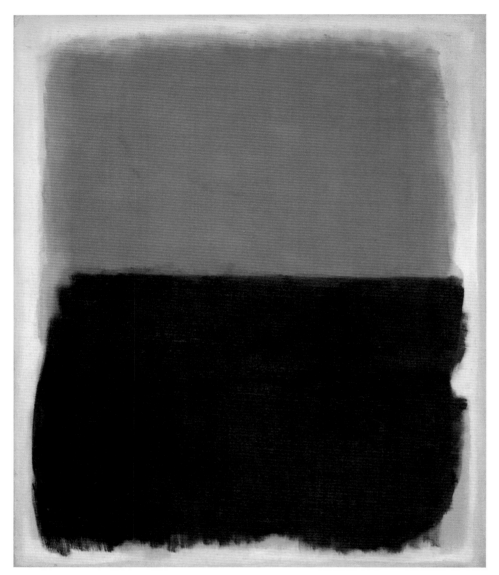

75
No.4 [Two Dominants]
(Orange, Plum, Black)
1950–1
Oil on canvas
170.2 × 139.7
Private collection, USA

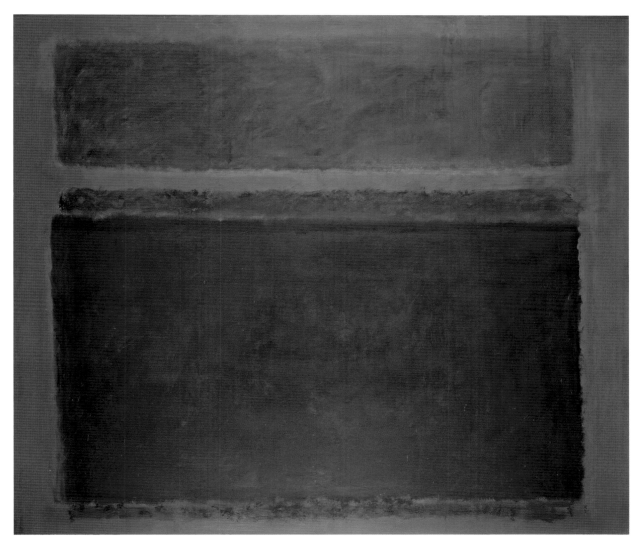

76
*No.15 [Dark Greens on
Blue with Green Band]*
1957
Oil on canvas
261.6 × 295.9
Collection of Christopher
Rothko

(figs.2, 3). In both of these works, Rothko had made extensive use of the dark blue-green combination that he observed in nature. *Untitled* 1928 also foreshadows the light created in the 1957 blue-green paintings. In this early landscape, the blue and green dabs of paint that form the leaves of the trees are illuminated by the white of the clouds, which itself is broken up by the pale blue sky. The sunlight reflecting off the clouds in the early landscape lights up the otherwise dark painting. This is not to suggest that Rothko's blue-green paintings of 1957 are references to landscape, but that the lessons he learned about the manipulation of paint and colour early in his career contributed to the luminosity he achieved in these paintings.

Although Rothko continued to explore the use of closely related hues, his intention was not primarily motivated by the darkening of his palette; he continued to use bright colour combinations such as orange and red, as well as the deeper tones of blue and green, or red, brown and black through the early 1960s. Another element besides the close tonality that is consistent in most of the paintings of 1957–8 is the free-floating white rectangle that he perfected in *No.14* 1957. White fields appear in his earlier paintings, but in works such as *Untitled* 1951–2 (fig.74), they seem denser in mass and stabilised by the adjacent colour bands. These canvases were painted to be viewed under the bright lighting conditions that Rothko prescribed for his installations in the early 1950s and therefore would have glowed uniformly, whereas the dim lighting makes the closely related hues

smoulder as a unit, allowing the fluorescing white form to detach itself from this block and float free.

Another characteristic that distinguishes these paintings from the previous classic paintings is the wide border surrounding the rectangular forms. Instead of using a contrasting colour for the underlying field (which also forms the border) as in previous paintings, the borders in the canvases of 1957–8 tend to be painted in a hue closely related to the other dominant colours. As a result, the dark or more intense colours as in *No.16* 1957 (fig.72 on p.121) frame the white area, like an aperture, contributing to the effect that light has been projected onto the white field. As previously noted, Rothko, in his figurative paintings, did not treat the figure and its surroundings as two distinct areas (fig.79). Following the examples of Cézanne and Weber, he allowed the two areas to form each other. He continued this practice in his abstract paintings. The relationship between the central rectangular shapes and the border becomes increasingly important in the paintings of 1957–8.

Rothko was fascinated by the illusion of projected light long before he had arrived at his classic paintings. Of particular interest is a late 1930s self-portrait set in a theatre (fig.77). The screen is a brightly illuminated white field painted with irregular brushstrokes like the white rectangles in the paintings of 1957–8. The underlying beige ground seeps through the white, transforming it into an ethereal, glowing rectangle. The projected light is contained at the sides between two

curtains; the one to the left and closest to the viewer is red, the other, a beige curtain, almost blends in with the white light. A dark green balcony contains the illuminated area at its lower edge, while the top is almost completely cropped by the upper edge of the gesso board. Rothko and a companion are depicted sitting in the foreground, leaning on the balcony. The artist's elongated head glances backward, perhaps at the viewer, or towards the source of the projected light behind him.

In some of the paintings of 1957–8, Rothko substituted black fields for white, as in *Light Red over Black* 1957 (fig.78). As in the paintings with the white rectangles, the close hues of the border and other forms, whether bright red or dark brown, blend as a unit that frames the black field or fields. The wider border in these paintings also gives the blacks greater room to breathe and fluctuate between projected and recessive space. In *Light Red over Black*, Rothko paired two black regions; the top one is painted more densely and uniformly with defined edges, while the bottom black is more thinly painted and allows more of the red field below to bleed through. The diffused top and bottom periphery of this form creates an atmospheric effect. Consequently, the top black area appears to recede in depth and expand at its sides, whereas the black at the bottom projects forward.

Rothko's early classic paintings are resplendent with unique colour combinations that are unprecedented even in his own paintings of the 1920s, 1930s and 1940s. The works of 1957–8 revisit the colours that typified his Expressionistic paintings of the 1920s and 1930s. These earlier paintings demonstrate that Rothko was aware of the perceptual effect these colour combinations had on form. Besides the blue-green combination found in his early landscapes, the earthy browns and reds of these youthful paintings reappear in the paintings of the late 1950s. In such early portraits as *Untitled* 1935–6 (A78) and *Portrait* 1936 (fig.79), the deep-red background complements the figure, which projects forward in space and glows with light. Rothko's re-use of these colours in the late 1950s suggests that he intended to achieve a similar effect of framing and projected illumination. The fluorescent effect in *No.9* 1958 (fig.80), for instance, is similar to areas of chiaroscuro in earlier paintings such as *The Red Blouse* 1933–4 (fig.81), in which the expressionistically painted white blouse detaches itself as a separate glowing form from the surrounding deep, red-coloured garment.

Rothko was working on these deep-hued paintings when he was commissioned in 1958 to produce large paintings for the Seagram Building in New York, designed by Mies van der Rohe with Philip Johnson. The project, which was for the Four Seasons restaurant designed by Johnson, initially appealed to Rothko who had been seeking a controlled environment for his paintings. He produced approximately thirty paintings for the project, purportedly in three series, from 1958 to 1959, but ultimately decided that the restaurant was not the appropriate setting for

77
Self-Portrait 1938–9
Oil on gesso board
12.5 × 17.7
Collection of Gilbert M. Frimet, Michigan

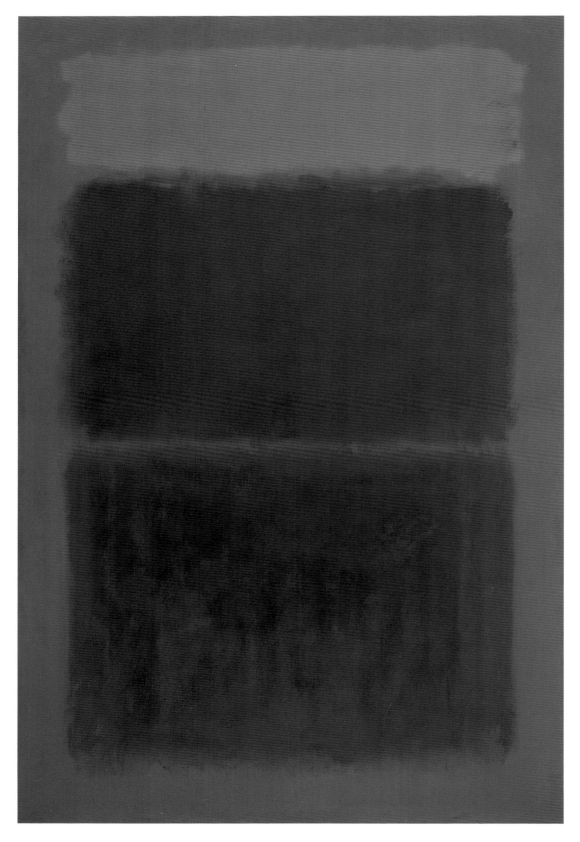

THE ROTHKO BOOK

78 (opposite page)
Light Red over Black 1957
Oil on canvas
232.7 × 152.7
Tate

79
Portrait 1936
Oil on canvas
91.8 × 55.7
National Gallery of Art,
Washington
Gift of The Mark Rothko
Foundation, Inc.

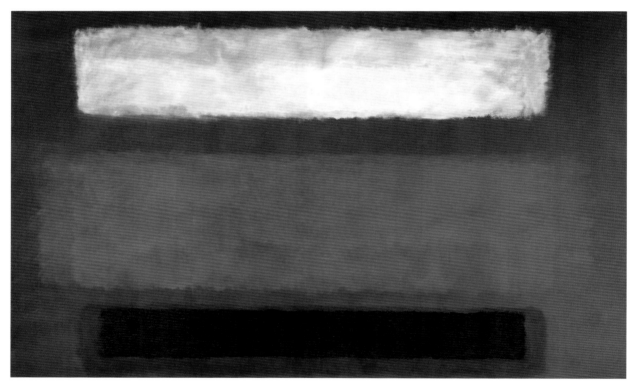

80
No.9 [White and Black on Wine] 1958
Oil on canvas
266.7 × 421.6
Private collection

his work and withdrew from the commission. Johnson and Phyllis Lampert, acting on behalf of her father, the owner of the Seagram Company, gave Rothko carte blanche in developing the programme for the murals. The proposed room in the Four Seasons was 17 x 5 meters, with a large window at the end. This room would provide a more intimate dining experience than the larger, tree-filled main dining room. The doors separating the two spaces would be open, providing diners in the main area a view of Rothko's paintings, and those sitting in the smaller room a view into the larger space. As Michael Compton observed, 'Rothko's room, being raised relative to [the main dining room], was like a stage set.'[6] The artist's plan to raise the paintings so that they cleared the table tops would have contributed to this effect.

The canvases Rothko painted just prior to the Seagram murals provide some clues about his primary interests at the time. As previously noted, these paintings display a wider border than the earlier works, and harmonious colours are used to create a unified field. Paintings with white rectangles glow with the illusion of projected light, whereas their blackened counterparts recede as well as advance in space. The Seagram paintings should be seen as his continued drive to contain, reflect and generate light, and to create an infinite space that would provide viewers with the experience of the human condition.

No.9 [White and Black on Wine] 1958 (fig.80), a painting in the classic stacked arrangement, is the only work that has been clearly identified as part of Rothko's initial scheme for the Seagram commission. As his instructions for the installation of his retrospective at the Whitechapel Art Gallery in 1961 indicate, this enormous horizontal painting (266.7 × 421.6 cm) 'is a transitional piece between the earlier pictures of that year and the mural series',[7] executed in the rich, earthy tones that preoccupied Rothko in the late 1950s. He decided early in the planning process to fill the horizontal wall with a continuous frieze of paintings rather than individual canvases separated from one another.

To achieve his plan, Rothko abandoned the classic format for a new image of vertical and rectangular shapes surrounding an open area in a palette similar to the deep-hued paintings of 1958 (figs.83–5, 90–101). Dan Rice, one of Rothko's studio assistants at the time during which some of the Seagram murals were painted, reported that the vertical arrangement was arrived at when Rothko turned the classic pictures on their side.[8] There are some precedents for the vertical format of the Seagram murals in Rothko's earlier work, such as the double verticals of No.17/No.15 1949 (fig.61 on p.94). With its play of deep red, yellow and black, this late multiform even shares a palette with the Seagram murals. The explanation for Rothko's use of a single rectangle could simply be that it replicated Johnson's architecture for the room, with its three, large, squarish openings into the main dining room. A similar pattern appears in his proposal for the Social Security Building in Washington, D.C. from 1940, in which a series

81
The Red Blouse 1933–4
Oil on canvas
79.4 × 40.6
Collection of Kate Rothko
Prizel

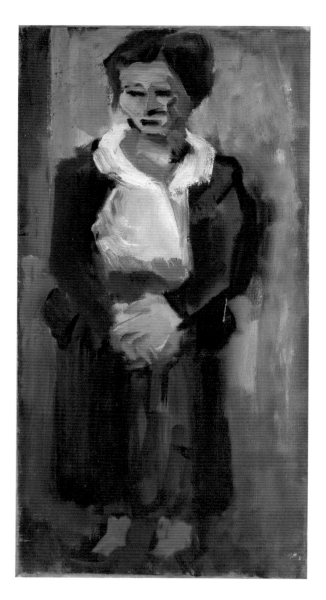

of doorways form squarish interludes in his scenes from the life of Benjamin Franklin.[9]

Other architectural sources have been suggested for the novel Seagram mural compositions. Soon after he began working on the commission, Rothko travelled to Europe in the summer of 1959. During this trip, he visited Michelangelo's Laurentian Library in Florence. The architectural characteristic of the Seagram murals' window-like forms may have been influenced subconsciously by Michelangelo's blind-window construction, as Rothko himself remarked.[10] This type of architectural detail was also pervasive in New York buildings and appears in Rothko's paintings of the 1920s and 1930s (fig.82).

The Seagram murals share with the Laurentian Library a reversal of the relationship between inside and outside. As the tempera on paper studies for the murals suggest, Rothko at one point in the evolution of the project envisioned each painting as its own episode in a continuous line of abutting canvases. It is tempting to compare the vertical forms in these paintings to markers defining space, much like the zips in Newman's works. But Rothko's paintings do not seem to suggest any system of measure that would help viewers locate themselves in space. In fact, the murals have the opposite effect. By modulating the relationship of light and dark in these paintings, so that the forms endlessly shift their positions as inside and outside space, Rothko creates a situation whereby viewers advance into the murals, only to find themselves outside of a space that, once it is penetrated, opens up into another space (fig.83). The endless journey through this frieze of paintings traps viewers in a claustrophobic labyrinth. Rothko reportedly hoped to achieve an effect in these paintings that was so overwhelming that diners would want to 'butt their heads forever against the wall'.[11]

The experience of illumination in the Seagram murals is extraordinary. Rothko achieved it by controlling the apertures of the fields to create light. In order to benefit from the effect, the viewer must first discard any traditional notions of the figure/ground relationship in these paintings. Such works as *Mural for End Wall* 1959 (fig.90), *Untitled [Seagram Mural Sketch]* 1958 (fig.84), and *Sketch for 'Mural No.4'* 1958 (fig.85) all have a bright-orange aperture that contains and intensifies the darker reddish-brown areas it surrounds, making them appear simultaneously as surface and as deep recesses in space. Since these dark areas are the same as the stained ground that encircles the aperture, both the dark border and the interior rectangles appear to be eclipsing the orange glow. The orange areas are expressionistically brushed and rubbed, allowing the darker colours beneath to modulate their density. Rothko scattered pale highlights across the surface, perhaps in an attempt to simulate the glow of candle light flickering on the gilded frescos of the early Renaissance.[12]

These paintings demonstrate that Rothko was well aware of phenomenological effects, whether or not he had consulted the works of pioneering psychologists such as Katz, as

82
Interior 1936
Oil on hardboard
60.6 × 46.4
National Gallery of Art,
Washington
Gift of The Mark Rothko
Foundation, Inc.

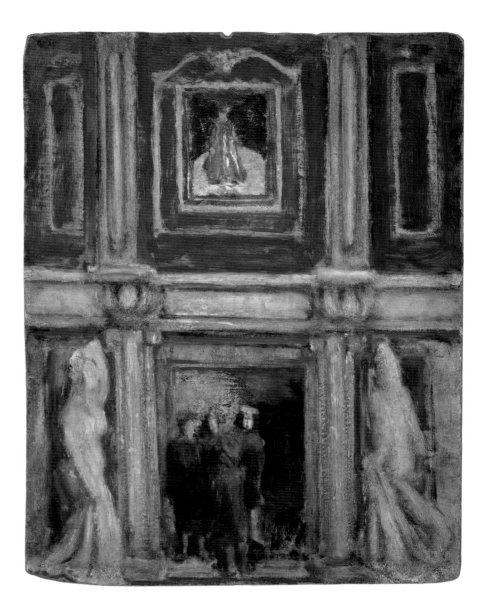

83
Red on Maroon [Seagram Mural] 1959
Oil on canvas
266.7 × 457.2
Tate

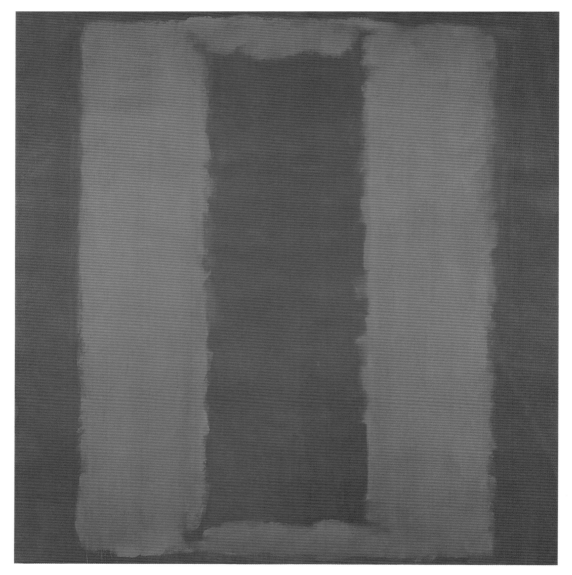

84
*Untitled [Seagram Wall
Sketch]* 1958
Oil on canvas
266.1 × 252.4
National Gallery of Art,
Washington
Gift of The Mark Rothko
Foundation, Inc.

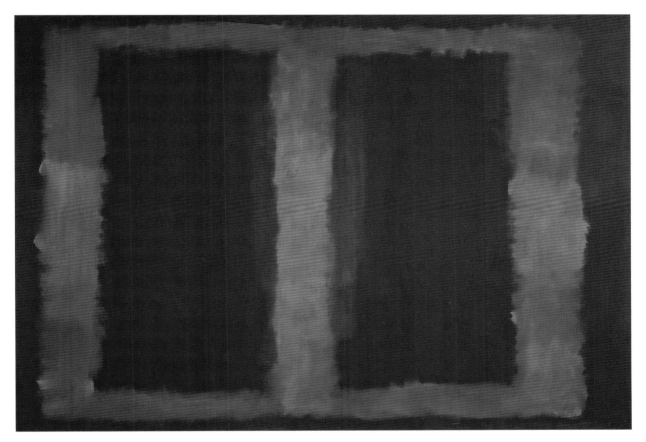

85
Sketch for 'Mural No.4'
[Seagram Sketch] 1958
Oil on canvas
265.8 × 379.4
Kawamura Memorial
Museum of Art, Chiba-Ken

suggested by Seitz and more recently by John Gage. The effect in the Seagram murals is related to a 1939 painting of a subway entrance, in which Rothko keenly observed how the dark interior of the subway entrance frames and contains the rectangle of daylight, making it look simultaneously opaque and infinite (fig.86). The wall of the entrance to the subway forms an aperture like the openings in the Seagram murals.

The tempera studies on paper for the Seagram murals reinforce this impression. These friezes pulsate with light and dark as Rothko dilates and contracts the aperture. This results in the lateral transformation of forms in the entire ensemble, causing them to expand and shrink without rest in the eyes of the observer.

Rather than marking an abrupt change in Rothko's work, the Seagram murals are part of a continuum of thought and experimentation that dates back to the beginning of his career. His paintings were the product of a philosophical understanding of the way in which the mind comprehends space. With the environmental arrangement of the Seagram murals, however, Rothko placed even greater emphasis on the viewer's physical as well as perceptual participation. To experience the classic Rothko painting, the viewer stands transfixed at the painting's centre. The Seagram mural frieze as planned for the Four Seasons, however, would have required the viewer to scan the paintings from one end of the grouping to the other. Moreover, the diners at the Four Seasons would have looked at the paintings from a seated position. Raised approximately four feet off the ground, the canvases would have hovered slightly above them. The installation of these paintings in the 1961 retrospective at the Museum of Modern Art and at the Whitechapel Art Gallery underscores Rothko's intention. Although the canvases were not abutted to one another, Rothko grouped them in the exhibition in terms of related colours, 'according to their best effect upon each other', so that they would create a complete environment.[13] The neighbouring paintings would always intrude on the viewer's peripheral vision.

Rothko's experience with the Seagram murals and with the installation of his paintings for his retrospective influenced his scheme for his second mural commission, offered by Harvard University in Cambridge, Massachusetts. The commission, which he received in 1961, was for the penthouse of the university's Holyoke Center (fig.87). For this room, which was to be used by the Society of Fellows of Harvard College, Rothko produced five monumental panels – a triptych and two related canvases. The murals repeated the composition of the Seagram murals, with the addition of a notch at the top and bottom of the vertical form, which created the illusion of a colonnade. These verticals read like columns from Classical architecture rather than as exposed stained ground because their contours are painted with a sharper line than the soft-edge apertures of the Seagram murals. The colonnade itself harks back to Rothko's early subway paintings with the frieze-like arrangement of metal supports.

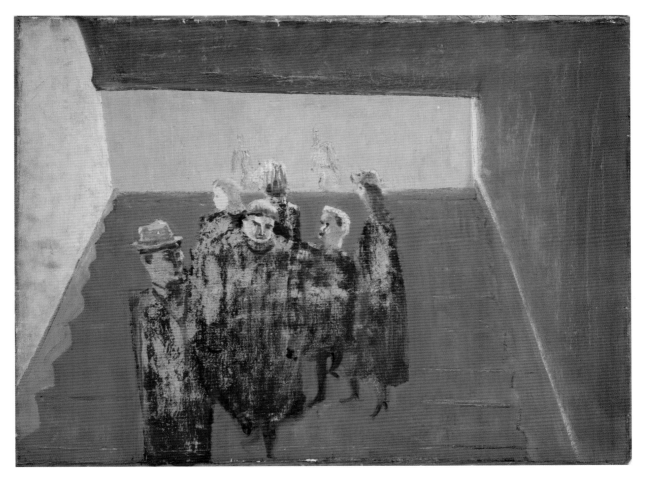

86
*Untitled [Subway
Entrance]* 1939
Oil on canvas
61 × 81.3
Collection of Kate Rothko
Prizel

The colours continued the dark hues of the Seagram paintings with their deep crimsons and blacks, but did not repeat the fiery oranges. (The colours of these paintings have faded considerably over the years due to exposure to light and the properties of the paint Rothko used.)

Rothko created a few related drawings using crisp lines to delineate the notched Harvard mural motif. Not since his Surrealist period had he used line to define his forms. His painting on paper executed in the late 1950s are in his classic format and, like the canvases, the shapes are soft-edged, without any defining linear elements. Even the tempera studies on coloured construction paper for the Seagram murals were not drawn with lines. The drawings he made in the early 1960s, however, are distinguished by his use of line to create contour and space (fig.92). In addition to these, Rothko produced a group of tempera works on coloured construction paper as studies for the Harvard murals (fig.88). Most are characterised by the sharp contour of the column shape and demonstrate Rothko's concentration on controlling the density of the vertical shapes by varying their widths. In one of the tempera studies, Rothko cut a piece of construction paper into the shape of the verticals, using paper that was the same mulberry colour as the background, then glued the cut-out verticals on top of the large black shape painted on the underlying paper. He softened the edge of the cut-out slightly by brushing the edges and the notches at top and bottom with the same black paint as that used for the large form. Not only does the collaged paper sharpen the edge of the forms, but it also literally projects slightly forward, since the paper is glued on top of the dark form. In the murals, Rothko used contrasting colours for the shapes, which make the verticals project as columns. Gestalt psychology demonstrates that the mind can only recognise an ambiguous image one way at a time; it is this phenomenon that causes a perceived reversal of positive and negative forms. If one sees the dominant painted forms in Rothko's Harvard murals as solid, then the verticals look like voids. Conversely, if the eye concentrates on the openings and allows the darker areas to recede as shadows, then they appear as solid columns.[14] By abutting three of the Harvard canvases to form a continuous frieze, Rothko created a pattern of light and dark that fluctuates laterally.

Rothko continued to explore the uncanny effects of the Harvard murals in a little-known series of black paintings from 1964, which are in turn related to his last major commission, the Rothko Chapel in Houston, Texas. In these 1964 canvases, he painted a large black rectangle surrounded by another black area (fig.89). It is not clear when he began this series, but there is a photograph by Hans Namuth of him in the summer studio he rented in Amagansett, New York, in 1964, which features one of these works. We initially perceive these paintings as a black rectangle on a black field. Upon closer observation, however, it is revealed that the forms are two distinct areas on the same plane, separated by a well-defined edge, rather than a figure on a ground. The

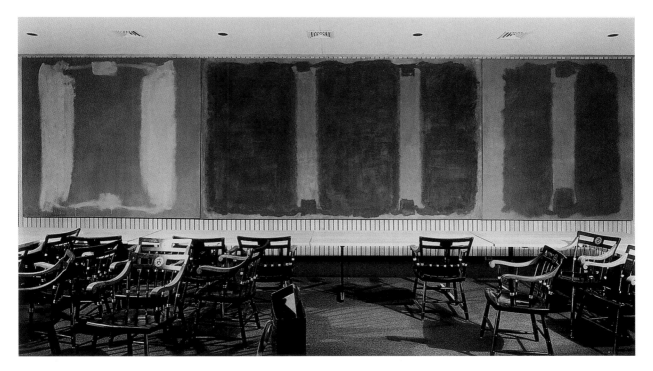

87
*Harvard Murals
Installation, Panels One,
Two and Three*
Holyoke Center, Harvard
University

88
Untitled 1961
Tempera and collage on
coloured construction
paper
17.8 × 30.8
Harvard University

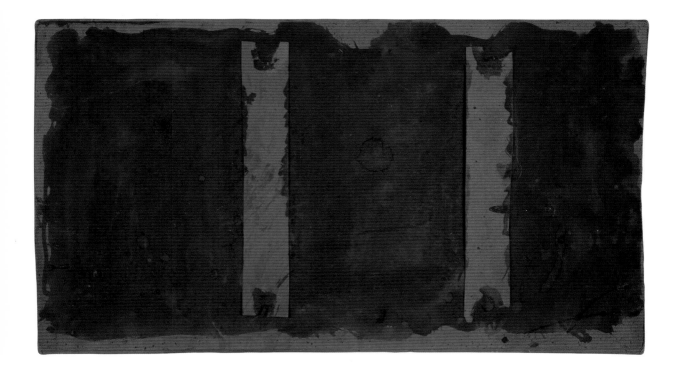

89
No.2 [Black on Deep
Purple] 1964
Oil on canvas
266.7 × 203.2
Collection of Robert
Meyerhoff, Maryland

rectangle asserts itself as the subject because it is a self-contained form that can be comprehended as a complete shape. The surrounding area is more difficult to understand as an irregular form because its narrow top and sides function like a border for the central rectangle, while its larger bottom portion competes for attention with the rectangle. The pigment in this work was applied fairly flat, with minimal variation thereby minimising the atmospheric effect of the classic paintings. Rothko maintained a tactile quality, however, by giving the central rectangle a glossy finish that projects it forward in space, and the surrounding area a matte surface that causes it to recede.

Although these paintings are uniform in their darkness, the undercoats are in stains of hot magenta, plum or ochre. The longer the viewer stands before them the more the vibrant hues buried beneath the black areas shine through. Although the border separating the rectangle from the surrounding area is a hard edge, created with a rule or tape, the two black forms barely touch, and a slight aura of the underlying colour radiates around the rectangle. Moreover, these works can only be experienced in person, not in reproduction, since the energy between the blacks and the brightly stained canvas underneath are generated gradually in the viewer's eye. Rather than seeing these forms as figure and ground, the viewer tends to become consumed by the infinite dark space.

The monochrome paintings of 1964 are often seen as another abrupt departure for Rothko. However, the way in which he concentrated on the slight gap between the two black forms is similar to his manipulation of the apertures in the Seagram murals. For example, *Mural for End Wall* 1959 (fig.90), with its combination of deep wine and bright orange, operates like the monochrome paintings with their magenta and plum auras. In the Seagram murals the deep wine colour that forms both the border and the central rectangle seems to be compressing the light that emanates from the orange between them, much as the two blacks in the later monochrome works allow the light generated by the magenta or plum stains to squeeze through the slight gap surrounding the central rectangle. One of the main differences between the works in these two series is the width of the aperture, which is formed in the Seagram mural by the wide border and central rectangle that regulates the orange band, and in the monochrome paintings by the two black rectangles that allow only the slightest amount of light to escape between them. (Another distinction is that the orange is painted over rather than under the dark field.)

These monochrome paintings are often compared to Ad Reinhardt's black canvases of the early 1960s. Reinhardt had been painting hard-edged, geometric abstractions with close-hued colour relations since the 1950s. By the early 1960s, he limited his palette to a darker spectrum of colours, producing what appear to be black paintings, although they were in fact composed of quadrants of contrasting hues. The longer viewers look, the more obvious the contrast between the hues

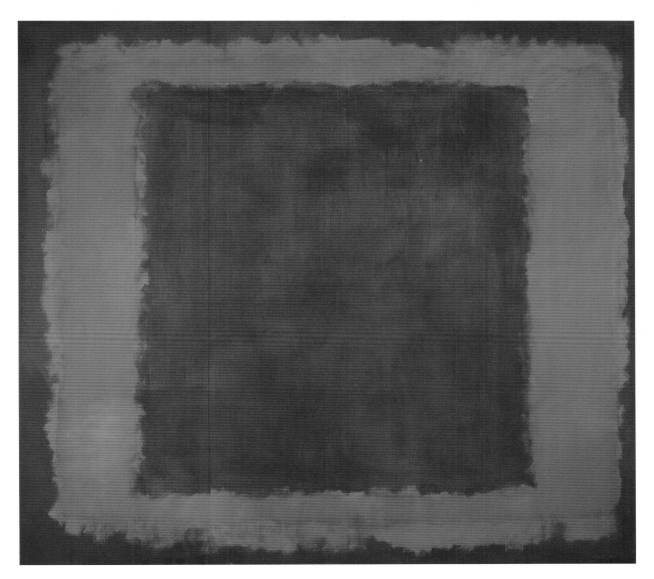

90
*Mural for End Wall
[Seagram Mural]* 1959
Oil on canvas
265.4 × 288.3
National Gallery of Art,
Washington
Gift of The Mark Rothko
Foundation, Inc.

becomes. Although competition with Reinhardt may have accelerated Rothko's development of his monochrome paintings of 1964, they could just as easily have been the natural conclusion of his own experimentation and observations, as we have seen. It is hard to ignore, however, that these monochrome paintings parallel the emergence of 'hard-edge' painting as a characteristic of the New York School in the early 1960s. Sheldon Nodelman described 'hard-edge' as the style of the moment, which 'was widely espoused by younger generation artists, and many – including some established figures of the older generation – abandoned their Abstract Expressionist composition and brushwork in favor of it or other currently fashionable alternatives.'[15] Nodelman also stated, 'Even Newman, beginning in the early sixties, exchanged the relatively loose edges and subtly variegated surfaces of his paintings for sharply ruled edges, even rendering, and pure poster-like colors and maintained this new manner consistently hence forward.' Nodelman also suggested that in using hard edges in the monochrome series, Rothko 'could be seen as "modernizing" in response to current developments, demonstrating his mastery over the preferred means of expression of his younger contemporaries, and indeed outdoing them in the virtuoso use of it.'[16] By opting for the hard-edge painting that was in vogue, Rothko 'aligned himself – consciously or not – with a more radical modernist conception of the relation between artist and work than the reactionary Romantic one that

Abstract Expressionist ideology had asserted.'[17]

The similarity between Rothko's work and that of some of the younger generation in the 1960s might also be explained by the fact that both Rothko and the younger artists were pursuing a similar investigation into perception as a means of making viewers self-aware. As stated earlier, it is clear from Douglas MacAgy's 1949 article in the *Magazine of Art* that Rothko considered the early twentieth-century advances of science and perception essential to the philosophical position he advanced in his late multiforms. As Seitz noted, the interest in phenomenology and Gestalt in understanding perception was widespread among New York artists in the early 1950s. These principles had become part of the curriculum for a new generation of art students and artists, including Roy Lichtenstein, who studied with the pioneering educator in perception, Hoyt Sherman, at Ohio State University. Princeton University (where artists Frank Stella, Carl Andre and Walter Darby Bannard, as well as art critic Michael Fried were students in the mid-to-late 1950s), had a perceptual studies programme similar to Ohio State University's. Moreover, Seitz was an influential teacher at Princeton during this time, when his research for his dissertation on the Abstract Expressionists was still fresh.[18]

Stella, in particular, was intrigued by the perceptual characteristics of painting. Although he did not attend courses on phenomenology, he remembers long conversations with Bannard on the subject

while they were in Princeton.[19] In his first important series of paintings comprised of alternating black and white stripes, which he painted in 1958–9, shortly after graduating from Princeton, Stella followed the principles of perceptual unity by creating a symmetrically arranged image that could be observed in a flash (fig.91). Writing in the 1990s, he described his desire to depict space that is understood in terms of 'ordinary vision' rather than the pictorial conventions of 'artistic vision'.[20] (These distinctions are similar to the tactile and illusionary space Rothko described in *The Artist's Reality*; see pp.74, 77–8.) In his famous statement 'What you see is what you see',[21] made in a radio interview in 1964, Stella was not only suggesting that his compositions were meant to be seen as single, self-contained objects, he was further pointing out that his work dealt with perception. His statement could be rephrased as: what you see is *how* you comprehend what you see.[22]

Stella's black stripe paintings are often described in terms of formalist criticism rather than perceptual response. Critics chose to characterise these paintings as the artist's effort to flatten the picture plane. Stella, however, was thinking about Newman's zip paintings when he painted the stripe series.[23] As he wrote: 'In the end, it was left to Barnett Newman to break definitively with easel painting and to account finally and determinedly for the emergent binocular vision of twentieth-century abstraction. The marvelous thing about this is that through the magic of abstract art we can almost digest this space as one experience, with one stare.'[24] Newman accomplished this feat because of the ability of his stripes 'to attach themselves to and into the background. They fit beautifully, zipping the space together.'[25] Stella's alternating black and white stripes also act as contained spatial fields of light and darkness. Although from a distance they look like hard-edge paintings, the lines are in fact not sharp. The black paint blends into the white pin stripe, causing a vibration that keeps the painting alive. Sandwiched between two black stripes, the narrow white lines glow with light; conversely, a black stripe viewed as contained between two white lines becomes a dark space. The ruled edges contribute to the spatial reversals of dark and light, as in the verticals of Rothko's Harvard murals. One of Rothko's drawings that is contemporary with the Harvard murals uses a concentric-stripe pattern in the top rectangle, much like Stella's paintings at the time (fig.92). Despite the similarity, Rothko seems to have used the lines to suggest layers of space rather than to attempt to replicate the scheme of Stella's works. The contrast of reflective and matte surfaces, which is seen in Rothko's monochrome series, was also an important element in Stella's metallic paintings, which followed the black and white stripes series. The metallic pigment creates a sheen that reflects ambient light and therefore literally exists in the viewer's space, whereas the white lines are the matte, raw canvas.

Rothko is categorised art historically as an Abstract Expressionist working in the romantic tradition, and Stella is considered a

Minimalist who was primarily interested in the formal problems of modernism. These categories have begun to disintegrate as a broader approach has been applied to their works. Whether or not Rothko was interested in Stella's paintings is not the point here. Both artists were influenced by the ideas about perception and pictorial issues that were current during their time, and both followed philosophical pursuits based on real vision rather than illusionary space created through linear perspective. Each recognised the conflict between the objective vision of what one sees with the subjective response to the space created by the colours and forms. These parallel interests led Rothko and Stella to place greater emphasis on the relationship between their paintings and the viewer.

Perhaps the greatest similarity between Rothko's perceptual approach to his paintings and that of the next generation of artists can be discovered on the West Coast of the United States. Robert Irwin, in California, believed that the isolation and naiveté of artists on the West Coast made it possible for them to look differently at work by the first generation New York School. The second-generation artists in New York, he suggested, were fixed in their belief that Abstract Expressionist paintings traced the 'artist's existential confrontation with his own reality'.[26] One of the first shows held at the Ferus Gallery in Los Angeles, in January 1960, was *Fourteen New York Artists*, which included Rothko. In Irwin's opinion, 'Los Angeles in 1960 offered a vacuum into which these stray crystals were able to fall and then form, in unique ways.'[27]

91
Frank Stella
The Marriage of Reason and Squalor II 1959
Enamel on canvas
230.5 × 337.2
Museum of Modern Art, New York
Larry Aldrich Foundation Fund

92
Untitled 1961
Pen, ink and pencil on
wove paper
28 × 21.7
National Gallery of Art,
Washington
Gift of The Mark Rothko
Foundation, Inc.

Initially, Irwin saw the gesture of Abstract Expressionist painting as its subject, but his appreciation for artists such as Rothko changed as he began to develop his work according to 'its own physicalnessand how that physicalness was experienced perceptually.'[28] As he noted, the West Coast artist 'worked in the domain of perception'.[29] These initial experiments were based primarily on his observations of Abstract Expressionist painting and his own experimentation. James Turrell, however, studied experimental psychology at Pomona College, near Los Angeles, and provided Irwin with a scientific basis for his work when the two artists collaborated in the Art and Technology Program at Los Angeles Country Museum of Art in 1968. Their notes for this collaboration are similar to the philosophical position that Rothko set out for himself in the late 1940s. For example, they wanted to allow 'people to perceive their perceptions. We've decided to investigate this and to make people conscious of their consciousness'.[30] One of the experiments conducted by Irwin and Turrell was to place volunteers in a dark chamber, in which they were totally deprived of sound and vision. Irwin described the results as follows:

When you're in a space having no visual or audio input, which are the two primary senses, you tend to begin taking in more information through the other senses. You start spending more time making a tactile read, building your world in that black, soundless space with information from those other senses, so that when you come out, that shift simply persists for a while, it continues to be honored, and you take in different degrees of information. And we all know that the complexity out there is we might as well say infinite.[31]

Turrell understood the illumination and space illusion in Rothko's paintings and aimed to make them concrete in his lightworks from the late 1960s. In *Rayzor* 1982 (fig.93), for example, Turrell constructed a small wall in front of a larger wall. The fluorescent lights installed behind the small wall creates an aura that radiates toward the viewer, causing the small wall to recede into a dark space.

In 1968, while Irwin and Turrell were making their perceptual discoveries with their dark chamber, they were unaware that Rothko had just completed his murals for the Houston Chapel, with similar results. Houston art patrons John and Dominique de Menil had approached Rothko in 1964, at the urging of Douglas MacAgy, to invite him to create murals for a chapel that they were building at the University of St Thomas. For this octagonal building, initially designed by Philip Johnson, Rothko planned five, large, single panels and three triptychs in a dark palette of black, mulberry and plum. Rothko had previously used the triptych arrangement for the Harvard commission, however, in the context of the Chapel the triptychs raise associations with church alters. Rothko, in fact, informed Dominique de Menil that he had been inspired in his conception of the Chapel by his memory of the twelfth-century basilica of Santa Maria

93
James Turrell
Rayzor 1982
Installation at
Center on Contemporary
Art, Seattle

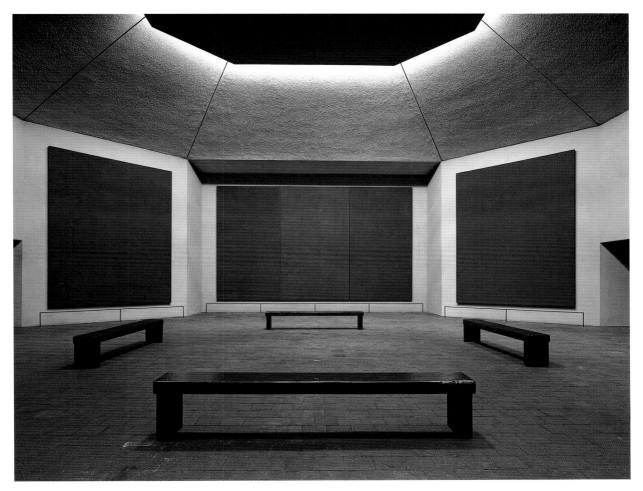

94
*The Rothko Chapel,
Houston, Texas. North-
west, North, and North-
east Paintings* 1965–6
Oil on canvas
Menil Collection, Houston,
Texas

95
*The Rothko Chapel,
Houston, Texas. South,
Southwest, West Paintings*
1965–6
Oil on canvas
Menil Collection, Houston,
Texas
[Photographed before
renovation]

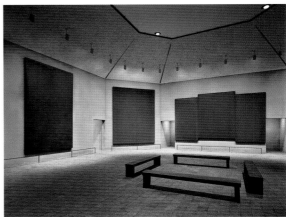

Assunta on the island of Torcello, in the Venetian lagoon, which he had visited a few years earlier. At one end of the basilica is an enormous mosaic of the Last Judgment, and in the half-cupola of the facing apse is the Epiphany of Virgin and Child.[32] Rothko had considerable control over the architectural design of the Chapel (a situation that caused Johnson to leave the project, replaced by Howard Barnstone and Eugene Aubry). The octagonal plan suggested the traditional design of Early Christian Baptistries (fig.94).

As Nodelman pointed out in his book on the Chapel, the initial impression of the murals is of an overall darkness. At first, all the paintings look completely monochrome. This is due in large part to their contrasting relationship with the lighter surface of the walls of the interior, which became an integral part of the Chapel scheme.[33] The paintings are not as dark and monochrome as they at first seem, however. The single panel on the south entrance wall and the east-wall and west-wall triptych continue the format of the monochrome paintings of 1964: a single, hard-edge rectangle surrounded by another form (fig.95). Here, however, the black rectangle is so large and dominant that it seems to fill the entire canvas. On the south entrance wall panel the surrounding area is a dark red, and on the west-wall triptych, a dark mulberry. These slight contrasts in colour become more visible the longer one looks at them.

The apse triptych and remaining panels take up an unprecedented, single-form, monochromatic composition. Here, the pigment is stained into the fabric itself. The woof and warp of the canvas modulates their plum tones, creating a subtle atmospheric effect that becomes more apparent when viewed without the contrast of the white wall. As Nodelman observed, despite the apparent differences, the atmospheric quality of these single-form monochromes links them to the classic Rothko works of the preceding decade.[34]

When a single work is viewed in a rectangular room, the paintings flanking it interfere with the viewer's peripheral vision. This situation distorts the neighbouring paintings through foreshortening; consequently, the viewer learns to concentrate on a single painting and ignore the interference of nearby works. One of the problems that Rothko had previously encountered in his exhibitions was the distraction of views through doorways. (Goldwater, for example, commented on how at the MoMA retrospective, the rooms containing paintings of a related palette were disrupted by the unavoidable glimpse of a dissonant work in another room.) The octagonal plan of the Chapel, however, was an ingenious way of creating a new, active viewing experience.

As Nodelman has remarked: 'The octagon space, in contrast to the familiar rectangular room in which we are accustomed to see paintings, provides a "wraparound" viewing situation overtly centered upon the observer.'[35] It protects the cohesion of the murals by thwarting views into the outside space. Nodelman also noted that the angling

of the Chapel walls bends the peripheral zone into a more frontal relationship to the eye, 'so that its contents are more assertive perceptually and cognitively more intelligible.'[36] The intimate scale of the Chapel makes it 'impossible for the viewer to find a satisfactory viewing position that does not at the same time include, at minimum the target of focus, the adjacent walls to either side and the penumbra beyond.' The deep doorway passages also add true shadow and depth to the illusionistic space of the murals. Rothko constructed a full-size replica of a portion of the space in his New York studio so that he could examine the relationship between the paintings and the structure while working on them. He would not live to see them installed in the Chapel itself.

Nodelman came to the conclusion that the paintings for the Chapel are not separate pictures in the traditional sense, because Rothko made certain that they cannot be seen one painting at a time. In this dynamic space, 'the viewer's experience is one of a continually unfolding event'.[37] As the viewers scan the room, they discover a pulsating effect caused by the variations in the proportions of the central black rectangles, which make the dark space in each painting look as if it is shrinking or expanding in relation to the surrounding margin.[38]

In his plan for the Chapel, Rothko succeeded in fully integrating the viewer into his work, and, as Nodelman pointed out, the paintings force viewers to test with their bodies and minds their understanding of the literal and illusionistic space of the architecture. 'The visitor', he suggested, 'becomes aware of himself or herself not as passive spectator but as a determining factor in the installation'.[39] In Rothko's classic paintings, forms grow and vibrate within each canvas. By 1961, as was suggested by his instructions for the installation of his retrospective at the Whitechapel Art Gallery, he was clearly interested in allowing his paintings to react upon each other. In the Rothko Chapel murals, this energy is deliberately generated in relation to the entire ensemble as well as within the discrete borders of each canvas.

Nodelman also suggested that the spatial effects in the Chapel were created through a complex system based on perspective. Viewers accustomed to the conventions of linear perspective would sense that the black rectangles that filled almost the entire canvas, leaving just a narrow border, appear closer than the smaller rectangles on panels with wider borders. In traditional paintings based on perspective, all the objects in the work are fixed in relation to each other and to the viewer. Viewers project themselves imaginatively into this fictive space and comprehend the size and distance of these objects in relation to their own body. Based on Nodelman's reading of Rothko's paintings in terms of perspective, the experience of space in the Chapel is different from the conventional use of perspective. As the space created by each painting seems to twist the actual dimensions of the Chapel,

viewers are constantly shifting their relationship to the paintings. At one moment the space is close, at another it is far away.[40]

The perspectival reading of the Chapel is difficult to avoid if the viewer perceives the rectangles as a figure on top of a ground. However, if one looks at the surrounding border as an aperture containing the black field, the effect is different. As in his classic paintings, the borders in Rothko's Chapel murals regulate the colour in the central area, transforming it into a palpable filmic colour. In the case of the Chapel's monochrome paintings, the white wall itself becomes the framing element that modulates the atmospheric colour. The dark red or mulberry borders of the black, hard-edge paintings are in a matt finish that makes the field recede, while the glossy finish of the black rectangles reflects light into the viewer's space, so the rectangles seem closer to the eye, a contradiction to the rule of perspective which holds that dark colours recede. Nodelman observed that the result of this exchange between forms is the sensation of 'an unfamiliar uncanny sort, both inviting and forbidding entry, invading the "real" space of the chapel to envelop the spectator while dilating the boundaries of that space into an ambiguous and vaguely menacing beyond.'[41]

Bearing in mind that Rothko told Dominique de Menil that he admired the basilica of Santa Maria Assunta, with its mosaic of the Last Judgment, one might think here of the dark abyss, the gaping mouth of hell, represented in medieval Last Judgment scenes. In the Chapel a dark abyss is created in the unfathomable realm of the triptych on the west wall (fig.95) through the large black rectangles surrounded by deep red borders. In contrast, the monochrome paintings without painted borders appear to expand outward and beyond, puncturing the walls and opening the space of the Chapel to a view of infinity and the unknown (fig.94).

Rothko worked almost exclusively on the Chapel murals from 1964 to 1967. On New Year's Day of 1966 he expressed to the de Menils his appreciation for the opportunities that the Chapel commission had provided him: 'The magnitude, on every level of experience and meaning, of the task in which you have involved me, exceeds all my preconceptions. And it is teaching me to extend myself beyond what I thought was possible for me. For this I thank you.'[42] The Chapel murals represent the most complex expression of his desire to create paintings about pictorial space based on a philosophical position. By controlling the entire environment and limiting the visual input to low-value hues, Rothko succeeded in creating a situation in which viewers could constantly test and think about what they saw with their eyes and felt with their bodies in relation to the real and illusionistic light and space of the Chapel. In order to resolve this conflict, the viewer has to select one space intuition or the other as a test of reality. As in the experiment with the dark chamber conducted by Irwin and Turrell, this experience eventually leads the

participant to a heightened sense of awareness as the mind penetrates the dark spaces of the black rectangular panels and drifts into the infinite light of the monochrome paintings.

In May 1968 Rothko suffered an aneurysm of the aorta. In his weakened state, his doctors recommended that he restrict his paintings to a maximum of forty inches in height. Nevertheless, he could have had his assistants continue to help him paint large canvases, just as they had for the Chapel. Instead, he chose to work almost exclusively on a smaller scale on paper, using fast-drying acrylic paint (fig.96). His works on paper from 1968, however, should not be considered miniature versions of his classic canvases. Goldwater reported that despite the paper's small scale, Rothko 'saw them as big, both in their effect and in their possibilities, and in discussing them he returned constantly to this question of their implicit size.'[43] In the large canvases, the forms fill the viewer's entire field of vision, whereas in the small works on paper the shapes dominate the work in a manner comparable to his expressionistic paintings in which figures loom large in comparison to the field. The forms in the large canvases are not perfectly symmetrical and Rothko allowed drips and other variations to activate the surface. The large scale, however, disguised these inconsistencies. Rothko took a different approach with the small works on paper. The forms are more precisely centred, and unlike the canvases, which are covered with several thin layers of paint, typically only a single colour is applied on top of the stained paper. With their symmetry, tidy execution and minimal gesture, the small works on paper seem more quintessential Rothko than many of his canvases.

During the summer months of 1968, Rothko set up his studio in the seaside town of Provincetown, Massachusetts, where he began a series of works on paper consisting of combinations of brown and grey acrylic paint (fig.97). In these works, he divided the vertical sheets of paper into two horizontal areas, painting the top space brown with minimal inflections and the bottom area in vaporous grey tones. They were executed on large sheets of paper, averaging 60 by 48 centimeters.

Although the colour combination of the brown-and-grey works is unprecedented in Rothko's classic paintings, he had gravitated to these hues in the late 1930s. Unlike his classic paintings, most of the brown and grey works are framed by a white border created by the masking tape he used to attach his paper to his easel. This created a crisp white edge around the image, which must have appealed to him, for it became a characteristic of his late works. Even if its origin in the brown and grey works on paper was serendipitous, it became a deliberate part of the composition in the related black and grey canvases. Rothko's experience with the Chapel murals provides some clues as to why he incorporated the hard-edge white border into these paintings. In the monochrome Chapel murals in particular, the white wall forms an aperture around the

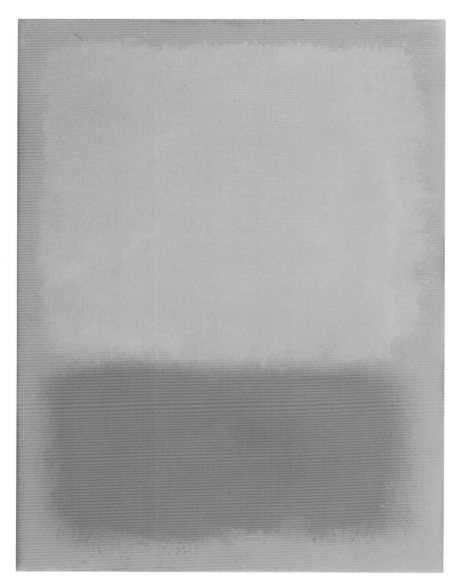

97 (opposite page)
Untitled 1969
Acrylic on paper
183.1 × 122.4
Collection of Christopher
Rothko

96
Untitled 1968
Acrylic on paper mounted
on Masonite
60.8 × 45.4
Museum of Modern Art,
New York. Gift of the Mark
Rothko Foundation, Inc.

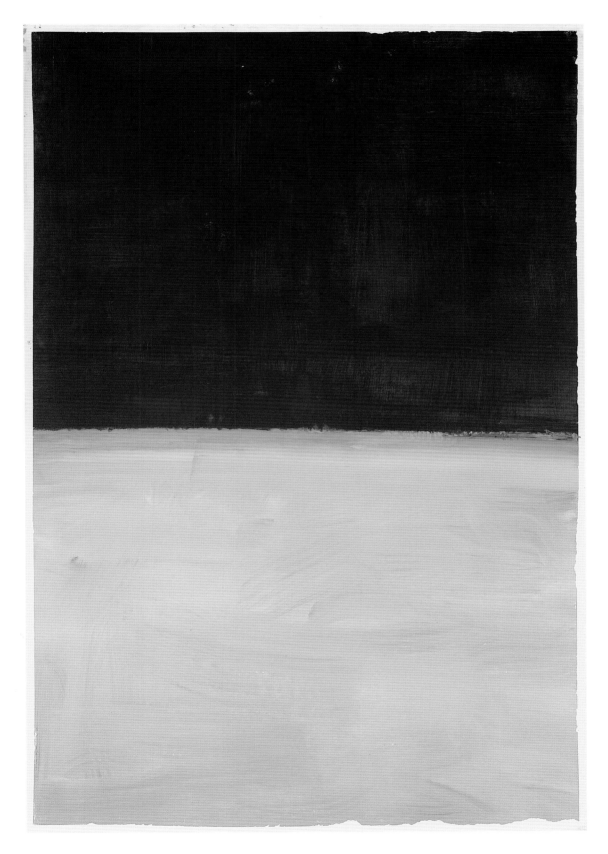

canvas that modulates the illumination of dark space in the paintings. The white edges of the works on paper and related canvases create similar hard-edge apertures.

The sharp edge, then, was not novel in Rothko's work. It was a further exploration of the framing that typifies the black monochrome series of 1964 and the black rectangle paintings for the Chapel. There are two major differences between these earlier paintings and the brown and grey works: the line has been pushed all the way to the painting's edge, and Rothko has added a horizontal division of the two colours in place of the single, centred monochrome form. In this sense, these paintings revisit the compositions of two dominant forms that Rothko had explored in the early 1950s (fig.75). Rather than allowing the two forms to fight for domination, as in the earlier paintings, however, he created a stasis in these later paintings by firmly anchoring them to the surrounding white edge.

The brown and greys and black and greys are often erroneously perceived in relation to landscape painting because of the suggestion of a horizon line. The white edge, however, limits the expansion of space at the perimeters. Rothko condensed the spatial and perceptual oscillation created by the murals and architecture of the Chapel within the confines of each of these works. If one focuses on the top, minimally modulated area, the experience is of dark space. The effect is reversed when attention is devoted to the bottom region, where the light expands toward the viewer. Because the line separating the two areas is so well defined, it also competes for the viewer's eye. Drawn to this 'horizon', the viewer imaginatively travels into infinity. The white edge of these works, especially in the case of the canvases, becomes indistinguishable from the white wall. As a result, the paintings seem to puncture the wall, opening it to the space beyond. This brings to mind Rothko's window paintings of the late 1930s in which the painted facade is the continuation of the wall supporting the canvas (fig.18).

Unlike his oil and mixed-media paintings of the 1950s and 1960s, which were painted on a coloured prepared surface, the black and grey canvases are executed in acrylic on a white ground (fig.98). The way in which the white paper of the brown and grey works provided an inner glow may have inspired Rothko to harness this light-generating effect in his black and grey canvases by painting on the white surface. He showed these works to visitors to his studio with great enthusiasm, anxiously awaiting a sign of approval. He even held a party in his studio in December 1969 to unveil them to his friends and colleagues. When Dore Ashton first saw the brown and grey works, she recalled that Rothko 'named the exact number with pride, as though to say "with all my trouble I was able to do this".'[44] During Irving Sandler's last visit to the studio, Rothko expressed concern over whether people realised that the white border was part of the composition.[45]

Rothko did not devote himself

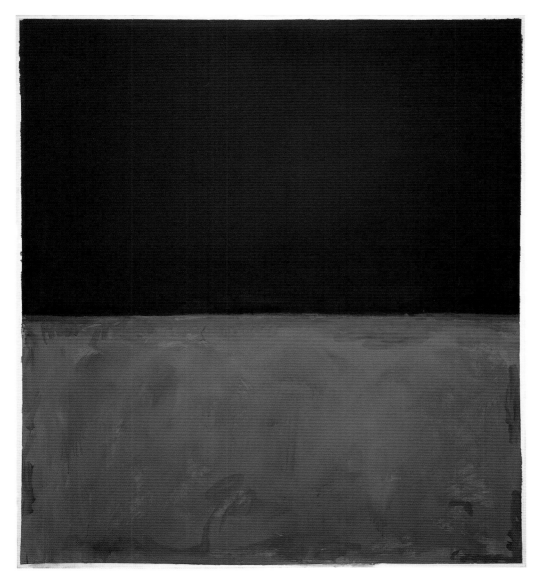

98
Untitled [Black and Grey]
1969
Acrylic on canvas
176.9 × 157.8
National Gallery of Art,
Washington
Gift of The Mark Rothko
Foundation, Inc.

exclusively to grey paintings during the last years of his life. He produced a number of works on paper in delicate tones of pale blue, mauve, and mustard yellow, which Jeffrey Weiss observed share a palette and pictorial structure with Alberto Giacometti's paintings that were exhibited at Sidney Janis in late 1968, and which Weiss contends Rothko undoubtedly saw.[46] Some of his richest colour orchestrations appear in a number of works on paper from these years. Velvety black and bottle-green rectangles eclipse the radiant blue field in *Untitled* 1969 (fig.99), while brilliant orange slashes and a sizzling yellow strip make another work on paper of the same year shine with blinding light. These late, vibrant paintings on paper contain a force created by the inks that illuminate the paper's field, an effect not experienced in his earlier works on paper. With their dense, unmodulated surface, they do not flicker with the atmospheric light of the classic paintings; rather, they generate a strong, constant glow. In these works, Rothko seemed to be searching for ways to bring more light into his paintings, even when dominated by a dark palette.

Rothko reintroduced bright colours to his canvases for the first time since the early 1960s. One of these canvases was inspired by the dark, greenish-black and brilliant-blue works on paper. Rothko attempted to duplicate the effect of the light in these works by painting dark green and black over bright blue. Once again, the white primer he used on his canvas contributes to the overall radiance of the painting. In a canvas

unfinished at the time of his death, Rothko made an attempt to capture the glow of the brightly coloured works on paper by painting reds over a white ground. The overpainting is so thinly applied that the white ground breaks through the pigment, causing the monochrome to divide into two repelling areas of red (fig.100).

As previously stated, many writers have succumbed to the romantic interpretation that the brown and greys and black and greys were the creation of a depressed and suicidal artist. This only serves to trivialise Rothko's work. In order to experience his paintings fully, it is essential to view them, as he advised, without mediation. He always contested the attempt by critics and historians to categorise his work. Limiting his paintings to the art-historical period of Abstract Expressionism impedes the recognition that he continued to develop his ideas on perception and space in his work until his death in 1970, and that his investigation paralleled the interests of the subsequent generation of artists. As Arthur Danto recently stated, he was a pioneer in the perceptual work that defined much of the art created from the late 1960s to the present.[47] Nodelman, without knowing that Rothko was, indeed, interested in space intuition, demonstrated that the Rothko Chapel succeeded in eliciting a complex perceptual response from the viewer. The time was ripe for a perceptual reading of Rothko's work. Nodelman's sensitivity as a viewer may have been conditioned by his own experience, for at the time he was researching and writing

99
Untitled 1969
Acrylic and ink on paper
135.3 × 107.2
Museum of Modern Art,
New York
Gift of The Mark Rothko
Foundation, Inc.

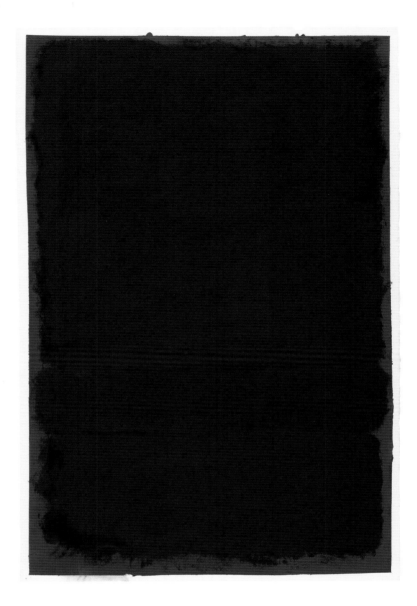

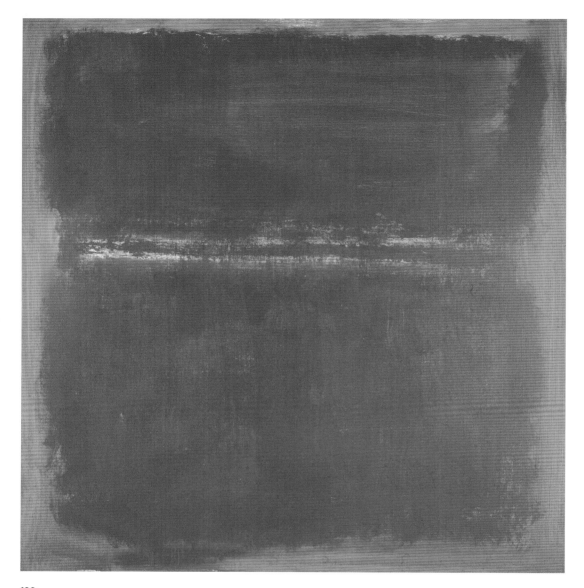

100
Untitled 1970
Acrylic on canvas
152.4 × 145.1
National Gallery of Art,
Washington
Gift of The Mark Rothko
Foundation, Inc.

his book on the Chapel, he was teaching at the University of California, San Diego, where Irwin had a strong presence that included the installation of a major site-specific work, *Two Running Violet V Forms* in 1983, based on his studies of perception and the viewer's understanding of light and space. It is not surprising that among the first observers to comprehend that the light and spatial qualities of Rothko's work paralleled those of Irwin and Turrell was the Italian collector Giuseppe Panza di Biumo, who not only owned major dark paintings by Rothko, but was also an early collector and patron of Turrell. Panza wrote in 1985 that:

Among the emerging New York painters in the 1950s, Rothko was the one most concerned with light. Usually, the illusion of light's existence on the flat surface of the canvas was given with the differences between bright and dark colours. Rothko was able to achieve an even stronger feeling using only very dark colours. In the almost black paintings of the Rothko Chapel in Houston, the light became a psychological condition of the mind. Lost almost completely was any reference to something we can see with the eyes.[48]

Rothko was not interested in the push-pull of space and colour for its own sake. The drama consisting of a battle of forms contained by a momentary stasis presented, in purely abstract form, the mythic conflict between Apollo and Dionysius that was fundamental to his philosophical position.

When he declared to Seitz that he was not concerned with colour or space, he was referring to their formal arrangement. The linear perspective of space invented during the Renaissance was the measurable empty area between objects. In his classic paintings, space influences the experience of colour and light, making it into a palpable object or thing that acts through its own volition in relation to the viewer.

Rothko was insistent that it is not enough to react to his work in terms of how it is painted or the space created in the coloured areas. One must ask, what does this space mean? His paintings were the product of thought, and they forced a new self-awareness on viewers, who must constantly test their understanding of what they see and feel. Rothko created for the viewer a sense of being in a world that was expansive and infinite. With the shifting forms of his classic paintings and the dark spaces of the paintings of the 1960s, he captured the essence of myth that is 'timeless and universal'. But even the blackest paintings contain a sublime light that beckons the viewer into what Rothko described as an unknown adventure in an unknown space.[49]

The Tate Murals

'You must understand that the whole idea sprang newly born as we sat facing each other. Since then, the idea seemed better and better.'[1] Writing in 1965 to Sir Norman Reid, the director of the Tate Gallery, Rothko reveals his initial excitement for the museum's proposal to create a gallery devoted to a large number of his paintings. The ensuing negotiations, initiated after the triumphal reception of Rothko's retrospective at the Whitechapel Art Gallery, resulted in a major gift from Rothko to the Tate of a series of paintings originally created for the Seagram building in New York, as well as one additional painting. Rothko considered the Tate Gallery the 'best place for these paintings'.[2] The prospect that his works would hang in their own room and be treated with the same deference as the Tate's holdings of works by Picasso, Matisse and Giacometti, provided one of the true bright moments during the last years of his life.

Rothko always contended that his paintings were meant to be installed in a group, so as to create an environment that would surround the viewer. In September 1969 Reid even provided Rothko with a small cardboard model of the designated gallery space, which Rothko could use in his New York studio to plan the arrangement of the paintings. Rothko cut a sample of the wall colour from his studio wall, which he sent to Reid to match. The gift was finalised on 7 November 1969, but Rothko never saw the paintings installed. He died almost at the same moment that his paintings arrived in London. As planned, the Rothko paintings were installed in the gallery now known as Tate Britain.

Since 1970 the Tate has thus held the distinction of being the only museum with a gallery devoted to the paintings of Rothko, as selected and grouped by the artist to create the ideal environment. In 2000, the Rothko paintings were moved to the new Tate Modern, where they were again installed in their own gallery, replicating Rothko's original instructions as closely as possible.

Rothko created three groups of paintings for the Four Seasons restaurant designed by Philip Johnson for New York's Seagram building. He worked on this commission from 1958 to 1959 but ultimately withdrew from the project as he did not feel the venue was appropriate. Six of the paintings donated to the Tate Gallery had been included in the 1961 retrospective organised by the Museum of Modern Art in New York, which travelled to the Whitechapel Art Gallery the same year. Rothko presided over the selection and installation of these paintings at the MoMA. He chose four murals in addition to those later given to the Tate, including some of the brighter

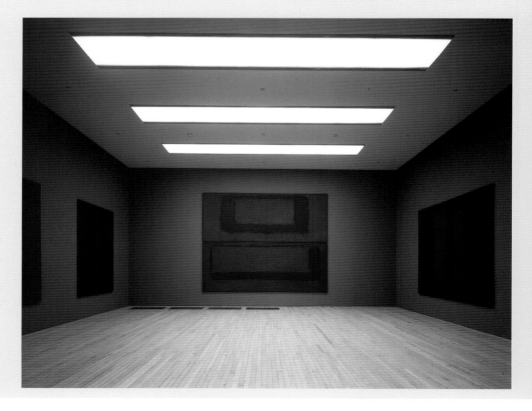

101
The Rothko Room at
Tate Modern

Seagram mural paintings in orange and wine: sketch for *Mural No.1* 1958 (A639), sketch for *Mural No.4* 1958 (fig.85) and *Mural for End Wall* 1959 (fig.90). Rothko grouped canvases of similar colour as units installed in their own room, arranging them 'to their best effect on each other'.[3] The Seagram murals were distributed between two galleries, three of the dark paintings being installed in their own chapel-like gallery. *Mural Section No.3* (A658) was positioned in the centre of one wall, with *Mural Section No.5* and *Mural Section No.7* (fig.101 bottom and top far wall) hung in close proximity on the two flanking walls. According to critic Robert Goldwater this was the most successful arrangement, 'Partaking of the same somber mood, they reinforce each other, as they were designed to do.'[4]

Rothko's tempera on paper sketches for the Seagram murals suggest that originally he may have planned to arrange some of the canvases in a continuous frieze, as he later did with the Harvard murals. However, in the retrospective and for the Tate Gallery he instructed them to be installed as individual paintings. Goldwater observed that the arrangement of the hang at MoMA made it difficult to look at a single painting in isolation.[5] But this seems to have been part of Rothko's plan, as he emphasised the impact on the viewer's peripheral vision in his arrangement of paintings for his last mural series, the Rothko Chapel, which he worked on from 1964 to 1967. In preparation for the Tate installation Rothko sketched scaled versions of the murals on maroon contstruction paper, which he arranged on the simple fold-up paper model of gallery 18 of the Tate Gallery supplied by the museum. On this model he glued his miniature murals, grouping canvases of similar size and stacking the two narrow paintings. Although he previously indicted that these paintings were intended to be installed four feet six inches above the ground, he ultimately decided to hang them a little above the gallery's wainscoting (fig.101 is a recent installation at Tate Modern).

Although the Seagram murals that Rothko donated to the Tate Gallery were painted in 1958–9, his installation plan was contemporary with the Chapel: consequently the installation at the Tate Gallery can be considered as an extension of his work on the Chapel. As in the Chapel, the canvases Rothko selected for the Tate are generally painted in the darker palette of blacks, maroon and deep wine, rather than the orange and wine canvases. Although the room at the Tate is not octagonal like the Chapel, Rothko hung the paintings so close to each other that they cannot be viewed in isolation: the flanking canvases always interfere with the viewer's peripheral vision. The lighting in both the Tate installation and the Chapel is controlled to an overall dimness so that the paintings slowly reveal themselves to the viewer.

Rothko's Painting Technique

Mary Bustin

Introduction

In *Red on Maroon*, painted in 1958 (fig.102), a rich cherry-red figure hovers in front of a rising mist. Luscious and glossy, its sensuous, full-bodied paint flickers outwards over haloes of a matt red afterglow. By contrast, the field appears ephemeral – thin washes create successive waves of broken cirrus cloud forms, in which the paint is so heavily diluted that it teeters on the point of disintegration, then seemingly explodes in vapour trails of feathered dry pinks and greys. Large dabs of thin paint ooze and drip sideways.[1]

Mark Rothko's sophisticated understanding of the physical potential of his materials is seasoned by a twist of wit; playfully, he sometimes allows the paint to take control. *Red on Maroon* demonstrates how he could deliberately alter the physical properties of oil paint to obtain a wide range of effects, then push it further still to see what happens.

For *Red on Maroon* he took artist's tube oil paint as his starting point. He boosted its paste-like glossy qualities by adding alkyd painting medium[2] to the cherry red oil paint. As it dried, it settled into a soft, rich, translucent impasto. Moving to the opposite extreme for the field, he then diluted oil paint with turpentine to a point at which it no longer formed a cohesive film; pigments and medium separated out into natural wave formations. The paint, originally mixed to a soft grey colour, gradually became paler as the turpentine evaporated and a haze appeared. Successive layers of paint compounded the effect. A soft sheen gradually formed on the surface. Curiously, the field is hazy but not matt.

This slow build-up of colour is of paramount importance to Rothko's technique. It is akin to musical improvisation in paint, in which 'voices and structures keep weaving in and out, modifying and reshaping one another'.[3] Rothko spent hours in contemplation of his paintings before making the next mark.[4] For if he made a mark then changed his mind, reversal was not possible. Occasionally he tried: at the lower left edge of *Red on Maroon*, he rubbed at a grey drip in an attempt to

remove it without success; a halo remains.

Rothko seemed to enjoy allowing the act of painting to remain visible. He accepted splashes and dribbles, even bold dabs of paint so heavily diluted that they ran. He had deliberately turned the large canvas onto its side to work on it, so that paint gathered at one edge then dribbled slightly – now seemingly sideways. Turning the canvas certainly enabled easier access to its wide expanse for painting, but the frequency of dribbles running in uncommon directions throughout his work suggests that this practical measure had evolved into a visual device to challenge our concepts of gravity and orientation.

Rothko's paintings have proved to be more robust than previously anticipated.[5] As time passes, particular ageing characteristics emerge: the development of a white exudate on the later black paintings, for example, on the Houston Chapel paintings,[6] and fading of a single red pigment that caused dramatic change to the Harvard Murals.[7] But predominately, as more is understood about the behaviour of his paint, and the qualities of its surface, certain safeguards are introduced to protect the paintings. These include respect for the artist's preference for low lighting of his later paintings (which retards fading), and a reverence for the untouchable surface, to a deeper understanding of the effect of the environment upon his materials. Restoration practice has changed to meet the new criteria, and the treatments of the 1960s, when Rothko paintings were varnished or lined, are now rarely undertaken.[8]

Fundamental issues of Rothko's technique illustrated by *Red on Maroon*

Red on Maroon, painted for the Seagram Mural cycle, demonstrates Rothko's painting technique at its height – a technique rooted in his experiments in the early multiforms,[9] developed through exploration of space, light and colour in the classic paintings, and culminating in the Houston Chapel series, in which he eschews colour in pursuit of the ultimate surface reflectance qualities.[10]

In the Seagram series, Rothko pared his colour range down to red, maroon and black, and explored the surface texture and reflectance qualities of oil paint through considered use of additives that could include egg, dammar, and synthetic resins or 'plastic paint'.[11]

The technique of modifying oil paint to change its handling properties and appearance is as old as oil painting itself.[12] Although Rothko studied drawing briefly at the New School of Design, and then painting with Max Weber at the Art Students league in the mid-1920s, his technique evolved through contact with his contemporaries.[13] In 1950, Ralph Mayer, author of 'The Artists' Handbook of Materials and Techniques', noted a particular trend: 'a number of American painters ... use egg/oil emulsion as a standard recipe, varying the composition of the oily ingredient according to individual references.'[14] Rothko's multiforms of this period incorporated several different media in the same painting. His description in 1947 lists these as tempera, oil and watercolour.[15] Analysis of the multiforms in the collection of the National Gallery of Art, Washington, has identified the presence of oil, egg, gum, glue, shellac, natural resin and protein media.[16]

Rothko's personal odyssey with his materials is governed by his recognition that subtle shifts in surface gloss, depth of colour, and texture could produce rich, lively and expressive illusions in the substance of paint itself. In his three mural series, this fascination with surface illusion fed his need to create 'a place'[17] – an environment – in which emphasis moves from colour to the very materiality of his paintings. Working within pre-determined and controlled parameters of display space and living environment, he recognised that his paintings would be affected by the direction of light, the proportions of the room, wall colour, furnishings and, ultimately, its function.

Studio

As Rothko's first opportunity to orchestrate a whole environment, the commission from the Seagram Corporation to paint a mural cycle brought about a considered change in his working practice. In a holistic approach

to the problem of how to create a natural symbiosis between his paintings and the architectural proportions and lighting of the Four Seasons Restaurant, he built a replica room within his studio, an old basketball court on 222 Bowry, New York, out of studding and brown paper.[18] With the grimy windows on one side and an uplighter theatrical lamp at the centre to bounce light off the ceiling, Rothko created a stage setting for the painting of the murals (fig.103). Michael Compton notes that the Seagram paintings are sharply affected by any change in the intensity, colour and direction of light: 'the pictures have their own light and if there is too much light the colour in the picture is washed out and a distortion of their look occurs'.[19] Lighting in the studio was crucial. Dore Ashton, who visited Rothko's 'cavernous studio with its deep dyed red floor' in 1959 to view paintings in the Seagram Mural series, was entranced by an optical illusion of a 'deep maroon with a collapsing crimson rectangle that seemed to sway like a censor in its ambiguous space.' 'Rothko had no lights on, and the great space was as dim as a cathedral.'[20]

Canvas support

The size of *Red on Maroon* is governed by two parameters – the proportions of the restaurant and the width of the bolt of cotton-duck fabric.[21] Apart from an early use of linen, Masonite[22] and his works on paper, Rothko favoured cotton-duck canvas.[23] 'He liked what he called the taut vibration of the canvas as he worked with his brushes and rags.'[24] In the years following the Second World War, cotton duck was widely available, being manufactured in many weights for a multitude of uses including those of the US Army,[25] awning companies[26] and sail-makers.

Rothko stretched the cotton duck over simple strainers custom-made by his carpenter and his assistant from lengths of softwood fixed at the corners and braced with cross bars.[27] In a technique developed during his classic period, cross bars were offset on the reverse of the strainers to avoid the visual calamity of paint slewing against the edge of the bars as the canvas deflected under[28] pressure of the brush.[29] Later, after the painting was finished, the bars were cut down and inserted tightly between the outer bars, thereby creating a symbiotic relationship with the tension in the cloth: as the cotton tightens, the bars bow outwards a little; as it slackens, they straighten. Whether by chance or by conscious design, this system is one of the best at maintaining constant tension across a large piece of fabric. It avoids the problems of a keyed expandable stretcher that tends to overstrain the corners and create diagonal cracks in the paint.

Considerations of edge

Rothko deliberately stapled the cotton duck to the reverse of the strainer rather than the sides. The left- and right-hand edges of *Red and Maroon* (the visible edges[30]) are painted in a plum base colour. Further paint layers spill over from the front in short runs lending a richness of texture to the painted edge. This liveliness has increased with age: the trails are becoming more apparent because a maroon pigment in the priming is fading more quickly than the more stable artists' paint on top.[31]

Painted canvas edges appear only later in Rothko's career. His early expressionist-realist paintings had minimal tacking edges. Dana Cranmer, restorer to The Mark Rothko Foundation, noted that in these early works: 'the canvas support often did not even extend beyond the edge of the wooden strainer, and there was so little fabric that it must have been with great difficulty that the canvas was pulled and tacked to the edge of the strainer.[32] The economy of fabric persisted after Rothko had decided to incorporate the edges into the painted field. If the canvas did not cover the whole edge, he painted the wood and staples as well, as on *No.19* 1949 in the Art Institute of Chicago (A403).

Alison Langley notes in her study of the multiforms in the National Gallery of Art, Washington, that 'some tacking edges exhibited ground colours related to the final image, while others contrasted dynamically with the palette of the final image, acting almost as a framing device.'[33]

102
Red on Maroon
1958
Oil on canvas
266.7 × 238.8
Tate

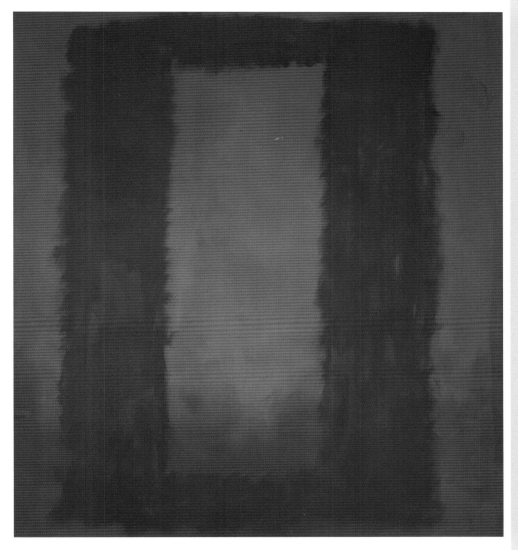

Priming

From his classic period onwards, Rothko prepared the stretched cotton duck with powder pigments, chalk and barytes[34] stirred into animal-skin glue size, gently heated then applied all in one go from one side to the other to achieve an evenly coloured ground.[35] No lines, joins or patches were acceptable.[36]

It is a traditional technique with a twist. Sizing a canvas with plain animal-skin glue stiffens and seals the fabric. It forms a base layer for a layer of oil priming.[37] In *Red on Maroon*, Rothko combined the concept of size layer and primer by both colouring his glue size and by making it sufficiently thick to fill the weave. By adding chalk fillers, he created a ground that would absorb oil medium from overlying paint and leave a matt, but intense colour.[38] All three mural cycles have a plum-coloured, glue-size ground.

The origins of this coloured glue ground appear to lie in a quest for an absorbent priming that would mimic the qualities of paper. Studies of his smaller multiforms[39] suggest that initially Rothko preferred an egg priming, and only later switched to glue. Coincidentally J.M.W. Turner also favoured an egg ground for his smaller paintings.[40] Egg priming would be impractical on a large canvas, especially if an even distribution of colour is required, because this priming is

stiff, brushy, difficult to apply evenly and requires a lot of eggs.[41]

Painting materials

In 1964, while he was painting the Houston murals, Rothko was photographed in his studio. This iconic, and perhaps staged, image gives us an insight into his materials. The artist stands behind a table covered in tins of paint, a shoe brush, boxes of eggs, an electric whisk, a plastic bottle of synthetic polymer medium, jars of red, blue and black powder pigments, masking tape, brown bags with unreadable labels, and in the background, a large tin of turpentine. Recycled coffee tins contain Rothko's carefully mixed oil paint. Behind him, a canvas waits, suspended from pulleys, for the next phase of painting.

The jars of pigment are interesting. These appear to be artists' powder pigments, yet Dan Rice, Rothko's assistant on the Seagram Murals, recalls that for the priming he bought pigment in brown paper bags from the local store.[42] Mayer described the source of powder pigments:

dry colors are sold in small amounts in some artists' supply stores; they are put up in small packages by some of the well-known manufacturers of prepared artists' materials ... A complete line of practically every available pigment used by artists, carefully selected and assembled from world-wide sources and sold in small or large amounts, will be found at Fezandié and Sperrlé, 205 Fulton Street, New York. The prices of dry colors are usually greatly reduced when larger quantities are purchased.

Mayer advised:

While painters who use dry colors should insist upon securing the purest highest-grade pigments, there are some purposes for which more common-place and more easily obtained grades are useful. These grades are universally sold in paint stores.[43]

From evidence in the Harvard Murals[44] and slow fading of one layer in the Seagram Murals[45] we know that Rothko used one red powder pigment that is not stable in strong continuous light. This was identified it as lithol red with some caution, given the analytical techniques available at that time.[46] Through fading of this one component, dramatic colour shifts from deep maroon to denim blue have occurred in some of the Harvard Murals. The maroon is mixed from the fugitive red, synthetic ultramarine and Mars Black; as the red faded, the bluer component became more prominent.

Whitmore also identified another red elsewhere in the Harvard murals: naphthol red [PR9].[47] In *The Materials of the Artist* Max Doerner had noted the emergence of new red pigments with potential for the artists' market in 1934. 'Helio Fast Red R. B. L. No 9 ... [and] lithol fast red R. N., No. 8, are coal tar lakes which may serve as substitutes for vermilion. Helio Fast Red is a brilliant color, which has proved itself permanent in water color, tempera and in indoor fresco.' From this recommendation, Rothko would have had little forewarning that his red could fade so dramatically. Doerner's tests had indicated that helio fast red was sound but he issued a note of caution for other new reds: 'I have personally made satisfactory experiments with helio fast red, but others say it turns brown in oil. There are today many vermilion like coal tar colors for artists' use whose permanency under light and in lime will have to be tested in every single case.'[48] This would suggest that Rothko selected one of these unstable reds by chance, not by choice. Given the stability of the majority of his paint, there is little evidence that Rothko deliberately selected fugitive materials.

The prescient questions put to Rothko by the restorer Elizabeth Jones, when she prepared the Harvard Murals for their removal to Boston in 1962 revealed insightful information about Rothko's technique. But they also gave rise to the Woolworth's legend.

I asked him about the paint he used ... He said it was mostly oil, that he had glazed over with egg white areas that he decided to repaint ... and that when he ran out of paint he had gone downstairs to the Woolworth's and bought some more paint – he didn't know what kind it was.'[49]

Although this comment has widely been interpreted as evidence for Rothko's selection

of household paint, there is no analytical proof as yet of its use in the paintings.[50] Christopher Rothko suspects that his father may have been pulling Jones's leg. In 1958 Woolworth's had embarked on a drive to cast off its dime-store image and move upmarket by forming a fine Art Department. Initially this was at the Fifth Avenue store, then later, when the venture proved a huge success, it went US-wide in 1959–60. Woolworth's stocked 'a wide selection of brushes canvases, easels and oil and water-based paints. All were regular or superior quality, and all were sold at dime-store prices, at under half the rates you would find in a specialist store.'[51] Store workers from this era recollected selling construction paper, which Rothko is thought to have used for the sketches for the Seagram Murals.[52] Thus the story may well have a snippet of merit.

Rothko's oil paint is commercially made artist's oil paint, some of which he bought from Leonard Bocour, who manufactured Bellini oil paint.[53] Bocour and Sam Golden also developed the radical new synthetic paint Magna – 'Artist's Permanent Plastic paint' in the late 1940s.[54] Based on the synthetic resin Acryloid F10, a polybutyl methacrylate, manufactured by Rohm and Haas, it dissolved in turpentine. 'Bocour and Golden kept the pigment concentration in Magna paints deliberately high, so that the paint could be thinned with considerable amounts of solvent and still produce a saturated, intense colour.'[55] In a marketing drive at the end of the 1950s, Bocour gave away free samples of Magna, both the paint and the pure medium itself, to encourage artists to try out his new product: 'the first new painting medium in 500 years'.[56] 'Artists such as Mark Rothko, Willem de Kooning, Barnett Newman, Kenneth Noland and Morris Louis would visit the shop on 15th Street in New York to obtain the paint and discuss their use of it with Bocour.'[57] Rothko appears to have incorporated Magna into his paintings soon after Bocour's promotion, both in pure resin form, and as the tube colour. It has been found in his classic paintings,[58] the Seagram Murals,[59] and in the Houston Murals.[60] In the Houston Murals, it was brushed on as a discrete layer over the priming at a fairly late stage in the painting. Rothko's assistants mixed powder pigments into the resin solution and applied it evenly to modify the tone of the priming made of glue size and the powder pigments bone black, ultramarine blue and a synthetic red.[61]

Parallels with watercolour painting

Rothko ran parallel strands in his oil and watercolour paintings from the outset of his career. He expanded his repertoire of brushwork in the early 1940s, and by the surrealist period, his oil painting surfaces display 'an increasing mastery of glazing, scumbling, and scrafitto techniques'.[62] A 'remarkable symbiosis occurred between the watercolours and the oils', Clearwater notes, 'He began to use oil as if it were watercolour, thinning the medium and applying it in overlapping glazes.'[63] This relationship was perpetuated throughout his working life. Cranmer noticed that 'often he applied what he developed in one medium to the other. At times, the works on paper appear to be in close stylistic harmony with the works on canvas but on paper he experimented more freely, developing techniques and effects in advance of applying them to canvas.'[64] This synchronicity between watercolour and oil-painting techniques is apparent in his exploratory sketches for the Harvard Mural cycle, as seen in this description of the watercolour sketch for Panel Three:

a fluid veil of deep purple was then covered by one of an icy, light blue, then by a deep brownish magenta glaze which left a syrupy cloud with glossy tide-line edge puddle at the bottom right and zigzagging through the left vertical. Finally, Rothko freely coated all of these layers with a wash of cherry red and then, as if to give dimension to the motif, he rubbed water into and erased the bare ground on either side of the image, fading the plum ground.[65]

To mimic this in oil paint, an absorbent ground is essential. 'Thinned pigments blend and bleed with greater subtlety on absorbent paper than on canvas. The paper's fibres soak up the fluid paint, resulting in a surface almost devoid of the artist's gesture.'[66]

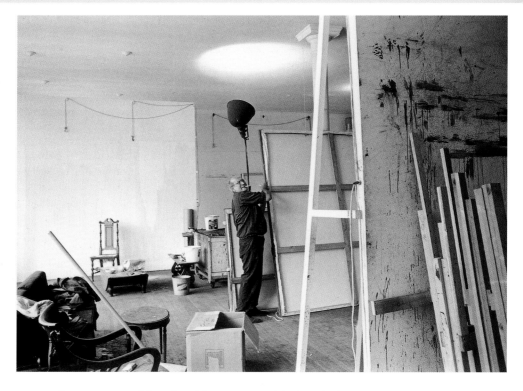

In *Red on Maroon*, Rothko takes this method of building layer upon layer of oil paint thinned with turpentine to critical levels, where the colour itself disperses in primordial conformations of cloud or sea-like patterns. The absorbent red priming draws in excess medium so that subsequent washes can be superimposed without pooling. Each pass of the brush over the hazy field enriches the surface with another pattern. Gradually the build-up of medium saturates the priming, giving the initially matt field a slight sheen. Mayer cautions: 'If a matt finish is attempted by diluting a ready-made paint excessively with turpentine, the effect may be matt, but the film may also be weakened to such an extent that the pigment is liable to chalk off eventually, or the film to crack or display other defects'.[67] The development of sheen suggests that Rothko was using additives in this paint to ensure that it did not flake off.

Not all his fields are this complex. *Light Red over Black* 1957 (fig.78)[68] is primed with the flat wash of the water-based paint made from glue size and an organic red powder pigment with chalk.[69] Over this base coat he applied a thin, brushy layer of well-diluted artist's cadmium orange oil paint. He left deliberate gaps in the orange to let the underlying colour peep through. As Sally Avery reflected, 'He painted in such a way that his paint was layered, color on top of color, so that you had a sense of light coming through.'[70]

The paint may be thin, but the brushwork is vigorous, lively. Oliver Steindecker, one of Rothko's assistants, recalled that: 'he worked with large brushes, like paint brushes for housepainters – they might be 6 or 7 inches wide – really heavy duty brushes and he really got into his painting, his whole body would go up, down with the sweep of the brush on canvas; it was like he was really into it rather than just moving his arm. His whole body moved up and down with each stroke.'[71]

In both *Red on Maroon* and *Light Red over Black*, Rothko explored the dichotomy of simple and complex structures in form and field. The relatively simple painting of the field in *Light Red over Black* is offset by complexity of layer structure in the three forms, each with its own character:

I use colors that have already been experienced

through the light of day and through the states of mind of the total man. In other words my colors are not colors that are laboratory tools which are isolated from all accidentals or impurities so that they have a specified identity or purity.[72]

Whereas the light red colour is opaque, the central black rectangle has a base of velvety blue-black whose coolness is emphasised by matt bands of synthetic ultramarine, and heightened by a layer of glossy black flicked over the centre. Rothko changed his basic tube oil paint by adding resin varnish, probably dammar, to achieve this high-gloss surface. The lowermost, browner black band is more complex still. It has a slightly dusky interior. Vertical brushmarks are almost wiped down the painting in a haze-like scumble. Mars brown oil paint, tinted with chrome orange, is overlaid by bone black, modified with small amounts of cobalt violet and possibly manganese blue. Although it is also glossy, the paint has a fatness that is reminiscent of oil paint cut with an egg/resin mixture.

In all the studies of Rothko's technique, egg and resin appear as a normal part of his painting medium.[73] Mayer gives the standard recipe used by American painters in 1950 as two parts of whole egg diluted with four parts of water added to a mixture of one part each of stand oil and dammar. The ingredients are shaken up then reserved in a bottle and may be added to artist's oil paint. The proportions were flexible, varying the oily ingredient according to need, unlike those of the egg-oil mixtures in which egg predominates. In that instance, too much deviation from the standard recipe is likely to produce erratic behaviour.

For the smaller multiforms, it is possible that Rothko added the egg and resin in a pre-mixed concoction, as described by Mayer. By the time he was working on the massive Houston paintings, his assistants recollected that he extemporised, taking 'unmeasured amounts of the tube oil paint, whole beaten eggs, turpentine and dammar resin'[74] in buckets. The result is a subtle, measured surface in which the plum glue size sparkles, while the egg-oil mix of the black forms a quiet lustre.[75]

As well as mixing egg and resin into the oil to change its visual properties, Rothko also used an established technique of interlayers – coating existing layers of oil paint with egg-white varnish before painting on top. Reasons for this may be to bond fresh paint with dried pigment or to coat barely dry paint to seal it temporarily so that a different colour can be quickly laid on top without disturbing the under layer or muddying the new colour. It can also add lustre to the surface by saturating the colour and slightly increasing the gloss.

Rothko switched to using acrylic paint almost exclusively in his last paintings, which include the red on pink and black on grey themes. These last works are painted in acrylic on sheets of paper cut from a large roll. Sheets were taped to boards to give a hard, unyielding surface on which to paint. When the tape was removed, a thin white unpainted border was exposed.

Rothko's practice was to send the sheets for mounting onto thick supports to John Krushenick, his framer in the early 1960s, then later to Daniel Goldreyer, his restorer. Initially, 'the approximately one-inch-thick edge of the mount was covered with linen tape which the framer, following Rothko's instructions, painted the same color as the paper's stained field'.[76]

Later, as James Breslin describes, 'the possibility of preserving these dramatic white borders occurred to Rothko, an idea he adopted only after considerable hesitation and debate'. The white borders became an intrinsic part of the painting and 'sever the space of the work from the "actual" space around it'.[77]

Rothko's technique spans the traditional through to the modern era: from natural to synthetic paint. His paintings demonstrate his deep understanding of his materials and his desire to use stable paints. Infused through all his work is a fascination with the character and potential of his painting materials, and an underlying thrill as a new effect emerges when they are pushed beyond their normal range.

Selected Writings and Statements by Rothko

Draft letter to Edward Alden Jewell, art critic, *New York Times*, 1943

Any one familiar with the evolution of modern art knows what potent catalyzers negro sculpture and the art of the Aegean were at its inception. And since this inception the most gifted men of our time, whether they seated models in their studio, or found within themselves the models for their art, have distorted these models until they awoke the traces of their archaic prototypes and it is this distortion which symbolizes the spiritual face of our time.

To say that the modern artist has been fascinated primarily by the formal relationships aspects of archaic art is, at best, a partial and misleading explanation. For any serious artist or thinker will know that a form is significant only in so far as it expresses the inherent idea. The truth is therefore that the modern artist has a spiritual kinship with the emotions which these archaic forms imprison and the myths which they represent. The public, therefore, which reacted so violently to the primitive brutality of this art, reacted more truly than the critic who spoke about forms and techniques.

That the public resented this spiritual mirroring of itself is not difficult to understand. My art is simply a new aspect of the eternally archaic myth, and I am neither the first nor will be the last compelled to evolve these chimeras of our time.

Letter to Edward Alden Jewell, art critic, *New York Times*, 1943

June 7, 1943
Mr. Edward Alden Jewell
Art Editor, New York Times
229 West 43 Street
New York, N.Y.

Dear Mr. Jewell:

To the artist, the workings of the critical mind is one of life's mysteries. That is why, we suppose, the artist's complaint that he is misunderstood, especially by the critic, has become a noisy commonplace. It is therefore, an event when the worm turns and the critic of the TIMES quietly yet publicly confesses

his 'befuddlement' that he is 'non-plussed' before our pictures at the Federation Show. We salute this honest, we might say cordial reaction towards our 'obscure' paintings, for in other critical quarters we seem to have created a bedlam of hysteria. And we appreciate the gracious opportunity that is being offered us to present our views.

We do not intend to defend our pictures. They make their own defense. We consider them clear statements. Your failure to dismiss or disparage them is prima facie evidence that they carry some communicative power.

We refuse to defend them not because we cannot. It is an easy matter to explain to the befuddled that 'The Rape of Persephone' is a poetic expression of the essence of the myth; the presentation of the concept of seed and its earth with all its brutal implications; the impact of elemental truth. Would you have us present this abstract concept with all its complicated feelings by means of a boy and girl lightly tripping?

It is just as easy to explain 'The Syrian Bull', as a new interpretation of an archaic image, involving unprecedented distortions. Since art is timeless, the significant rendition of a symbol, no matter how archaic, has as full validity today as the archaic symbol had then. Or is the one 3,000 years old truer?

But these easy program notes can help only the simple-minded. No possible set of notes can explain our paintings. Their explanation must come out of a consumated experience between picture and onlooker. The appreciation of art is a true marriage of minds. And in art, as in marriage, lack of consummation is ground for annulment.

The point at issue, it seems to us, is not an 'explanation' of the paintings but whether the intrinsic ideas carried within the frames of these pictures have significance.

We feel that our pictures demonstrate our aesthetic beliefs, some of which we, therefore, list:
1. To us art is an adventure into an unknown world, which can be explored only by those willing to take the risks.
2. This world of the imagination is fancy-free and violently opposed to common sense.
3. It is our function as artists to make the spectator see the world our way – not his way.
4. We favor the simple expression of the complex thought. We are for the large shape because it has the impact of the unequivocal. We wish to reassert the picture plane. We are for flat forms because they destroy illusion and reveal truth.
5. It is a widely accepted notion among painters that it does not matter what one paints as long as it is well painted. This is the essence of academicism. There is no such thing as good painting about nothing. We assert that the subject is crucial and only that subject matter is valid which is tragic and timeless. That is why we profess spiritual kinship with primitive and archaic art.

Consequently if our work embodies these beliefs, it must insult anyone who is spiritually attuned to interior decoration; pictures for the home; pictures for over the mantle; pictures of the American scene; social pictures; purity in art; prize-winning potboilers; the National Academy; the Whitney Academy, the Corn Belt Academy; buckeyes; trite tripe; etc.
Sincerely yours,
Adolph Gottlieb
Marcus Rothko

130 State Street
Brooklyn, New York

[Also partially drafted by Barnett Newman. Published in *New York Times*, 13 June 1943]

The Portrait and the Modern Artist
MR. ROTHKO: The word portrait cannot possibly have the same meaning for us that it had for past generations. The modern artist has, in varying degrees, detached himself from appearance in nature, and therefore, a great many of the old words, which have been retained as nomenclature in art have lost their old meaning. The still life of Braque and the landscapes of Lurcat have no more relationship to the conventional still life and landscape than the double images of Picasso have to the traditional portrait. New Times! New Ideas! New Methods!.

Even before the days of the camera there was a definite distinction between portraits which served as historical or family

memorials and portraits that were works of art. Rembrandt knew the difference; for, once he insisted upon painting works of art, he lost all his patrons. Sargent, on the other hand, never succeeded in creating either a work of art or in losing a patron – for obvious reasons.

There is, however, a profound reason for the persistence of the word 'portrait' because the real essence of the great portraiture of all time is the artist's eternal interest in the human figure, character and emotions – in short in the human drama. That Rembrandt expressed it by posing a sitter is irrelevant. We do not know the sitter but we are intensely aware of the drama. The Archaic Greeks, on the other hand used as their models the inner visions which they had of their gods. And in our day, our visions are the fulfillment of our own needs.

It must be noted that the great painters of the figure had this in common. Their portraits resemble each other far more than they recall the peculiarities of a particular model. In a sense they have painted one character in all their work. This is equally true of Rembrandt, the Greeks or Modigliani, to pick someone closer to our own time. The Romans, on the other hand, whose portraits are facsimiles of appearance never approached art at all. What is indicated here is that the artist's real model is an ideal which embraces all of human drama rather than the appearance of a particular individual.

Today the artist is no longer constrained by the limitation that all of man's experience is expressed by his outward appearance. Freed from the need of describing a particular person, the possibilities are endless. The whole of man's experience becomes his model, and in that sense it can be said that all of art is a portrait of an idea.
…
Neither Mr. Gottlieb's painting nor mine should be considered abstract paintings. It is not their intention either to create or to emphasize a formal color – space arrangement. They depart from natural representation only to intensify the expression of the subject implied in the title – not to dilute or efface it.

If our titles recall the known myths of antiquity, we have used them again because they are the eternal symbols upon which we must fall back to express basic psychological ideas. They are the symbols of man's primitive fears and motivations, no matter in which land or what time, changing only in detail but never in substance, be they Greek, Aztec, Icelandic, or Egyptian. And modern psychology finds them persisting still in our dreams, our vernacular, and our art, for all the changes in the outward conditions of life.

Our presentation of these myths, however, must be in our own terms, which are at once more primitive and more modern than the myths themselves - more primitive because we seek the primeval and atavistic roots of the idea rather than their graceful classical version; more modern than the myths themselves because we must redescribe their implications through our own experience. Those who think that the world of today is more gentle and graceful than the primeval and predatory passions from which these myths spring, are either not aware of reality or do not wish to see it in art. The myth holds us, therefore, not thru its romantic flavor, not thru the remembrance of the beauty of some bygone age, not thru the possibilities of fantasy, but because it expresses to us something real and existing in ourselves, as it was to those who first stumbled upon the symbols to give them life.

[Adolph Gottlieb and Mark Rothko, 'The Portrait and the Modern Artist', typescript of a broadcast on 'Art in New York,' Radio WNYC, 13 October 1943]

Personal Statement

I adhere to the material reality of the world and the substance of things. I merely enlarge the extent of this reality, extending to it coequal attributes with experiences in our more familiar environment. I insist upon the equal existence of the world engendered in the mind and the world engendered by God outside of it. If I have faltered in the use of familiar objects, it is because I refuse to mutilate their appearance for the sake of an action which they are too old to serve; or for which, perhaps, they had never been intended.

I quarrel with surrealist and abstract art only as one quarrels with his father and mother, recognizing the inevitability and function of my roots, but insistent upon my dissension: I, being both they, and an integral completely independent of them.

The surrealist has uncovered the glossary of the myth and has established a congruity between the phantasmagoria of the unconscious and the objects of everyday life. This congruity constitutes the exhilarated tragic experience which for me is the only source book for art. But I love both the object and the dream far too much to have them effervesced into the insubstantiality of memory and hallucination. The abstract artist has given material existence to many unseen worlds and tempi. But I repudiate his denial of the anecdote just as I repudiate the denial of the material existence of the whole of reality. For art to me is an anecdote of the spirit, and the only means of making concrete the purpose of its varied quickness and stillness.

Rather be prodigal than niggardly. I would sooner confer anthropomorphic attributes upon a stone, than dehumanize the slightest possibility of consciousness.
[In David Porter, *Personal Statement, Painting Prophecy –1950*, Washington 1945]

Clyfford Still

It is significant that Still, working out West, and alone, has arrived at pictorial conclusions so allied to those of the small band of Myth Makers who have emerged here during the war. The fact that his is a completely new facet of this idea, using unprecedented forms and completely personal methods, attests further to the vitality of this movement.

Bypassing the current preoccupation with genre and the nuance of formal arrangements, Still expresses the tragic-religious drama which is generic to all Myths at all times, no matter where they occur. He is creating new counterparts to replace the old mythological hybrids who have lost their pertinence in the intervening centuries.

For me, Still's pictorial dramas are an extension of the Greek Persephone Myth. As he himself has expressed it his paintings are 'of the Earth, the Damned, and of the Recreated.'

Every shape becomes an organic entity, inviting the multiplicity of associations inherent in all living things. To me they form a theogony of the most elementary consciousness, hardly aware of itself beyond the will to live – a profound and moving experience.
[Foreword in *First Exhibition Paintings: Clyfford Still*, exh. cat., Art of This Century, February 1946]

From an undated manuscript, 1930s to 1940s

Now what is the essential difference between the sort of space which is characteristic of tactile painting and that which is characteristic of illusory plasticity? And why do we designate one as tactile and the other as illusory? That is, why does one kind of space actually give us the sensation of things that can be felt by touch while the other can be perceived only by the eye, this later type of perception apparently a specialized or departmentalized function of sight?

Tactile space, or, for the sake of simplicity, let us call it air, which exists between objects or shapes in the picture, is painted so that it gives the sensation of a solid. That is, air in a tactile painting is represented as an actual substance rather than as an emptiness. We might more readily conceive it if we picture a plate of jelly or, perhaps, soft putty, into which a series of objects are impressed at various depths.

The artist who creates illusory space, on the other hand, is interested in conveying the illusion of appearance. In his very attempt to be faithful to appearances, however, he cannot give air any appearance of actual existence, for a gas cannot be seen. Hence we have an appearance of weight for objects themselves and none for the air that surrounds them. In other words, there is no way to represent the appearance of this all-pervasive substance which we know has a pressure of fifteen pounds per square inch. As a result, the appearance the illusory artist achieves is of things moving about in an emptiness. The only way in which the air can even be hinted at as a solid is by the introduction of certain apparent gasses into

the picture. As a result, we have the introduction of such things as clouds, smoke, or mist and haze as the only means by which the appearance of existence can be imparted to the atmosphere. Another method is the knowledge of atmospheric perspective. By this science we know that objects of a certain color become grayer in color as they recede in space. So if we paint objects at various spatial intervals into the canvas, we can imply the existence of air through the visible effects upon these objects by the intervening air.

This is why a certain fuzziness occurs in some masters' work, particularly the impressionists, and by those we mean all painters who tried to give a sensation of atmosphere through illusory methods. They were aware that the picture lacked atmospheric solidity if air was not represented. Hence the introduction of a haze, but one which had to involve the representation of the object as well as the surrounding air, since to have imparted the haze to the air without imparting it to the figure would have necessarily involved a discrepancy. Hence the paintings of these artists obscure the outlines of their shapes, and we obtain what can be described as a fuzziness of effect.
[First published in *The Artist's Reality: Philosophies of Art,* edited and with an introduction by Christopher Rothko, New Haven and London 2004, pp.56–7]

Personal Statement
A picture lives by companionship, expanding and quickening in the eyes of the sensitive observer. It dies by the same token. It is therefore a risky and unfeeling act to send it out into the world. How often it must be permanently impaired by the eyes of the vulgar and the cruelty of the impotent who would extend their affliction universally!
[from *Tiger's Eye*, no.2, December 1947, p.44]

The Romantics Were Prompted
The romantics were prompted to seek exotic subjects and to travel to far off places. They failed to realize that, though the transcendental must involve the strange and unfamiliar, not everything strange or unfamiliar is transcendental.

The unfriendliness of society to his activity is difficult for the artist to accept. Yet this very hostility can act as a lever for true liberation. Freed from a false sense of security and community, the artist can abandon his plastic bank-book, just as he has abandoned other forms of security. Both the sense of community and of security depend on the familiar. Free of them, transcendental experiences became possible.

I think of my pictures as dramas; the shapes in the pictures are the performers. They have been created from the need for a group of actors who are able to move dramatically without embarrassment and execute gestures without shame.

Neither the action nor the actors can be anticipated, or described in advance. They begin as an unknown adventure in an unknown space. It is at the moment of completion that in a flash of recognition, they are seen to have the quantity and function which was intended. Ideas and plans that existed in the mind at the start were simply the doorway through which one left the world in which they occur.

The great cubist pictures thus transcend and belie the implications of the cubist program.

The most important tool the artist fashions through constant practice is faith in his ability to produce miracles when they are needed. Pictures must be miraculous: the instant one is completed, the intimacy between the creation and the creator is ended. He is an outsider. The picture must be for him, as for anyone experiencing it later, a revelation, an unexpected and unprecedented resolution of an eternally familiar need.

On shapes:
They are unique elements in a unique situation.
They are organisms with volition and a passion for self-assertion.
They move with internal freedom, and without need to conform with or to violate what is probable in the familiar world.
They have no direct association with any particular visible experience, but in them one recognizes the principle and passion of organisms.

The presentation of this drama in the familiar world was never possible, unless everyday acts belonged to a ritual accepted as referring to a transcendent realm.

Even the archaic artist, who had an uncanny virtuosity found it necessary to create a group of intermediaries, monsters, hybrids, gods and demi-gods. The difference is that, since the archaic artist was living in a more practical society than ours, the urgency for transcendent experience was understood, and given an official status. As a consequence, the human figure and other elements from the familiar world could be combined with, or participate as a whole in the enactment of the excesses which characterize this improbable hierarchy. With us the disguise must be complete. The familiar identity of things has to be pulverized in order to destroy the finite associations with which our society increasingly enshrouds every aspect of our environment.

Without monsters and gods, art cannot enact our drama: art's most profound moments express this frustration. When they were abandoned as untenable superstitions, art sank into melancholy. It became fond of the dark, and enveloped its objects in the nostalgic intimations of a half-lit world. For me the great achievements of the centuries in which the artist accepted the probable and familiar as his subjects were the pictures of the single human figure – alone in a moment of utter immobility.

But the solitary figure could not raise its limbs in a single gesture that might indicate its concern with the fact of mortality and an insatiable appetite for ubiquitous experience in face of this fact. Nor could the solitude be overcome. It could gather on beaches and streets and in parks only through coincidence, and, with its companions, form a tableau vivant of human incommunicability.

I do not believe that there was ever a question of being abstract or representational. It is really a matter of ending this silence and solitude, of breathing and stretching one's arms again.
[from *Possibilities*, no.1, Winter 1947–8, p.84]

'Statement on his Attitude in Painting'

The progression of a painter's work, as it travels in time from point to point, will be toward clarity: toward the elimination of all obstacles between the painter and the idea, and between the idea and the observer. As examples of such obstacles, I give (among others) memory, history or geometry, which are swamps of generalization from which one might pull out parodies of ideas (which are ghosts) but never an idea in itself. To achieve this clarity is, inevitably, to be understood.
[From *Tiger's Eye*, no.9, October 1949, p.114]

Rothko rarely made statements about his art after 1950: see p.109, above

From 'A Symposium on How to Combine Architecture, Painting', held at the Museum of Modern Art, New York, 19 March 1951

Mr. Rothko: I would like to say something about large pictures, and perhaps touch on some of the points made by the people who are looking for a spiritual basis for communion.

I paint very large pictures. I realize that historically the function of painting large pictures is something very grandiose and pompous. The reason I paint them however – I think it applies to other painters I know – is precisely because I want to be very intimate and human. To paint a small picture is to place yourself outside your experience, to look upon an experience as a stereopticon view or reducing glass. However you paint the larger picture, you are in it. It isn't something you command.
[Published in *Interiors*, 10 May 1951, p.104]

From Lecture at Pratt Institute, Brooklyn, 27 October 1958

Q: Don't you feel that we have made a new contribution in terms of light and color (ambience)?
A: I suppose we have made such a contribution in the use of light and color, but I don't understand what ambience means. But these contributions were made in relation to the seven points. I may have used colors and shapes in the way that painters before have used them, but this was not my

purpose. The picture took the shape of what I was involved in. People have asked me if I was involved with color. Yes, that's all there but I am not against line. I don't use it because it would have detracted from the clarity of what I had to say. The form follows the necessity of what we have to say. When you have a new view of the world you will have to find new ways to say it.

Q: How does wit and play enter your work?

A: In a way my paintings are very exact, but in that exactitude there is a shimmer, a play … in weighing the edges to introduce a less rigorous, play element.

Q: Death?

A: The tragic notion of the image is always present in my mind when I paint and I know when it is achieved, but I couldn't point it out – show where it is illustrated. There are no skull and bones. (I am an abstract painter.)

Q: On philosophy?

A: If you have a philosophic mind you will find that nearly all paintings can be spoken of in philosophic terms.

Q: Shouldn't the young try to say it all … question control?

A: I don't think the question of control is a matter of youth or age. It is a matter of decision. The question is: is there anything to control.

I think that a freer, wilder kind of painting is not more natural with youth than with gray old men. It isn't a question of age; it is a question of choice. This (idea) has to do with fashion. Today, there is an implication that a painter improves if he gets more free. This has to do with fashion.

Q: Self-expression … communication vs expression. Cannot they be reconciled? Personal message and self-expression.

A: What a personal message means is that you have been thinking for yourself. It is different from self-expression. You may communicate about yourself. I prefer to communicate a view of the world that is not all of myself. Self-expression is boring. I want to talk of something outside of myself – a great scope of experience.

Q: Can you define abstract expressionism?

A: I never read a definition and to this day I don't know what it means. In a recent article I was called an action painter. I don't get it and I don't think my work has anything to do with Expressionism, abstract or any other. I am an anti-expressionist.

Q: Large pictures?

A: Habit or fashion. Many times I see large pictures whose meaning I do not understand. Seeing that I was one of the first criminals, I found this useful. Since I am involved with the human element, I want to create a State of intimacy – an immediate transaction. Large pictures take you into them. Scale is of tremendous importance to me – human scale. Feelings have different weights; I prefer the weight of Mozart to Beethoven because of Mozart's wit and irony and I like his scale. Beethoven has a farmyard wit. How can a man be ponderable without being heroic? This is my problem. My pictures are involved with these human values. This is always what I think about. When I went to Europe and saw the old masters, I was involved with the credibility of the drama. Would Christ on the cross if he opened his eyes believe the spectators[?]. I think that small pictures since the Renaissance are like novels; large pictures are like dramas in which one participates in a direct way. The different subject necessitates different means.

Q: How can you express human values without self-expression?

A: Self-expression often results in inhuman values. It has been confused with feelings of violence. Perhaps the word self-expression is not clear. Anyone who makes a statement about the world must be involved with self-expression but not in stripping yourself of will, intelligence, civilization. My emphasis is upon deliberateness. Truth must strip itself of self which can be very deceptive.

[Typed transcript, excerpted from Mark Rothko, *Writings on Art*, ed. Miguel López-Remiro 2006, pp.125–7]

From an interview with Peter Selz, Autumn 1960

As I have grown older, Shakespeare has come closer to me than Aeschylus, who meant so much to me in my youth. Shakespeare's tragic concept embodies for me the full range of life from which the artist draws all his tragic materials, including irony; irony becomes a weapon against fate.

[Peter Selz, *Mark Rothko*, exh. cat., Museum of Modern Art, New York 1961, p.12.]

Criticism and Commentary on Rothko's Art, 1933–71

Sunday Oregonian, July 1933

Rothkowitz, the young New York artist and instructor of the children whose work is on display currently at the Portland Museum of Art, used to live in Portland, attended Lincoln high school, began his studies of art here and has, since moving on to New York, reached the one-man show stage in a career that promises to be highly successful.

Catherine Jones, 'M. Rothkowitz, Instructor of Children's Art Work Now on Display Here, Wins Fame' [review of Portland Museum exh.], *Sunday Oregonian*, 30 July 1933, sec.3, p.5

Sunday Oregonian, July 1933

The watercolors are chiefly landscapes and studies of forests in which the artist has sought to retain the effect of complexity one finds in the out-of-doors and to show its ultimate order and beauty. A hint of his admiration for Cézanne is in these watercolors. They are carefully thought out and in no way theatrical or dramatic, as are the temperas which were spontaneously conceived and executed and which depend upon the richness of their blacks against white for effect. Those who admire the rich and velvety quality of the temperas will be mildly surprised to discover that the artist combined only black watercolor or show card, the sheets from a lo-cent tablet of linen writing paper, with his own skill to get the desired effect.

Catherine Jones, 'Noted One-Man ShowArtist One-Time Portland Resident' [review of Portland Museum exh.], *Sunday Oregonian*, 30 July 1933, sec.3, p.5

An Exhibition of Oils, Water-colors, Drawings by Marcus Rothkowitz

Mr. Rothkowitz is interested in people, and it is his treatment of his subject matter that makes his canvas vibrate.

…

Last summer Mr. Rothkowitz was invited to hold a one-man exhibition of watercolors and drawings at the Portland Art Museum. This is his first one-man exhibition in New York.

An Exhibition of Oils, Water-colors, Drawings by Marcus Rothkowitz, exh. cat., Contemporary

Arts Gallery, New York, 21 November –
19December 1933, unsigned text.

New York Sun, December 1933

Although he paints the figure chiefly, his
peculiarly suggestive style, with its
dependence on masses and comparative
indifference to establishing any markedly
definite form, seems better adapted to
landscape, and to landscape in watercolor at
that.

 'Lively Doings in Art Circles' [review of
Contemporary Arts Gallery exh.], *New York
Sun*, 1 December 1933, p.30

Art News, December 1933

The newcomer is Maurice [sic] Rothkowitz.
No aid from the catalog is necessary to
inform us of his art education. The
ponderous structure of the "Nude" harks
back to the 'Eight figures' of Max Weber. In
other works, here is the full-fledged
influence of Cézanne.

 Jane Schwartz, 'Around the Galleries',
[review of Contemporary Arts Gallery exh.],
Art News, 2 December 1933, p.16

Brooklyn Daily Eagle, December 1935

Nine artists in search of a tenth – they've
already christened themselves 'The Ten' – are
introducing themselves as an independent
group at the Montross Gallery. Maybe it is
just one more case of a number of non-
conforming individuals not believing in
organizations and all of them feeling so
strongly and harmoniously on the subject
that they formed one of their own. There is
no doubt about this group being composed
of kindred spirits. Never have I seen such a
well-balanced, harmonious ensemble.

 Charles Z. Offin, 'A Glance at Current Art
Exhibits: Introducing "The Ten"', *Brooklyn
Daily Eagle*, 22 December 1935

New York Times, January 1940

Mark Rothko's 'Entrance to the Subway' well
constructed and light of palette, is offset by
the seemingly pointless distortion in both
color and form of 'The Party.'

 'Exotics and the Groups' [review of
Neumann-Willard Gallery exh.], *New York
Times*, 14 January 1940. sec.9, p.10x.

3rd Annual, December 1948 – January 1949

Motherwell's images might spring from his
imagination, but their projection appears to
engage memories of the outer worlds of
space. If we acknowledge the spatial idiom
itself as a profound philosophical symbol, we
may assume that these painters, however
various their outlook, depend in some ways
on certain dimensional limits of knowledge.
In recent years it has become increasingly
apparent that Clyfford Still and Mark Rothko
have been moving beyond these limits
[T]ogether their painting eludes the hall-
marks of conventional spatial meaning. It is
a common practice of abstract painters to
refer to three-dimensional space by a kind of
pictorial metaphor. The medium of painting
itself, being physically spatial, supports the
imaginative allusion. Still and Rothko move
in the opposite dimensions. Their metaphor
invests the physical dimensions of painting
with the values of a human realm that has
been inaccessible to Western art.

 Jermayne MacAgy, in *3rd Annual*, exh.cat.,
California Palace of the Legion of Honor, San
Francisco, 1 December 1948 – 16 January 1949

Magazine of Art 1949

If we subscribe to the notion of painting as a
symbolic act, we are on the way to
understanding what Mark Rothko means
when he says that a painter commits himself
by the nature of the space he uses. To Rothko
the commitment is profound. The
implications of his remark turn up a clue to
the major distinction between his vision and,
say, the vision of Picasso. Their paintings are
symbols of diverse attitudes.

 Recently a critic wrote about Rothko's
'refusal to come to grips with a particular
vision' and wished for 'something more
specific' in his work. These comments
suggest the critic's failure to make the initial
adjustment to Rothko's type of vision.
Particular and specific considerations are
quite alien to this type. They are symbols of
another kind of world. Unless we take
distinctions of this sort into account, we are
apt to find ourselves talking about
something other than Rothko's kind of form.

 Douglas MacAgy, 'Mark Rothko', *Magazine
of Art*, vol.42, no.1, January 1949, pp.20–1.

Art News, April 1949

Mark Rothko first made his reputation as a most skillful and cunning adjuster of extravagant linear shapes on soft, and flat backgrounds. So it is surprising to find that today he has almost entirely abandoned his magnificent calligraphy for abstractions of flat, thin, colored areas that float like clouds or fall like heavy rain over the large canvases. At first the pictures seem to work by color alone – wild contrasts of green, orange, yellow and scarlet create a savage, rhetorical impact. But under this extremely emotional level is a strength of composition which is almost Oriental in its reticence – in fact, in many respects the Orientalism of Rothko could be compared with that of Whistler. In both, emphasis is on the idea of mood, on the effect of the whole. But where Rothko surpasses and simultaneously fails to equal Whistler is in his insistence on making the grand gesture, on building in a huge scale. The very ambition which went into covering such immense surfaces, the very refusal to exploit the full resources of the oil medium, has resulted in the ambiguity of the decoration which cannot be decorative.

T.[homas] B. H.[ess], 'Reviews and Previews' [review of Parsons exh.], *Art News* 48, no.2, April 1949, pp.48–9.

Art Digest, 1949

But the unfortunate aspect of the whole showing is that these paintings contain no suggestion of form or design. The famous 'pot of paint flung at the canvas' would apply here with a nicety.

M.[argaret] B.[reuning], 'Fifty-Seventh Street in Review: Mark Rothko at Parsons' [review of Parsons exh.], *Art Digest*, 15 April 1949, p.27

New York Times, January 1950

[Rothko's] big new canvases at the Betty Parsons Gallery are vibrant, even strident, with color and without what we usually call subject matter. He seems to be trying to achieve a kind of fluid Mondrian effect, abandoning sharp edges and lines but keeping more or less such areas as Mondrian used more geometrically. How far such a procedure can go and what goal it may reach is not yet clear.

Howard Devree, 'In New Directions: Current Shows Reveal Steady Expansion of Modern Movement's Horizons' [review of Parsons exh.], *New York Times*, 8 January 1950, sec.2, p.10.

Art News, February 1950

Mark Rothko's recent exhibition of large oils was this talented New Yorker's most brilliant show to date, and proves him to be one of the most gifted manipulators of color at work today. The big untitled canvases, whose background seemed washed with hues rather than painted, are divided into soft rectangles and a few fragmentary shapes by the most subtle sort of passages. There are almost no textural plays; the flattened pigment takes on the pattern of the absorbent canvas, or occasionally clots in shiny masses over it. Yet with this minimum of means Rothko has accomplished some of the most sumptuous effects in contemporary painting.

T.[homas] B. H.[ess], 'Reviews and Previews' [review of Parsons exh.], *Art News* vol.48, no.10, February 1950, p.46.

Art Digest, November 1954

Rothko's vision is a focus on the modern sensibility's need for its own authentic spiritual experience. And the image of his work is the symbolic expression of this idea. Now it is virtually impossible to articulate in rational terms what this might be; we can have only intimations of it which come first to us from our artists.

…

The beauty of Rothko's painting is its evocation of the idea and the feeling that it is still possible for us to discover serenity in the midst of turbulence and that by accepting the contradictions of our transitional times and the complexity of our desires, it is possible to create an abstract form of poise. His achievement is that with the simplest artistic means he has made a symbol of contemporary experience that has the implication of a moment of peace while stating at the same time our worst foreboding.

Hubert Crehan, 'Rothko's Wall of Light: A Show of his New Work at Chicago', *Art Digest,*

1 November 1954, pp.5, 19

Art Institute of Chicago Quarterly, November 1954

The exhibit, drawn only from the last four years, shows how completely the artist's late work relies on color. Here are canvases where relationships of color are so basic as to become both form and content. Depending chiefly on proportion and intensity of color relations, these paintings produce strange moods – sometimes somber and smoldering, sometimes ecstatic.

Katharine Kuh, 'Mark Rothko', *Art Institute of Chicago Quarterly*, 15 November 1954, p.68

Arts Digest, May 1955

There has been some trepidation in art circles regarding Rothko's new exhibition, a nervous tendency to dismiss it as the proof that his direction is no direction at all. [Quotes Rothko] 'The relations of dimensions,' he remarked, 'present the artist with one of the most difficult problems. And the closer he approaches the ultimate consequences of his art the more difficult is his task.'

L.[averne] G.[eorge], 'Fortnight in Review' [review of Janis exh.], *Arts Digest*, 1 May 1955, p.23

Art News, Summer 1955

To this reviewer, it was one of the most enjoyable shows in several years, and once again emphasized the international importance of Rothko as a leader of post war Modern Art. His leadership (like Clyfford Still's) is in the direction of simplification – to oversimplify the case in order to heighten by redefining both visual impact and effects (a distinction that must be made in any such exhibition where originality is apt to become 'difficulty').

...

The worked edges of the colors remind you immediately of Bonnard, but also of Renaissance painting – background skyscrapers with stony vapors, crystallization of evanescence. But there are no European reminiscences in the hues themselves; their surfaces are as New York as neon.

T.[homas] B. H.[ess], 'Reviews and Previews' [review of Janis exh.], *Art News*, no.54, Summer 1955, p.54.

New Yorker, April 1955

The purpose is to surround the spectator with such huge areas of color that he is swallowed up in and slightly dizzied by it all, and – to its credit, as it turns out – the gallery has gamely taken the artist at his word and crammed its walls with Rothkos hung so close that there are tensions not only within but between the pictures – a green-and-blue one, say, mere inches from a yellow-and-pink or an ochre-and-orange one, surprisingly, the venture pays off.

...

Yet the fact is that largely through the size and the compactness of their arrangement the canvases in the current collection do take on a brooding glow and a towering, almost totemic import that is quite impressive. On the whole, I think this is a collective effect and not the impact of any one canvas.

Robert M. Coates, 'The Art Galleries: Pros and Semi-Pros' [review of Janis exh.], *New Yorker*, 23 April 1955, pp.121–2

Art International, March–April 1958

His usual practice here and in the past to make his pictures color-tight is to keep the color contrasts close in value, or to keep the spectral closeness when he wants stronger value contrast. Thus no planular differentiation between field and field is asserted. However, in the new huge painting called 'Two Whites, Two Reds,' resembling a white screen flooded with light from a projector in a reddened room, Rothko seems to be striking out with an idea that he can actually find strong color *and* value contrast whose areas, under perfect control, can accomplish the resonance of color with more boldness and yet not introduce distracting or ruinous form.

E. C. Goossen, 'The End of Winter in New York' [review of Janis exh.], *Art International*, no.2, March–April 1958, p.37.

Arts & Architecture, April 1958

I cannot avoid thinking of these paintings in concert. The gradations of feeling, pressed one above the other in tissue-thin layers, are

different in each painting, but yet seems related to feeling in other paintings much as the parts of a Mozart mass are inseparable, yet can stand alone, esthetically complete.

...

In the night-like center of several paintings here, the eye strains to penetrate behind, and finally can.

...

There are those who will say that Rothko had no place to go with his simplified schemes, that the shadows which play behind these newer works are the beginning of a return to figuration. To my eye, these new paintings are simply more accented. The shadows were always the paradoxical substance of his work.

Dore Ashton, 'Art' [review of Janis exh.] *Arts & Architecture*, April 1958, pp.8, 29, 32

Art News Annual, 1958

There is a good deal of controversy as to the meaning or intention of Rothko's art. People tend to have strong convictions about it, which, as often as not, contradict the artist's own idea. Since he conceives of painting as a moral act, it flows for him that the *reaction* of the spectator, perceiving or misunderstanding the intention of the painting, is also in the sphere of the moral. His relation to the spectator, therefore, can often be one of opposition. His paintings are sometimes explained in mystical terms, but Rothko disclaims mysticism.

...

His paintings, reduced to about as close to nothing as a painting can be and still exist, have a remarkable range of expression in mood. 'I exclude no emotion from being actual and therefore pertinent,' says the artist. 'I take the liberty to play on any string of my existence. I might, as an artist, be lyrical, grim, maudlin, humorous, tragic. I allow myself all possible latitude. Everything is grist for the mill.'

Elaine de Kooning, 'Two Americans in Action: Frank Kline, Mark Rothko', *Art News Annual 27*, 1958, pp.86–97.

Art News, February 1961

In the context of two great Romantic painters, Casper David Friedrich's *Monk by the Sea* of about 1809 and Joseph Mallord William Turner's *Evening Star*, Mark Rothko's *Light Earth over Blue* of 1954 reveals affinities of vision and feeling. The tiny monk in the Friedrich and the fisher in the Turner establish, like the cattle in *Gordale Scar*, a poignant contrast between the infinite vastness of a pantheistic God and the infinite smallness of His creatures. In the abstract language of Rothko, such literal detail – a bridge of empathy between the real spectator and the presentation of a transcendental landscape – is no longer necessary; we ourselves are the monk before the sea, standing silently and contemplatively before these huge and soundless pictures as if we were looking at a sunset or a moonlit night. Like the mystic trinity of sky, water and earth that, in the Friedrich and Turner, appears to emanate from one unseen source, the floating, horizontal tiers of veiled light in the Rothko seem to conceal a total, remote presence that we can only intuit and never fully grasp. These infinite, glowing voids carry us beyond reason to the Sublime; we can only submit to them in an act of faith and let ourselves be absorbed into their radiant depths.

Robert Rosenblum, 'The Abstract Sublime', *Art News*, February 1961, pp.38–41, 56, 58

Arts, March 1961

Rothko claims that he is 'no colorist,' and that if we regard him as such we miss the point of his art. Yet it is hardly a secret that color is his sole medium. Of course what Rothko means is that the enjoyment of color for its own sake, the heightened realization of its purely sensuous dimension, is not the purpose of his painting. Yet over the years he has handled his color so that one must pay ever closer attention to it, examine the unexpectedly joined hues, the slight, and continually slighter, modulations within the large area of any single surface, and the softness and the sequence of the colored shapes. Thus these pictures compel careful scrutiny of their physical existence, of their variations in handling and arrangement, all the while suggesting that these details are means, not ends.

Robert Goldwater, 'Reflections on the Rothko Exhibition' [review of MoMA exh.], *Arts* 35, no.6, March 1961, pp. 42–5

Time, March 1961

To Rothko, almost everything depends on the viewer's being able to approach a painting as a pure and unique experience, for which he should not be prepared. The impact of color, the electric shimmer of an edge, the intensity of a shape must alone bear the message. There should be no associations, only sensations; since the viewer should recognize nothing, there should be no barriers to his flight.

'A Certain Spell' [review of MoMA exh.], *Time*, 3 March 1961, pp.72–3, 75

Observer, October 1961

In the 1940s he taught for a time on the West Coast with Clyfford Still, and here Rothko's style crystallized.

Alan Bowness, 'Absolutely Abstract', [review of Whitechapel Art Gallery, London, exh.], *Observer*, 15 October 1961, p.27

New Statesman, October 1961

These paintings are beyond poetry as they are beyond picture-making. To fantasize about them (as the catalogue does), discover storm-clouds or deserts in them; or sarcophagi, or aftermaths of nuclear explosions, is as corny as looking at Gothic architecture and thinking of the noonday twilight of the forest. These paintings begin and end with an intense and utterly direct expression of feeling through the interaction of coloured areas of a certain size. They are the realization of what abstract artists have dreamed for 50 years of doing – making painting as inherently expressive as music. More than this: for not even with music, where the inevitable sense of the performer's activity introduces more of the effects of personality, does isolated emotion touch the nervous system so directly.

David Sylvester, 'Mark Rothko' [review Whitechapel Art Gallery, London, exh.] *New Statesman*, 20 October 1961, pp.573–4

Art News, November 1970

The *Black and Grey* paintings seem very much a part of Rothko's sensibility: the elegance (in a mathematician's sense of the word) with which the paint is applied, the extreme sensitivity of the 'horizon' where black and grey meet, the particular gleam in the white edge – a kind of dancing light.

...

I am reminded of Barnett Newman's remark that when an artist gives up colors and moves to black and white, he is clearing the decks for something new, freeing himself for fresh experiment. Rothko's paintings have this nascent excitement. – And at that point his life ended. He was hard at work painting until the day of his death. He had started on a new voyage.

Thomas B. Hess, 'Rothko: A Venetian Souvenir' [review of Ca'Pesaro, Venice, exh.], *Art News*, no.69, November 1970, pp. 40–1

Art in America, March–April 1971

In their somber colors or lack of color, in their starkness and quiet, above all in a remoteness of a kind never evident in any of his previous work, they seem already to contain the mood that led to his tragic end.

Robert Goldwater, 'Rothko's Black Paintings', *Art in America*, no.59, March–April 1971, pp.58–63

Chronology

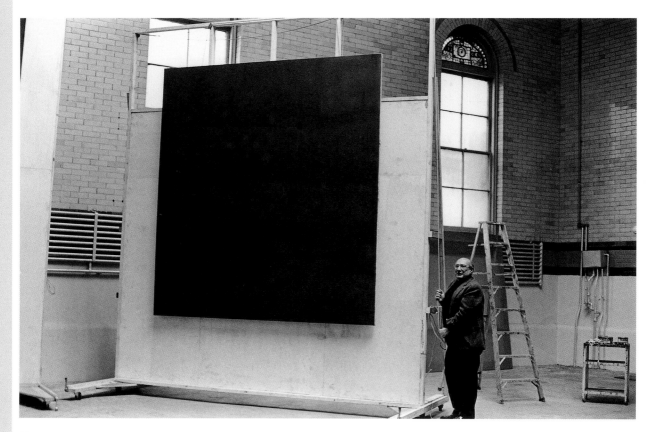

92
Mark Rothko in his studio
c.1964
Photograph by Hans
Namuth

DATE	ROTHKO'S LIFE
1903	Born Marcus Rothkowitz in Dvinsk, Russia, on 26 September.
1910	Father Jacob Rothkowitz, immigrates to the United States.
1912	Brothers Moise and Albert Rothkowitz sail from Bremen, Germany, in December. Emigrates to the United States with his mother Anna and sister Sonia.
1913	Arrives in the United States on 17 August. After a brief visit with cousins in New Haven, Connecticut, the family travels to Portland, Oregon.
1914	Father dies 27 March.
1921	Graduates from Lincoln High School in June. Enters Yale University on scholarship in the autumn.
1923	In the autumn, leaves Yale without graduating and moves to New York.
1924	Enrols in George Bridgeman's drawing class at the Art Students League in New York in January. Returns to Portland where he studies acting.
1925	Returns to New York. Enrols at the New School of Design. In October, enrols in Max Weber's still-life class at the Art Students League. Continues his studies with Weber until May 1926.
1927	Commissioned to draw maps and illustrations for *The Graphic Bible* by Lewis Browne.
1928	Sues Lewis Browne and MacMillan, the publisher of *The Graphic Bible*, when he is not credited in the book. Loses the case in the New York Supreme Court. Included in his first group exhibition at the Opportunity Gallery, New York, 15 November – 12 December.
1929	Begins teaching art to children at the Brooklyn Jewish Center. Meets Adolph Gottlieb.
1932	Meets his first wife Edith Sachar, in Lake George, New York, 2 July. The couple are married on 12 November.
1933	Travels with Edith to Portland to introduce her to his family. First solo museum exhibition presented at the Portland Art Museum. The exhibition includes works by his students at the Center Academy. Returns to New York in autumn. The Contemporary Arts Gallery presents his first solo exhibition in New York, *An Exhibition of Paintings by Marcus Rothkowitz*, 21 November – 9 December.
1934	Organises an exhibition around his students' work at the Brooklyn Museum, 8–25 February. 'New Training for Future Artists and Art Lovers' is published in the February–March issue of the *Brooklyn Jewish Center Review*.
1935	Joins Ben Zion, Ilya Bolotowsky, Gottlieb, Louis Harris, Kufeld, Schanker, Joseph Solman, and Nahum Tschacbascov in the founding of 'The Ten' in the autumn. Their first exhibition, *The Ten: An Independent Group*, is held at the Montross Gallery, New York, 16 December 1935 – 4 January 1936.

1936	Enrolled in the Treasury Relief Art Project (TRAP) of the WPA in September. Exhibition with 'The Ten' in Paris at Galerie Bonaparte, 10–24 November.
1937	Separates from wife in the summer, but reunites with her in the autumn.
1938	Becomes a naturalised citizen of the United States on 21 February. *The Ten: Whitney Dissenters*; at the Mercury Galleries, New York, 15–26 November.
1939	Final exhibition of 'The Ten' at the Bonestell Gallery, New York, 23 October – 4 November.
1940	Shortens his name to Mark Rothko (legally changes his name in 1959).
1941	Included in the first *Annual Exhibition of the Federation of Modern Painters and Sculptors*, Riverside Museum, New York, 9–23 March.
1942	Included in exhibition organised by Samuel Kootz at R. H. Macy Department Store, 5–26 January. Shows paintings based on mythological subjects for the first time, including *Antigone* 1939–40 (fig.31) and *Oedipus* 1940 (A179).
1943	Participates in *American Modern Artists: First Annual Exhibition*, Riverside Museum, 17 January – 27 February. The exhibition is organised as a protest to the Metropolitan Museum of Art's exhibition *Artists for Victory*, which opened 7 December 1942. Catalogue essay by Barnett Newman. Also participates in a second protest exhibition *New York Painters: First Exhibition*, at 444 Madison Avenue, New York, 13–27 February. His participation in the *Federation of Modern Painters and Sculptors: Third Annual*, at Wildenstein, 3–26 June, becomes the focus along with Gottlieb of Edward Alden Jewell's criticism in the *New York Times*. Rothko and Gottlieb, with Barnett Newman's assistance, send a letter to Jewell on 7 June in response to his review. Jewell includes the entire letter in his column in the *New York Times* on 13 June. Separates from his wife Edith in June. Enters hospital after suffering a possible breakdown. Travels to Portland to visit his family. Visits Berkley, California, where he meets Clyfford Still. In August, travels to Los Angeles to visit his friends Louis and Annette Kaufman, who take him to see the private collection of Walter and Louise Arensberg. Upon returning to New York in the autumn, meets Howard Putzel, advisor to Peggy Guggenheim, who convinces her to show Rothko's work in her Art of this Century gallery.
1944	Divorce to Edith is granted 1 February. Included in the first *Exhibition in America of Twenty Paintings* at Art of this Century in the spring. Meets Mary Alice (Mell) Beistle in December who becomes his second wife.
1945	First solo exhibition at Art of This Century, *Mark Rothko Paintings*, 9 January – 4 February. Participates in *A Painting Prophecy – 1950*, The David Porter Gallery, Washington. Marries Mell Beistle in Linden, New Jersey, 31 March. Selected for inclusion in the *Annual Exhibition of Contemporary Painting*, Whitney Museum of American Art, New York, 27 November 1945 – 10 January 1946.
1946	Included in *Annual Exhibition of Contemporary American Sculpture, Watercolors, and Drawings*, Whitney Museum of American Art, 5 February – 13 March. Writes catalogue foreword for Still's solo exhibition at Art of this Century, 12 February – 7 March. *Mark Rothko: Watercolors* held at the Mortimer Brandt Gallery, New York, 22 April – 4 May. The San Francisco Museum of Modern Art presents *Oils and Watercolors by Mark Rothko*, 13 August – 8 September. Exhibition travels to the Santa Barbara Museum of Art.

1946
Included in *Annual Exhibition for Contemporary American Painting*, Whitney Museum of American Art, 10 December 1946 – 16 January 1947.
San Francisco Museum of Modern Art acquires *Slow Swirl at the Edge of the Sea* 1944 (fig.43) for its permanent collection.

1947
Included in *The Ideographic Picture*, organised by Newman at the Betty Parson Gallery, 20 January – 8 February.
First solo exhibition at the Betty Parsons Gallery, *Mark Rothko: Recent Paintings*, 3 – 22 March.
Teaches summer sessions at the California School of Fine Arts, San Francisco, 23 June – 1 August.
Included in *Annual Exhibition of Contemporary American Paintings*, Whitney Museum of American Art, 6 December 1947 – 25 January 1948.

1948
Included in the Whitney's *Annual Exhibition of Contemporary American Sculptures, Watercolors, and Drawings*, 31 January – 21 March.
Second solo exhibition held at Parsons, *Mark Rothko: Recent Paintings*, 8–27 March.
Meets with Still, Robert Motherwell and Baziotes in June to discuss the formation of a new art school (Still abandons his role). Barnett Newman provides the name 'The Subjects of the Artist' for the new school which holds its first session at 35 East 8th Street, New York.
Mother dies on 10 October.

1949
Parsons presents *Mark Rothko: Recent Paintings*, 28 March – 16 April.
Subjects of the Artist School closes by spring.
Included in *Annual Exhibition of Contemporary American Sculpture, Watercolors and Drawings*, Whitney Museum of American Art, 2 April – 8 May.
Teaches at the California School of Fine Arts, 5 July to 12 August.
Included in *Annual Exhibition of Contemporary American Paintings*, Whitney Museum of American Art, 16 December 1949 – 5 February 1950.

1950
Solo exhibition *Mark Rothko*, held at the Parson Gallery, 3–21 January.
Sails to Europe with Mel on the Queen Elizabeth on 29 March. Makes first visits to Paris, Venice, Florence, Venice, Rome and London.
On 20 May, Rothko's name is included with twenty-eight other artists protesting the upcoming exhibition *American Painting Today*, at the Metropolitan Museum of Art.
Daughter Kathy Lynn (Kate) is born in New York, 30 December.
Participates in *Annual Exhibition of Contemporary American Painting*, Whitney Museum of American Art, 10 November – 30 December.

1951
Poses with seventeen other artists for the 'Irascibles' photograph in *Life* magazine, which appears in the 15 January issue.
Appointed Assistant Professor of Design at Brooklyn College.

1952
Included in *Fifteen Americans*, The Museum of Modern Art, New York, 9 April – 27 May.

1954
Included in *9 American Painters Today*, Sidney Janis Gallery, 4–23 January. Joins the Janis Gallery after leaving Parsons.
The Art Institute, Chicago, presents *Recent Paintings by Mark Rothko*, organised by Katharine Kuh, 18 October – 31 December.

1955
First solo exhibition at Sidney Janis Gallery, 11 April to 14 May.
Teaches for eight weeks as guest lecturer at the University of Colorado, Boulder.

1957
Serves as visiting artist at Newcomb Art School, Tulane University, New Orleans, February – March.
Solo exhibition, *Mark Rothko*, presented by the Contemporary Art Museum, Houston, 5 September – 6 October

1958
Sidney Janis Gallery presents its second solo exhibition of Rothko, 27 January – 22 February.
Commissioned to paint murals for the Four Seasons restaurant in the Seagram Building, New York, June.
Chosen to represent the United States along with David Smith, Mark Tobey, and Seymour Lipton at the XXIX Venice Biennale, 14 June – 19 October.
Delivers lecture at the Pratt Institute, New York, 27 October.

1959
Legally changes name to Mark Rothko.
Sails to Naples, Italy with Mel and Kate, 15 June. Sees the wall of paintings in the Villa of Mysteries in Pompeii and Michelangelo's Laurentian Library in Florence. Visits Paris, Brussels, Antwerp, Amsterdam, and England. Sails for the United States, 20 August.
Withdraws from the Seagram Mural project.

1960
Paintings by Mark Rothko, presented by the Phillips Collection, Washington, D.C., 4–31 May.

1961
The Museum of Modern Art, New York, presents retrospective, *Mark Rothko*, 18 January – 12 March. Exhibition travels to the Whitechapel Art Gallery, London, Amsterdam, Brussels, Basel, and Rome.
Sails to London in early October to see exhibition at the Whitechapel Art Gallery.
Commissioned to paint murals for a new building for the Society of Fellows at Harvard University, Cambridge, Massachusetts.

1963
Solomon R. Guggenheim Museum shows the five mural panels for Harvard University, 9 April – 2 June.
Joins Marlborough Fine Arts Gallery, New York.
Son Christopher Hall Rothko is born, 31 August.

1964
Supervises the installation of his murals at Harvard University in January.
First solo exhibition at Marlborough, London, *Mark Rothko*, February – March.
Dominque de Menil visits Rothko in New York and commissions him to create murals for a proposed chapel on the campus of the University of St Thomas, Houston, Texas.

1965
Works exclusively on the Chapel Murals.
Wins the Medal Award at Brandeis University Creative Arts Awards, 28 March.
Sir Norman Reid, Director of the Tate Gallery, London, visits Rothko in October to discuss the creation of a gallery dedicated to his paintings.

1966
Travels with family to Europe, visiting Lisbon, Majorca, and Rome, Spoleto, Assisi, France, the Netherlands, Belgium, and London. Rothko visits the gallery space in which the Tate proposes to install his work.

1967
Completes the fourteen paintings and four alternate paintings for the chapel in April. After making minor adjustments to the paintings in June, the paintings are placed in storage until the chapel's completion.
Travels with family by train to the University of California at Berkeley, where he accepts a one-month summer teaching position. Continues on to visit his family in Portland.

1968	The Museum of Modern Art, New York, includes *Slow Swirl at the Edge of the Sea* in *Dada, Surrealism, and Their Heritage*, 27 March – 9 June.
	Suffers an aortic aneurysm on 20 April and is admitted to New York Hospital. Discharged 8 May, and is confined to bed for another three weeks.
	Inducted into the National Institute of Arts and Letters, 28 May.
	Draws up a new will on 13 September with the assistance of his accountant Bernard Reis that divides his estate between his family and the Mark Rothko Foundation.
	Begins inventorying the more than eight hundred works that are still in his possession. Adds dates to paintings as part of the inventory process.
1969	Leaves his wife Mell on 1 January and moves to his studio on 69th Street in New York.
	Begins painting the *Black and Grey* canvases during the spring.
	Receives an honorary doctorate from Yale University, 9 June.
	The Mark Rothko Foundation is incorporated on 12 June with Rothko, Morton Feldman, Robert Goldwater, Morton Levin, Bernard Reis, Theodoros Stamos and Clinton Wilder as directors.
	Diagnosed with bilateral emphysema, 30 September.
	Teaches several classes at Hunter College, New York.
	Included in *New York Painting and Sculpture 1940–1970*, 18 October 1969 – 1 February 1970. Sees Frank Stella at the opening, who he invites for a future visit to his studio.
	Donates nine Seagram murals to the Tate Gallery.
1970	Commits suicide on 25 February. He is buried on 28 February in North Shore, Long Island.
	The Rothko Room opens at the Tate Gallery, London
1971	Rothko Chapel in Houston is dedicated on 27 February as an interdenominational chapel.

Chronology sources include: James E. Breslin, *Mark Rothko: A Biography*; David Anfam, *Mark Rothko: The Works on Canvas: Catalogue Raisonné*; The Mark Rothko and his Times Oral History Project, Archives of American Art, Smithsonian Institution; and 'Chronology', *Mark Rothko,* National Gallery of Art, Washington.

Works in Public Collections

United Kingdom

London

TATE

Twelve paintings: nine paintings from the Seagram's Mural Series installed in the Rothko Room at Tate Modern, including *Black on Maroon* 1958 (A636) *Red on Maroon* 1959 (A657); also *Untitled* 1946–7 (A324); *Untitled* 1950–2 (A447); *Light Red over Black* 1957 (A601). One work on paper

Argentina

Buenos Aires

MUSEO NACIONAL DE BELLAS ARTES

One painting: *No.36 (Light Red over Dark Red* 1955–7 (A540)

Australia

Canberra

THE NATIONAL GALLERY OF AUSTRALIA

Two paintings: *Untitled [Multiform]* 1948 (A380); *No.20 (Deep Red and Black)* 1957 (A596). One drawing, one screenprint

Melbourne

NATIONAL GALLERY OF VICTORIA

One painting: *Untitled [Red]* 1956 (A551)

Canada

Ottawa

THE NATIONAL GALLERY OF CANADA

One painting: *No.16 (Two Whites, Two Reds)* 1957 (A590)

Denmark

Humlebaek

LOUISIANA MUSEUM OF MODERN ART

One painting: *Untitled* 1964 (A767)

France

Paris

MUSEE NATIONALE D'ART MODERNE, CENTRE GEORGE POMPIDOU

One painting: *No.14 (Browns over Dark)* 1963 (A755)

Germany

Berlin

STAATLICHE MUSEEN PREUSISCHER
KULTURBESITZ, NATIONALGALERIE

One painting: *No.5 (Reds)* 1961 (A695)

Cologne

MUSEUM LUDWIG

One painting: *Earth and Green* 1955 (A532)

Düsseldorf

KUNSTSAMMLUNG NORDRHEIN-WESTFALEN

One painting: *Untitled [Three Blacks in Dark Blue]* 1960 (A676)

Essen

MUSEUM FOLKWANG

One painting: *White and Brick on Light Red (White, Pink and Mustard)* 1954 (A519)

Stuttgart

STAATSGALERIE

One painting: *Untitled* 1962 (A720)

Iran

Tehran

MUSEUM OF CONTEMPORARY ART

Two paintings: *No.11[?]/No.2 (Yellow Center)* 1954 (A511); *Untitled [Sienna, Orange and Black over Dark Brown]* 1962 (A728)

Israel

Jerusalem

THE ISRAEL MUSEUM

One painting: *Untitled* 1955 (A533)

Tel Aviv

THE TEL AVIV MUSEUM

Two paintings: *Untitled* 1947 (A340); *No.24 [Untitled]* 1951 (A466)

Japan

Fukuoka

FUKUOKA ART MUSEUM

One painting: *Untitled* 1961 (A699)

Karuizawa

SEZON MUSEUM OF MODERN ART

One painting: *No.7* 1960 (A673)

Osaka

CITY MUSEUM OF MODERN ART

One painting: *No.17 (Bottle Green and Deep Reds)* 1958 (A626)

Sakura-Shi, Chiba-Ken

KAWAMURA MEMORIAL MUSEUM OF ART

Seven paintings: *Untitled [Deep Red on Maroon] [Seagram Mural Sketch]* 1958 (A635); *Mural Sketch [Seagram Mural Sketch]* 1958 (A638); *Sketch for 'Mural No.1' [Seagram Mural Sketch]* 1958 (A639); *Sketch for 'Mural No.4' [Orange on Maroon] [Seagram Mural Sketch]* 1958 (A641); *Mural Sketch [Seagram Mural Sketch]* 1959 (A654); *Mural Section 1 [Seagram Mural]* 1959 (A656); *Untitled [Black on Maroon [Seagram Mural Section]* 1959 (A659)

Shiga

THE MUSEUM OF MODERN ART

One painting: *No.28* 1962 (A727)

Tokyo

MUSEUM OF CONTEMPORARY ART

One painting: *Black Area in Reds* 1958 (A633)

Wakayama

THE MUSEUM OF MODERN ART

One painting: *Tan and Black on Red* 1957 (A607)

Korea

Seoul

HO-AM ART MUSEUM

Four paintings: *White Over Red* 1956 (A547); *Blue Cloud* 1956 (A569); *Four Reds* 1957 (A604); *Untitled [Black and Orange on Red]* 1962 (A715)

Mexico

Mexico City

MUSEO RUFINO TAMAYO

One painting: *No.18/No.16 [Untitled/Plum; Orange, Yellow]* 1949 (A402)

The Netherlands

Amsterdam

STEDELIJK MUSEUM

One painting: *Untitled [Umber, Blue, Umber, Brown]* 1962 (A726)

Rotterdam
MUSEUM BOIJMANS VAN BEUNINGEN
One painting: *No.8 [Grey, Orange on Maroon]* 1960 (A674)

Spain
Bilbao
GUGGENHEIM MUSEUM
One painting: *No.10 [?] [Untitled]* 1952–3 (A483)

Madrid
FUNDACIÓN COLECCION THYSSEN-BORNEMISZA
One painting: *Untitled [Green on Maroon]* 1961 or 1964 (A709)

Switzerland
Basel
OFFENTLICHE KUNSTSAMMLUNG BASEL, KUNSTMUSEUM
Two paintings: *No.16 (Red, White and Brown)* 1957 (A591); *No.1* 1964 (A773)

Bern
KUNSTMUSEUM BERN
One painting: *No.7 [Dark Brown, Grey, Orange]* 1963 (A748)

Zurich
KUNSTHAUS ZURICH
One painting: *Untitled [White, Black, Greys on Maroon]* 1963 (A758)

United States
Arizona: Tucson
UNIVERSITY OF ARIZONA MUSEUM OF ART
One painting: *Green on Blue (Earth-Green and White)* 1956 (A543)

California: Berkeley
UNIVERSITY ART MUSEUM, UNIVERSITY OF CALIFORNIA
One painting: *No.207 [Red over Dark Blue on Dark Grey]* 1961 (A707)

California: Los Angeles
LOS ANGELES COUNTY MUSEUM OF ART
Two paintings: *No.4/No.32* c.1949 (A411); *White Center* 1957 (A576)

California: Los Angeles
MUSEUM OF CONTEMPORARY ART
Ten paintings: *Untitled* 1947 (A348); *No.2 (Yellow and Orange)* 1949 (A409); *No.61 (Rust and Blue [Brown, Blue, Brown on Blue]* 1953 (A492); *No.9 (Dark over Light Earth/Violet and Yellow in Rose)* 1954 (A508); *Purple Brown* 1957 (A593); *No.46 [Red, Ochre, Black on Red/Black, Ochre, Red over Red]* 1957 (A597); *Brown over Red [Red and Brown]* 1957 (A605); *No.301 [Reds and Violet over Red/Red and Blue over Red]* 1959 (A665); *No.12 (Black on Dark Sienna on Purple)* 1960 (A678); *Untitled [Black on Grey]* 1969–70 (A829). One watercolour

California: San Francisco
SAN FRANCISCO MUSEUM OF MODERN ART
Four paintings: *Unitled* 1947 (A347); *No.14 [Untitled]* 1955 (A531); *Untitled* 1960 (A672); *No.14* 1960 (A679). One watercolour

Connecticut: Hartford
WADSWORTH ATHENAEUM
One painting: *No.19 [Untitled]* 1948–9 (A395)

Connecticut: New Haven
YALE UNIVERSITY ART GALLERY
Four paintings: *Untitled* 1947 (A343); *Untitled* 1954 (A502); *Orange* 1957 (A580); *No.3 (Untitled/Orange)* 1967 (A810)

Georgia: Atlanta
HIGH MUSEUM OF ART
Three paintings: *Untitled/Votive Figure [?] or Orison [?]* 1946 (A301); *Untitled* 1947 (A328); *Untitled* 1952 (A481)

Illinois: Champaign
KRANNERT ART MUSEUM AND KINKEAD PAVILION, UNIVERSITY OF ILLINOIS
One painting: *No.13* 1949 (A397)

Illinois: Chicago
THE ART INSTITUTE OF CHICAGO
Three paintings: *No.19* 1949 (A403); *Untitled [Purple, White and Red]* 1953 (A497); *Untitled (Painting)* 1953–4 (A500)

Illinois: Chicago
THE DAVID AND ALFRED SMART MUSEUM OF ART, UNIVERSITY OF CHICAGO
One painting: *No.2* 1962 (A712)

Iowa: Des Moines

DES MOINES ART CENTER

One painting: *Light over Gray* 1956 (A567)

Iowa: Iowa City

UNIVERSITY OF IOWA MUSEUM OF ART

One painting: *Untitled* 1941–2 (A193)

Maryland: Baltimore

THE BALTIMORE MUSEUM OF ART

One painting: *Black over Reds [Black on Red]* 1957 (A600)

Massachusetts: Andover

ADDISON GALLERY OF AMERICAN ART, PHILLIPS ACADEMY

One painting: *Ritual II* 1944 (A233)

Massachusetts: Cambridge

FOGG ART MUSEUM, HARVARD UNIVERSITY

Eight paintings: Six panels for the Harvard Murals installation 1962 (A737–41); *Untitled* 1947 (A342); *The Black and The White* 1956 (A572)

Michigan: Detroit

THE DETROIT INSTITUTE OF ARTS

One painting: *No.202 (Orange, Brown)* 1963 (A752)

Minnesota: Minneapolis

WALKER ART CENTER

Five paintings: *Ritual/Ritual* 1944 (A232); *No.6 [?]/No.12* 1949 (A413); *Untitled [Red, Black, Orange, Yellow on Yellow]* 1953 (A489); *No.44 (Two Darks in Red)* 1955 (A539); *No.2 [Untitled]* 1962 (A744)

Missouri: Kansas City

THE NELSON-ATKINS MUSEUM OF ART

One painting: *No.11* 1963 (A750)

Missouri: Saint Louis

THE SAINT LOUIS ART MUSEUM

One painting: *Red, Orange, Orange on Red* 1962 (A714)

Nebraska: Lincoln

SHELDON MEMORIAL ART GALLERY, UNIVERSITY OF NEBRASKA-LINCOLN

One painting: *Yellow Band* 1956 (A555)

New Hampshire: Hanover

HOOD MUSEUM OF ART

One painting: *No.8 (Lilac and Orange over Ivory)* 1953 (A490)

New York: Albany

EMPIRE STATE PLAZA ART COLLECTION

One painting: *Untitled* 1967 (A806)

New York: Buffalo

ALBRIGHT-KNOX ART GALLERY

Two paintings: *Orange and Yellow* 1956 (A548); *No.22 [Untitled]* 1961 (A703)

New York: New York

THE BROOKLYN MUSEUM OF ART

Three paintings: *Untitled [Two Seated Women]* 1933–4 (A51); *Subway* 1939 (A166); *Untitled* 1947 (A338)

New York: New York

THE METROPOLITAN MUSEUM OF ART

Six paintings: *No.21 [Mutliform/Untitled]* 1949 (A405); *Untitled* 1949 (A421); *Untitled* 1950 (A446); *No.13 [White, Red on Yellow]* 1958 (A620); *No.16* 1960 (A683); *Untitled* 1964 (A771)

New York: New York

THE MUSEUM OF MODERN ART

Fourteen paintings: *Slow Swirl at the Edge of the Sea* 1944 (A248); *No.5/No.24* 1948 (A386); *No.1 [Untitled]* 1948 (A390); *No.3/No.13 [Magenta, Black, Green on Orange]* 1949 (A410); *No.5/No.22* 1950 (A442); *No.10* 1950 (A449); *Red and Orange* 1955 (A542a); *No.16 (Red, Brown and Black)* 1958 (A624); *No.37/No.19 (Slate Blue and Brown on Plum)* 1958 (A632); *No.14 (Horizontals, White over Darks)* 1961 (A710); *Untitled* 1969–70 (A828). Two watercolours, and one drawing

New York: New York

SOLOMON R. GUGGENHEIM MUSEUM

Seven paintings: a double-sided composition: *Untitled [Still Life with Rope, Hammer and Trowel]* c.1937 (A109) and *Untitled [Still Life with Mallet, Book and Scissors]* c.1937 (A110); *Untitled* 1942 (A201); *Untitled* 1947 (A363); *Untitled [Violet, Black, Orange, Yellow on White and Red]* 1949 (A420); *No.18 [Black, Orange on Maroon]* 1963 (A756); *Untitled [Black on Grey]* 1969–70 (A830). One watercolour

New York: New York

THE WHITNEY MUSEUM OF AMERICAN ART

Three paintings: *Agitation of the Archaic* 1944 (A240); *No.4 [Untitled]* 1953 (A487); *Four Darks in Red* 1958 (A611)

New York: Poughkeepsie

THE FRANCES LEHMAN LOEB ART CENTER AT VASSAR COLLEGE

One painting: *No.1 (No.18, 1948)* 1948–9 (A396)

New York: Purchase

NEUBERGER MUSEUM OF ART, PURCHASE COLLEGE, NEW YORK STATE UNIVERSITY

Four paintings: *Untitled [Two Nudes Standing in Front of a Doorway]* 1939 (A173); *Untitled* 1941–2 (A194); *Untitled* 1947 (A326); *Old Gold over White* 1956 (A571)

New York: Utica

MUNSON-WILLIAMS-PROCTOR INSTITUTE MUSEUM OF ART

Two paintings: *No.11 [Untitled]* 1947 (A334); *No.18* 1951 (A464)

Ohio: Cincinnati

CINCINNATI ART MUSEUM

One painting: *Untitled [Brown, Orange, Blue on Maroon]* 1963 (A757)

Ohio: Cleveland

THE CLEVELAND MUSEUM OF ART

One painting: *No.2 (Red Maroons)* 1962 (A718)

Ohio: Oberlin

ALLEN MEMORIAL ART MUSEUM

One painting: *The Syrian Bull* 1943 (A214)

Ohio: Toledo

THE TOLEDO MUSEUM OF ART

One painting: *Untitled* 1960 (A670)

Oregon: Portland

THE DOUGLAS F. COOLEY MEMORIAL ART GALLERY, REED COLLEGE

One painting: *Beach Scene* c.1927 (A9)

Pennsylvania: Philadelphia

PHILADELPHIA MUSEUM OF ART

Two paintings: *Gyrations on Four Planes [Horizontal Procession]* 1944 (A241); *Untitled* 1955 (A541)

Pennsylvania: Pittsburgh

THE CARNEGIE MUSEUM OF ART

One painting: *Yellow and Blue [Yellow, Blue on Orange]* 1955 (A528)

Rhode Island: Providence

MUSEUM OF ART, RHODE ISLAND SCHOOL OF DESIGN

One painting: *Untitled* 1954 (A518)

Texas: Austin

THE BLANTON MUSEUM OF ART, UNIVERSITY OF TEXAS AT AUSTIN

One painting: *Untitled* 1943 (A218)

Texas: Dallas

DALLAS MUSEUM OF ART

Three paintings: *No.26* 1947 (A336); *Untitled* 1952 (A471); *Orange, Red and Red* (A721)

Texas: Fort Worth

MODERN ART MUSEUM OF FORT WORTH

One painting: *Light Cloud, Dark Cloud* 1957 (A574)

Texas: Houston

THE MENIL COLLECTION

Twenty-eight paintings: *Astral Image* 1946 (A302); *No.21 [Untitled]* 1949 (A407); *The Green Stripe* 1955 (A524); *Plum and Brown* 1956 (A568); *No.10* 1957 (A585); *Untitled ['Predella' to Harvard Mural Panel Four]* 1963 (A760); *Untitled ['Predella' to Harvard Mural Panel Two]* 1963–5 (A761); *Untitled [Study for Rothko Chapel Mural]* 1965 (A782); fourteen paintings for the Rothko Chapel 1965–7 (A791–804); six additional Chapel paintings 1966 (A785–790)

Texas: Houston

THE MUSEUM OF FINE ARTS

One painting: *No.14 (Painting)* 1961 (A701)

Virginia: Norfolk

CHRYSLER MUSEUM OF ART

One painting: *No.5 [Untitled]* 1949 (A412)

Virginia: Richmond

VIRGINIA MUSEUM OF FINE ARTS

One painting: *Untitled* 1960 (A677)

Washington: Seattle

SEATTLE ART MUSEUM

One painting: *Untitled* 1947 (A337)

Washington, D.C.

NATIONAL GALLERY OF ART

In 1985 and 1986, The Mark Rothko Foundation made a gift to the National Gallery of Art, Washington, of hundreds of paintings and drawings by Rothko, making the National Gallery of Art one of the most important repositories of work by the artist. (Over thirty of these works are illustrated in this publication: see individual credit lines.)

Notes

Introduction

1 Mark Rothko, *The Artist's Reality: Philosophies of Art*, ed. with intro. Christopher Rothko, New Haven and London 2004, p.15.
2 Ibid., p.14.

1. Early Years

1 See Francis M. Naumann, 'Frederic C. Torrey and Duchamp's Nude Descending a Staircase', in Bonnie Clearwater (ed.), *West Coast Duchamp*, Miami Beach, Florida 1991, pp.11–23.
2 James E.B. Breslin, *Mark Rothko: A Biography*, Chicago and London 1993 (paperback ed., 1998), p.35.
3 Catherine Jones, 'M. Rothkowitz, Instructor of Children's Art Work Now on Display Here, Wins Fame', *Sunday Oregonian*, 30 July 1933, sec.3, p.5.
4 Breslin 1993, p.50.
5 Ibid., p.62.
6 Max Weber, *Essays on Art*, New York 1916, p.26.
7 Rothko, *The Artist's Reality: Philosophies of Art*, p.41.
8 Weber 1916, p.39.
9 David Anfam, *Mark Rothko: The Works on Canvas: Catalogue Raisonné*, New Haven and London 1998 (repr. 2001), pp.27, 41. Also see David Anfam, 'Hopper's Melancholic Gaze', *Edward Hopper*, exh. cat., Tate Modern, London 2005, pp.34–47.
10 Weber 1916, p.39.
11 Friedrich Delitizsch, *Babel and Bible: Two Lectures before the Members of the Deutsche Orient-Gesselschaf in the Presence of the German Emperor*, ed. with intro. by C.H. Johns, New York and London 1903.
12 The trial was held at New York's Supreme Court, 28 December 1928 – 7 January 1929. The referee of the trial ruled against Rothko's claim. For an extensive discussion of the trial, see Breslin 1993, pp.65–78. The significance of Rothko's statements in this trial and the reference to his sources were first discussed in Bonnie Clearwater, 'Tragedy, Ecstasy, Doom: Clarifying Rothko's Theory on Art', College Art Association of America Annual Meeting, session 'New Myths for Old: Redefining Abstract Expressionism', New York, February 1986. Extensive comparisons between Rothko's mythic paintings and these early illustrative sources were shown in slides, including the Assyrian Bull in the *Graphic Bible* illustrations as a model for the archaic features of Rothko's mythic figures.
13 Rothko trial transcript.
14 Mark Rothko, 'New Training for Future Artists and Art Lovers', *Brooklyn Jewish Center Review*, Feb.–March 1934, pp.10–11; Rothko, *Writings on Art: Mark Rothko*, ed. and with an introduction by Miguel López-Remiro, New Haven and London 2006, p.1.
15 Mark Rothko, 'Scribble Book', Mark Rothko, Manuscripts and Sketchbook, c.1935–1943, Getty Research Institute, Los Angeles; microfilm, Mark Rothko Foundation Papers, Archives of American Art, Smithsonian Institution, Washington.
16 Ibid.
17 Catherine Jones, *Sunday Oregonian*, 30 July 1933, sec.3, p.5.
18 Eulogy for Milton Avery, delivered 7 January 1965, New York Society for Ethical Culture: transcript published in *Mark Rothko*, exh. cat., Tate Gallery, London 1987, p.89.
19 Rothko, 'Scribble Book'. In Rothko, *Writings on Art*, López-Remiro gives a c.1934 date to these notes. However, Rothko's references to statements by Viennese art teacher Franz Cizek that were published in Wilhelm Viola, *Child Art and Franz Cizek*, Vienna 1936, suggest that these notes were written later.
20 Sally Avery, transcript of interview with Tom Wolfe, Archives of American Art, Smithsonian Institution, Washington.
21 Breslin 1993, p.102.
22 Mark Rothko, 'The Portrait and the Modern Artist', typescript of a broadcast with Adolph Gottlieb on 'Art in New York', Radio WNYC, 13 October 1943; *Mark Rothko* (Tate Gallery), p.79; Rothko, *Writings on Art*, p.38.
23 Anfam 1998, p.29. Anfam also cites specific paintings by Rothko that may have been modelled after Rembrandt's paintings, pp.29–32.
24 Ibid., p.36.
25 Adolph Gottlieb in 'Artist Sessions at Studio 35' (1950), in Robert Goodnough (ed.), *Modern Artists in America*, New York 1951, pp.12–13.
26 Rothko, *The Artist's Reality: Philosophies of Art*, pp.44–5.
27 Joseph Solomon, quoted in Breslin 1993, p.106.
28 Jerome Klein, 'The Critic Takes a Glance around the Galleries', *New York Post*, 19 January 1935, p.4.
29 Edward Alden Jewell, 'Art Review', *New York Times*, 20 Dec. 1936, sec.x, p.11.
30 Mark Rothko and Bernard Bradden, '*The Ten' Whitney Dissenters*, exh. brochure (n.p.), Mark Rothko Foundation Archives, National Gallery of Art, Washington.
31 Breslin 1993, p.104.
32 Adolph Gottlieb, quoted in Breslin 1993, p.163.

Untitled: Still Life with Mallet, Scissors and Glove

1 New Rochelle Post Office Murals Competition, 1938. See Anfam 1998, p.40.
2 Rothko, *The Artist's Reality: Philosophies of Art*, p.58.
3 Ibid., p.59.
4 Rothko would have known Giotto's work primarily from black-and-white reproductions prior to his trip to Europe in the summer of 1950. The Metropolitan Museum of Art had only one Giotto (*The Epiphany*, possibly c.1320, tempera on wood, gold ground)

at the time that he could have studied there first hand.
5 Ibid., p.46.
6 Ibid., p.88.

2 The Spirit of Myth: Painting in the Early 1940s

1 Rothko, *The Artist's Reality: Philosophies of Art*.
2 Lewis Kachur, *Displaying the Marvelous*, Cambridge, Massachusetts, and London 2001, pp.112–13. For Dali's *Dream of Venus* pavilion at the New York World's Fair, also see pp.107–60, and *Dream of Venus*, exh. cat., Museum of Contemporary Art, North Miami 2002. Ingrid Schaffner, *Salvador Dali's Dream of Venus*, New York 2002.
3 Viola 1936, p.24.
4 Rothko, 'Scribble Book'; Rothko, *Writings on Art*, p.9.
5 Viola 1936, p.28.
6 Rothko, *The Artist's Reality: Philosophies of Art*, p.6.
7 Ibid., p.10.
8 Ibid., p.76.
9 Ibid., p.82.
10 Friedrich Nietzsche, *The Birth of Tragedy*, trans. Walter Kaufmann, New York 1967, p.33.
11 Ibid., p.66.
12 Rothko, *The Artist's Reality: Philosophies of Art*, p.85.
13 Ibid., p.83.
14 Ibid., p.94.
15 Anfam 1998, p.47.
16 Clearwater 1986.
17 Anfam 1998, p.50.
18 Rothko, *The Artist's Reality: Philosophies of Art*, p.87.
19 Breslin 1993, pp.166–7; Anna Chave, *Mark Rothko: Subjects in Abstraction*, Hartford, Connecticut 1989, pp.83, 88–9.
20 Mark Rothko in Sidney Janis, *Abstract and Surrealist Art in America*, New York 1948, p.118; *Mark Rothko* (Tate Gallery), p.81.
21 Trial transcript.
22 As Rothko did not date many of his paintings it is difficult to provide an accurate chronology. In the late 1960s he and his assistants inventoried all the works still in his possession. At that time he assigned a date of 1938 to *Antigone*. Anfam assigns a date of 1939–40 in the catalogue raisonné. In the exhibition *New Works by Marcel Gromaire, Mark Rothko, Joseph Solman*, Neumann-Willard Gallery, New York, 8–27 January 1940, Rothko only showed figurative paintings such as *Entrance to Subway* c.1938 (fig.12) (as the emphasis of the exhibition was on 'new works' this painting may in fact be later). None of the myth-based paintings were publicly exhibited until the Macy's show in 1942. Rothko also noted that he began making paintings based on myths during the Second World War, which suggests 1939 as the earliest date (if he meant during America's participation in the war, then this painting would be dated 1942).
23 Samuel Kootz, letter to the *New York Times*, 10 August 1941.
24 Samuel Kootz, '"Bombshell" Clarified', *New York Times*, 5 October 1941, p.9.
25 Barnett Newman, foreword to catalogue for *American Modern Arstists: Firste Annual Exhibtion*, exh.cat., Riverside Museum, New York 1943.
26 Ibid.
27 According to Morris Calden, a boarder in Rothko and Edith's home in 1940, Rothko suffered an emotional collapse during a separation from his wife. Calden reports that Rothko could not leave his bed, and consequently it is likely that he did not paint much during this period. Morris Calden, interview with Bonnie Clearwater and Barbara Shikler, 30 June 1982, Mark Rothko Foundation Papers, National Gallery of Art, Washington.
28 Anonymous statement, brochure for the Federation of Modern Painters and Sculptors, 2 June 1943; Federation of Modern Artists and Sculptors Papers, Archives of American Art, Smithsonian Institution.
29 Newman equated American Regionalism painting with the United States' political isolationism prior to the attack on Pearl Harbor. In an unpublished essay, 'What about Isolationist Art?', drafted by Newman in late spring 1942, he observed that although America's participation in the Second World War terminated a period of political isolationism, American culture continued to be dominated by the official art world's xenophobia. Newman wrote: 'Publishers and critics, art dealers and museum directors willingly or unwillingly are completely dominated by an isolationist aesthetic that permits no deviation.' Isolationism in any form was dangerous because it is the result of the 'same intense, vicious nationalism', that gave rise to 'Hitlerism'. See Barnett Newman, 'What about Isolationist Art?', in *Barnett Newman: Selected Writings and Interviews*, ed. John P. O'Neill, Berkeley and Los Angeles 1992, pp.22, 23.
30 Edward Alden Jewell, 'The Realm of Art: A New Platform and Other Matters: "Globalism" Pops into View', *New York Times*, 13 June 1943, p.x9.
31 Edward Alden Jewell, 'Modern Painters Open Show Today', *New York Times*, 2 June 1943, p.28.
32 Jewell, 'The Realm of Art', p.x9.
33 Ibid.
34 Mark Rothko, draft letter to Edward Alden Jewell, Research Library, Getty Research Institute, Los Angeles; Rothko, *Writings on Art*, pp.30–4. See Bonnie Clearwater, 'Shared Myths: Reconsideration of Rothko's and Gottlieb's Letter to the *New York Times*', *Archives of American Art*, vol.24, no.1, 1984, pp.23–5.
35 Ibid. Anfam identified the abstracted and fragmented figure in *The Syrian Bull* as based on the winged Assyrian Bull in *The Graphic Bible* and the Assyrian Winged Bull, 885–860 BC in the collection of the Metropolitan Museum of Art, New York; Anfam 1998, p.52. Rothko noted in *The Artist's Reality: Philosophies of Art* that the Assyrians respected the power of beasts whereas the Greeks, who had conquered many wild animals, used them to represent evil; Rothko, *The Artist's Reality: Philosophies of Art*, p.86.
36 Ibid., draft letter to Jewell.
37 Rothko in 'The Portrait and the Modern Artist'; *Mark Rothko* (Tate Gallery), p.79.
38 See Naomi Salweson Gorse, 'Hollywood Conversations: Duchamp and the Arensbergs', in Clearwater 1991, pp.24–5. Diane Waldman suggested that there was a connection between Duchamp and Rothko's work. She noted: 'The existence of a link between Duchamp and Rothko remains an intriguing if hitherto unexplored possibility.' Diane Waldman, *Mark Rothko: A Retrospective 1903–1970*, New York 1978, p.56. According to Aaron Siskind and William Rubin, Rothko cited Duchamp and Roberto Matta as influences on his work: see Anfam 1998, p.67.
39 The swirling, girating form appears in *Untitled* 1943 (A221), which Anfam postulates was exhibited in *Small in Size*, Gallery of Modern Art, New York, 25 October – 13 November 1943.
40 Buffie Johnson, interview with Barbara Shikler, 3 November 1982, transcript, Archives of American Art, Smithsonian Institution, Washington.
41 See Breslin 1993, pp.212–16.
42 Peggy Guggenheim, letter to Grace L. McCann Morley, Director of San Francisco Museum of Modern Art, 1 June 1946; Mark Rothko, letter to Morley, 20 August 1946, Mark Rothko Foundation Archives. See Breslin 1993, p.601.
43 Rothko, *The Artist's Reality: Philosophies of Art*, p.87.
44 Rothko, letter to Barnett and Annalee Newman, 31 July 1945, Barnett Newman Papers, Archives of American Art, Smithsonian Institution, Washington; Rothko, *Writings on Art*, p.47.
45 Rothko, *The Artist's Reality: Philosophies of Art*, p.54.
46 Mark Rothko, 'Personal Statement', in *Painting Prophecy, 1950*, exh. cat., David Porter Gallery, Washington 1945; *Mark Rothko* (Tate Gallery), p.82; Rothko, *Writings On Art*, p.45.
47 Ibid. See Robert Goldwater, *Primitivism in Modern Painting*, New York and London 1938 (repr. as *Primitivism in Modern Art*, Cambridge, Mass. 1986), p.218, for a discussion of the relationship between Surrealism and primitive art.
48 Mark Rothko, 'The Romantics Were Prompted', *Possibilities 1*, Winter 1947–8, p.84; Rothko, *Writings on Art*, p.58.
49 Ibid.; Rothko, *Writings on Art*, pp.58–9.

Sacrifice of Iphigenia

1 Rothko, *Writings on Art*, p.126.

2 Anfam suggests that the totem on the right is based on the illustration of the Babylonian god Madre that appeared in *Babel and Bible* and therefore represents a cosmic deity, Anfam 1998, p.53.
3 Rothko, *Writings on Art*, p.126. In a letter to Alfred Jensen, April 1956, Rothko wrote about the impact *Fear and Trembling* had on him: 'I found that [Kierkegaard] was writing almost exclusively about the artist who is beyond all others. And as I read him more and more I got so involved with his ideas that I identified completely with the artist he was writing about. I was that artist.' Breslin 1993, p.392.

3 The Irascibles

1 Michel Seuphor, 'Paris, New York', *Art d'aujourd' hui*, 1951, trans. Francine du Plessix and Florence Weinstein. Published in English in *Modern Artists in America* (Goodnough 1951), p.118. According to the editors of *Modern Artists in America*, Seuphor may have been the first European critic to write 'sympathetically and understandably' on the American avant-garde.
2 Ibid.
3 Thomas B. Hess, *Barnett Newman*, exh. cat., Museum of Modern Art, New York 1971, p.48.
4 Rothko, letter to Barnett and Annalee Newman, 10 August 1946, Barnett Newman Papers, Archives of American Art, Smithsonian Institution, Washington; Rothko, *Writings on Art*, p.50.
5 Mark Rothko, introduction, *Clifford Still*, exh. cat., Art of This Century, New York 1946, unpag.; *Mark Rothko* (Tate Gallery) 1987, pp.82–3; Rothko, *Writings on Art*, p.48. Permission to reproduce a work by Still in the present publication was declined.
6 Ibid.
7 Rothko, 'The Romantics Were Prompted' in *Mark Rothko* (Tate Gallery), pp.83–4; Rothko, *Writings on Art*, p.58.
8 Rothko, 'Scribble Book'; Rothko, *Writings on Art*, p.8.
9 Barnett Newman, 'The Sublime Is Now', *Tiger's Eye*, 15 December 1948, p.51.
10 Rothko, letter to Herbert Ferber written about autumn 1947; Rothko, *Writings on Art*, p.53.
11 Rothko, letter to Barnett and Annalee Newman, 19 July 1947, Barnett Newman Papers, Archives of American Art, Smithsonian Institution, Washington; Rothko, *Writings on Art*, p.52.
12 Ibid.
13 Rothko, letter to Clay Spohn, 24 September 1947, Rothko, *Writings on Art*, p.55.
14 Douglas MacAgy, 'Mark Rothko', *Magazine of Art*, vol.42, no.1, January 1949, pp.20–1. *No.18* was reproduced in MacAgy's article with the date of 1948. This date coincided with the first time these works were exhibited at the Betty Parsons Gallery. As with most

paintings by Rothko the dating of these works is problematic as he rarely dated them at the time they were painted. Anfam dates *No.18* to 1946, based on an inscription on the reverse of the canvas indicating this date. He recognises that it is difficult to fix the dates with any certainty. The record keeping at the Betty Parsons Gallery was not always reliable either, so the dates it provided for reproductions may not have been accurate (Anfam conversation with the author). Moreover, many of the inscriptions on the back of canvases were added at later dates. However, the fact that MacAgy and/or Rothko chose this work to be reproduced suggests that it embodies some of the new formal elements that appeared in Rothko's paintings the summer of 1947 as a result of his new thinking about pictorial space. It is possible that this work was painted in the latter half of 1947 or that he reworked a painting that was dated 1946 on the reverse.
15 MacAgy 1949, p.20.
16 Rothko wrote, 'If one understands … the particular kind of space to which a painting is committed, then he has obtained the most comprehensive statement of the artist's attitude toward reality. Space, therefore, is the chief manifestation on the artist's conception of reality', *The Artist's Reality: Philosophies of Art*, p.59.
17 William M. Ivins, Jr, *Art and Geometry: A Study in Space Intuitions* (1946) New York 1964, p.2. In his footnote on peripheral vision, Ivins cited W.S. Elder, *Text Book of Opthalmology*, for his scientific evidence: 'It is said that at a point two and a half degrees from the points of nearest sharpness of vision there is a 50 percent decrease in acuity, and that at forty-five degrees the acuity has fallen to 2 1/4 percent'; p.2, n.2. Rothko's undated manuscript probably was written over a period of several years. MacAgy's reference to Ivins's book *Art and Geometry* (1946) suggests that the section dealing with space intuition in Rothko's manuscript postdates the publication of this source.
18 Ibid., pp.2–3.
19 Ibid., p.7.
20 Rothko, *The Artist's Reality: Philosophies of Art*, p.60.
21 Ibid., p.56.
22 MacAgy 1949, p.20.
23 Ibid.
24 Rothko, *The Artist's Reality: Philosophies of Art*, p.54.
25 Motherwell quoted in *American Art at Mid-century: The Subjects of the Artist*, exh. cat., National Gallery of Art, Washington 1978, p.15.
26 Barnett Newman, introduction, in *The Ideographic Picture*, exh. cat., Betty Parsons Gallery, New York 1947, unpag. Barnett Newman Papers, Archives of American Art, Smithsonian Institution, Washington.
27 Ibid.
28 Yve-Alain Bois, 'Newman's Laterality', in Melissa Ho (ed.), *Reconsidering Barnett Newman*,

Philadelphia 2002, p.32.
29 Barnett Newman, 'The Sublime Is Now', *Tiger's Eye*, December 1948; *Barnett Newman: Selected Writings and Interviews*, pp.170–3.
30 Barnett Newman, letter to Sidney Janis, 9 April 1955; *Barnett Newman: Selected Writings and Interviews*, p.20.
31 Rothko, letter to Clay Spohn, 11 May 1948, Clay Spohn Papers, Archives of American Art, Smithsonian Institution, Washington; Rothko, *Writings on Art*, p.62.
32 Dorothy Sieberling, *Life*, 8 August 1949, pp.42–5.
33 Rothko, letter to Barnett and Annalee Newman, 16 April 1950; Barnett Newman Papers, Archives of American Art, Smithsonian Institution, Washington.
34 Breslin 1993, p.285.
35 Rothko, letter to Barnett Newman, 6 April 1950; Rothko, *Writings on Art*, p.66.
36 See *Barnett Newman: Selected Writings and Interviews*, pp.34–6.
37 Rothko, letter to Barnett and Annallee Newman, 30 June 1950, Barnett Newman Papers, Archives of American Art, Smithsonian Institution, Washington; Rothko, *Writings on Art*, p.68.
38 Rothko, letter to Barnett and Annallee Newman, 7 August 1950, Barnett Newman Papers, Archives of American Art, Smithsonian Institution, Washington; Rothko, *Writings on Art*, p.70.
39 Irving Sandler, *The Triumph of American Painting: A History of Abstract Expressionism*, New York 1970, p.214.
40 *Barnett Newman: Selected Writings and Interviews*, editor's note, p.34.
41 Sandler 1970, p.214.
42 Alfred Jensen quoted in Breslin 1993, p.313.
43 Barnett Newman, letter to Betty Parsons, 1 December 1955; *Barnett Newman: Selected Writings and Interviews*, p.206.
44 Barnett Newman, 'Statement', 1950; *Barnett Newman: Selected Writings and Interviews*, p.178.
45 Ann Temken, *Barnett Newman*, exh. cat., Philadelphia Museum of Art 2002, p.38.

No.18

1 Rothko, *The Artist's Reality: Philosophies of Art*, p.59.
2 Rothko, 'The Romantics Were Prompted'.

4. The First Picture

1 Chave 1989, pp.111–3.
2 Ibid., p.111.
3 Rothko's Papers, c.1954, Rothko, *Writings on Art*, p.111.
4 Mark Rothko, in 'A Symposium', *Interiors*, 10 May 1951; *Mark Rothko* (Tate Gallery), p.85; Rothko, *Writings on Art*, p.74.
5 Barnett Newman, introduction in *Theodoros Stamos*, exh. cat., Betty

Parsons Gallery, New York 1947 (n.p.).
6 Dore Ashton, *About Rothko*, New York 1983, pp.112–13.
7 Bernice Rose, *Rothko: A Painter's Progress*, exh. cat., Pace Wildenstein, New York 2004, p.20.
8 William C. Seitz, *Abstract-Expressionist Painting in America: An Interpretation Based on the Work and Thoughts of Six Key figures* (PhD. Dissertation, Princeton University, 1955), Cambridge, Massuchusetts 1982, p.78.
9 Ibid. John Gage wrote about the possible influence of Katz on Rothko's approach to colour in John Gage, 'Rothko: Color as Subject', in *Mark Rothko*, exh. cat., National Gallery of Art, Washington 1998, p.255.
10 Ibid., p.78.
11 Ibid., p.79.
12 Rothko, *The Artist's Reality: Philosophies of Art*, p.50.
13 Seitz 1955 (1982), p.102. Seitz reported from his conversation with Rothko how the essence of myth functioned in his painting, noting that 'Antitheses ... are neither synthesized nor neutralized in his work, but held in a confronted unity which is a momentary stasis.'
14 Rothko's Papers, c.1950–60, Rothko, *Writings on Art*, p.144.
15 Rothko, *The Artist's Reality: Philosophies of Art,*, p.41.
16 Mark Rothko, letter to Barnett Newman, August 1950, Barnett Newman Papers, Archives of American Art, Smithsonian Institution, Washington D.C.; Rothko, *Writings on Art*, p.72.In 1950 Rothko had received several requests for written statements on his work, which, if he accepted the invitation would have been published at the same time in *Tiger's Eye* and another unidentified publication for Robert Motherwell (possibly Modern Artists in America, 1951). He was concerned about this trend in the New York art world to have artists clarify their work in the face of the many recent attacks on modern art in the media (see: 'A Life Round Table on Modern Art', *Life*, 9 October 1948, pp.56–68, 70, 75–6, 78–9; Robinson Jeffers, *New York Times Magazine*). In his letter to Newman he wrote: 'I simply cannot see myself proclaiming a series of nonsensical statements, making each vary from the other and which ultimately have no meaning whatsoever'.
17 Interview with William Seitz, 22 January 1952, transcript of interview, William Seitz Papers, Archives of American Art, Smithsonian Institution, Washington.
18 Ibid.
19 Ibid., quoted in Breslin 1993, p.260.
20 Alfred Barr, *Cubism and Abstract Art*, exh. cat., Museum of Modern Art, New York 1936, p.15.
21 Spohn in Breslin 1993, p.260. Breslin edited the grammar and order of Spohn's questions.
22 Ibid., p.261.

23 Ibid., pp.313–14.
24 Rothko, transcript of lecture at the Pratt Institute, 1958, quoted in Breslin 1993, p.390. See also Rothko, *Writings on Art*, pp.125–8.
25 Ibid., p.395.
26 Ibid.
27 Ibid.
28 Kenneth Burke, in 'The Western Round Table on Modern Art (1949)', in Douglas MacAgy (ed.), *Modern Artists in America*, p.28.
29 Rothko quoted in Breslin 1993, p.395.
30 Ibid., p.396.
31 Ibid., pp.396–7.
32 Mark Rothko, quoted in Peter Selz, *Mark Rothko*, exh. cat., Museum of Modern Art, New York 1961, p.12.
33 Rothko, statement in *Tiger's Eye*, no.9, October 1949, p.114; Rothko, *Writings on Art*, p.65.
34 Excerpts from notes taken at a lecture by Mark Rothko at the Pratt Institute, in Dore Ashton, 'L'Automne à New York: Letter from New York', *Cimaise*, December 1958, pp.37–40; *Mark Rothko*, (Tate Gallery) p.87.
35 Ibid.
36 Ibid.

No.3

1 Anfam 1998, p.313.
2 Rothko's Papers, c.1954, Rothko, *Writings on Art*, p.112.

5 Eyes of the Sensitive Observer

1 Excerpts from edited transcript, 'The Western Round Table on Modern Art', San Francisco, 1949, in *West Coast Duchamp*, pp.111–12.
2 Marcel Duchamp's edited version of the transcript of 'The Western Round Table on Modern Art', San Francisco Art Institute Papers, Archives of American Art, Smithsonian Institution, Washington.
3 Marcel Duchamp, 'The Creative Act', text of talk given in Houston at the meeting of the American Federation of the Arts, April 1957, in *The Writings of Marcel Duchamp*, eds. Michael Sanowillet and Elmer Peterson (1973), New York 1989, p.140.
4 Rothko, *Tiger's Eye*, October 1949.
5 Seitz 1955 (1982), p.9.
6 Ibid., p.29.
7 Adolph Gottlieb, interview with Gladys Kashdin, 28 April 1965; transcript on file at The Adolph and Esther Gottlieb Foundation, New York.
8 Clement Greenberg, 'American Type Painting' (1955, 1958); reprinted in Clement Greenberg, *Art and Culture: Critical Essays*, Boston, Massachusetts, 1961; 1965, p.211.
9 Ibid., p. 225.
10 Irving Sandler, *From Avant-Garde to Pluralism*, Lenox, Massachusetts 2006, pp.64–5.
11 Greenberg 1955, 1958, p.226.
12 Seitz 1955 (1982), p.52.
13 Ibid., p.53.
14 Ibid., p.54.

15 Notes taken at Rothko's lecture at the Pratt Insitute, 1958, published in an article by Dore Ashton in *Cimaise,* December 1958; *Mark Rothko* (Tate Gallery), p.87.
16 Breslin 1993, p.330.
17 Rothko, *Tiger's Eye*; *Mark Rothko* (Tate Gallery), p.83.
18 Rothko draft letter to Jewell.
19 Breslin 1993, p.331.
20 Robert Rosenblum, 'The Abstract Sublime', *Art News*, February 1961, pp.38–41; Robert Rosenblum, *Modern Painting in the Northern Romantic Tradition: Friedrich to Rothko*, New York 1975.
21 Robert Rosenblum, 'Notes on Rothko and Tradition', *Mark Rothko* (Tate Gallery), p.24.
22 Rosenblum, 'The Abstract Sublime', p.38.
23 Rosenblum, 'Notes on Rothko and Tradition', p.24.
24 Ibid., pp.24–5.
25 Robert Rosenblum, 'The Abstract Sublime', pp.38, 56.
26 Jeffrey Weiss (ed.), *Mark Rothko* , exh. cat. National Gallery of Art, Washington 1998, pp.306.
27 Gage 1998, p.258.
28 Quoted in Seldon Rodman, *Conversations with Artists*, New York 1957, pp.93–4.
29 Elaine De Kooning, 'Two Americans in Action: Franz Kline and Mark Rothko', *Art News*, November 1957; see Breslin 1993, pp.381–9.
30 Mark Rothko, 'Editor's Letters', *Art News*, December 1957, p.8.
31 Robert Goldwater, 'Reflections on the Rothko Exhibition', *Arts*, March 1961, pp.42–5; *Mark Rothko* (Tate Gallery), pp.32–5.
32 Robert Goldwater, *Primitivism in Modern Painting*, New York and London 1938, repr. as *Primitivism in Modern Art*, Cambridge, Mass. 1986.
33 Robert Goldwater, 'The Western Round Table', in *Modern American Artists*, p.34.
34 Ibid., p.37.
35 Goldwater, 'Reflections on the Rothko Exhibition', *Mark Rothko* (Tate Gallery), p.33.
36 Ibid.
37 Ibid.
38 Ibid.
39 Ibid., p.34.
40 Mark Rothko, letter to Lloyd Goodrich, 20 December 1952; *Mark Rothko* (Tate Gallery), pp.85–6; Rothko, *Writings on Art*, pp.83–4.
41 Dorothy Miller, quoted in Breslin 1993, p.303.
42 Katharine Kuh Papers, Institutional Archives, Art Institute of Chicago; Rothko, *Writings on Art*, p.99.
43 Ibid.
44 Ibid.
45 Ibid.
46 L[averne].G[eorge]., 'Fortnight in Review', *Arts Digest*, 1 May 1955, p.23.
47 Newman explained why he would not attend Rothko's exhibition in a letter to Sidney Janis: 'I am frankly bored with the uninspired, or to put it more

accurately, I am bored with the too easily inspired.' Still similarly declared his rejection of Rothko and reasons for his absence from Rothko's exhibition in a letter to Janis. See Breslin 1993, pp.343–4, Newman, *Selected Writings and Interviews*, pp.201–2. The editor noted that Newman may have never sent this letter.
48 Sidney Janis, interview with Avis Berman, Part 1, 15 October 1981, Archives of American Art, Smithsonian Insitution, Washington.
49 Thomas Hess, 'Reviews and Previews', *Art News*, Summer 1955, p.54.
50 Ibid.; Robert M. Coates, 'The Art Galleries', *New Yorker*, 23 April 1955, pp.121–2.
51 E.C. Goosen, 'The End of Winter in New York', *Art International*, March–April 1958, p.37.
52 Dore Ashton, 'Art', *Arts & Architecture*, April 1958, pp.8, 29, 72.
53 Goldwater, 'Reflections on the Rothko Exhibition', *Mark Rothko* (Tate Gallery), p.34.
54 Ibid.
55 Ibid., pp.34–5.
56 'Suggestions from Mr Mark Rothko regarding the installation of his paintings at the Whitechapel Gallery, 1961.' Notes drafted and sent by the Museum of Modern Art, New York, Archive of the Whitechapel Art Gallery, London; *Mark Rothko* (Tate Gallery), p.88. See also Bonnie Clearwater, 'How Rothko Looked at Rothko', *Art News*, November 1985, pp.100–3.
57 Ibid.
58 Ibid.
59 Ibid.
60 Ibid.
61 Duncan Phillips to Sidney Janis, 6 January 1958, photocopy in Mark Rothko Foundation Papers, National Gallery of Art, Washington.
62 Interview with the author, 1985. Donald Blonken, former president of The Mark Rothko Foundation, was an early collector of Rothko's paintings. The artist arranged his paintings in Blinken's New York apartment in the early 1960s by pairing two dark canvases away from the brighter canvases and watercolours. Rothko insisted on low lighting for the display of his paintings in Blinken's living room.

6 Containing Light

1 Bonnie Clearwater, *Mark Rothko: Works on Paper*, exh. cat., American Federation of Arts and the Mark Rothko Foundation, New York 1984, pp.57–9, Anfam 1998, pp.97–8. Anfam suggests that Plato's Cave may provide the clues to the 'Black and Grays', see ibid., pp.98–9.
2 E.A. Carmean, Jr, Sean Avery Cavanaugh, Christopher Rothko et al., *Coming to Light: Avery, Gottlieb, Rothko*, exh. cat., Knoedler Gallery, New York 2002.
3 Mark Rothko, letter to Yale University;

Rothko, *Writings on Art*, p.157.
4 Mark Rothko, letter to Elise and Stanley Kunitz; Rothko; *Writings on Art*, p.156. In a letter to Herbert Ferber, 19 July 1967, from Berkeley, Rothko wrote of his pleasure in working with art students, adding: 'This is an episode that I value, for in N.Y. I have not found a way to connect with the young that is as illuminating' (Rothko, *Writings on Art*, p.155). Rothko made attempts to connect with younger artists in New York. For instance, he invited Frank Stella to his studio when he saw him at the opening of *New York Painting and Sculpture 1940–1970*, at the Metropolitan Museum of Art in October 1969. Stella, then thirty-three, was preparing for his first retrospective at the Museum of Modern Art. The studio visit never took place as Rothko died a few months later (author's interview with Frank Stella, 2005).
5 According to Pat Trivigno who was a Tulane University, New Orleans, when Rothko taught there in the spring of 1957, Rothko painted *White and Greens in Blue* during this time, and he considered it a 'breakthrough'; see Pat Trivigno, letter to Diane Waldman, 25 August 1977, in the Solomon R. Guggenheim Museum curatorial files.
6 Michael Compton, 'Mark Rothko: The Subjects of the Artist', *Mark Rothko* (Tate Gallery), p.60.
7 Suggestions from Mr. Rothko.
8 Dan Rice, in *Rothko: The 1958–1959 Murals*, texts by Arnold Glimcher and Dan Rice New York: Pace Gallery, 1978, unpag.
9 For his proposal for the Social Security Building mural Rothko may have been following the advice in Edwin Howland Blashfield's book *Mural Painting in America*: 'To the true decorator the circumscribing of lines of any wall or ceiling space cry aloud announcing their own peculiar decorative needs, and it is at once his consideration and his great pleasure to compose his lines and masses within such wall spaces that they shall re-echo the framing and in a delicate way repeat some of the important lines of the architectural ornament which lies about or near them', p.192. Although there is no evidence that Rothko consulted this book he clearly was familiar with Blashfield as he cited descriptions of Renaissance painting from his book *Italian Cities*; see Rothko, *The Artist's Reality: Philosophies of Art*, pp.44–5, 49.
10 As Breslin notes, Rothko mentioned Michelangelo's Medici Library as a source for the Seagram Murals to many of his friends, Breslin 1993, pp.400–1.
11 John Fischer, 'The Easy Chair: Mark Rothko: Portrait of the Artist as an Angry Man', *Harper's*, no.241, July 1970, p.16. Fischer quoted Rothko's remarks on the Seagram Murals: 'After I had been at work for some time, I realized that I was much influenced subconsciously by Michelangelo's Wall in the staircase room of the Medicean

Library in Florence. He achieved just the kind of feeling I'm after – he makes the viewers feel that they are trapped in a room where all the doors and windows are bricked up, so that all they can do is butt their heads forever against the wall.'
12 It is possible that Rothko was responding to Blashfield's description of Giotto's murals. Blashfield in *Italian Cities* wrote that the 'richness of color' in Giotto's frescos was 'greatly enhanced by reflections of gilding from off other walls and the candle lighted alters', Edwin Howland Blashfield, *Italian Cities*, New York 1900, p.129.
13 'Suggestions from Mr Mark Rothko ...'
14 Jeffrey Weiss, 'Rothko's Unknown Space', in Weiss 1998, pp.320–1.
15 Sheldon Nodelman, *The Rothko Chapel Paintings: Origins, Structure, Meaning*, Houston and Austin 1997, p.106–7.
16 Ibid., p.107. There is some debate as to the relationship between the black monochrome series and the paintings for the Rothko Chapel. Nodelman believes they may be early ideas for the Chapel before the architecture was finalised.
17 Ibid.
18 For the prevalence and impact of perceptual studies on art education in the United States after the Second World War see David Dietcher, *Teaching the Late Modern Artist: From Mnemoinics to the Technology of Gestalt*, Ph.D dissertation, The City University of New York 1989; and 'Unsentimental Education: The Professionalization of the American Artist', in *Hand-Painted Pop, American Art in Transition, 1955–62*, exh. cat., Museum of Contemporary Art, Los Angeles 1993, pp.95–118; Michael Lobel, 'Technology Envisioned: Lichtenstein's Monocularity', *Oxford Art Journal*, 24 January 2001, pp.131–54; and Bonnie Clearwater, *Roy Lichtenstein: Inside/Outside*, exh. cat., Museum of Contemporary Art, North Miami 2001.
19 Frank Stella, in 'Interview with Frank Stella by Sidney Tillim', 1969, transcript, Archives of American Art, Smithsonian Institution, Washington, pp.12–3.
20 Frank Stella, 'Grimm's Ecstasy', in Bonnie Clearwater, *Frank Stella at 2000: Changing the Rules*, exh. cat., Museum of Contemporary Art, North Miami 1999, p.68.
21 Frank Stella in 'Questions to Stella and Judd', interview by Bruce Glaser, ed. Lucy R. Lippard, in Gregory Battcock (ed.), *Minimal Art: A Critical Anthology*, New York 1968, p.149.
22 Frank Stella in conversation with the author, 1999.
23 Frank Stella, 'Picasso', in *Working Space*, Harvard 1986, p.84.
24 Ibid.
25 Ibid. p.123.
26 Quoted in Lawrence Weschler, *Seeing Is Forgetting the Name of the Thing One Sees: A Life of Contemporary*

Artist Robert Irwin, Berkeley and Los Angeles, and London 1982, p.49.
27 Ibid.
28 Ibid., p.63.
29 Ibid., p.78.
30 Ibid., p.127.
31 Ibid, p.129.
32 Nodelman 1997, pp.92–3. The modulated surface of the monochrome Chapel paintings may have been inspired by the light flickering off the mosaics in the apse of the basilica. Nodelman also suggested that Friederich Kiesler's large installation, *Last Judgement* 1955–9, 1964–5, may have influenced Rothko's plan for the Rothko Chapel; pp.55–6.
33 Ibid., p.94.
34 Ibid.
35 Ibid., p.163.
36 Ibid.
37 Ibid., p.165.
38 Ibid., p.167.
39 Ibid.
40 Ibid.
41 Ibid., p.179.
42 Rothko, letter to John and Domique de Menil, 1 January 1966; Menil Foundation, Houston: excerpt from letter in *The Rothko Chapel* (Houston 1979), p.4.
43 Robert Goldwater, 'Rothko's Black Paintings', *Art in America*, no.59, March–April 1971, p.58.
44 Dore Ashton, personal unpublished notes, 26 February 1969.
45 Irving Sandler in conversation with the author, January 1982.
46 Weiss 1998, pp.326–9.
47 Arthur Danto, *Embodied Meanings: Critical Essays and Aesthetic Meditations*, New York 1994, pp.ix–x; quoted in Anfam 1998, p.97.
48 Count Guiseppe Panza di Biumo, 'Artist of the Sky' in Julia Brown (ed.), *Occluded Front: James Turrell*, Los Angeles 1985, p.69.
49 Rothko, 'The Romantics were Prompted'.

The Tate Murals

1 Rothko, letter to Sir Norman Reid, 1965, Tate Archives.
2 Rothko, letter to Reid, 24 April 1967.
3 Suggestions from Mr. Rothko.
4 Goldwater, 'Reflections on the Rothko Exhibition' (Tate Gallery), pp.34–5.
5 Ibid.

Mark Rothko's Painting Technique

1 *Red on Maroon* 1958, Tate Collection T01165.
2 Oil-modified alkyd resin, first produced in 1927, was adopted by the commercial paint industry as an alternative to linseed oil in household paint after the Second World War. In artist's materials, its primary use is as a modifier to change the working properties of oil paint. See Jo Crook and Tom Learner, *Impact of Modern Paints*, London 2000, pp.17–21. In 1958, Grumbacher produced a painting medium based on an alkyd resin.

3 Ann Farber.
4 See James Breslin, 'Out of the Body: Mark Rothko's Paintings' in Kathleen Adler and Marcia Pointon (eds.), *The Body Imaged: The Human Form and Visual Culture since the Renaissance*, Cambridge 1994, pp.43–51.
5 Significant early studies of Rothko's work raised the important issue of the delicate nature of his paintings and speculated that they were not built to last. Thankfully, this prescient warning alerted custodians of his work to the unusual properties and has helped to ensure longevity; Dana Cranmer, *Ephemeral Paintings on Permanent View: The Accelerated Ageing of Mark Rothko's Paintings*, ICOM-CC, Sydney 1987, vol.1, pp.283–5; Dana Cranmer, 'Painting Materials and Techniques of Mark Rothko: Consequences of an Unorthodox Approach', in *Mark Rothko*, (Tate Gallery 1987), revised ed. 1996, pp.189–97.
6 See Carol Mancusi Ungaro, *The Rothko Chapel: Treatment of the Black-Form Triptychs*, IIC, Brussels 1990, pp.134–7, and Carol Mancusi Ungaro and Pia Gottschaller, *The Rothko Chapel: Reflectance, Reflection and Restoration, Zeitschrift für Kunsttechnologie und Konserveiung*, 2, Worms 2002, pp.215–23.
7 Marjorie B. Cohn, Karyn Escelonis, Teresa Hensick *et al.*, *Mark Rothko's Harvard Murals*, Harvard University Art Museums, Cambridge, Massachusetts 1988.
8 Rothko himself employed Daniel Goldreyer to restore his paintings. Goldreyer lined, varnished and retouched four of the Seagram Murals before they entered the Tate Collection in 1970. These paintings now exhibit different characteristics from the unlined paintings.
9 Alison Langley, 'The Materials of Mark Rothko's Multiforms', research paper submitted to *Journal of the American Institute for Conservation*, 2006. I am grateful to Alison Langley for kindly making her paper available to me prior to publication.
10 Carol Mancusi-Ungaro, 'Nuances of Surface in the Rothko Chapel Paintings', in *Mark Rothko: The Chapel Commission*, exh. cat., The Menil Collection, Houston 1996.
11 Tom Learner and Joyce Townsend, analysis reports, Tate Conservation Science. Mary Bustin, 'The Rothko Room' in *The Picture Restorer* 2001. See Mancusi-Ungaro 1990, pp.134–7 for a description of mixing paint with Ray Kelly in reconstructions of the Houston Murals.
12 Whilst producing a lustrous and intense coloured paint, oil also has drawbacks as painting medium: it is slow to dry, it can slump, wrinkle, and lack body. Artists and paint manufacturers have long sought to modify oil paint with driers, extenders and bulking agents to improve handling and drying properties.
13 Breslin 1993, p.56.

14 Ralph Mayer, *The Artist's Handbook of Materials and Techniques*, New York 1950, p.188.
15 Rothko, 1947, Resumé San Francisco School of Fine Arts Archives, quoted in Langley 2006.
16 Susanne Lomax, FTIR and GCMS analysis, in Langley 2006.
17 'I have made a place'; Rothko quoted in Dore Ashton, *About Rothko*, New York 1983, p.155.
18 Dan Rice, interview with Mary Bustin and Jo Crook, 2000.
19 Michael Compton, in *Mark Rothko: The Seagram Murals*, Tate Gallery, London 1987, p.59.
20 Ashton 1983, p.155.
21 *Red on Maroon* (Tate Collection T01165) is 266.7cm high. The top and bottom edges are selvedges.
22 Hardboard.
23 Roy Edwards, interview, June 1970, in 'Working with Rothko, A Conversation between Roy Edwards and Ralph Pomeroy, *New American Review*, 12, Simon and Schuster, New York, p.109.
24 Herbert Ferber interviewed by Phyllis Tuchman, 2 June 1981, Archives of American Art, transcript p.7.
25 US Army Duck was used for *Untitled* (estate number 3257.39) 1945, National Gallery of Art, Washington, illustrated in Cranmer 1996, p.190; catalogued in Anfam 1998, p.228.
26 Dan Rice, Rothko's assistant on the Seagram Murals, recollected that Rothko obtained his canvas from an awning company; BBC interview, David Thompson and Francis Whately at Tate Britain, London 2000.
27 Rice recalls that Lou Skroi's workshop was upstairs. Together they machined lengths of wood, which Rice would then fashion into stretchers. Rice, interview with Bustin and Crook, 2000.
28 Cross bars meet the outer bars in a butt-join, which looks precarious but is held firmly by screws driven through the sides.
29 Mancusi-Ungaro 1998, p.284.
30 Top and bottom edges are not painted.
31 It is not uncommon to find that Rothko's painted edges have been repainted, not by the artist but either by his restorer or by later hands.
32 Cranmer 1996, p.190.
33 Langley 2006.
34 Barium white, barium sulphate, permanent white, used as a filler or extender in paints. See Rutherford J. Gettens and George L. Stout, *Painting Materials: A Short Encyclopedia*, New York 1966, p.96 (first published 1942 by D. Van Nostrand Co.).
35 Rice, BBC interview 2000. For example, *Red on Maroon* is primed with maroon and ultramarine powder pigments bound in animal-skin glue size: Tom Learner, analysis report, animal glue, High Performance Liquid Chromatography (HPLC), Tate Conservation Science, October 2005; Joyce Townsend, maroon pigment with synthetic ultramarine, cross-section analysis, January 1999.

36 Rice, BBC interview, 2000, and Rice, interview with Bustin and Crook, 2000.
37 Rothko's early paintings were on pre-primed canvas with white grounds; Cranmer 1996.
38 'When normally glossy pure oil colours are applied over grounds that are considerably more absorbent than the average prepared artist's canvas, usually enough of the excess oil is absorbed into the ground to produce a mat surface on the painting.' Mayer 1950. Absorbent grounds were the subject of much experimentation in the preceding century. 'Basically the Venetian method of painting as understood in [Mérimée 1839 and Fielding 1839] entailed the use of an absorbent ground made with size. When oil paint was applied to this ground, much of the oil was absorbed; this was thought to result in more brilliant and lasting colours.' Leslie Carlyle, *The Artist's Assistant*, London 2001, p.166.
39 Langley 2006.
40 Joyce Townsend, *Turner's Painting Techniques*, London 1993, p21.
41 I am grateful to Joyce Townsend for this insight.
42 Rice, interview Bustin and Crook, 2000.
43 Mayer 1950, p.514.
44 See Cohn 1988.
45 The right-hand side of *Red on Maroon* has faded slightly since a restoration treatment in the late 1970s. Retouching carried out in 1973 in stable pigments is now slightly redder than the surrounding paint.
46 Paul Whitmore, in Cohn 1988, pp.61–2.
47 Hensick in Cohn 1988, p.17.
48 Max Doerner, *The Materials of the Artist and their Use in Painting: With Notes on Techniques ofhte Old Masters.* trans Eugen Neuhaus (1935), San Diego and New York 1984, p.75.
49 Elizabeth Jones, memorandum, 15 March 1971, quoted in Cohn 1988, p.10.
50 Rothko had a rather dry, sarcastic wit. Christopher Rothko, personal communication, April 28 1999.
51 Paul Seaton, Hon. Archivist and Historian to Woolworths Group plc, personal communication, http://museum.woolworths.co.uk.
52 Ethel Franks, '"Yesterdays": Those Woolworth Days', 22 June 2006: www.townonline.com
53 Dana Cranmer artists' ephemera collection: a tune of Rothko's paint – Bellini oil colour made by Leonard Bocour.
54 Learner and Crook 2000, p.25.
55 Learner 2000, p.26.
56 Advertisement for Magna, 'Artist's permanent plastic paint', 1956.
57 Learner 2000, p.27.
58 Cranmer 1996.
59 Tom Learner, analysis, Tate, London 2005.
60 Tom Learner, analysis in Mancusi Ungaro and Gottschaller 2002, pp.215–23.
61 Ungaro 1990, p.35.

62 Cranmer 1996, p.191.
63 Clearwater 1984, p.30.
64 Cranmer 1996, p.189.
65 Study 477, Mary E. Schneider, in Cohn 1988, p.35.
66 Clearwater 1984, p.39.
67 Mayer 1950, p.138.
68 Tate Collection, T00275.
69 Joyce Townsend, cross-section and EDX analysis report, Tate, London, 19 May 2000.
70 Sally Avery interviewed by Tom Wolf, 19 February 1982, in *Rothko and his Times*, interviews, Archives of American Art.
71 Oliver Steindeker, interview with the Rothko Foundation, May 10 1983, Mark Rothko files, National Gallery of Art, Washington; Breslin 1993, p.526.

Select Bibliography

Entries are listed chronologically within each section.

Catalogue raisonné of works on canvas

Illustrations David Anfam, *Mark Rothko: The Works on Canvas*, New Haven and London 1998. Reference numbers beginning with 'A' given in the text refer to entries in this publication

Writings and contributions by Rothko

Illustrations in Lewis Browne, *The Graphic Bible: From Genesis to Revelation in Animated Maps and Charts*, New York, 1928

'Scribble Book', manuscripts and Sketchbook, c.1935–43, acc. no. 2002.M.8 (box 2), Research Library, Getty Research Institute, Los Angeles. Repr. in Glen Phillips and Thomas Crow (eds.), *Seeing Rothko*, Los Angeles and London 2005, pp.232–61

Statement by Marcus Rothkowitz and Bernard Braddon, in *The Ten: Whitney Dissenters*, exh. leaflet, Mercury Galleries, New York 1938

Letter by Marcus Rothko and Adolph Gottlieb with unacknowledged collaboration of Barnett Newman, in Edward Alden Jewell, 'The Realm of Art: A New Platform and Other Matters: "Globalism" Pops Into View', *New York Times*, 13 June 1943, sec.2, p.9

'The Portrait and the Modern Artist', transcript for a joint broadcast by Mark Rothko and Adoph Gottlieb on Radio WNYC (New York) 13 Oct. 1943. Repr. in *Mark Rothko 1903–1970*, exh. cat., Tate Gallery 1987, pp.78–81

Personal statement, in David Porter, *Personal Statement, Painting Prophecy – 1950*, Washington 1945

'Foreword' in *First Exhibition Paintings: Clyfford Still*, exh. cat., Art of This Century, New York 1946

Personal statement, in 'The Ides of Art: The Attitudes of Ten Artists on their Art and Contemporaneousness', *The Tiger's Eye*, no.2, Dec. 1947, p.44

'The Romantics Were Prompted', *Possibilities 1*, Winter 1947–8, p.84

'Statement on his Attitude in Painting', *The Tiger's Eye*, no.9, Oct. 1949, p.114

'A Symposium on How to Combine Architecture, Painting and Sculpture' (held at the Museum of Modern Art, New York, 19 March 1951), *Interiors*, 10 May 1951, pp.100–5 [includes statement by Rothko on large paintings, p.104]

'Editor's Letters', *Art News*, vol.56, no.8, Dec. 1957, p.6

Lecture at the Pratt Institute, Brooklyn, October 1958. Repr. in James E.B. Breslin, *Mark Rothko: A Biography*, Chicago and London 1993, chap.13

The Artist's Reality: Philosophies of Art, ed. and with introduction by Christopher Rothko, New Haven and London 2004

Writings on Art, ed. and with intro. by Miguel López-Remiro, New Haven and London 2006

Articles on Rothko

'Brown Belittles Drawings in Book', *New York Times*, 5 Jan. 1929, p.7.

Catherine Jones, 'Noted One-Man Show Artist One-Time Portland Resident', *Sunday Oregonian*, 30 July 1933, sec.3, p.5.

Jane Schwartz, 'Around the Galleries', *Art News*, 2 Dec. 1933, pp.8, 16.

Jerome Klein, 'Ten Who Are Nine Return for Second Annual Exhibit', *New York Post*, 19 Dec. 1936, p.24 [review of Montross Gallery exh.].

J.[eannette] L.[owe], 'Three Moderns: Rothko, Gromaire and Solman', *Art News*, 20 Jan. 1940, p.4.

Jewell, Edward Alden, 'Modern Painters Open Show Today', *New York Times*, 2 June 1943, p.28 [review of Wildenstein exh.]

Edward Alden Jewell, '"Globalism": of Windmill Tilting and Cheshire Cats', *New York Times*, 27 June 1943, sec.2, p.6

Maude Riley, 'The Mythical Rothko and his Myths', *Art Digest*, 15 Jan. 1945, p.15 [review of The Art of This Century exh.]

Douglas MacAgy, 'Mark Rothko', *Magazine of Art*, vol.42, no.1, Jan. 1949, pp.20–1

T.[homas] B. H.[ess], 'Review and Previews', *Art News*, no.48, April 1949, pp.48–9 [reviewof Parsons exh.]

Michel Seuphor, 'Paris, New York', trans.

Francine du Plessix and Florence Weinstein, in *Modern Artists in America*, New York 1951, p.118

Hubert Crehan, 'Rothko's Wall of Light: A Show of his New Work at Chicago', *Art Digest*, 1 Nov. 1954, pp.5, 19

Katherine Kuh, 'Mark Rothko', *Art Institute of Chicago Quarterly*, 15 Nov. 1954, p.68

Robert M. Coates, 'The Art Galleries: Pros and Semi-Pros', *New Yorker*, 23 April 1955, pp.121–2 [review of Sidney exh.]

G.[eorge] L.[averne], 'Fortnight in Review: Mark Rothko', *Arts Digest*, 1 May 1955, p.18 [review of Janis exh.]

Clement Greenberg, 'American-Type Painting', *Partisan Review*, no.22, Spring 1955, pp.179–96

Thomas B. Hess, 'Reviews and Previews', *Art News*, no.54, Summer 1955, p.54 [review of Janis exh.]

Dore Ashton, 'Art: Mark Rothko', *Arts & Architecture*, vol.74, no.8, Aug. 1957, pp.8, 31

Dore Ashton, 'Lettre de New York', *Cimaise*, no.5, March–April 1958, pp.30–2 [review of Janis exh.]

Dore Ashton, 'Art: Lecture by Rothko', *New York Times*, 31 Oct. 1958, p.26

Dore Ashton, 'L'Automne à New York: Letter from New York', *Cimaise*, no.6, Dec. 1958, pp.37–40

E.C. Goossen, 'The End of Winter in New

York', *Art International*, no.2, March–April 1958, p.37 [review of Janis exh.]

Alan Bowness, 'Absolutely Abstract', *Observer*, 15 Oct. 1961, p.27 [review of Whitechapel exh.]

Rosenblum, Robert, 'The Abstract Sublime', *Art News*, no.59, Feb. 1961, pp.38–41.

Robert Goldwater, 'Reflections on the Rothko Exhibition', *Arts*, no.35, March 1961, pp.42–5.

David Sylvester, 'Rothko', *New Statesman*, 20 Oct. 1961, pp.573–4

Lawrence Alloway, 'Notes on Rothko', *Art International*, no.6, Summer 1962, pp.90–4

D.[onald] J.[udd], 'New York Exhibitions: In the Galleries, Mark Rothko', *Arts*, no.37, Sept. 1963, pp.57–8 [review of Guggenheim exh.]

Brian O'Doherty, 'Art: Rothko Panels Seen', *New York Times*, 10 April 1963, p.36 [review of Guggenheim exh.]

Max Kozloff, 'The Problem of Color-Light in Rothko', *Artforum*, no.4, Sept. 1965, pp.38–44

Norman Reid, 'The Mark Rothko Gift: A Personal Account', in *The Tate Gallery 1968–70*, London 1970

John Fischer, 'The Easy Chair. Mark Rothko: Portrait of the Artist as an Angry Man', *Harper's*, no.241, July 1970, pp.16–7

Grace Glueck, 'Mark Rothko, Artist, a Suicide Here at 66', *New York Times*, 26 Feb. 1970, pp.1, 39

Thomas B. Hess, 'Editorial: Mark Rothko, 1903–1970', *Art News*, no.69, April 1970, pp.29, 66

Hilton Kramer, 'A Pure Abstractionist: Rothko's Work, in Color, Conveyed Luminosity Yet an Extreme Serenity', *New York Times*, 26 Feb. 1970, p.39

Dore Ashton, 'The Rothko Chapel in Houston', *Studio International*, no.181, June 1971, pp.273–5.

Roy Edwards and Ralph Pomeroy, 'Working with Rothko', *New American Review*, no.12, 1971, pp.108–21

Robert Goldwater, 'Rothko's Black Paintings', *Art in America*, no.59, March–April 1971, pp.58–63

Brian O'Doherty, 'The Rothko Chapel', *Art in America*, no.61, Jan.–Feb. 1973, pp.14–6, 18, 20

Barbara Rose, 'The Environment of Faith', *Vogue*, Dec. 1972, pp.133–5

Ann Gibson, 'Regression and Color in Abstract Expressionism: Barnett Newman, Mark Rothko and Clyfford Still', *Arts Magazine*, no.55, March 1981, pp.144–53

Bonnie Clearwater, 'Shared Myths: Reconsideration of Rothko's and Gottlieb's Letter to The New York Times', *Archives of American Art Journal*, vol.24, no.1, 1984, pp.23–5

Stephen Polcari and Ann Gibson, 'New Myths for Old: Redefining Abstract Expressionism', *Art Journal*, vol.47, Fall 1988 [special issue]

Mancusi-Ungaro, Carole, 'The Rothko Chapel: Treatment of the Black-Form Triptychs', in *Cleaning, Retouching and Coatings*, John S. Mills and Perry Smith (eds.) International Institute for Conservation of Historic and Artistic Works, London 1990

David Anfam, 'Rothko's Hopper: A Strange Wholeness', in Sheena Wagstaff (ed.), *Edward Hopper*, exh.cat., Tate Modern, London 2004

Solo exhibition catalogues

Mark Rothko, Contemporary Art Museum, Houston 1957

Mark Rothko, Museum of Modern Art, New York 1961

Mark Rothko, Whitechapel Art Gallery, London 1961

Mark Rothko, Marlborough New London Gallery, London 1964

Rothko: The 1958–1959 Murals, Pace Gallery, New York 1978

Mark Rothko 1903–1970: A Retrospective, Solomon R. Guggenheim Museum, New York 1978

Mark Rothko: The Surrealist Years, Pace Gallery, New York 1981

Mark Rothko 1949: A Year in Transition – Selections from the Mark Rothko Foundation, San Francisco Museum of Modern Art 1983

Mark Rothko: Seven Paintings from the 1960's, Walker Art Center, Minneapolis 1983

Mark Rothko: Subjects, High Museum of Art, Atlanta 1983

Mark Rothko: Works on Paper, American Federation of Arts and the Mark Rothko Foundation, New York 1984

Mark Rothko, 1903–1970, Tate Gallery, London 1988

Mark Rothko: The Seagram Mural Project, Tate Gallery, Liverpool 1988

Mark Rothko: Multiforms, Pace Gallery, New York 1990

Mark Rothko, National Gallery of Art, Washington 1991

Mark Rothko: Multiforms, Galerie Daniel Blau, Munich 1993

Mark Rothko: The Last Paintings, Pace Gallery, New York 1994

Mark Rothko, National Gallery of Art, Washington 1998

Mark Rothko, essays by Oliver Wick, Marjorie B. Cohn *et al.*, Fondation Beyeler, Basel 2001

Group exhibition catalogues

Dorothy C. Miller (ed.), *15 Americans*, Museum of Modern Art, New York, New York 1952

New York Painting and Sculpture: 1940–1970, Metropolitan Museum of Art, New York 1969

The Natural Paradise: Painting in America 1800–1950, Museum of Modern Art, New York 1976

Abstract Expressionism: The Formative Years, Herbert F. Johnson Museum of Art, Ithaca, New York 1978

American Art at Mid-Century: The Subjects of the Artist, National Gallery of Art, Washington 1978

The Interpretive Link: Abstract Surrealism into Abstract Expressionism, Works on Paper, 1938–1948, Newport Harbor Museum, Newport Beach 1986

Abstract Expressionism: The Critical Developments, Albright-Knox Gallery, Buffalo, New York 1987

Bonnard/Rothko: Color and Light, Wildenstein and PaceWildenstein, New York 1997

Publications on Rothko

John Perreault, *A Personal View of the Rothko Chapel and the Newman Obelisk*, Houston 1972

Russell Bowman, 'The Theme of Tragedy in the Work of Mark Rothko', MA dissertation, University of Chicago 1975

Sheldon Nodelman, *Marden, Novros, Rothko: Painting in the Actuality*, Houston 1978

Lee Seldes, *The Legacy of Mark Rothko*, New York 1978

Deborah Wye, 'Mark Rothko in the Thirties and Forties: A Stylistic Analysis and Proposed Chronology for a Largely Unknown Body of Early Works' MA dissertation, City University of New York, Hunter College 1979

Anna C. Chave, 'Mark Rothko's Subject Matter', Ph.D. dissertation, Yale University 1982

Dore Ashton, *About Rothko*, New York 1983

Mark Rothko Foundation, *Eliminating the Obstacles Between the Painter and the Observer*, New York 1986

Marjorie B. Cohn (ed.), *Mark Rothko's Harvard Murals*, Cambridge, Mass., 1988

Susan J. Barnes, *The Rothko Chapel: An Act of Faith*, Austin, Texas 1989

Anna C. Chave, *Mark Rothko: Subjects in Abstraction*, New York and London 1989

Marc Glimcher (ed.), *The Art of Mark Rothko: Into an Unknown World*, New York 1991

James E.B. Breslin, *Mark Rothko: A Biography*, Chicago and London 1993

Sheldon Nodelman, *The Rothko Chapel Paintings: Origins, Structure, Meaning*, Houston and Austin 1997

E.A. Carmean, Jr, Sean Avery Cavanaugh, Christopher Rothko *et al.*, *Coming to Light. Avery, Gottlieb, Rothko: Provincetown Summers 1957–1961*, New York 2003

Klauss Ottman, *Mark Rothko*, New York 2003

Glen Phillips and Thomas Crow (eds.), *Seeing Rothko*, Los Angeles and London 2005

General publications on art

William C. Seitz, 'Abstract-Expressionist Painting in America: An Interpretation Based on the Work and Though of Six Key Figures', PhD dissertation, Princeton University 1955, Cambridge, Massachusetts 1982

Jeffery Weiss, 'Science and Primitivism: A Fearful Symmetry in the Early New York School', *Arts Magazine*, no.57,

March 1983, pp.81–7

Selden Rodman, *Conversations with Artists*, New York 1957

Irving Sandler, *The Triumph of American Painting: A History of Abstract Expressionism*, New York 1970

Robert Rosenblum, *Modern Painting and the Northern Romantic Tradition: Freidrich to Rothko*, New York 1975

Stephen Polcari, 'The Intellectual Roots of Abstract Expressionism', Ph.D. dissertation, University of California at Santa Barbara 1980

Serge Guilbaut, *How New York Stole the Idea of Modern Art: Abstract Expressionism, Freedom and the Cold War*, Chicago and London 1983

David Anfam, *Abstract Expressionism*, London 1990

Michael Leja, *Reframing Abstract Expressionism: Subjectivity and Painting in the 1940s*, New Haven and London 1993

John Golding, *Paths to the Absolute: Mondrian, Malevich, Kandinsky, Pollock, Newman, Rothko and Still*, Princeton, New Jersey 1997

David Craven, *Abstract Expressionism as Cultural Critique: Dissent During the McCarthy Period*, Cambridge 1999

Erika D. Passantino and David W. Scott (eds.), *The Eye of Duncan Phillips: A Collection in the Making*, New Haven 1999

Robert Rosenblum, *On Modern American Art: Selected Essays*, New York 1999

Nancy Jachec, *The Philosophy and Politics of Abstract Expressionsim: 1940–1960*, Cambridge and New York 2000

Sheldon Nodelman, 'Reading Rothko' [review of *The Artist's Reality*] in *Art in America*, 1 Oct. 2005

Irving Sandler, *Avant-Garde to Pluralism: An On-the Spot History*, Lenox, Mass., 2006

Katharine Kuh, *My Love Affair with Modern Art: Behind the Scenes with a Legendary Curator*, ed. Avis Berman, New York 2006

Copyright Credits

Photographic Credits

Index